Monet in Normandy

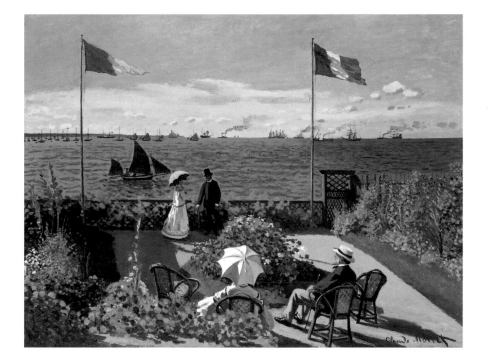

Monet in Normandy

Heather Lemonedes · Lynn Federle Orr · David Steel

WITH ESSAYS BY
Richard Brettell

RIZZOLI
NEW YORK

Published in conjunction with the exhibition *Monet in Normandy*:
Fine Arts Museums of San Francisco, June 17–September 17, 2006
North Carolina Museum of Art, October 15, 2006–January 14, 2007
The Cleveland Museum of Art, February 18–May 20, 2007

FRONT COVER: Detail, cat. 30.
BACK COVER: cat. 54.
HARDCOVER ENDPAPERS: Detail, road map of Normandy, Edouard Frère, *Guide du voyageur en Normandie*. Rouen: A. Le Brument, 1844. Courtesy Collections de la Bibliothèque municipale de Rouen, Photographies Thierry Ascencio-Parvy.
HARDCOVER CASE: cat. 41.
PAGE 1: cat. 6. PAGES 2–3: Detail, cat. 21. OPPOSITE: Detail, cat. 47. PAGE 10: Detail, cat. 43.
PAGES 12–13: Detail, cat. 16. PAGES 50–51: Detail, cat. 35.

Hardcover back cover quotation as translated by Bridget Strevens Romer in Kendall 1989, 181.

First published in the United States of America in 2006
by Rizzoli International Publications, Inc.
300 Park Avenue South
New York, NY 10010
www.rizzoliusa.com

© 2006 Fine Arts Museums of San Francisco,
North Carolina Museum of Art, and The Cleveland Museum of Art

2006 2007 2008 2009 / 10 9 8 7 6 5 4 3 2

Printed in China

Hardcover ISBN-10: 0-8478-2842-5
Hardcover ISBN-13: 9-780-8478-2842-5
Paperback ISBN-10: 0-8478-2899-9
Paperback ISBN-13: 9-780-8478-2899-9

Designed by Laura Lindgren

Library of Congress Catalog Control Number: 2006921452

Directors' Foreword

Claude Monet's central and enduring artistic relationship with the French region of Normandy—its dramatic coastline, commercial port cities and picturesque villages, countryside, and rivers—has never before been the focus of a major exhibition. Building on the scholarship of Robert Herbert and Joachim Pissarro, among others, *Monet in Normandy* marks the first comprehensive consideration of this essential aspect of Monet's artistic career in the exhibition format. *Monet in Normandy* concentrates on the prolonged and intimate relationship between France's premier landscape artist and the scenery, both natural and man-made, that formed and nurtured him artistically throughout a long career. Although born in Paris, Monet moved with his parents to Normandy as a small child, beginning a lifelong intimacy with Normandy and the Norman coastal region of the English Channel. Monet's earliest pictorial experiments were made on or near its shores, and he returned to Normandy many times over the ensuing decades. In the 1880s, Monet moved his family to the opposite side of Normandy, to the village of Giverny—Paris's gateway to this rich agrarian province. In Giverny Monet painted the nearby villages, fields, and waterways. Then with the new century, Monet turned his artistic attention to the private gardens that he had designed and crafted, a personal landscape that monopolized Monet's energy until his death there in 1926.

Initial ideas for this exhibition developed out of conversations between Dr. David Steel (Curator of European Art, North Carolina Museum of Art, Raleigh) and Dr. Richard R. Brettell (Margaret McDermott Distinguished Professor of Art and Aesthetics, The University of Texas at Dallas), who became the exhibition's guest curator. In 2002, Dr. Lynn Federle Orr (Curator in Charge of European Art, Fine Arts Museums of San Francisco) was invited to join the curatorial team, which was finalized when Dr. Heather Lemonedes (Assistant Curator of Prints and Drawings, The Cleveland Museum of Art) became Cleveland's curatorial representative on the project. This stunning exhibition has been a cooperative effort of our three institutions, which have shared all intellectual, organizational, and administrative responsibilities.

We particularly want to single out Katharine Lee Reid (former director at The Cleveland Museum of Art) and Harry S. Parker (former director at the Fine Arts Museums of San Francisco). These two accomplished museum professionals helped to fashion the early vision of this project; their efforts and valuable support are evident in the rich array of masterworks secured for the exhibition.

This handsome publication has also been a team enterprise. Noted specialist Richard R. Brettell has contributed three far-ranging and insightful essays to the exhibition's catalogue, each dealing with Normandy itself: Normandy as the first region of France to be intensively exploited as a site of tourism; Normandy and its characterization in art prior to Monet; and Normandy as depicted and mythologized in the art of Monet. This

rich contextual approach helps to craft a clearer picture of the relationship between the artist, his subject matter, and the artistic traditions of Normandy. These elements are further explored through the scholarly entries on the individual paintings written by exhibition curators Heather Lemonedes, Lynn Orr, and David Steel. What emerges is a complex and detailed look at one of France's most gifted artists and the natural environment that formed and inspired him.

The success of any art exhibition is determined by the quality of the visual experience it provides for its visitors. In this regard, we have been heartened by the support received from over forty prestigious museums and private collectors, who have generously lent important paintings from their collections. To each lender we extend our deepest appreciation.

As recognition of the importance of the exhibition and this scholarly catalogue, financial support has come from several sources. Bank of America continues to underwrite arts programs in the Bay Area, providing generous funds for the exhibition in San Francisco. Generous support for the presentation of the exhibition at the North Carolina Museum of Art has been provided by GlaxoSmithKline and Progress Energy. The exhibition is also supported by an indemnity from the Federal Council on the Arts and Humanities.

Monet in Normandy, as both exhibition and accompanying catalogue, greatly enhances our understanding of the artistic heritage of Normandy and of the artists who worked there. More specifically, it traces with works of singular beauty the fullness and complexity of Monet's "image" of Normandy—its beaches, villages, rivers, agriculture and tourist industries, as well as the grandeur and historical importance of its capital city, Rouen, and finally Monet's own property in Giverny. We are privileged to bring this splendid group of paintings to our respective audiences.

<div align="right">

JOHN E. BUCHANAN, JR.
Fine Arts Museums of San Francisco

LAWRENCE J. WHEELER
North Carolina Museum of Art

TIMOTHY RUB
The Cleveland Museum of Art

</div>

Acknowledgments

Bringing together more than sixty paintings of Norman subjects by Claude Monet has been an extraordinarily satisfying experience. Amassing such a number of works by one of the best-loved artists of all time and persuading more than forty collections, public and private, in the United States, Europe, and Asia to part with some of their most treasured paintings, even for a few months, has been a unique challenge. In this regard, we benefited from the efforts of both Katharine Lee Reid, former director of The Cleveland Museum of Art, and Harry S. Parker, former director of the Fine Arts Museums of San Francisco, who enthusiastically supported the exhibition during their tenures.

The organizing curators wish to recognize Dr. Richard R. Brettell, who in his role as guest curator brought an extraordinary dimension to this project. His three catalogue essays add significantly to an understanding of the complex and evolving relationships Monet (and his artistic forbears and contemporaries) had with the province of Normandy.

The organizers have also benefited from working in conjunction with FRAME, French Regional and American Museum Exchange, a unique bilateral consortium that stresses the importance of regional artistic culture. This association has given the exhibition curators direct access to French scholars, archives, curators, and collections. We particularly wish to thank Laurent Salomé, Director of the Museums of the City of Rouen, for his early involvement and advice on this project.

Bringing this exhibition and accompanying publication to fruition required the tireless collaboration of the professional staffs of the three organizing museums: the Fine Arts Museums of San Francisco, the North Carolina Museum of Art, and The Cleveland Museum of Art. Among the many shared responsibilities, San Francisco acted as project registrar, the North Carolina Museum of Art oversaw production of the catalogue, and Cleveland managed the exhibition finances.

From The Cleveland Museum of Art, we would particularly like to thank Dr. Charles L. Venable, Deputy Director for Collections and Programs, for helping to secure numerous loans that have greatly contributed to the success of the exhibition. We extend our profound thanks to Heidi Domine Strean, Head of Exhibitions, for guiding this project from inception to completion. Special thanks are also due to Morena L. Carter and Tiara L. Paris in the Exhibitions Department. We are grateful for the scholarly contribution of Dr. William Robinson, Curator of Modern European Art, and Margaret Burgess, Cleveland Fellow for European Painting, who contributed an entry to the catalogue. Others deserving recognition include: Marcia Steele, Conservator of Paintings; Laurence Channing, Head of Publications; Barbara J. Bradley, Editor; Mary Suzor, Chief Registrar; Kathleen Kornell, Rights and Reproductions Coordinator; Betsy Lantz and Christine Edmonson at the Ingalls Library at The Cleveland Museum of Art; and Ed Bauer, Controller.

From the Fine Arts Museums of San Francisco, we would like to express our gratitude to Krista Bugnara Davis, Director of Exhibitions; Allison Satre, Exhibitions Assistant; and Therese Chen Higgins, Director of Registration, among many others, for their dedication to this project. We also wish to thank Marion C. Stewart, Associate Curator of European Paintings, for her continuing support and thoughtful insights.

From the North Carolina Museum of Art special thanks go to Emily S. Rosen, who was the project manager for the exhibition catalogue; Joelle Rogers, who secured rights and reproductions for the project; Karen Malinofski, Head Photographer; Christopher Ciccone, Photographer; William Holloman, Photo Services Researcher; Natalia Lonchyna, Head Librarian; Caroline Rocheleau, GlaxoSmithKline Curatorial Research Fellow; Carrie Hedrick, Registrar; and John Coffey, Deputy Director for Collections. The staff at the Sterling and Francine Clark Art Institute, in particular Karen Bucky, Collections Access and Reference Librarian; Mattie Kelley, Registrar; and Marc Simpson, Curator of American Art, provided valuable assistance to David Steel in researching several of the catalogue entries.

Rizzoli International is responsible for the design and production of this catalogue. We would like to especially thank Charles Miers, Publisher; Christopher Steighner, Senior Editor; Laura Lindgren of Laura Lindgren Design, Inc.; and Jonathan Jarrett. Emily C. Pearl copyedited the manuscript. Karen Broderick managed all permissions.

Thanks also go to Pierrette Lacour (Assistant to Professor Brettell, FRAME American office at The University of Texas at Dallas) for her support.

Our colleagues at the many lending institutions deserve special recognition for their scholarly help and assistance in securing loans. In addition, the authors would like to thank specifically: Christoph Becker, Director, Kunsthaus, Zürich; Ernst Beyeler, Beyeler Foundation; John Buchanan, Jr., former director, Portland Art Museum; E. John Bullard, Director, New Orleans Museum of Art; Michael Clarke, Director, The National Galleries of Scotland; Michael Conforti, Director, Sterling and Francine Clark Art Institute; James Cuno, Director, The Art Institute of Chicago; Douglas Druick, Searle Curator of European Painting and Prince Trust Curator of Prints and Drawings, The Art Institute of Chicago; Catherine Evans, Chief Curator, Columbus Museum of Art; Sjarel Ex, Director, Museum Boijmans van Beuningen; Kathryn Calley Galitz, Assistant Curator, Department of Nineteenth-Century, Modern, and Contemporary Art, The Metropolitan Museum of Art; Jay Gates, Director, The Phillips Collection; Gloria Groom, Curator, The Art Institute of Chicago; Anne d'Harnoncourt, The George D. Widener Director, Philadelphia Museum of Art; Annette Haudiquet, Director, Musée Malraux, Le Havre; Gregory Hedberg, Hirschl & Adler Galleries; Willard Holmes, Director, Wadsworth Atheneum; Siegmar Holsten, Deputy Director, Staatliche Kunsthalle Karlsruhe; David Jaffé, Senior Curator, The National Gallery, London; Adrienne L. Jeske, Collection Manager, Medieval through

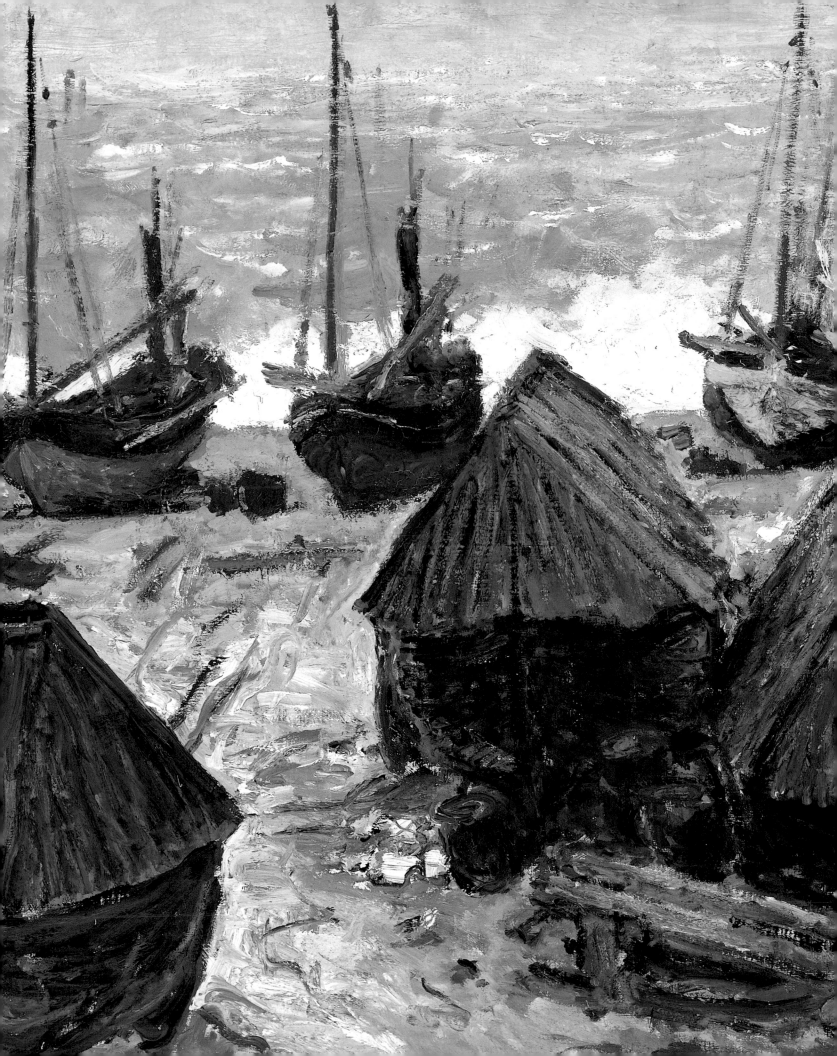

Modern European Painting, and Modern European Sculpture, The Art Institute of Chicago; Koichi Kabayama, Director, The National Museum of Western Art, Tokyo; Richard Kendall, Consultative Curator, Sterling and Francine Clark Art Institute; Paul Knolle, Rijksmuseum Twenthe; Yukitaka Kohari, Chief Curator, Shizuoka Prefectural Museum of Art; Dorothy Kosinski, Senior Curator, Dallas Museum of Art; John R. Lane, Director, Dallas Museum of Art; Allison Langley, Assistant Conservator of Paintings, The Art Institute of Chicago; Sarah Lees, Curator, Sterling and Francine Clark Art Institute; Arnold Lehman, Director, Brooklyn Museum of Art; Serge Lemoine, Director, Musée d'Orsay; Thomas W. Lentz, Director, Fogg Art Museum; Tomàs Llorens, Chief Curator, Museo Thyssen-Bornemisza; Miyuki Minami, Curator, Shizuoka Prefectural Museum of Art; Charles S. Moffett, Sotheby's New York; Philippe de Montebello, Director, The Metropolitan Museum of Art; Linda Muehlig, Curator of Painting and Sculpture, Smith College Museum of Art; Patrick Noon, Curatorial Chair, The Minneapolis Institute of Arts; Robert Noortman, Maastricht; Alexander Lee Nyerges, Director, The Dayton Art Institute; Vincent Pomarede, Director, Musée des Beaux-Arts, Lyon; Timothy Potts, Director, Kimbell Art Museum; Earl A. Powell III, Director, National Gallery of Art; Richard Rand, Senior Curator, Sterling and Francine Clark Institute; August Bernhard Rave, Director, Staatsgalerie Stuttgart; Jock Reynolds, Henry J. Heinz II Director, Yale University Art Gallery; Joseph Rishel, Curator of European Painting, Philadelphia Museum of Art; Malcolm Rogers, Director, Museum of Fine Arts, Boston; Dr. Klaus Schrenk, Director, Staatliche Kunsthalle Karlsruhe; Hajime Shimoyama, Director, Shizuoka Prefectural Museum of Art; Solfrid Söderlind, Director, Nationalmuseum Stockholm; Penelope Hunter Stiebel, Consultative Curator of European Art, Portland Art Museum; Susan M. Taylor, Director, Princeton University Art Museum; Pierre Théberge, Director, National Gallery of Canada, Ottawa; Gary Tinterow, Engelhard Curator in Charge, The Metropolitan Museum of Art; Alison Whiting, Christie's New York; Stephanie Wiles, Director, Allen Memorial Art Museum, Oberlin College; James Wood, former director, The Art Institute of Chicago; and Eric Zafran, Curator of European Art, Wadsworth Atheneum.

To those specifically mentioned here and to the many others who helped us in the lengthy process from initial idea to exhibition and catalogue, we express our deepest appreciation.

HEATHER LEMONEDES
Assistant Curator of Prints and Drawings
The Cleveland Museum of Art

LYNN FEDERLE ORR
Curator in Charge of European Art
Fine Arts Museums of San Francisco

DAVID STEEL
Curator of European Art
North Carolina Museum of Art

Essays

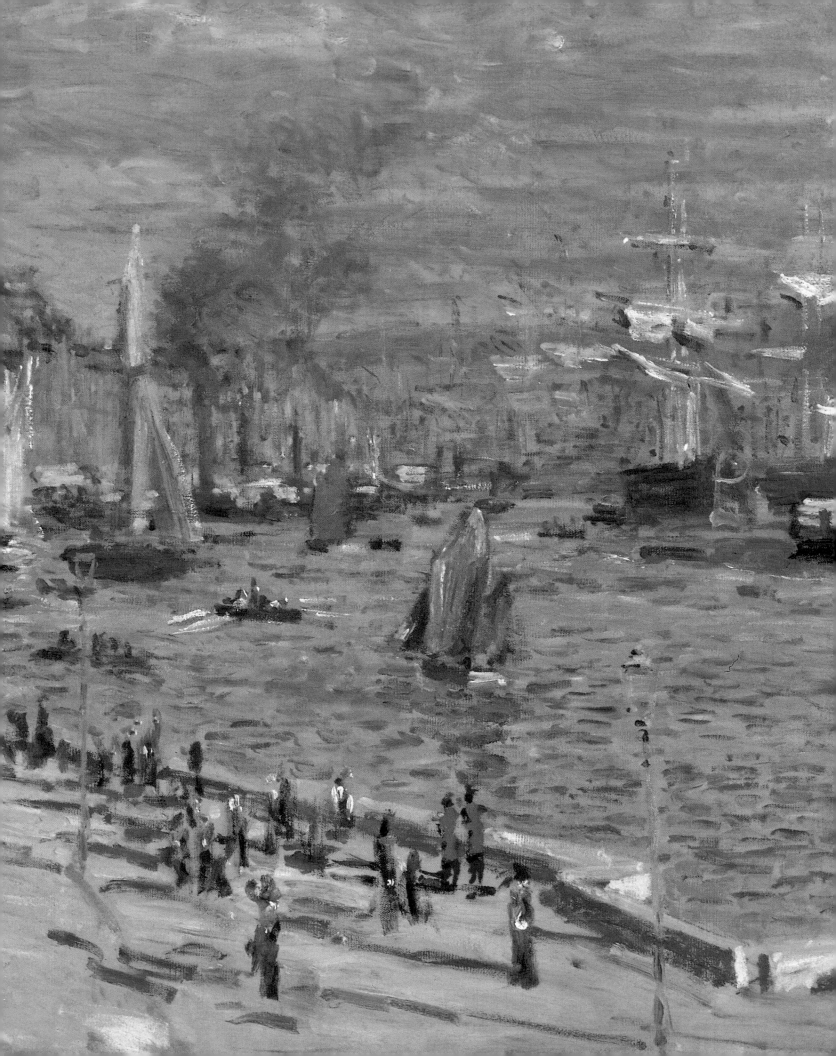

Monet's Normandy before Monet

ART, HISTORY, AND CULTURE

There is little doubt that the Impressionist painter Claude Monet was the greatest visual poet of Normandy. He painted the coasts, cities, fields, and villages of Normandy literally hundreds of times in his long, productive life, far surpassing in quality, if not quantity, the thousands of watercolors, pastels, oil sketches, and paintings by his mentor and informal teacher, Eugène Boudin. Monet's preeminence as *the* painter of Normandy would suggest, quite naturally, that he himself was a Norman, like Boudin, Jean-François Millet, and Marcel Duchamp. In fact, however, he had no Norman blood whatsoever and was born not in Le Havre, Sainte-Adresse, or Honfleur, which he often painted, but in Paris. Even his Paris pedigree was—at least on his father's side—short. His paternal grandfather was born in Provence in the papal city of Avignon and came from a family from the Dauphinois, and his paternal grandmother was born in Lyon, the second largest city in France and very far geographically and culturally from Normandy. Their son, Monet's father, was born in Paris and married a Parisian woman, Louise-Justine Aubrée, making this couple's second son, the future painter, a *Parisien de Paris* (a Parisian of Paris). This was rare indeed in the nineteenth century, when Paris's population swelled with immigrants from throughout the length and breadth of France. Most children born in Paris in 1840, the year of Monet's birth, were decidedly not *de Paris*.

The Monet family moved to Le Havre in 1845, somewhat before the painter's decisive fifth birthday (decisive, because French male children have their hair cut short and begin to wear pants at the age of five, when they become "little boys" rather than genderless "infants"), and the painter's father assumed a position with his own brother-in-law by marriage, Jacques Lecadre, who owned a successful wholesale grocery business. The future painter's childhood in the great port city of Normandy at the mouth of the Seine has been well recorded by many biographers, who have combed school, church, and civil records to discover the movements of Monet's parents, the location of the family business, the names of his teachers at school, and, perhaps most tragically, the death of his mother in 1857, before the painter's seventeenth birthday. If Monet was *de Paris*, he had a decidedly "Norman" childhood and adolescence, and nearly all of his later memories of early life were centered in Normandy. Indeed, Monet didn't actually paint Parisian views until 1867, when he was twenty-seven years old and already known in the capital's advanced art world as a promising painter of Norman landscape scenery.

It was, indeed, in Normandy that Monet first developed as an artist—not as the painter of vivacious, light-filled landscapes for which he is known today, but for amusing caricatures of famous people and passers-by, works of art in which the subject had a small body and immense and exaggerated head. Again, although many of his subjects were either Norman or drawn from life in Normandy, the models for their caricatural transformation lay not in the historic province of France, but in the long history of caricature in Paris itself, most notably in the practice of Daumier, Carjat, and

others. Monet was so accomplished at this art that, by his eighteenth birthday, he had made a small income from the sale of these caricatures and from their exhibition in the shop windows of a certain M. Gravier, who sold paper, frames, and colors on the Rue de Paris in Le Havre. In these windows Monet exhibited caricatures of famous Parisians (whose features would have been known to most French people from the voluminous illustrated press that defined contemporary fame) and well-known locals, some of whom must have been surprised to find themselves in Gravier's windows! Art, for Monet, was not something associated with museums and academies but was, instead, rooted in the illustrated press and urban popular culture. Magazines, not museums, were the crucibles of Monet's early artistic vision.

Yet it was precisely in Gravier's shop and on the beaches and quays of Le Havre and the nearby towns haunted by the aspiring young artist that Monet met an artist—more than fifteen years his senior—named Eugène Boudin. Unlike Monet, Boudin was a Norman of many generations, the son of a fisherman in the picturesque seaport of Honfleur, across the Seine estuary from Le Havre. Boudin had become an artist who haunted the beaches, fishing ports, quays, and rural landscapes of Normandy. He attended rural ceremonies, witnessed the return of fishing boats after weeks in the frigid north Atlantic, observed the mercurial shifts of the coastal sea, studied the cloud-strewn skies, and came, increasingly, to specialize in depicting the numerous Parisian, British, Scandinavian, and American tourists who began to flock to the Norman coast by the middle of the nineteenth century. In contrast to Boudin, a "Norman" who opened himself up to the modernizing landscape animated by tourists, Monet had no family connection to the deep traditions of coastal Normandy. For that reason alone, each visualized—and represented—the same landscape differently.

This exhibition celebrates the Normandy of Claude Monet for the first time in the United States. It is intended to bring both popular and scholarly attention to the painter's lifelong quest to record the landscape of his childhood. He began to paint that landscape in and around his childhood home of Le Havre, venturing westward across the wide estuary of the Seine to the picturesque fishing village of Honfleur, as well as trudging eastward along the coast to the fishing village of Sainte-Adresse and—a little further afield—to Étretat, with its famous cliffs, thatched fishing boats, and protected beach. In the 1870s, when Monet solidified his fame, he painted landscapes around Rouen, the capital city of Upper Normandy, to which he returned later in his career. He ended his long life as a painter by living and painting for more than forty years in the Norman village of Giverny, just opposite the town of Vernon, which is described in most guidebooks to Normandy as the "entryway" to Normandy from the Île-de-France as one sails down the Seine from Paris through Rouen to Le Havre.

FIG. 1. Jean-François Millet, *The Peasant Family*, 1871–72, 43½ x 32 in. (110.4 x 81 cm), National Museum and Gallery of Wales, Cardiff.

The span of these representations covers more than sixty years. Indeed, the Norman landscape—in all its variety—was to become the only lifelong landscape of France's greatest nineteenth-century landscape painter. Monet painted along the Mediterranean, in the Île-de-France, and, on one short trip, on the Ligurian coast of Italy. He painted Venice, London, the mountains of Norway, the rocky coasts and coastal islands of Brittany, and the rugged landscapes of France's Massif Central. But these were "occasional" worlds to Monet, who returned to the landscape of his boyhood, mining it in all its variety. From the sublime isolation of the great chalk-limestone cliffs around Étretat and Dieppe, to the rural roads and farms of its center, to the Gothic spires of its greatest city, to his own Norman farm transformed into fairy-tale garden, Monet's landscape world was to define modern Normandy, not only for the French national audience, but also for the international world of modernist, capitalist travel and collecting that has embraced Impressionism. Yet in spite of this very ubiquity, Monet's Normandy has never been thought quite so "essential" either to Monet or to Impressionism as Cézanne's Provence. Indeed, the number of exhibitions, scholarly articles, and books that deal with that fabled painter in "his" landscape dwarf those dealing with Monet in Normandy.

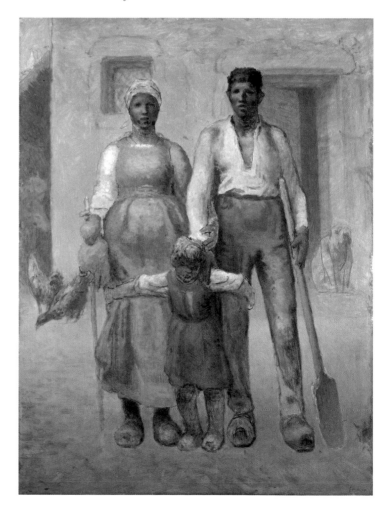

There is, in fact, only one significant study of Monet in Normandy, Robert L. Herbert's brilliantly researched and beautifully written book *Monet in Normandy*.¹ This superb study confines itself to the landscape of Monet's boyhood and the adjacent coastal landscapes that he mined pictorially in the first half of the 1880s and the end of the 1890s. This dramatic landscape in which water, air, and rock come together in the form of cliffs and rocky beaches pounded with waves, is, perhaps, the central component of the "Norman" Monet. But it is not the only one. Monet's two pictorial campaigns in Rouen, the first in 1872 and the second in 1893, produced as "Norman" a contribution to his oeuvre as his cliffs at Étretat, and the enfolding hilly landscape of Giverny, with its small farms, wheat fields, walled fruit and vegetable gardens, and gurgling rivulets and creeks, are "Norman" too. Our aim in mounting this exhibition and creating this catalogue is to restore all of Normandy to Monet and to explore his lifelong relationship with this fabled part of France in all its variety.

Before doing so, however, it is crucial to become acquainted with Normandy itself—its landscape, history, and culture. For many of us, Normandy is merely the landscape of D-Day and the great allied invasions; we know too little about its fascinating— and sometimes equally tumultuous —earlier history. This history would have been known to every cultured tourist to Normandy through the nineteenth century as well as to every child trained in the history-saturated curriculum of French schools. Our aim here is also to create a pictorial context for Monet's Norman achievement in the paintings, photographs, and prints of artists from his own and the previous two generations. We know from Monet's own library, preserved for scholars in Giverny, and from his numerous letters that he was well read, particularly in French literature, and that he looked at a great deal of art other than his own. From his visits to dealers and Salon exhibitions in the 1860s in Paris to his train and automobile trips to that same city in the early twentieth century, when he saw exhibitions and talked with dealers and collectors, Monet kept abreast of the latest developments in art. Thus, his own production was anything but naïve. Although he painted the landscape in front of him with complete directness throughout his life, he did so with a deeply layered understanding of that landscape as it was "represented" in the words and images of others.

Normandy and Normandie

Fortunately for Americans, Normandy is as "English" as it is "French," and the words used to describe this famous French place are nearly identical in both languages. Both those words contain two parts: the first syllable refers to "Norse" or "North" and modifies the second syllable, "man," reflecting the fact that this part of France was settled as early as the 8ᵗʰ century by men from the North—in this case Scandinavians who invaded the north coast of France from what is now Denmark. Every history

of Normandy in every encyclopedia or guidebook produced in either England or France tells us this story and continues to stress that these orderly, if bellicose "Norsemen" stayed in the landscape, intermarrying with the native Gauls, and forming blended communities that were highly stable and productive. They brought a well-developed maritime culture to this coastal landscape and learned from the Gauls the techniques of farming and husbandry that had been developed in the landscape for more than a millennium. Hence, these technically and politically advanced immigrants learned from the locals, uniting experiment with tradition, movement with stability, military with civil authority. Within three centuries, the "Normans" were already defined and became, with their conquests of England and Sicily, among the most admired and powerful people of Europe. Indeed, the first Duke of Normandy, Rollo, is described in all English guidebooks to Normandy as a "Viking Chief."

It is important to note that Normans are not purely "French" and that, historically, they looked outward to the sea rather than inward up their largest river, the Seine, to the French capital, Paris, and its landscape, the Île-de-France. This is particularly clear when the modern tourist visits the lower Norman town of Bayeux, which has long been home to the most powerful artistic document in European history, the so-called Bayeux Tapestry, which records the invasion of England by William the Conquerer in 1066. This invasion is, in some senses, the historical antecedent to D-Day, and, in the tapestry's retelling of it, it was less a military conquest than—again—a blending of similar cultures across a body of water well known for its perilous conditions. Both the "Normans" and the "British" had assimilated Norse elements, principally from modern Denmark, and each had embraced the best elements of its conquerors, allowing them to appropriate a fundamentally Roman system of order. For that reason, the "Norman Conquest," as we learned to call it in America, was more a uniting of likes than an imposition of one culture on another.

The subsequent history of Normandy is as interwoven as are its origins. Six "Dukes of Normandy" between 1066 and 1216 were also "Kings of England," and Normandy was not united with the French crown until 1204. Even this connection became tenuous in 1315 with the creation of the Norman Charter with France, granting Normandy "provincial" status and the right to self-governance. This document held in place throughout the turbulent centuries to follow, until all French law was toppled by the revolution in 1789 and the imposition more than a decade later of the Napoleonic Code that divided Normandy into five *departments* of a centralized French administration. The history of this self-governing quasi-state in the next centuries is a kind of ping-pong ball of history between England and France, as we know from Shakespeare's history plays, with invasions by England under Charles III in 1346 and Henry V in 1415. And all of us are familiar with the trial and torture of Joan of Arc in Rouen in 1431 and of her role in the "glorious" battles for French national integrity that are so important for our modern understanding of France. It is, perhaps, worth noting here that

Joan of Arc was both canonized and made the patron saint of France not in her own lifetime, but during Monet's, making clear the importance of Normandy to French national mythology in modern times.

The Tourist Landscape: Normandy in the Nineteenth Century

It is hardly surprising, given the repeated struggles for dominance between England and France that fill the pages of European history, that Normandy was perceived by each modern nation as partly—or wholly—theirs. When one adds to this combustible mixture the "neutral" technologies of the steam engine, rail travel, and the illustrated press, Normandy was positioned to become a shared landscape in the nineteenth century. Shakespeare was revived strenuously at this time, in both French and English, and *Henry V*, the play most relevant here, was fodder for discussion in classrooms and drawing rooms in England and France alike. The sheer economic dominance of England in the nineteenth century did a great deal to give the British a sense of "entitlement," and Normandy was the first landscape associated with both nations that was *almost* equally accessible from either. Taking a steamboat from any of the numerous southern ports in England, crossing the "English Channel," and spending time in Normandy was almost as important a part of nineteenth-century British travel as Rome was a part of the "Grand Tour" in the eighteenth century.

A good many crucial scenes in English nineteenth-century fiction occur in Normandy, whether in George Meredith's superb novel *Beauchamp's Career* or George Eliot's *Daniel Deronda*, which actually begins in Normandy. Normandy plays second place only to Paris in nineteenth-century English guidebooks. In many ways, Monet's Normandy was almost as important for the English as for the French, and its position between Paris and London was noted in many sources. The casino of Deauville and the breeding stables for racecourses in lower Normandy played very large roles in the life—and the fiction—of England as well as France, and the cheeses of Normandy—Camembert, Pont l'Evèque, and Livarot—appeared increasingly on British cheese boards.

It is, by now, almost banal to point out the importance of tourism for "modernity," particularly for the urban "consumption" of the modern landscape. As it became quicker and cheaper to move from one place to another in the nineteenth century, and as boats and trains began to stop and start at regular points in the landscape, a whole system of hotels, restaurants, temporary homes, and tourist "sites" developed—all of which fundamentally altered the small-scale rhythms of a landscape and seascape defined earlier by horse-drawn and sail-powered transport. The little "inns" with terrible food and worse beds, fodder for much eighteenth-century travel literature, gave way in Monet's century to an almost industrialized tourism, financed with urban capital for urban consumption. Large hotels, many owned by conglomerates, restaurants designed to appeal to the leisure class, and shops selling curios, tourist trinkets, and regional wares began to define towns and villages formerly inhabited exclusively by local fishermen, small businessmen, and farmers. "Traditional" Normandy began to be sought by urbanites from both sides of the English Channel—each, in certain ways, equally foreign to the Norman "natives" who received them.

What were these men and women looking for? First of all, they sought the sea, which, as the nineteenth century proceeded, came increasingly to be seen as a place to restore one's health and spirits with bracing "sea air" and, eventually, sea bathing. Neither of these aspects of the sea had appealed to seventeenth- or eighteenth-century travelers, who tended to flee inland as quickly as possible. This antipathy to the sea lasted almost until the twentieth century, as one sees in Philip Hamerton's great 1885 book, *Landscape,* in which he writes about "the real awfulness of the sea" in his final chapter, "The Two Immensities," concluding that it is "without history" and, hence, to be feared by man.[2] Yet, in both France and England, a strong counter to this primal human fear of the sea was manifest in the increasing popularity of seaside vacations and resort towns, most of which were situated near older fishing villages with large beaches. These, together with the leisure-time piers built on both sides of the English Channel in the nineteenth century, brought the urbanite face to face with the sea itself without danger or discomfort. When the great historian of nineteenth-century France Jules Michelet wrote his books on nature while living in exile from France in the Second Empire, he devoted one entirely to the sea, extolling its virtues, immense wealth, and, in opposition to Hamerton's later view, its importance in human history. One of the great French writers of the nineteenth century Victor Hugo, who also lived in exile during the second Empire on the British Channel island of Guernsey (nearer France than England), extolled the power and importance of the sea as well.

Another phenomenon associated with modern transport technology that had a profound effect on the urban consumption of the landscape was the ready access of many formerly distant places to major cities. This lead to a real increase in rural tourism and either the adaptation of traditional rural buildings to "country house" status or the construction of new "country houses," most often in the style of the region in which they were built. These dwellings, often occupied only in the summer months, were constructed or adapted with increasing regularity as railroad lines plunged further and further into the rural landscapes of France. And given the easy access to both Paris and southern England of the Norman countryside by boat and major train lines, it was not long until smaller railroads began to cross this region, which had never before been mechanized. The families who bought or built these houses had both disposable income and access to the latest urban technologies, and many of them had no real family connections to the places in which they spent their holidays. Indeed, Normandy came to be the first "French" landscape that was made completely accessible to the urban tourist. By the

middle of the nineteenth century, its population in the summer months was more than double that of the rest of the year.

Normandy in Romantic Travel Imagery and Literature

One publication of the 1820s popularized Normandy for the French public. In it, works of graphic art were paired with texts, allowing the purchaser of the illustrated publication to take an "armchair trip." This was the first volume of what became a twenty-volume compendium published over a period of fifty years, collectively entitled *Voyages pittoresques et romantiques dans l'ancienne France* (*Picturesque and Romantic Voyages through Old France*). This immense undertaking, perhaps the largest such publishing venture in Europe in the first half of the nineteenth century, was begun in 1820 and lasted until one year before the death of its entrepreneurial founder, Baron Isodore Taylor, in 1879. It is no accident that the first two volumes of the twenty were devoted to Normandy, the single part of France that had already become a tourist landscape. The first volume, *Normandie*, appeared in 1820 and the second, *Ancienne Normandie*, five years later. These volumes defined "picturesque and romantic Nomandy" for a generation, evoking a landscape filled with immense, partially ruined abbeys; tumble-down villages with half-timbered houses and medieval churches; spectacular cathedrals with thrusting spires from Avranches to Rouen; and picturesque fishing towns with wooden and stone churches and harbors crammed with traditional wooden fishing boats.

The medium chosen for the illustrations was the relatively recently perfected lithography, which developed in both England and Germany faster than it did in France and which, for that very reason, caused the French to attempt to surpass in this international competition with an illustrated book of unprecedented—and unsurpassed—grandeur and quality. The artists, not surprisingly, included a handful of Englishmen, most notably Delacroix's friend, Richard Parkes Bonington, and this international collaboration continued into the non-Norman volumes, some of which were even printed in London with lithographs by Thomas Shotter Boys, James Duffield Harding, Louis Hayge, and several others. Thus, Normandy was not only the "mother landscape" of Romantic travel writing and illustrations, it was also, because of factors of geography and history, a landscape on which both English and French sensibilities played with equal ease and entitlement.

What can be said about these illustrations that may help us understand later Norman imagery, particularly that of Monet? First of all, the illustrations and their texts were obsessed with "Old France"—that is, with the visual remains of the contested history of Normandy, particularly during periods of "French" dominance. Joan of Arc as yet played no role—that was to come later in the century—but the abbeys, cathedrals, castles, "ancient" villages, and other reminders of the long human history of Normandy prevailed. Landscape, in fact, played a lesser

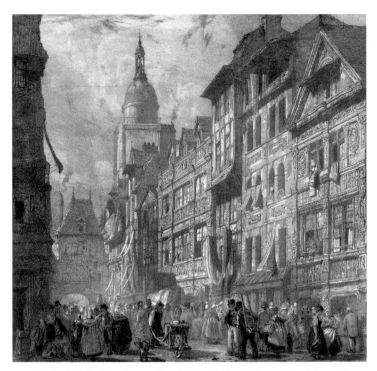

FIG. 2. Richard Parkes Bonnington, *Rue du Gros-Horloge à Rouen*, 1824, lithograph, 9¼ x 9¾ in. (23.5 x 25 cm), Iris B. Gerald Cantor Center for Visual Arts at Stanford University.

role than man's transformation of it through architecture. The entire image of Normandy preserved in both the words and lithographs is of a living architectural museum in which the human past provided constant reminders of past glory to the modern, urban people who subscribed to these volumes.

Today one of the most famous lithographs from the first two volumes is Bonington's view of the *Gros-Horloge* (medieval clock tower) of Rouen (fig. 2). Here the sky is filled with windblown clouds and the street with people who seem to have walked off the set of a historical opera in Normandy in the sixteenth century. Wooden wheelbarrows and ladders, heavily woven twig baskets, stocky work horses, and wolflike dogs are the "props" of men and women wearing clothing that their great-grandparents and even more distant ancestors would have worn. For the "picturesque and romantic" traveler, Normandy was the opposite of "modern." It was a history museum in which medieval France seemed to have survived the revolution unchanged.

Normandie Photographique

One of the very greatest nineteenth-century French photographers Henri Le Secq de Tournelles was from Normandy. He was an assiduous recorder of the historical monuments of Rouen and other Norman towns and cities. In a sense, his aim as a photographer was virtually identical to that of the Romantics,

FIG. 3. Gustave Le Gray, *Beach at Sainte-Adresse*, 1856–57, 12⅓ x 16⅓ in. (31.3 x 41.3 cm), Collection Gary Sokol, courtesy Robert Koch Gallery.

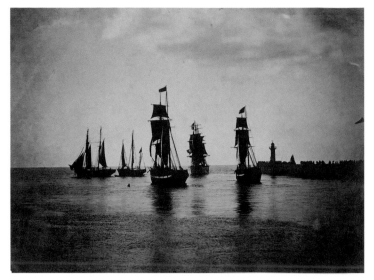

FIG. 4. Gustave Le Gray, *Ships Leaving Harbor (Napoleon III's Fleet at Le Havre)*, c. 1856–59, 12¼ x 15⅞ in. (31.1 x 40.3 cm), Museum of Art, Rhode Island School of Design, Bequest of Lyra Brown Nickerson, by exchange.

whether English or French. Yet for him the recording of these crumbling buildings was unaffected by the almost operatic exaggerations of the watercolorists and the lithographers. No anachronistically clad figures populate his photographs, which are, instead, dispassionate records of architectural form designed to preserve on paper the stones cut and carved by Norman ancestors. It was the power and endurance of the anonymous Norman craftspeople that fascinated Le Secq and also led him to amass a major collection of European forged ironwork (with splendid examples from Normandy, of course) that has an almost scientific completeness and rigor. This collection now resides in a museum in Rouen that bears his name.

Le Secq's photographs are dispassionate—especially as they were gathered into various groups designed to document the Norman past rather than to induce emotions or reverie in a particular viewer. They were made to record ancient France for "posterity" and not to move a contemporary viewer. This comparative coolness is at odds with the artists of the *Voyages pittoresques*, and the insistent planarity of Le Secq's architectural subjects and the complete absence of clouds or other indicators of weather endow these documents of the "Gothic" past with an almost classical rigor. This surely stems from the fact that they were part of a nationally sanctioned project begun, partly in response to Baron Taylor's ongoing "Romantic" series, under the Department of the Interior and directed by François Guizot as "General Inspector of Historical Monuments." This position, while not at the cabinet level, came increasingly to be seen as that of the national director of a systematic process of documentation of French historical architecture. This process soon harnessed the infant medium of photography to achieve more objective ends than were possible with the "artistic" medium of lithography.

Perhaps the greatest photographs of Normandy made in the years before Monet began his own project were produced by a non-Norman, Gustave Le Gray, who started to record the very same seas, ports, and beaches of Normandy that Monet was to record in the 1860s. Le Gray (born Legray), who taught Le Secq photography and maintained a close friendship with him, was trained as a painter and went on to become the most important technical writer about photography in France in the 1850s. In the year of the International Exhibition of 1855, Le Gray seems to have gone northward to the Norman coast, where he spent at least four years in a systematic attempt to record not the historical monuments that had appealed to the artists associated with Baron Taylor and to his own friend Le Secq, but the existing conditions of the very cities, towns, and villages that were later to appeal to Monet. We see Honfleur, Le Havre, Sainte-Adresse, and Dieppe in these large-plate photographs, and these places are presented neither as the living past of Baron Taylor's project nor as the clinical past of Le Secq's. Instead, we see each rock on the beach of Sainte-Adresse (fig. 3), the bathers and changing cabins of Dieppe, and the fleet of Napoleon III leaving the harbor of Le Havre (fig. 4). There is a kind of aesthetic—and literal—distance from these motifs that allows the viewer, whether then or now, to observe them without emotion, to move freely throughout their detailed areas, to relish the varied visual aspects of ordinary life in what is, in photographic terms, an eternal present. These photographs, perhaps more than the famous seascapes of waves and skies that so anticipated the somewhat later Norman seascapes of Monet, beg comparison to the slightly later paintings of Monet, who, being young and experimental, was surely attracted to the newest modes of representation. In no case is there a direct relationship between a photograph by Le Gray and a painting by Monet, but without having to know about the other, each injected the present into a Normandy that had been consigned by Romantic representation to the past.

Literary Normandy, 1850–1880

There is no greater monument to modern—or to Norman—fiction than Gustave Flaubert's *Madame Bovary*, published serially in 1856–57. This, arguably the greatest nineteenth-century novel produced in France (and the competition is hardly inconsequential), takes place almost entirely in Normandy, either in the provincial town of Ry, fictionalized as Yonville-l'Abbaye in the novel, or the Norman capital city of Rouen. The novel lays bare a nineteenth-century world of desire, deceit, sexual abandon, and guilt that was, perhaps, the first and most pure example of modernist yearnings: to move away, to feel passion, to have secrets, and to live radically in the present rather than in a world determined fundamentally by social mores of the past. It is the provincial person's fantasies of escape, and what seem to be the inevitable—and hence tragic—repercussions of that escape that animate this novel and that, in a sense, determined many of the qualities of fiction set in Normandy for the remainder of the nineteenth century.

Normandy scarcely disappeared from Flaubert's fiction after the spectacular notoriety of *Madame Bovary* made him famous. Indeed, two of his subsequent works—*Les Trois Contes* (*Three Tales*) and *Bouvard and Pecouchet* are each set in the province. The former is concerned with the remembered and repeated tales of ordinary Normans, none of whom, in Flaubert's book, could read. It represents for a modern and urban reader a world of simple Normans from earlier times who sustain themselves through memory and local relationships, unable to learn from the larger urban world unless the lessons are told to them by others from the outside. The combination of helplessness and fortitude that animates all three major characters in these tales was a perfect counter to the comic idiocy of Bouvard and Pecouchet, who, as copy clerks with no previous acquaintance from different parts of France, retire to a country house in Normandy—determined to live out the rest of their lives in an adventure of discovery that was, for Flaubert, the ironic modern equivalent of the mock-heroism of Don Quixote and Sancho Panza.

It was, for Flaubert, the extent of the contrast between the ageless traditions of rural Normandy and the ambitions of modern Parisians and their technology that provided the foundation for his tragicomic realist fiction. In all but one of the realist novels—the exception being *Sentimental Education* of 1869, the setting is the Normandy in which Flaubert grew up and in which he lived a good deal of his adult life. His Normandy was not the romanticized or picturesque Normandy of Baron Taylor's writers nor the objective historicist Normandy of the photographers, but was, rather, a traditional world throughout which modernity wrecked havoc with both the locals and the moderns. No one, in Flaubert's Normandy, was safe from the onrush of technology, the media, and the resulting displacement of which he became a supremely self-conscious scribe.

Guy de Maupassant, born into a family from Dieppe well known to Flaubert, managed to build on the brilliantly flawed edifice of Flaubert, mostly by electing a lapidary course of fiction writing, in contrast to the full-scale quarrying of his master. For every ambitiously scaled book by Flaubert, there are several novellas and scores of short stories by Maupassant, in which most of the action centers on Paris and its surrounding landscape. Yet, Maupassant often allowed his characters to vacation, summer, or spend a weekend in the writer's native Normandy. Although Maupassant was Monet's contemporary, his fiction corresponds more fully to the patterns set in the 1850s with *Madame Bovary* than to the more au courant naturalist and symbolist literary advances of the 1870s and 1880s, during which most of his fiction was actually written. In almost every tale, the "modern" characters—displaced as they often are—play out narratives in which danger lurks almost everywhere, mostly because these men and women are uprooted and, hence, unsure. Even their healing visits to the Norman beach resorts or to the beautifully isolated houses that line the Seine between Le Havre and Vernon do little to disrupt the psychic traumas of modernization that beset them. In most of these novellas and stories, Normandy is a perfectly idealized "set" for families beset with infidelity, illegitimacy, and misplaced passion. Neither its traditions nor its calm beauties can reverse the plights of these modern urbanites who seek refuge—always without success.

The very idea of Normandy as an idyllic landscape "after the fall" animates almost all of the Norman fiction of these two great French authors, and it is never far from the British fiction also set in Normandy. Both Charles Dickens and George Meredith created bi-national relationships in *A Tale of Two Cities* and *Beauchamp's Career* respectively, but the latter relationship is located fully in Normandy—that landscape claimed earlier by both modern nations and, hence, contested territory even to the modern urbanite. George Eliot's 1876 novel, *Daniel Deronda*, begins in the casinos of Normandy, and there is a sense in which the problems of modern England are being traced to their origins in France. The literary idea of Normandy is little different than a provincial "Garden of Eden," in which men and women play out their frailties in a landscape thought by many to be devoid of such debasement.

The Two Normandies of Geography: Upper and Lower

If there is "Normandy" and "*Normandie*" (that is, British and French Normandy); if there is "modern" and "historic" Normandy, there is also another vital distinction in this otherwise unified province of France—that between Upper (*Haute*) and Lower (*Basse*) Normandy. Upper Normandy is, essentially, the eastern half of the landmass of the province. Its major natural route is the Seine, and it is a landscape defined by a soft Cretaceous limestone that appears—when the topsoil and vegetation are worn away by wind and water—along the length of its coast and at many points inland, particularly in the cliffs along the winding Seine. It is comparatively hilly, and its capital city is historic Rouen, the most important cathedral city in all of all Normandy. The secondary cities are Le Havre, Dieppe, Deauville, Lisieux, and

Evreux. Lower Normandy is the western half of the landmass and rests on a rocky base of granite and metamorphic rock, like that of Brittany, in contrast to Upper Normandy's soft limestone. Its capital is Caen, on its eastern edge, and its secondary cities are Cherbourg, St. Lo, Falaise, Bayeaux, Mayenne, and Coutances. If Upper Normandy is linked to the Île-de-France by geology and river traffic, Lower Normandy is linked to Brittany. History, rather than geology or geography, link them so that they become "Normandy."

The representations of Normandy that fill pages of guidebooks treat both of these Normandies with reasonable equanimity, but in the history of painting, Upper Normandy predominates, with an almost ferocious hold on the urban imaginations of both London and Paris. No town in Lower Normandy, no matter how great its cathedral or abbey, can compete with the sheer number of painted representations of Deauville, Trouville, Honfleur, Le Havre, Étretat, Dieppe, Jumieges, Rouen, or Vernon. The Seine itself—the great watery link paralleled by the major railroad lines—forced a connection to Paris, and the port cities of Le Havre and Dieppe were more persuasively linked to London and southern Britain than any of the port cities of Lower Normandy, Cherbourg included. One has to go to the local museums in Lower Normandy, filled as they are with works of art by more-or-less local artists, to find the visual iconography of Coutances, Bayeux, Mayenne, or Cherbourg. Only Mont Saint Michel, which looks warily from its island vantage point at both Brittany and Lower Normandy, has a truly spectacular iconography, but even it was only occasionally represented by great painters until Signac went there late in the nineteenth century.

Lower Normandy is almost severely local in its iconography, and in this way it is in utter contrast to Upper Normandy. Perhaps only the relatively placeless properties of horse breeders—those visited by the likes of Degas and discussed in the next essay—are part of the modernist pictorial iconography of Lower Normandy. For painters, tied as they were to the Paris art world and its exhibitions, critics, dealers, and collectors, Upper Normandy was not only easier to travel to, but was also well known to the audiences to whom they wished to appeal.

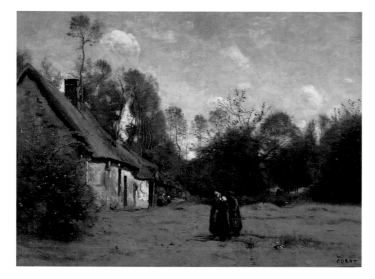

Corot in Normandy

There is no doubt that Camille Corot was the greatest landscape painter in France before Impressionism. Although his technical advances were not as influential for future art as those of his friend Theodore Rousseau or his somewhat younger competitor, Gustave Courbet, his sheer fidelity to landscape—and to the French landscape in particular—was essential to French self-definition in the century in which it was put to the most severe tests. Like many artists who painted in Normandy, Corot was not a Norman. Born in Paris to a family well versed in the world of small-scale urban capitalism, he was—as was his successor Monet—a *Parisien de Paris*. Yet when it came time to educate him, his hard-working parents elected to send him to family friends the Sennegons, who lived in a country house near Rouen in Normandy. This was the beginning of a lifelong relationship with Normandy, which was, for Corot, less important than it was for Monet, but which nevertheless provided motifs for some of his greatest landscapes.

Raised between the ages of fourteen and nineteen as a member of the Sennegon family, Corot became familiar with the hilly and forested landscapes south and west of that important city, which were, for him, of particular psychic importance because they were the landscapes of his adolescence. Although his mother, father, and sisters were often absent, the associations were so strong for Corot and his immediate family that he returned to Normandy often throughout his life. One of his sisters, in fact, married a Sennegon, the son of his guardian and a lifelong friend, in 1813, when Corot was twenty. Hence "Uncle Camille" visited Normandy frequently for family reasons alone.

Even before his famous and well-studied trips to Italy in 1825–28, 1836, and 1843, Corot practiced his landscape painting in Normandy. One of his earliest studies of architecture (fig. 5) represents an old *chaumière* (thatched farmhouse) on the property of his guardians. Its combination of cool rigor of organization with a pictorial love of French history makes the viewer think forward to the aesthetics of French photography of the next generation. Between his first and second trips to Italy, Corot combed the Norman countryside, painting in Lower Normandy at St. Lo and in Upper Normandy at Trouville, Honfleur, and Étretat, all places that would play large roles in the representation of Normandy in later art.

Perhaps Corot's earliest—and largest—Salon painting representing a French subject was an immense painting of the port of Rouen, now in the Musée des Beaux-Arts et de la Céramique of that city (fig. 6). Submitted to—and accepted for—the Salon of 1834, the painting represents the quays of Rouen, which, unlike the distant quays of Paris, were large enough to accept oceangoing vessels that penetrated deeply into Normandy on their way to Paris. Corot himself referred to the painting as a *marine*

FIG. 5. Jean-Baptiste-Camille Corot, *Farmhouse in Normandy*, c. 1872, 18 x 24¼ in. (45.7 x 61.6 cm), Norton Simon Museum, Norton Simon Art Foundation, Gift of Jennifer Jones Simon.

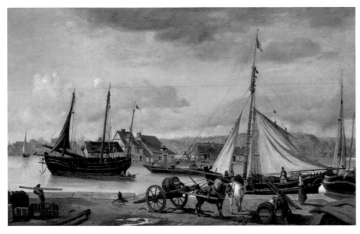

FIG. 6. Jean-Baptiste-Camille Corot, *The Merchant's Quay at Rouen*, 1834, 43⅜ x 68 in. (110 x 173 cm), Musée des Beaux-Arts et de la Céramique, Rouen.

rouennaise (a seascape of Rouen) in a letter of 1833.[3] The immense painting records the stately rhythms of commerce in Rouen before the construction of the railroad in the 1840s and the creation of huge ports in Le Havre in the late 1850s. No machines or tourists disrupt the thoroughly provincial townscape of this painting, which was made in response to both the huge series of port landscapes by Vernet created in the eighteenth century and a much busier and less successful painting of the port of Honfleur done in the 1820s by Auguste-Xavier Leprince. By the time that the reviews of this huge painting had appeared in the Parisian press in 1834, Corot was already off on his second trip to Italy.

Although he never completely abandoned Normandy as a source for landscape motifs, Corot cannot be considered a painter of the Norman landscape in the same category as Monet. Rather, Corot began to use France's increasingly sophisticated and efficient transportation system to represent virtually the entire country, allowing Normandy a pride of place without ever letting it dominate his pictorial world. Indeed, Corot was a "French" rather than a "Norman" landscape painter. Without the Norman landscapes, Corot would still be considered a great landscape painter. The same cannot be said of Monet.

Millet and Courbet in Normandy

Two painters of the generation before Monet made vital contributions to the pictorial understanding of Normandy—Jean-François Millet and Gustave Courbet. Millet himself was a Norman, born at the very northwestern tip of Lower Normandy in the tiny coastal hamlet of Gruchy, near the town of Cherbourg.

FIG. 7. Jean-François Millet, *Farm at Gruchy*, 1854, 21¼ x 2 ⅝ in. (54 x 72.7 cm), Smith College Museum of Art, Northampton, Massachusetts, Purchased, Tryon Fund (1931:10).

The son of farmers, his talent for art was recognized early, and the young Millet was sent to Cherbourg to learn to paint. Here he saw his first collection of Old Master paintings, the Thomas Henry Collection, now a part of the Musée de Cherbourg. Hence, Millet's entire idea of art—even of the Old Masters—was derived not from Paris but from provincial Lower Normandy, and it was not until he was twenty-three that he was given a scholarship from the town of Cherbourg to study in Paris. All students of Millet agree that he was deeply affected by his provincial rural origins, but in order to prove his worth as an artist, he needed to paint elsewhere. Hence his early fame as a painter of rural landscapes and their peasant populations was derived from work that he made in the villages and hamlets around the forest of Fontainebleau, southeast of Paris. Here he applied his deep knowledge of rural life to a population of rural workers very different than those of his native Normandy, and it was not until his career was well established that he returned to record the Norman landscape of his birth.

It was, perhaps, for reasons of both birth and affection that Millet became the greatest painter of Lower Normandy. It would have been easier for him to paint the portions of the Norman landscape more accessible to Paris—those along the Seine and around the port city of Le Havre. But this would not have permitted him to bring the considerable talents he had developed elsewhere to bear on the landscape of his birth. In fact, he married his first wife and met his second one in Cherbourg, and although he painted and exhibited paintings in Le Havre early in his career, he turned away from the landscapes around Cherbourg until 1853, when his mother died and he returned for her funeral for the first time in nine years. In this and, more intensively, the following summer, Millet made his earliest Norman landscapes, among which *Farm at Gruchy* (fig. 7) is the most important. Never sold in Millet's lifetime, it is one of the few paintings made in the summer of 1854, when the artist concentrated on making landscape drawings for later use. Its relative emptiness (one male peasant walks along the path near the walled field in the middle ground) and its inaccessibility to the viewer suggest the artist's

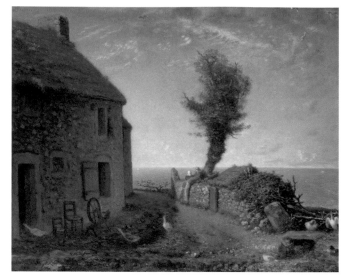

FIG. 8. Jean-François Millet, *End of the Hamlet of Gruchy*, 1866, 32⅛ x 39⅛ in. (81.6 x 100.6 cm), Museum of Fine Arts, Boston, Gift of Quincy Adams Shaw through Quincy Adams Shaw Jr, and Mrs. Marion Shaw Haughton.

FIG. 9. Jean-François Millet, *Fishing Boat*, 1871, 9¾ x 13 in. (24.7 x 33 cm), Museum of Fine Arts, Boston, Gift of Quincy Adams Shaw through Quincy Adams Shaw Jr, and Mrs. Marion Shaw Haughton.

distance from the landscape of his birth. But in its record of an anonymous, historically imprecise landscape without monuments, it evokes a condition of total France called by the French themselves, *La France profonde*—deep, ahistorical, mythic France.

Perhaps the most psychically powerful depiction of Millet's native landscape was painted not from life but from memory, more than a decade after the summer of 1854. *End of the Hamlet of Gruchy* (fig. 8) represents the houses in the village of Greville, near the hamlet of the painter's birth, that face the English Channel. Here the painter allows himself to bring all his memories of yearning and of the fears of departure to bear on a single painting. The granite peasant hut, so different from the half-timbered or thatched brick cottages of Upper Normandy painted by Corot and others, is protected from the winds of the sea by an earthen embankment. A peasant mother holds her infant up on the embankment to show the child the view of the sea, and the nearby tree curves out toward the sea as if to mimic the childish desire, so lovingly restrained by the mother. Sixteen years later, at the time of the Commune, Millet painted *Fishing Boat* (fig. 9), which represents not the peasant farmers with whom Millet grew up, but a fisherman. The latter's mastery of the sea and its fickle weather conditions may have prompted Millet to paint it, while he worried about his native France during these troubled times.

Although several of Millet's most famous figure paintings, including *The Sower* of 1850, suggest the Norman landscape rather than the landscape around Fontainebleau, one late peasant painting was definitely intended to evoke the population of Millet's birthplace. *The Peasant Family* (fig. 1), left unfinished at Millet's death in 1875, represents what can only be called a mythic peasant family. A young father and mother with their

small child stand, as if posing, in front of their granite peasant house, tools in hand. Their sheer physical and psychic presence is remarkable, as is their independence from us. There are no grandparents or other relatives present as they confront the urbanites who would have been their audience had the painting been finished for public exhibition in Monet's lifetime. In them, Millet suggests, is their own future, and, in a way, they judge us as much as we judge them.

If Millet was a proud, if conflicted Norman, who made use of his native landscape and its people throughout his life, his slightly younger contemporary Gustave Courbet was equally rooted in the landscape of his birth, in this case the mountainous eastern part of France called Franche-Comté. Like Millet, Courbet returned to his *pays natal* (landscape of birth) time and time again. Yet Courbet made many of his most persuasive and important landscapes in other parts of France, particularly in Normandy. His Normandy, roughly contemporary to that of Millet, was everywhere the opposite. Where Millet went home, Courbet traveled to the Upper Norman vacation towns of Étretat and Deauville, very much like any member of the urban leisure class. For him Normandy was a landscape of escape, and the vast majority of the works by this painter from a landlocked part of France represent the seacoast.

His first painting trip to Normandy took him to Trouville in the late summer of 1865. How odd it must have been for Courbet, whose own landscape paintings were virtually always unpopulated and wild, to spend time on a beach cluttered with urbanites from France and Britain. Children, nannies, portable bathing cabins, chairs, blankets, horses, and well-dressed women crowded the beaches on which he sought solace and escape. For that reason, he returned the next year in September and October, when the urbanites were in their apartments enjoying "the

season" of concerts, dinners, and other urban entertainments. Now that Courbet could walk the beaches virtually alone, he made a large sequence of *marines* (seascapes), all unpeopled and most confined to the beach, the sea, and the sky in utterly parallel bands. These paintings, of which there are many, were executed in as few as two hours and are hence among the first "Impressions." Illustrating only one does not accord proper emphasis to Courbet's serial intention—he exhibited more of these *marines* in his private exhibition at the Universal Exposition in 1867 than any other kind of painting. These works are crucial to an understanding of Monet's Normandy, because the younger artist visited Courbet's installation that year. For the purposes of this survey, the *Seaside in Palavas* (fig. 10) must suffice, although it is important to remember that Monet would have seen many such paintings on the walls of the 1867 exhibition.

We know, however, that the transient was never enough for Courbet, and it is important—indeed vital—to an understanding of artistic Normandy to consider two works by Courbet now in the Musée d'Orsay, painted not in 1865–66 like many of the seascapes, but in 1870. Both of these paintings were made near the fishing-village-turned-summer-resort of Étretat. Sandwiched between dramatic limestone cliffs that plunge into the English Channel, Étretat was the most scenic of the Upper Norman towns frequented by urban tourists. Its monumental pierced rock formations and limestone "Needle" were famous throughout France in the Second Empire—indeed, they were even re-created in miniature in an abandoned quarry for Adolphe Alphand's famous Parisian *Parc aux Buttes Chaumont*. Étretat's "iconography" is as large and important to the history of modern painting as that of any French town—an exhibition of paintings representing it would contain major works by Corot, Delacroix, Boudin, Jongkind, Courbet, Monet, and Matisse as well as many foreign artists, including the American George Inness, in addition to scores of minor paintings and, of course, thousands of prints and photographs.

FIG. 11. Gustave Courbet, *The Stormy Sea [The Wave]*, 1870, 24 x 36 in. (61 x 91.4 cm), Musée d'Orsay, Paris, France.

Yet it was Courbet who made the single work that became, for Frenchmen and foreigners alike, the definitive image of Étretat, *The Cliff of Étretat after the Storm* (fig. 59). This large, grandly conceived, and—it must be admitted—politically powerful painting captured the French sense of frustration and defiance when it appeared at the Salon of 1870, just months before the Franco-Prussian War, and it did so by using a symbol of the sheer physical resistance of France itself (in this case, its stony cliffs) to outside forces. The scattering of fishermen's boats in the foreground, together with the single boat that plies the waters of La Manche in the middle distance, visually embody the fragility as well as the strength of human life as it both battles and relies on nature. The cliffs, infinitely more ancient—and more patient—stand forever, weathering the next storm as they have weathered hundreds of thousands before.

When we consider Courbet's somewhat smaller, but still immense and powerful canvas *The Wave* (fig. 11), of the same year, it is clear that this artist from the Franche-Comté was able to transform his leisure-time Norman experience into a visual metaphor for France itself. Although the two works were not conceived as a pair, they function as images in tandem. The waves that roil from the English Channel, churning the rocks and sand of French soil, are the counter to the pierced rock of Étretat in the larger painting. Although a tourist in a landscape better known to Monet and Millet, Courbet created a pair of images that galvanized the French because they became effective embodiments of French myths of survival and persistence. Courbet, the non-Norman, had made the ultimate Norman landscapes because they communicated not only to Normans but to all French people. They allayed French anxieties because they embodied French fears—and French endurance. And Monet remembered them often.

FIG. 10. Gustave Courbet, *Seaside in Palavas*, c. 1854, 23⅝ x 29 in. (60 x 73.5 cm), Musée Malraux, Le Havre.

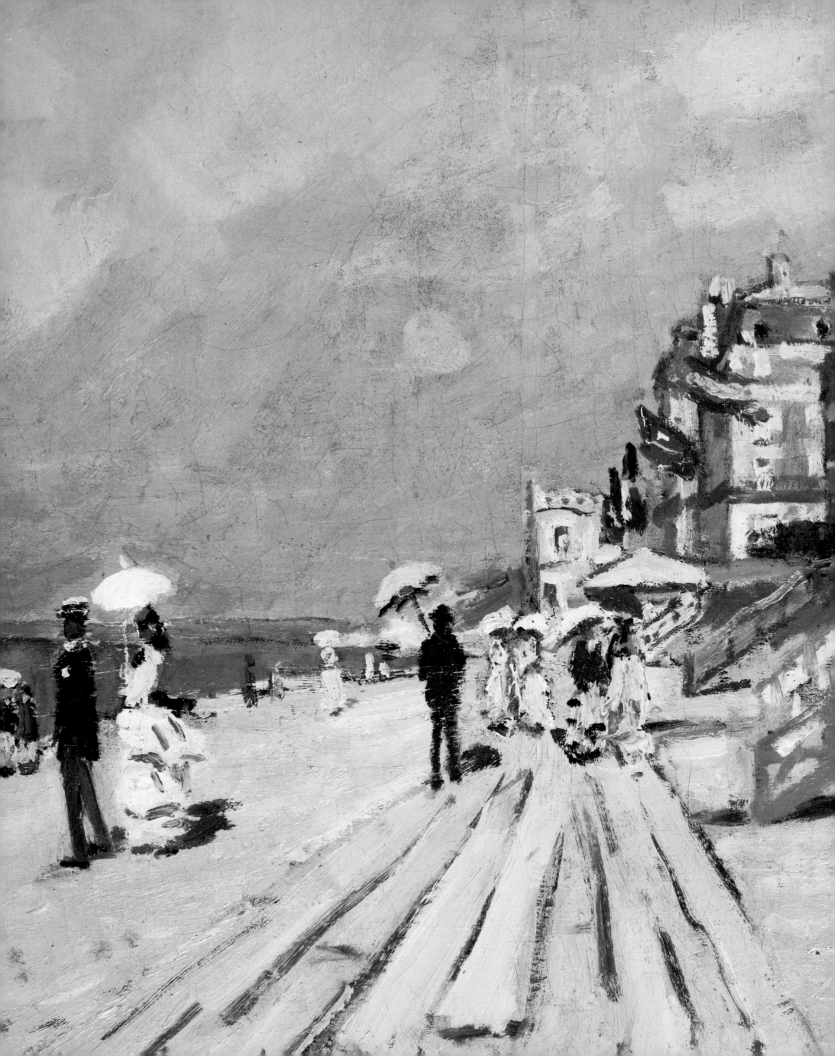

Normandy and Impressionism
THE CONTEXT FOR MONET

There is little doubt that, among the men and women who exhibited with the Impressionists between 1874 and 1886, Monet was *the* painter of Normandy. Indeed, the painting from which the entire movement received its name—*Impression: Sunrise* (fig. 56)—was Monet's representation of his Norman boyhood home, Le Havre, at dawn. He was far from the only important Impressionist painter in Normandy, however, and the purpose of this essay is to create a pictorial context in Impressionism for his "Norman" oeuvre. At first one might think that this "context" would be overwhelmed by the sheer ubiquity of Monet's own production, but that is far from the case. In fact, knowledge of the pictorial contributions to the imagery of Normandy made by Monet's friends and colleagues in the Impressionist movement allows us to better understand the context for his selection of motifs and his modes of portraying them. Far from being the only innovator as a painter of "modern" Normandy, Monet more often followed the leads set by others, purifying and strengthening what others had already done. Monet's Normandy comprised the north coast of Normandy, the landscape of his youth; the city and environs of Rouen, capital of Upper Normandy; and the agricultural landscapes around the hamlet of Giverny, where he spent the last half of his life. This "tripartite" aspect of Monet's Normandy is reflected in the late Norman work of his old friend Camille Pissarro, the eldest Impressionist, who lived the last twenty years of his life in Normandy and created a body of work describing Upper Normandy in both its urban and rural aspects almost as comprehensively as Monet.

Eugène Boudin, Charles Baudelaire, and the Invention of Modern Norman Painting

The tale of Monet meeting the man who would make him into a painter, Eugène Boudin, is told in every biography of either man. The encounter occurred sometime in 1858, when the younger painter was eighteen and his future mentor was thirty-five. Monet himself related the vivid story from memory to Boudin's patient biographer, G. Jean-Aubry:

> I remember our meeting as if it were yesterday. I was in the framer's shop, where I often exhibited the pencil caricatures which had won me some notoriety in Le Havre, and even a little money. I met Eugène Boudin there. He was then about thirty [Monet misremembered Boudin's age somewhat], and his expansive and generous personality was already apparent. I had seen his work on several occasions, and I must admit that I thought it was frightful. "These little things are yours, are they,

OPPOSITE: Detail, *The Beach at Trouville* (cat. 9).

27

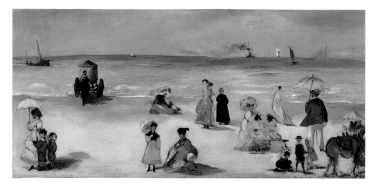

FIG. 12. Edouard Manet, *On the Beach, Boulogne-sur-Mer*, 1869, 12⅝ x 25⅝ in. (32 x 65 cm), Virginia Museum of Fine Arts, Richmond, Collection of Mr. and Mrs. Paul Mellon.

young man?" he asked. "It's a pity you don't aim higher, for you obviously have talent. Why don't you paint?"

I confess that the thought of painting in Boudin's manner didn't exactly thrill me. But when he insisted, I agreed to go painting in the open air with him. I bought a paint box and we set off to Rouelles, without much enthusiasm on my part. I watched him apprehensively, and then more attentively, and then suddenly it was as if a veil had been torn from my eyes. I had understood, I had grasped what painting could be. Boudin's absorption in his work, and his independence, were enough to decide the entire future and development of my painting.[1]

At that moment in his life, Boudin had recently completed his largest and most ambitious painting, *The Pilgrimage of Saint-Anne-la-Palud, Finistère* (Musée Malraux, Le Havre), which represented not his native Normandy, where it was actually painted, but the more exotic landscape and peasant traditions of the adjacent region, Brittany, where Boudin made the sketches he used to construct the big picture. Boudin himself disliked the painting, finding that its size and the comparative tightness of execution that comes from studio practice drained it of the life of nature itself. Indeed, he came in subsequent years to favor smaller canvases that could be worked up largely out of doors, thus retaining the freshness of execution and the fidelity to nature's effects that were difficult to achieve from memory in the studio.

It was, as Monet himself remembered, the very absorption that Boudin sustained in the face of nature that so moved the young artist, causing him to alter both his life and his art. Boudin transformed Monet from a graphic artist whose aims were resolutely social into a painter who spent the rest of his life working—most often alone—in nature. Boudin also made it clear to the younger man that true art was a process of lifelong struggle rather than something learned in school and simply applied to the production of paintings. For him the methods used by the artist were tested not against other works of art but against nature itself. If a painting could literally capture the quality of light in nature, it had succeeded at something profound and could, for

that reason, be compared favorably with any other work of art. Nature, thus, was first and foremost the touchstone against which one measured art.

Boudin also taught Monet another important lesson: that great art can be made more easily and effectively in a landscape intimately known by the painter. The sheer ubiquity and familiarity of the landscape in which one lived and breathed helped the painter capture its most subtle and refined aspects. Physically distant or exotic landscapes created conditions of "otherness" that the painter had to work to overcome, and, for that reason, both of these artists rooted their practice in the landscapes of their childhoods, extending to other parts of France and to foreign places like Venice or the Mediterranean only after they had so absorbed their own landscapes that they could apply deeply felt transcriptional lessons to others. Hence, Monet and Normandy derive profoundly from Boudin and Normandy.

We learn from Jean-Aubry that, just a few months after their meeting, Monet went to Paris, where he learned another lesson, one that he attempted—unsuccessfully—to pass on to Boudin: that the center of the art world was Paris and that one had to be there in order to become successful as an artist. His letter urging Boudin to come to Paris, written on May 19, 1859, is often quoted in the literature. In it Monet clearly recognized that, no matter where one achieved one's successes in the landscape, the paintings had to be recognized in Paris in order to become canonical—or even saleable!

What was important about Boudin for Monet—and for much future painting in and of Normandy—was the modernity of his subjects. Unlike the artists of the previous generations—and unlike Millet and Courbet after him—Boudin was completely absorbed by the leisure life of urbanites on the beaches of Deauville and Trouville, and he began what became a lifelong study of these men and women with their children, servants, dogs, and even horses as they walked, chatted in small groups, bathed, changed clothes, played, and read in the bracing Norman air. The buildings that crop up in the backgrounds of these utterly modern Norman landscapes are hotels, restaurants, and, on the odd occasion, country houses, most of which had been recently built and were occupied in the summer months by French and foreign tourists. Surely a good deal of this impetus to modernity must relate to the fact that Boudin met the great poet-critic Charles Baudelaire in 1859, when the writer devoted a long paragraph to the paintings of Boudin in his review of the Salon of that year.

Although Baudelaire wrote briefly and admiringly of Boudin's large-scale painting of Brittany, it was, instead, to the freely painted open-air landscape studies in pastel of Normandy—of which he saw "hundreds" in Boudin's studio—that he devoted his most gorgeous prose. As he wrote about the small studies—each of which was inscribed by the artist with the date, time of day, and conditions of wind and weather— Baudelaire lost himself in a poetic reverie as intense as any he had ever experienced from art:

Eventually, as these fantastically shaped and luminous clouds, these chaotic shadows, these immense green and pink forms, suspended and merging with each other, these gaping furnaces, these firmaments of black and violet satin, crumpled, rolled, or torn, these horizons in mourning, or streaming with molten metal—all these depths and all these splendors rose to my brain like a heady drink, or like the eloquence of opium. Rather strangely, in front of this liquid or aerial magic, I did not once regret the absence of man.[2]

Baudelaire went on to suggest that Boudin include his fellow men in his spectacle of nature—and Boudin followed his advice. Throughout the next four decades, the artist described nature's light as it played on crinoline gowns, satin top hats, and flounced bathing costumes with as much finesse as he had painted its effects on the clouds, waves, and sand that Baudelaire had transformed into fire and fabric. Indeed, Boudin mastered the setting for his human comedy of manners before he allowed the characters to enter.

Baudelaire and his mother spent a good deal of time in the last years of the poet's life escaping from Paris to the quaint—and increasingly fashionable—fishing village of Honfleur at the mouth of the Seine estuary opposite Le Havre. Here he observed a landscape in transition—from an economy of farming and fishing to one of modern transnational tourism. Farms were transformed into inns. Fields were sold to become gardens for country-house properties. Small town houses were transformed into shops and restaurants, and markets were relocated and publicized to attract tourists as well as the locals who had been their mainstay for centuries. It was *this* Normandy that, in a powerful sense, Baudelaire opened up for Boudin, and, in doing so, just shortly after that painter's meeting with the teenage Claude Monet, he inadvertently set the stage for the Impressionist or "modern" Normandy that so dominated the next four decades.

This "modern" Normandy was essentially the creation of the Second Empire, when the rail lines to and from Paris were laid; the great harbors of Rouen and Le Havre dug, excavated, and lined with massive stone quays; and the beach resorts developed with their hotels, casinos, and racecourses. Here the Empress Eugénie and her infamous sister-in-law, Princess Mathilde, took the waters and strolled on the beach. Here Baudelaire and Maupassant wrote decidedly modern poetry and prose. Here Parisians, Bostonians, Londoners, and New Yorkers passed each other on the beach, competing for attention. But in the decade of the 1860s the most important artist to record this spectacle of modernity at the height of its fashion was a Norman of humble birth who shunned great cities throughout his life. He was, in this sense, the most purely Baudelairian painter of Normandy. For

him the beaches were natural equivalents of the parks and boulevards of modern Paris or London. Perhaps it is only in the small scale of Boudin's figures and in their safe distance from the viewer that we are given a sense of the painter's own otherness. Far from being a part of the social world of the summer tourist, Boudin was a Norman who considered these men and women as temporary inhabitants of a landscape in which they moved, but did not belong.

Boudin, Jongkind, Courbet, Whistler, and Monet were the most important transcribers of the Normandy coast in the final decade of the Second Empire, and their work, as it was shown in Paris Salons and studios, essentially forced Normandy into the realm of "the modern," whether or not their works represented the "modern" aspects of the Norman coast. And surely it was the extraordinary pastels of the Norman coast described by Baudelaire that lead the supremely urban painter, Edgar Degas, to visit Normandy in 1869 and to make a large series of pastel landscapes of the coast. These remained essentially undiscovered in his lifetime, but they have become a part of the modern scholarly reappraisal of the artist, masterminded by Richard Kendall, who has also begun a simpler, parallel reappraisal of Monet as a maker of pastels.[3] It must be said that a good deal of the aesthetic impetus for these powerful works of art can be traced to Baudelaire's Boudin and thus to a modern Normandy perceived through the eyes of an urban outsider.

Oddly, this kind of Norman modernism became, in a sense, *the* image of France at the beach during the 1860s. Even Manet, when he visited the non-Norman north-coast city of Boulogne in the mid- and late 1860s, perceived it in ways that are rooted in the Normandy of Boudin. His representation of bathers on the famous beach at Boulogne (fig. 12) takes a subject often painted by Boudin and transforms it into an almost caricaturish indictment of modern bathing. In a sense the sheer "placelessness" of the beach on the north coast, and the ubiquity of its casinos, hotels, bathing establishments, and grandly informal seafood restaurants, created a situation in which Normandy was essentially indistinguishable from the coastal

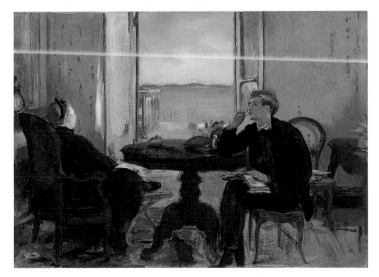

FIG. 13. Edouard Manet, *Manet's Family at Home in Arachon [Interior at Arachon]*, 1871, 15½ x 21⅛ in. (39.4 x 53.7 cm), Sterling and Francine Clark Art Institute, Williamstown, Massachusetts.

towns and beach resorts of Brittany and the north of France, located just east of Normandy. And this very condition of modern urban leisure at the beach is Manet's primary subject almost no matter which French destination he chose. In 1869, when he sat with his wife and adopted son wiling away the afternoon in a rented room overlooking the sea in the southwestern French town of Arcachon, near Bordeaux, it didn't really matter if he was—or was *not*—in Normandy (fig. 13). He was, instead, a displaced urbanite with time and money to spare and a desire for sea air and the curative displacement of a holiday at the edge of France.

And this is surely the case as well for Degas, who made several important works of art in Normandy in the 1860s and early 1870s that have no real "Norman" character. Degas's *Cliffs at the Edge of the Sea* (fig. 14) and *Marine* (fig. 15) are less direct—and less dramatic—than the Boudin pastels so vividly evoked ten years earlier by Baudelaire. Degas replaced Boudin's Norman intensity with a Parisian nonchalance. There is even a hint of boredom in Degas's landscape world, as if he was simply making art to fill the endlessly dull time of a summer holiday.

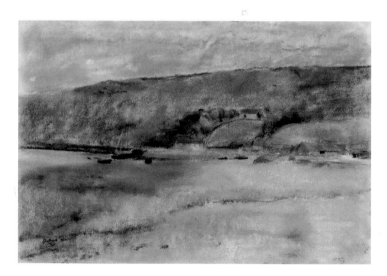

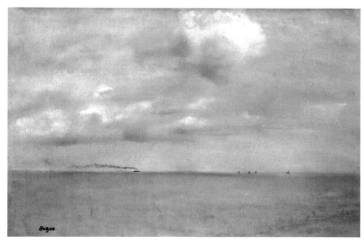

Normandy in Impressionist Painting of the 1870s

One can say without fear of exaggeration that the "great" decade for the representation of modern Normandy was the 1860s, the decade before the group of artists we call the Impressionists banded together to produce their first exhibition in 1874. It has long been known to historians of French art and culture that the fissure between the 1860s and the 1870s was a profound one—not simply the arbitrary passage of measured human time that separated, say, the 1850s from the 1860s. Instead of that simple shift in the calendar, the shift from the 1860s to the 1870s was marked by an international war with Germany in 1870 and a massive urban revolution shortly thereafter. The France of 1871 had lost two eastern provinces and the great city of Strasbourg to Germany and had agreed to pay immense war reparations that it could scarcely afford. It had also endured another rapid shift of government, lurching from an imperial government to one of the republican left during the Commune (at least in parts of Paris) to a center-right democracy at the onset of the Third Republic—all in less than two years. France's sense of confidence in the efficacy of its culture and the strength of its military had been shaken rather more severely than at any other time in the nineteenth century, and, for reasons that must be connected to this, its pictorial investigation of the contested Norman landscape dwindled to almost nothing. If Deauville, Trouville, Honfleur, Le Havre, Rouen, and Étretat were ubiquitous in French landscape painting, graphic arts, and photography during the previous three decades, they were stunningly replaced in advanced painting by the Île-de-France. Images of inland boating and suburban leisure at Argenteuil or Chatou filled some psychic need not met by the bracing sea-boating of the Norman coast, and few of the great French painters of the Impressionist circle spent prolonged periods in Normandy in the 1870s.

Monet, as we know, painted along the Seine near Rouen in 1872 and in and around Le Havre in 1873, but his works from these two short campaigns were dwarfed both numerically and aesthetically by his paintings in Argenteuil and Vetheuil, both of which are part of the landscape of the Île de France. Indeed, the capital city of Paris seems to have called back its artists from the Norman coast and created social and historical conditions in which they trained their sights on the capital and its proximate landscape. *La compagne de Paris* (the countryside of Paris) became a modern equivalent of the Roman *campagna*, where French landscape painting was born in the seventeenth century and reborn in the first half of the nineteenth century. It almost seems as if the French avant-garde shied away from French borders in the 1870s, preferring reassuring capital landscapes without hints of foreign intervention.

FIG. 14. Edgar Degas, *Cliffs at the Edge of the Sea*, 1869, pastel, 12¾ x 18¼ in. (32.4 x 46.9 cm), Musée du Louvre, Paris.

FIG. 15. Edgar Degas, *Marine*, c. 1869, pastel, 12⅕ x 18⅛ in. (31 x 46 cm), Musée d'Orsay, Paris.

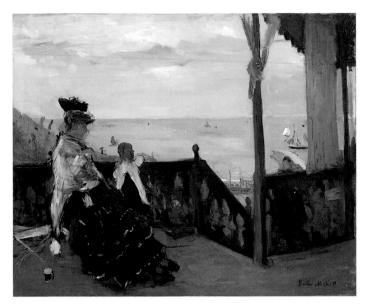

FIG. 16. Berthe Morisot, *In a Villa at the Seaside*, 1874, 19¼ x 24⅛ in. (50.2 x 61.3 cm), Norton Simon Museum, Norton Simon Art Foundation.

FIG. 17. Berthe Morisot, *Cliffs at Fécamp*, 1873, 9½ x 20 in. (24 x 51 cm), Private collection.

There are, of course, exceptions to this rule. Manet's close friend Berthe Morisot, who exhibited in seven of the eight Impressionist exhibitions between 1874 and 1886, spent a portion of the summer of 1874, immediately following the Impressionist exhibition, in the Norman fishing town of Fécamp. Although the Morisot family spent that summer with the Manet family, Edouard Manet himself worked most of that summer near Monet and Renoir in Argenteuil. For that reason the only Norman

paintings to survive from that first Impressionist summer are by Boudin, who was included in the 1874 exhibition, and Morisot. The greatest by far is Morisot's *In a Villa at the Seaside* (fig. 16), which represents the "Swiss" terrace of a rented house overlooking the beach and harbor of this picturesque Norman town. Morisot's steadfast pictorial refusal to deal with the natural—and the public—realms of the Norman town in this painting have been noted by scholars of her work and related, most often, to restrictions on the movement of haute-bourgeois women like Morisot. Yet its quality of self-indulgent ennui is surely Baudelairian and relates closely to Manet's own earlier representations of other French seaside resorts.

Morisot, like the other painters of modern Normandy, ignored both the traditional and the historical aspects of this picturesque town, and in only one painting do we catch a glimpse of Fécamp's famous white cliffs (fig. 17). Yet even here the powerful forms of the cliffs are rendered almost as a flat colored shape that invades the upper-left corner of this small canvas. An empty basket rests on a parapet, and a little girl, safely in the presence of a female nurse or guardian, looks back coyly at the viewer, seemingly uninterested in the beach. In none of the paintings created that summer by Morisot do we learn of the picturesque beauties of this historically important Norman fishing town, which Guy de Maupassant also visited with some frequency in the 1870s.[4] In painting Fécamp, Morisot quite deliberately avoided everything that would have been "interesting" to artists working in Normandy for the previous five decades. Human history, with all its complications and diversions, was not in keeping with her utterly urban modernism.

If one discounts the wonderful landscapes painted by Pissarro in the mid-1870s in the farming area of Montfoucault, the next

FIG. 18. Pierre-Auguste Renoir, *Road at Wargemont*, 31¾ x 39½ in. (80.7 x 100.3 cm), Toledo Museum of Art, Gift of Edward Drummond Libbey, 57.33.

had a real intensity, and the painter spent much of the summers of 1879–82 at Wargemont as a guest of the family. He seems to have compensated the Bérards with paintings made during his time with them, but the two paintings discussed here seem never to have belonged to the Bérards. Neither of them is in any sense a conventional Norman painting.

The *Road at Wargemont* (fig. 18) is completely original. Almost Rubenesque in its swelling curvilinearity, the painting represents one of the long gravel roads that winds through the hilly landscape around the château. Wargemont itself was well inland, visually disconnected from the sea that was so often the subject of modernist Norman painting. In painting this large landscape, Renoir chose a vantage point that was quite a walk from the château itself and selected a motif with little intrinsic interest. No important buildings, no distant village, no significant natural form, no glimpse of the sea is allowed into his quotidian landscape. Nor does the painter include human figures, carts, or horses to give scale to the landscape. Instead, we imagine ourselves as painter-viewers, alone on a windy summer day, immersing ourselves in a landscape in which light and air are in constant motion. We are encouraged to think neither of history nor of literature and are in a state of suspended animation on a particular day in Normandy in the summer of 1879. No guidebook

important pictorial campaign by an Impressionist painter in Normandy was made by Auguste Renoir. Although born in Limoges to working-class parents, Renoir had been raised in Paris and had little direct connection to the French countryside, Norman or otherwise. Most of his forays into the country were made to visit his mother, who had a small house in Louveciennes, just west of Paris, or to paint with Monet, who rented houses in Argenteuil. He also took the train to Chatou, where he befriended the owner of the famous "Restaurant Fournaise" and painted the picturesque sections of the Seine near the restaurant. Yet in 1879 the most important figure painter among the Impressionists received his first invitation to the large Norman country house of Paul Bérard, the Château de Wargemont near Dieppe. This visit was the first of many and, over the next six years, Renoir painted no fewer than forty works for the Bérards at Wargemont, including a series of decorative paintings for the library, the small drawing room, and the dining room of the imposing château. Most of these have no real "Norman" character.

There are, however, two major paintings Renoir made in the summer of 1879 that are both imposing and fascinating as contributions to the French representation of Normandy. His host at Wargemont, Paul Bérard, was a retired diplomat and banker with considerable private wealth, who lived in a large Parisian residence on the rue Pigalle not far from Renoir himself. Despite their differences in social standing and religion (Bérard was a Protestant, while Renoir was, at least nominally, a Catholic), Bérard remained a close friend of the painter until his own death in 1905, twelve years before that of Renoir. Their early friendship

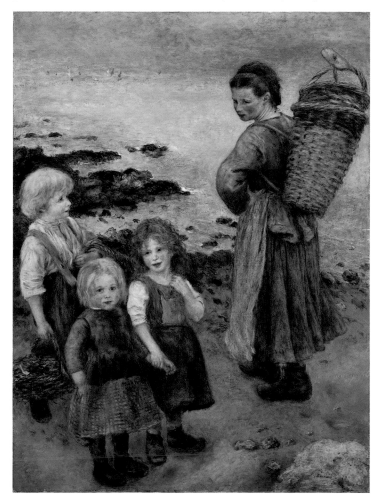

FIG. 19. Pierre-Auguste Renoir, *Mussel Fishers at Berneval*, 1879, 69 x 51¼ in. (175.3 x 130.2 cm), The Barnes Foundation.

would take us to this spot. No story by Maupassant would allow us to people it with "characters."

It was precisely the inhabitants of the coastal landscapes near Dieppe that became the subject of Renoir's second great Norman painting of that summer, the famous *Mussel Fishers at Berneval* (fig. 19). The coastal village of Berneval, near Dieppe, was a long walk from Wargemont, and it is likely that Renoir was driven there in the Bérard's carriage in order to paint. It is highly unlikely that he ever took this large canvas with him (it is almost six feet high!), but he surely made both landscape and figure studies along the coast. Given the varied poses and the highly detailed rendering of the homespun clothing, it is even likely that he paid the models and brought them to Wargemont itself to pose.

This ambitious painting was clearly intended for public exhibition, and Renoir sent it to the Salon of 1880, where it was accepted along with three other paintings by the artist, an important figure study painted in Paris and two portraits. Even the most sympathetic writers about Renoir have had trouble with the Berneval painting, and Barbara Ehrlich White, his most prolific recent historian, even suggested that Renoir conceived of the subject of what she called "Norman peasants" to curry favor with the peasant painter Jules Breton, whom he knew would be on the Salon jury.[5] While this cannot be ruled out, it is more likely that Renoir was simply fascinated by these Normans, whose blond and reddish hair and traditional clothes force us to think about their Scandinavian ancestry. Unlike any other important painter of Normandy before him, Renoir looked at the people—and, in this case, particularly the children—of Normandy rather than the international urban tourists whom other painters of modern Normandy favored.

Psychologically, the painting is fascinating, and, as a contribution to the French tradition of rural painting—essentially invented in the 1840s by the Norman painter Jean-François Millet—it is of major significance. Nothing quite like it springs to mind. In a certain way, it can be compared to Millet's *Gleaners*, in which impoverished peasants pick up the remains of the harvest so that they can live. Renoir's rural folk are equally impoverished, and the fact that there are three children (probably two boys and a girl) and a teenage girl without any adults present forces us to think of them as vulnerable. Only the smallest of them engages the viewer, although they are posed in such a way that we imagine they have stopped so that we can interact with them. The frowning, even suspicious demeanor and pose of the teenager—perhaps she is about to say, "Come along now!" to the children—suggests that the innocence and openness of childhood will soon disappear from these children as they become adults. When we contrast this painting to Renoir's recently completed portrait of Paul Bérard's daughter Marthe (fig. 20), we can see just how Renoir wrestled with social class in his representations of children made during that crucial year of his development. Therese is complacent, beautifully dressed, and—it must be said—perhaps a little lonely as she poses for Renoir. The poor children of Berneval seem to serve much more as visual emblems

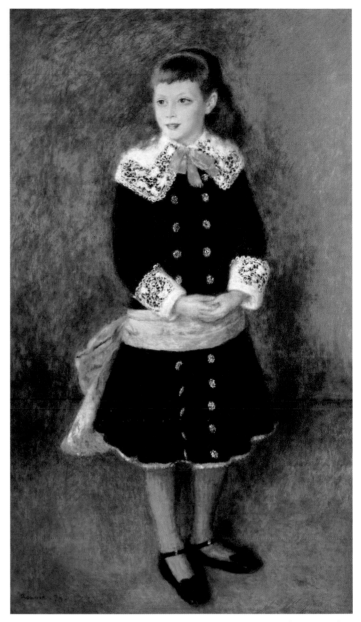

FIG. 20. Pierre-Auguste Renoir, *Marthe Bérard*, 1879, 50⅜ x 29¼ in. (128 x 75 cm), Museu de Arte, São Paulo.

for charity as they walk the beaches of Normandy, searching for mussels that their sister will sell in town.

Renoir also painted an extraordinary study of the waters of La Manche during that same summer (fig. 21). Using wonderfully thinned paint—almost the consistency of water itself—he evoked the gorgeous energies of seawater in a way that almost feminized the famously rough Channel. Renoir was away from Paris until May 3, 1882, and thus missed the seventh Impressionist exhibition with its series of seascapes painted by his friend Monet in the autumn seasons of 1880 and 1881, as well as the great Courbet retrospective. Surely he had a chance to see those works at Durand-Ruel's gallery in Paris before he returned to

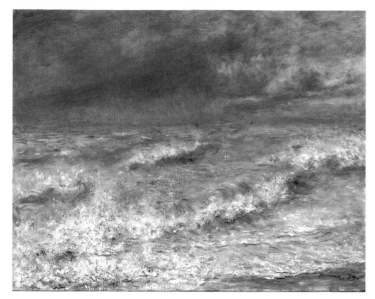

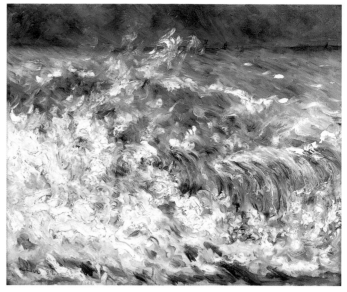

FIG. 21. Pierre-Auguste Renoir, *Seascape*, 1879, 25½ x 39 in. (64.8 x 99.2 cm), The Art Institute of Chicago.

FIG. 22. Pierre-Auguste Renoir, *The Wave*, 1882, 21 x 25 in. (53.3 x 63.5 cm), Collection of The Dixon Gallery and Gardens, Museum Purchase from Cornelia Ritchie and Ritchie Trust No. 4, provided through a gift from the Robinson Family Fund, 1996.2.12.

Wargemont in August, walked down to the sea, and painted a work of almost ferocious energy—the extraordinary *Wave* (fig. 22), signed and dated 1882. Here Renoir paid full homage to Courbet, who had died five years earlier, and to Monet, whose Norman marines of the early 1880s evoke Courbet's Normandy. In Renoir's *Wave*, we see the artist painting an act of homage that, in a profound sense, attempted to better the achievement of the men he so admired. The wild seas of Normandy, celebrated by Jules Michelet in his great book of 1860, *La Mer* (*The Sea*), are now unleashed in paint by Renoir.

The 1880s: Monet and Pissarro Move from the Île-de-France to Normandy

Camille Pissarro, the oldest of the Impressionists and, to many, the father-figure of the group, has never been considered a truly "Norman" painter. His lifelong Danish citizenship, Jewish origins, and left-wing politics link him much more to the aesthetic and political revolutionaries of Paris than to the people of Normandy. Yet, Pissarro moved from the Île-de-France landscape around the town of Pontoise in 1884, and, after a protracted search that included Versailles, L'Île Adam, and Compiègne, leased a large farmhouse in the village of Eragny, near the important Norman market town of Gisors. Eragny lies on the main road from Paris to Dieppe and was a two-hour train ride from Paris. Hence, it was embedded in the Norman countryside, making it just as easy for Pissarro to travel to Rouen or Dieppe as to Paris. The family lived in this house from 1884 until the death of Mme Pissarro in 1928 and actually bought it in

1892 with a down-payment loan of 15,000 francs from Monet, arranged secretly by Mme Pissarro.

Although Pissarro died in 1903 in Paris, where he had maintained a series of rented apartments, the Pissarro "home" was centered in Normandy, and, in the last nineteen years of the artist's productive life, he painted hundreds of landscapes of Normandy. These range from utterly modern Norman cityscapes of Rouen, Le Havre, and Dieppe, to figure studies of Norman harvests and rural markets, to landscape views of the village of Eragny and the neighboring village of Bazincourt. After Monet, Pissarro was the most important painter of Normandy among the Impressionists. Yet, whereas the Norman farmhouse of Monet at Giverny has been visited by millions of tourists and is included in every recent guidebook of both the Paris region and Normandy, Pissarro's well-preserved house in Eragny is still privately owned, is mentioned in no guidebook of real importance, and is visited by only a handful of Pissarro's faithful scholars and collectors in any given year. Thus, it remains much more "embedded" in Normandy than Monet's house in Giverny. Even though Pissarro's paintings of the surrounding countryside grace the walls of museums and private collections throughout the world, they provide little understanding of the place from which they come.

When Pissarro rented the house in Eragny, he had painted literally hundreds of populated rural landscapes in the Île-de-France. He had also worked actively with other artists, including Cézanne, Guillaumin, and Gauguin. Thus, he created a complex—and fundamentally collaborative—landscape practice that, when he arrived in Eragny, was ready to be tested in a new landscape. The large farms of central-eastern Normandy were rather different than the vegetable gardens and fruit orchards

FIG. 23. Camille Pissarro, *The House of the Deaf Woman and the Belfry at Eragny*, 1886, 25⅝ x 31⅞ in. (65.1 x 81 cm), Indianapolis Museum of Art.

that surrounded Pissarro's Pontoise, and the landscape was less hilly and hence somewhat less conventionally scenic and varied. As Pissarro began to work in this landscape, he had just embarked on a phase of his career devoted to "scientific" Impressionism, which put him at odds with his old friends Renoir, Degas, and Monet. Thus, for Pissarro in the early years of his time in Eragny, his manner of painting was more important to him than were his subjects. His annual production decreased dramatically, and his time-consuming new "dotted" technique so prolonged his working process that he often worked on paintings over several years. Hence, Pissarro's "Normandy" has often been equated with the "Neo-Impressionist" Pissarro, as scholars and critics deal more forcefully with his technique than his Norman imagery.

Before looking in some depth at a small group of what we might call canonical Norman paintings by Pissarro, it is perhaps best to characterize his Norman oeuvre as a whole. First of all, Normandy absolutely dominated Pissarro's pictorial world between 1884 and 1903, when he died in Paris. Although he painted superb urban landscapes of Paris, the majority of his diverse works of art represent Normandy. Pissarro's paintings of rural Eragny encompass all four seasons, planting and harvesting cycles, pasturage of sheep and cattle, fruit and vegetable gardening, and simple landscape views painted with loving attention to the particular characteristics of young fruit trees, the martial rhythms of poplar trees, and the regular furrows of plowed earth. We are also treated to scores of representations of the Norman people, in ways that Monet would

never attempt: peasant men and women working, resting, walking, bathing, and engaging in rituals of rural economy. Even the traditional thatched half-timber houses of the nearby village of Bazincourt, which Pissarro could see from his windows in Eragny, fold into the earth in ways that force us into direct links with the earlier representations of traditional rural architecture in Normandy by Corot (fig. 5). Pissarro's Normandy was populated by Normans who lived and worked in the landscape of their birth. There were no tourists or urbanites allowed into Pissarro's "modern" paintings of a thoroughly "traditional" rural Normandy.

When Pissarro arrived in Eragny, he lost no time in painting its various landscape views. He climbed the small hills and looked down into the Epte valley. He turned his attention to his own house and garden, field workers, local passersby on the unpaved road, indigenous workers in a traditional brick factory in the village, and old brick houses in the village. In his rural world, Pissarro celebrated the work of the hand—not only his own, as it moved deftly across the surface of his canvas with various small brushes, but also that of generations of Normans who lived—or had lived—in Eragny.

Indeed, even as Pissarro modified his painting technique late in 1885 and adopted the scientific, chromo-luminarist "dot" developed by Georges Seurat, his imagery remained utterly traditional and quotidian. Two of the Neo-Impressionist landscapes of Eragny included in the 1886 Impressionist exhibition represented simple Norman landscapes, without modern or urban encroachment of any sort. *The House of the Deaf Woman and the Belfry at Eragny* (fig. 23) represents a view from Pissarro's own farm, and the loving particularity of its execution (even of its title!) brings this small corner of Normandy completely alive. Surely Pissarro remembered his

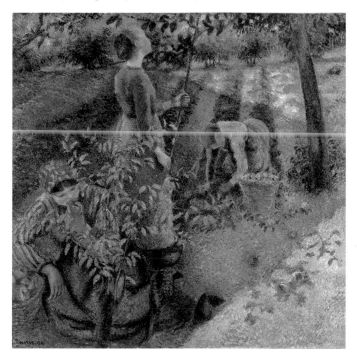

FIG. 24. Camille Pissarro, *The Apple Pickers*, 1886, 50⅜ x 50⅜ in. (128 x 128 cm), Ohara Museum of Art, Kurashiki.

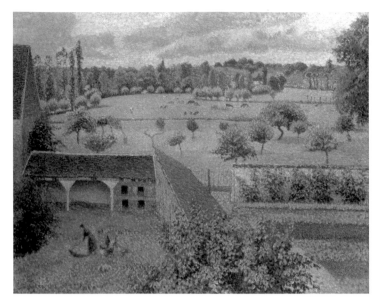

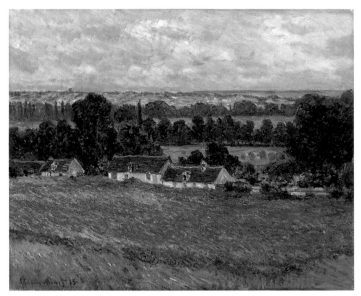

FIG. 25. Camille Pissarro, *View through a Window, Eragny*, 1888, 25½ x 31⅞ in. (65 x 81 cm), Ashmolean Museum, University of Oxford.

FIG. 26. Claude Monet, *Field of Poppies, Giverny*, 1885, 23⅝ x 28¾ in. (60 x 73 cm), Virginia Museum of Fine Arts, Richmond, Collection of Mr. and Mrs. Paul Mellon.

friend Cézanne's *Maison du Pendu* (*House of the Hanged Man*), shown in the first Impressionist exhibition of 1874, when he titled his own later picture; both titles take us completely into the realm of the local—referring, undoubtedly, to place names uttered frequently, but never written down. As if to make his immersion in Normandy completely clear, Pissarro also submitted a large figure painting to the same exhibition, *The Apple Pickers* (fig. 24), which, although begun before he moved to Normandy, was completely reworked with new models and new chromatic ideas in Eragny. Indeed, every visitor to Normandy knows of the ubiquity of apple orchards and of the consequent preference throughout the countryside for cider to wine, and Pissarro's figure painting completed in 1886 was, hence, utterly Norman.

In 1888 Pissarro completed a marvelous Norman landscape entitled *View through a Window, Eragny* (fig. 25). Here we see the orderly realm of the family's poultry yard, its vegetable garden, its fruit orchard, and the distant grain fields of what was essentially a classic Norman landscape. Although Pissarro was only renting the property, he took possession of it through the act of painting, clearly expressing a kind of pride that was, in itself, a form of ownership. No more "Norman" landscape was painted by a Neo-Impressionist painter. When we compare it to the early landscapes painted by Monet in and around his own farm garden in Giverny, its intimacy and immediacy make it unique. In none of the paintings of Giverny from the last half of the 1880s does Monet approach the intimacy—and love of the local—that is so much a characteristic of Pissarro's Norman landscapes. Never do we see rural workers in Monet's fields, and his view from the hill onto the field of poppies (fig. 26), though obviously particular to the landscape Monet painted in the character and location of the farm buildings, trees, and fields, has an almost placeless

generality of treatment that is antithetical to Pissarro's regional intimacy.

Guidebooks tell us that the nearby town of Gisors, from which Pissarro caught the train to Paris and where he was a frequent visitor, had its own provincial charms. Graced by the ruins of a medieval fortified château built by the son of William the Conqueror, it also had an important Gothic church with a major Renaissance façade, and just four miles away was a large seventeenth-century chateau designed by no less a figure than Jules Hardoin-Mansart. Several guidebooks also mention the rural beauties of the Epte valley, which runs from Pissarro's Gisors until it empties into the Seine near Monet's Giverny. Thus, the Norman landscapes of Monet and Pissarro were linked by a river. Yet Pissarro's Gisors was no more or less than a rural market town, and its inhabitants met frequently with the farmers from the surrounding landscape, who brought their fresh poultry and produce into the town for sale. This small-scale capitalism appealed strongly to Pissarro's left-wing, anti-capitalist (and anti-industrial) political sensibilities, creating a situation in which he was utterly open to the human drama of rural market economies in a way that would have been completely foreign to his friend Monet. The nearby town of Vernon had an important Gothic church that Monet painted with some frequency. By contrast, Pissarro was utterly uninterested in including the historical "treasury" of Gisors in his market scenes.

Pissarro and Norman Cities

If Pissarro emphasized the hearty work of the fields and the small-scale market commerce that it generated, he also turned a

good deal of his visual attention to the three large cities of upper Normandy—Rouen, Le Havre, and Dieppe. In fact, the first French place experienced by the young Pissarro when he was sent from his boyhood home in the Danish Antilles, the island of St. Thomas, was the port city of Le Havre. This Norman port and the Seine estuary were Pissarro's root landscapes in France, and there is no doubt that, on his arrival, he took a boat up the Seine to Paris, where he was met by family members and sent to school outside the great capital city. Hence, the riverscape of the Seine from its mouth to Paris—at least half of which lies in Normandy—was of primal psychic importance for Pissarro, and he remained faithful to it in the twenty years before his death. His earliest painting campaign in Rouen, in 1883, preceded his move to Normandy. While there he painted landscapes along the river, mostly from vantage points outside the city. He returned in 1895, after which he saw the exhibition of Monet's Rouen Cathedral series at Durand-Ruel's gallery. He returned early in 1896, remaining for more than three months, and returned again in the autumn for another three-month campaign. These sojourns yielded twenty-eight cityscapes of the Norman capital.

Although they were prompted by the example of Monet's series devoted to the façade of Rouen cathedral, Pissarro's paintings differed deliberately—and in fundamental ways—from Monet's example. Monet's façade fills the vertical format of the canvases he painted in groups, and, as the light plays across the craggy façade, it turns violet, deep gray, pink, orange, ochre, blue, and rose. In only three of the paintings are there hints of human figures—and these are little more than the "tongue licks" that Monet had been accused of making in the first important urban painting he exhibited in 1874. In the end, it was light and atmosphere rather than animate life that were Monet's true subjects. Rouen itself hardly impinged on the cathedral's magnificent façade, and, in a certain sense, the paintings therefore inhabited an almost "timeless" time with

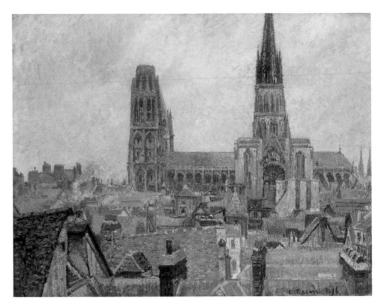

no visible historical referent—diurnal and seasonal, but not quotidian and human. Like the great cliffs of the north coast of France, the cathedral at Rouen endured through time as if itself ageless.

How different is Pissarro's Rouen! Because he rented rooms that faced the Seine in both his 1896 and 1898 campaigns, the vast majority of his paintings represent the teeming life of its ports. We see the bridges, the bustling quays, the loading and unloading of ships, the steam pouring forth from factory chimneys across the river from the historic town, and literally hundreds of people—workers and bourgeois, men, women, and children, pushing carts, riding horseback, sitting in omnibuses, and, occasionally resting in place (fig. 27). The sheer particularity of his views differs radically from Monet's slightly earlier representations of the same city, and, in the main, Pissarro de-emphasized the historical monuments of the city. In this way, the younger—and decidedly more "Norman"—painter preferred to represent Rouen in a way that links him directly to the painters, photographers, and printmakers of Romantic Normandy in the first half of the century. Pissarro was decidedly more modern than Monet.

Pissarro, however, did paint the great cathedral as the dominating form in one superb horizontal cityscape painted in 1896, and he painted it again several times during his final trip to Rouen in 1898. The earlier work, *The Roofs of Old Rouen, Gray Weather* (fig. 28) is in every way a contrast to Monet's serial representation of the same building. Pissarro's venerable Gothic cathedral rises out of a jumble of slate and red-tile roofs

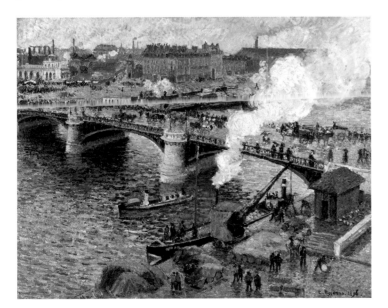

with their gaggle of adjacent chimneys, as if the town itself had given birth to this anonymous architectural masterpiece. Where Monet represents the building with little or no urban context in the most dramatic light conditions—at dawn, or dusk, or sunset, or with brilliant light falling across its façade, Pissarro shows us the city on a cold gray day—a day as monotonous, as "anti-picturesque" as Monet's days are exciting and varied. And for Pissarro one painting would suffice; he never repeated this composition in different conditions of light and atmosphere. The same can be said for his 1898 paintings, among them the *Rue de l'Épicerie, Rouen* (fig. 29), a vertical canvas that treats the cathedral as a fascinating backdrop to a crowded and light-filled scene of urban shopping. Gone, for Pissarro, were the becostumed Normans who littered the streets of Bonington's Rouen (fig. 2). In his day they were replaced by bustling urbanites who proved that Norman cities were more than relics of a lost historical glory. Pissarro's 1901–02 series of paintings of the Dieppe Harbor and of the glorious Gothic church of St. Jacques in that same city as well as his final Norman series devoted to the harbor in Le Havre, done in the year of his death in 1903, brought to a conclusion this great painter's pictorial hymn to Normandy. In these works we can see an artist who was, in the end, the true successor to Boudin as Normandy's modernist visual poet.

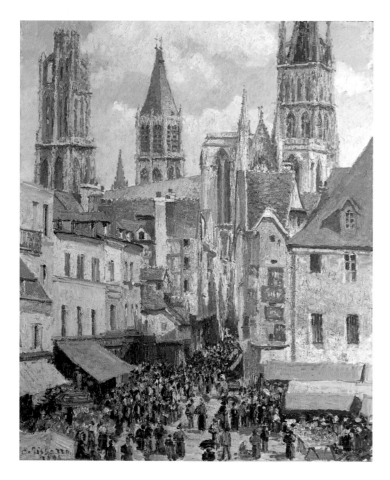

Degas's Norman and Northern Landscapes

In the first days of May 1891, Claude Monet installed what was to be the first true exhibition of landscapes painted in series. His one-person exhibition at the Durand-Ruel gallery contained fifteen paintings made in the fields near his farmhouse in Giverny in the previous two years, most of which had been brought to completion in the months preceding the exhibition. Variously called "haystacks," "grainstacks," and "wheatstacks" in the voluminous Monet literature, these agricultural landscapes created a sense of almost mythic, ahistorical time—a kind of cyclical agricultural time that had been experienced in France for several millennia. No figures, vehicles, or animals disrupted the play of light and weather over the stacks, and Gustave Geoffroy's ecstatic prose in the introduction to the catalogue compared the paintings to gemstones, fire, and blood in ways that derive utterly from Baudelairian criticism of a generation earlier.

A little more than a year later, Durand-Ruel opened another exhibition of landscapes, this time by the Parisian painter Edgar Degas. Degas had made landscapes in the late 1860s as well as the mid-1870s, but had rarely displayed them, except to close friends in his home or studio. Twenty-five pastel and monotype landscapes by Degas were shown together in Paris, clearly in response to Monet's haystacks. Interestingly, these works—like those shown by Monet the previous year—appealed to collectors, and the exhibition sold out. In creating these paintings, Degas chose bleak, simple Norman landscapes, most often along the coast, and treated them in ways that recall the late landscapes of Corot, who blurred and generalized forms to such an extent that we all but forget that the landscape represents an actual place. *Wheat Field and Green Hill* (fig. 30), and *Landscape* (fig. 31) are both worked in pastel over a monotype base, and each takes us on what amounts to a strange journey to the north of France, as if we are in a dream or evoking a place from dim memories of childhood. There are no figures or identifiable buildings, and many of the rocks and hills are so strange and visually unprecedented that we discover human bodies or animal forms hidden in them.

There is no doubt that Monet knew of this exhibition and that he borrowed a good deal of Degas's originality of conception in the creation of his late Norman coastal paintings. In a certain way, the example of the great Degas gave Monet the courage to move beyond the landscape motif itself, giving him a precedent in art to create mystical landscapes that are more in keeping with the Symbolist criticism of the 1890s than with earlier views of Normandy. And even Degas's other late landscapes—those behind the racehorses, dancers, or bathers in the last significant decade of his working life—seem more like mythical stage sets for action than precise invocations of particular places. Indeed, Normandy, that place in which Monet's career as a modern artist

FIG. 29. Camille Pissarro, *Rue de l'Épicerie, Rouen*, 1898, 32 x 25⅝ in. (81.3 x 65.1 cm), The Metropolitan Museum of Art, New York, Purchase, Mr. and Mrs. Richard J. Bernhard Gift, 1960. (60.5).

FIG. 30. Edgar Degas, *Wheat Field and Green Hill*, 1892, image: 10 x 13⅝ in. (25.4 x 34.6 cm), sheet: 10 ⅝ x 14 ⅝ in. (27 x 37.2 cm), Norton Simon Museum, The Norton Simon Foundation.

FIG. 31. Edgar Degas, *Landscape*, c. 1890–92, 18¹⁄₁₀ x 21½ in. (46 x 54.6 cm), Jan Krugier and Marie Anne Krugier Poniatowski Collection, Courtesy Galerie Jan Krugier, Ditesheim & Cie.

had incubated, had transformed itself through the example of Degas into a pictorial scaffolding for his experiments with what critics then called "pure" color, paint, and light. Monet retreated further and further from locative reality into memory and imagination, and his final Norman retreat took him from the landscape itself into his own garden.

The Normandy of Impressionism is clearly not limited to Monet—and, as we shall see in the following essay, the great Impressionist actually defined his own representation of Normandy, at least partially, in terms set by his friends and rivals in the movement. Indeed, the series of dialogues between Pissarro and Monet, and Degas and Monet are so powerful that one cannot discount the importance of these "others" in explaining Monet's own Norman oeuvre. We can see, however, that as often as not, the "influence" is just as often negative as positive. "If Pissarro does it this way," or so the reasoning goes, "I will do it the opposite way."

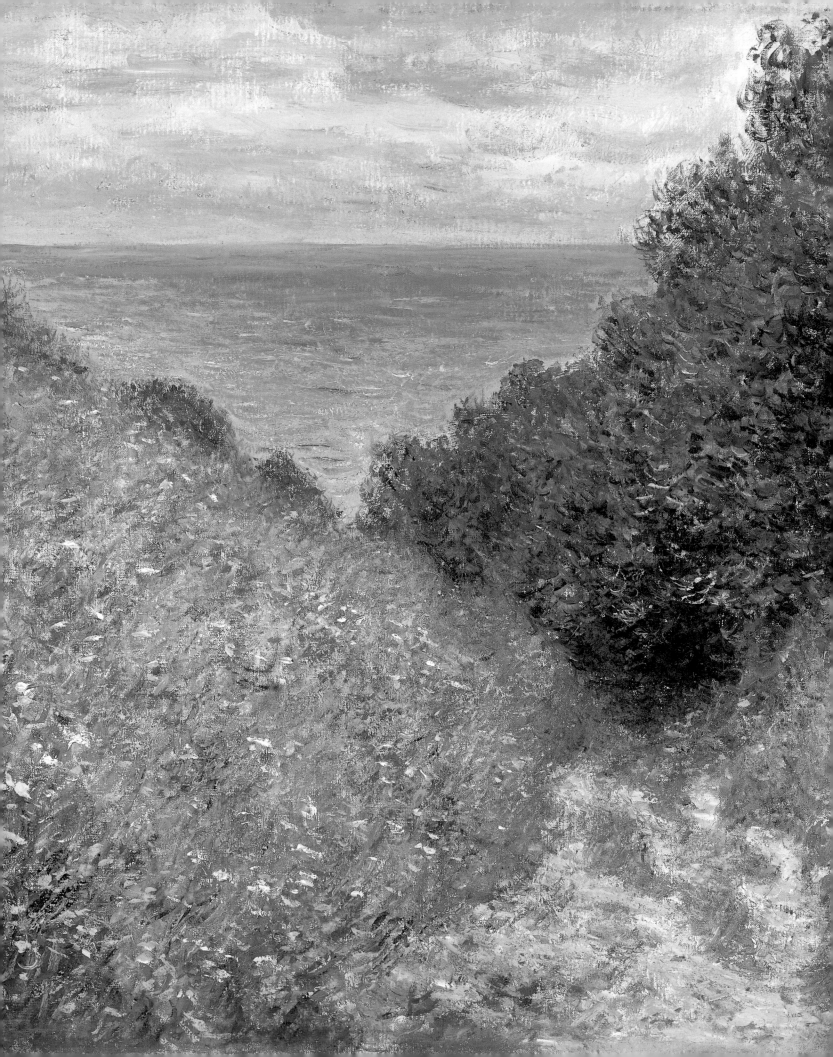

Monet and Normandy

NOTES TOWARD A PSYCHOLOGICAL APPRAISAL

Claude Monet painted more landscapes and figure paintings in Normandy than any other major painter, save his mentor Boudin. Yet with the exception of his Norman paintings of the 1860s and the sequences of Norman coastal view paintings of the 1880s and 1890s, his painted oeuvre has never been considered "Norman." The Rouen cathedral series—the third of his three famous series of the early 1890s—is more often discussed in terms of French modernist attitudes toward religion and science than in terms of the Norman capital city of its origins, and rarely has his extensive and varied oeuvre painted in and around the Norman hamlet of Giverny been considered as "Norman." Indeed, for Monet's oeuvre, the "modern" that condition of the placeless and cosmopolitan—has all but subsumed the "Norman"—with its associations of regional history and thus of a stubborn anti-modernism. It is the aim of this essay—and the scholarly entries that follow, written by the three cocurators of the exhibition—to consider Monet's Norman landscapes *as* Norman and to compare them to—and contrast them with—the numerous previous and contemporary Norman landscapes that would have been known to Monet—most of which have already been discussed.

In a sense the exhibition—shown in three "regional" American cities—addresses the same issues of "regionalism," "nationalism," and "cosmopolitan modernism" that underlie a good deal of nineteenth-, twentieth-, and now twenty first century civilization in the Euro-global world. In fact, only a handful of Monet's Norman paintings can now be found in Normandy itself—just as fewer than five of Cézanne's Provençal landscapes are today in Provence or fewer even than that of Gauguin's Tahitian landscapes are still in Tahiti. Instead, these works have essentially been highjacked by modernism and can be found today wherever international capitalism has taken them. They are not part of the landscape that inspired them and of the descendants of the people who figured in their illusory worlds. In this way they are like the rural workers of the Roman *campagna*, the hilly countryside around Naples, and the forest of Fontainebleau in France, "belonging" to a world far from that in the picture—a world that judges these works in terms unimportant to the people who inhabit the painted landscapes.

In a powerful way, Monet's "Norman" oeuvre is not at all "Norman" when we see it in New York, Canberra, Montreal, Boston, London, or even Paris. Rather, it is "Impressionist" and, by extension, "modern." Yet as we have seen, it contributes to an extensive visual discourse of "Normandy." Indeed, rather than deny the mythic and modernist aspects of Monet's Norman painting, this study situates them in the larger visual discourse. The same distance between Normandy and modern urban reality found in Monet's Normandy is also a powerful aspect of the respective "Norman" images of Corot, Boudin, Degas, and Pissarro, many of whom seem to try harder to create landscapes that appear to be "Norman." By personalizing—and making "mythic"—his Normandy, Monet actually enlarged and enriched this visual discourse as much as he might be thought to have repudiated it.

OPPOSITE: Detail, *Road at La Cavée, Pourville* (cat. 32).

Normandy versus Paris:
Monet's Normandy in the 1860s

Monet's Norman paintings of the 1860s form a visual counter-discourse to the "modernist" Normandy of Boudin and Manet. For every summertime tourist or country-house inhabitant in the works of Boudin and Manet, Monet counters with a fisherman, a worker, a peasant, or another kind of Norman. He painted Normandy in all seasons and was a particularly compelling painter of the "anti-vacation" Normandy, experienced in the depths of winter, when the urbanites from Britain and France were back in the their cities, with the fires stoked and the servants making rich and complicated meals. What is interesting, however, about Monet's Norman landscapes and portraits of the 1860s is that very few of them were seen by anyone who wasn't a close friend or relative of the painter during the decade in which they were made. Unlike his friend Pissarro, whose works were included in Salon exhibitions from 1865 onward, Monet had very mixed success at the Salons, for which he submitted large and important Norman landscapes and seascapes each year from 1865 to 1870. He had success twice—with two imposing paintings in 1865 and a single one in 1868 (the latter, depicting a three-masted ship departing the harbor of Le Havre, has unfortunately been lost). All of his other imposing Norman works submitted to the Salons—and he submitted at least one each year in 1867, 1868 (he submitted two that year), and 1869—were rejected and, hence, unseen by the public.

We have no real idea just why this was so, because equally imposing and difficult Salon landscapes by Pissarro and other aesthetic allies were accepted by the same juries that rejected those of Monet. Perhaps it was because Pissarro's mentor was the beloved Corot, a Parisian who could help his strongest followers with a word here or there to a powerful friend. In contrast, Monet's mentor was the comparatively little-known Boudin, who, we have seen, avoided the capital assiduously. Yet what is extraordinary when we look at these paintings today is just how original they were within the context set by Boudin. Only one of these paintings is in the present exhibition—the great seascape in the Kimbell Art Museum (cat. 2) shown in the Salon of 1865. Its companion in the Salon of that year, the extraordinarily lively *Mouth of the Seine at Honfleur* (fig. 39), is a painting in which the sheer roiling power of La Manche in Normandy is made pictorially manifest. This is emphatically not a tourist seascape, viewed from the safe vantage point of a beach or a pier. Instead, Monet positions himself—and, by extension, the viewer—in a boat that plies the mélange of fresh- and saltwater that make the mouth of the Seine so choppy. The wind manifests itself in the straining brown sails of the local fishing boats and the distant white sails of a single yacht. Seagulls play in the wind, and the clouds shift in the sky as the humid air from the sea comes into contact with that of the land. All the figures we can see in the beached boat on the left and the rowboat in the center of the composition are seamen, not tourists from Paris. Thus, Monet visually suggests that we, too, are native Normans, able to work in the bracing, cold climate of France's north coast.

FIG. 32. Claude Monet, *Portrait of Madame Louis Joachim Gaudibert*, 1868, 85 x 54⅜ in. (217 x 138.5 cm), Musée d'Orsay, Paris, France.

Four other Salon paintings—the one accepted in 1868 and those rejected in 1867, 1868, and 1869—also represent the Norman coast of Monet's youth. The earlier—an immense painting of the port of Honfleur with its gaggle of fishing boats, a lone steam-powered tug, and distant sailing ships—has no hint of the picturesque architecture that surrounded the port, concentrating, again, on the local fishing culture that had bred his mentor Boudin. Yet it is, in every sense, the opposite of Monet's two earlier Norman coastal views in the 1865 exhibition for its relative calm and pictorial containment. The painting may have been shown in a commercial setting in Paris after its rejection from the Salon, and it did make an appearance in an important international exhibition of marine painting held in Monet's boyhood home of Le Havre in 1868, where it won a silver medal. This "local" success was perhaps sweeter than we might today suspect for the ambitious young painter. He won a medal given by an international jury in the city where his exacting father and his powerful in-laws lived. The audience for the exhibition was, as we know, a thoroughly urban and international one, and the painting was purchased after the exhibition by a wealthy merchant from Le Havre.

Collectively, the Norman seascapes from the mid- and late 1860s sent by Monet to the Salon convey a powerful natural environment controlled by its native inhabitants with their bodies

FIG. 33. Claude Monet, *Le Dejeuner*, 1868, 90½ x 59 in. (230 x 150 cm), Städelsches Kunstintitut, Frankfurt.

and their skills in making and maneuvering boats. It is a defiantly seafaring Normandy, in which there are no sandy tourist beaches, no casinos, few pleasure boats, no farms, no orchards, and no historic buildings. Hence, it is neither *Normandie moderne* nor *Normandie historique*, but, rather, *Normandie des Normands* (Normandy of the Normans). The boats and figures make it a decidedly social landscape, but one precisely—and obviously intentionally—devoid of the leisure-class urbanites who were utterly transforming its economy and its culture. It is also devoid of interest in Norman agriculture, which is such an important part of the Normandy of the great Norman painter, Jean-François Millet. Indeed, Monet intended to carve out of the province of his youth a pictorial world unique to him and suggestive of a deep familiarity with the rhythms of coastal life.

Interestingly, he did paint Norman farmyards (W16 and 36), rural roads with no hint of the sea (W24–25 and 28–30), picturesque village architecture (W33–34), bourgeois flower gardens (W68–69), one regatta (W91, cat. 4), and delightful village churches (cat. 1 and 7), but none of the paintings were exhibited publicly during the decade in which they were painted. Hence, they cannot be considered part of Monet's Normandy as it was known to his Parisian contemporaries. While the Salon seascapes make manifest the bountiful power of the sea, the

smaller paintings give us glimpses of the enduring fecundity of the Norman landscape, and in certain of the paintings, Monet deals forthrightly—and courageously—with what we might call a "private" Normandy involving the painter's own family and their bourgeois friends.

We see his father and aunt in the Lecadre garden near Le Havre, his common-law wife and friends at the dinner table, Norman bourgeois family friends posing for portraits, and his son having breakfast with the family. In fact, two of his largest and most important figure paintings of the 1860s were painted in Normandy. The great "society portrait" of a family friend, Mme Gaudibert, was painted in a large villa or château just outside of Le Havre (fig. 32) and *Le Dejeuner* (fig. 33) represents Monet's own family in a rented house in Étretat, where Monet was to paint so often more than a decade later. Hence, even as a figure painter, Monet represents the "good bourgeoisie of Normandy" in their own finery and with the amplitude of provincial life known to him so intimately from his Norman childhood. In this way Monet's Normandy is not a landscape viewed by a vacationer, nor is it Boudin's Norman landscape filled with vacationers. It is, instead, an utterly personal and decidedly modern Normandy with a wide social variety—from rural workers to fishermen to servants to the haute-bourgeoisie—and a commensurate variety of landscapes and interiors in which these figures are placed.

It is, perhaps, worth dwelling for a moment on the contrast between Monet's intimate or personal Normandy as it was in reality and as it appears in his paintings. One of the several crises of Monet's personal life in the last half of the 1860s had its origins in his father's utter disapproval of his liaison with Camille Doncieux, a young woman of completely respectable bourgeois parentage who became the mother of Monet's first—illegitimate—child late in 1867. Monet's father actually advised his son to abandon Doncieux, which the young painter defiantly refused to do. But circumstances forced him to keep his own family life utterly separate from that of his father, brother, and aunt in Honfleur. Jean Monet, his first son, was registered and baptized in Paris, with Parisians as both witnesses and godparents. His Norman family did not acknowledge this relationship during the 1860s—even after the birth of Jean, and the Claude Monet family spent a good deal of 1868 and early 1869 in Normandy, but in different places—Fécamp and Étretat—than Monet's father and aunt who were in Le Havre and Sainte-Adresse.

Monet went so far as to include a single beautifully dressed young woman in his paintings of the gardens of his aunt, but she cannot have been Camille Doncieux (who was back in Paris, pregnant with their son). The isolation of this figure from others in these gardens is remarkable—contrasting sharply with the multiple appearances of Camille in amiable mixed groups in Monet's paintings made in the gardens of her parents near Paris or at staged picnics in the forest of Fontainebleau—both non-Norman contexts. This "family trauma" was a major part of Monet's life in the late 1860s, causing, to some extent, his own financial crises during that period. Yet none of this is allowed to disrupt the serenity of his painted representations of either family

in Normandy. Whether the dinners or lunches with his common-law wife and friends at Étretat or the garden scenes and bourgeois portraits of his father and his friends in Le Havre, each world is complete, and each, it seems, awaits the other.

Monet's paintings from the years 1866–68 veer between Normandy and the Île-de-France—the landscapes of his youth and of his professional and personal adulthood. Clearly, Monet attempted pictorially to reconcile those worlds, painting them in identical styles and with a similar combination of sunny optimism and a determined pictorial detachment. We might almost argue that his Normandy was a "real" modern Normandy—not the modern Normandy of tourism but that of a completely entrenched local bourgeoisie—provincial and modern at the same time. His Normandy was dependent to an extent on Paris but did not appear to be so, and its sheer pictorial originality in the history of French "Norman" art is extraordinary. Indeed, the only pictorial equivalent in the history of art is Constable's representation of the intimate landscape of his youth, work that Monet could not have known in the 1860s but that bears an uncanny resemblance to his own personalized provincial life.

Perhaps the most original of the Norman paintings conceived for the Parisian Salons in the 1860s is not a coastal view at all but is, instead, a winter landscape representing a hedged wall and hand-made wooden gate in front of a traditional thatched Norman farmhouse. Entitled *La Pie* (*The Magpie*; fig. 34), this Norman landscape is buried under a recent snowfall and illuminated from within the painting by the brilliant winter sun. The blue and violet shadows cast by the sun animate the foreground of the landscape, whose sole inhabitant is the magpie of the painting's simple title. This bird sits jauntily on the gate, as if it has just alighted and might just as soon depart. Because of its sunny brilliance, the painting conveys little of the sense of bone-chilling cold that would have made it off-putting, and Monet was clearly competing with Courbet, who had shown a number of snowscapes in his Pavilion outside the International Exhibition in Paris in 1867. In fact, Monet had already painted Normandy in winter a good number of times before he submitted this painting to the Salon—and all these works represented a Normandy without tourists.

When we tally up the impressive group of paintings of Normandy—and Normans—made by Monet in the 1860s, it is unmatched in emotional and aesthetic range by those of any other artist, Boudin included. Monet painted the provincial churches of Honfleur and Sainte-Adresse; the old shops and houses along the main street of Honfleur; the beaches of Sainte-Adresse and Étretat; the jetty of Le Havre; the road near the farm at Saint-Siméon; the flower gardens of his relatives and their friends in Sainte-Adresse; old farm buildings near Honfleur; and other utterly Norman sites. If these works were brought together in exhibition form with those of his friends, competitors, and enemies who also painted Normandy at the time, they would utterly overwhelm the others with their depth and variety. It can, however, be said that with the exception of one regatta scene on the beach at Sainte-Adresse and the trio of garden landscapes painted in the same area, Monet's Normandy was traditionally Norman. By comparison, the utterly Norman Boudin had "sold out" to the urban modernism promulgated by Baudelaire. Monet's paintings were completely modern in their facture and bold composition, but their subjects were nearly always the opposite. It was, instead, the modernity of his eye and his sensibility rather than that of his subjects that set Monet's Normandy apart.

Monet finally married Camille Doncieux in Paris in June 1870. The wedding was witnessed by Gustave Courbet, suggesting a personal relationship between the two artists that could not, at that point in Monet's oeuvre, be measured very strongly in pictorial terms. War with the Prussians was already in the air, and Monet no doubt married at least in part in order to avoid conscription in the army. He had surely seen Courbet's great *The Cliff of Étretat after the Storm* (fig. 59) at the Salon that spring, and there is little doubt that Courbet's summation of the Norman coast moved the young painter enormously. He may have already completed the great *Rough Sea at Étretat* (fig. 35), which is the single painting of the 1860s that pays overt homage to Courbet. A month after the wedding, the young couple went to Trouville for a sort of honeymoon with Boudin and his wife, taking along young Jean, and Monet painted his first utterly modern tourist pictures (cat. 8–10), paying the closest homage to Boudin in his life. Indeed, it was only at the end of the 1860s and the beginning of the 1870s that Monet looked to the example of Courbet and Boudin for his own pictorial inspiration. His earlier painting was more strongly affected by Manet and Pissarro, and his Normandy was decidedly original.

An Impressionist Interlude in the Île-de-France, 1872–80

The 1870s was, for Monet, the first decade of his professional life in which his painting was widely recognized, sold, and discussed

FIG. 34. Claude Monet, *The Magpie*, 1869, 35 x 51⅛ in. (89 x 130 cm), Musée d'Orsay, Paris.

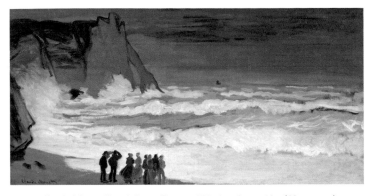

FIG. 35. Claude Monet, *Rough Sea at Etretat*, 1868–69, 26 x 51⅝ in. (66 x 131 cm), Musée d'Orsay, Paris.

in print. His comparative failure at the Salon in the 1860s was more than made up for by his success in the Impressionist exhibitions of 1874, 1876, 1877, and 1879, as well as in the extensive critical press associated with those endeavors. He also attracted the attention of several important collectors and began, by 1872, to sell well enough to afford to live comfortably, free from family help. It is perhaps not surprising, therefore, that his oeuvre during that decade was overwhelmingly devoted to the city and landscape of his own personal success—Paris and the Île-de-France. With the exception of short visits to Rouen in 1872 and Le Havre in 1873, Monet stayed in Paris and Argenteuil, moving late in the decade to the Île-de-France river town of Vetheuil.

His landscapes of this decade are overwhelmingly modern in both subject and style. When he painted Paris, he concentrated on the spectacle of its parks, boulevards, decorated streets, railroad stations, and gardens. When he painted the fundamentally suburban landscape of Argenteuil, it is inhabited mostly by Parisians, who boated, ate out of doors, walked along the Seine, and lived in rented houses and gardens. Rarely does the painter confront the local peasantry or the small-town bourgeoisie of the Île-de-France. Monet's landscape of the 1870s was linked by train and boat to Paris, and any sense of the connected or the traditional is lacking. The "Norman" painter essentially gave up Normandy.

Monet did visit his brother, Leon, who lived outside of Rouen in March 1873, painting about ten calm and beautifully observed river landscapes that were clearly intended for sale in Rouen itself. Indeed, Monet did exhibit two paintings in the twenty-third Municipal Art Exhibition held in Rouen during the month he was there. With the exception of one rather daringly composed landscape devoted to industrial buildings and a rushing train (W213) and a marvelous study of suburban farms in the hills east of Rouen, his paintings done there were soothing and utterly unproblematic. His engagement with Rouen was not nearly as powerful as was his small, but intensely experimental, series of paintings made in Le Havre in 1873.

It is important to remember that, among Monet's 1870s landscapes, one of the most important and famous, *Impression: Sunrise* (fig. 36), was painted in neither Paris nor the Île-de-France, but in the painter's boyhood home city, Le Havre, the largest seaport of Normandy. Yet not even its title betrays this fact, and Monet wanted his viewers to think more about the time of day and the mode of painting than about his subject, which is not mentioned. Indeed, if any painting of Normandy by Monet from the 1860s were compared to this early masterpiece of Impressionism, it would seem a virtual repudiation of the famous painting that gave the movement its name. This is an essentially invisible Normandy—a seaport in the mist with no locative specificity in particular buildings or boat types—all but dissolved in the light of the rising sun. For Monet the recognition of its "Norman" subject was not necessary for the success of the painting.

His 1873 campaign in Le Havre harbor was, however, more complex than we might first think from this single example. He painted the harbor from several vantage points, at several times of day (and night!), and on canvases of different formats—almost suggesting through this group of works the range and variety of his talent as a transcriber of water, atmosphere, and motion. It is surely not an accident that the only work of architecture that plays a strong role in any of the paintings is the Museum at Le Havre, which graces the center of the largest canvas of the group, now at the National Gallery, London (cat. 14). In fact, it seems that Monet wanted to paint "Whistlerian" monochrome atmospheric paintings, but in a thickly painted, gestural manner associated more with French painting. Indeed, when he painted in this Norman port city of his boyhood in 1873, he thought more of art than of life.

This did not last long, and when Monet returned to Le Havre in 1874 (or so it is thought) to paint another sequence of paintings of the harbor, he was as open to the particular features of Le Havre itself as he had been closed to them the year before. He painted a pair of large paintings of the harbor (W296 and 297, cat. 15), one of which (W296) he included in the Impressionist exhibition of the same year. One wonders, given the fact that *Impression: Sunrise* has been proven to have been mistakenly dated 1874 by Monet, whether the entire sequence of paintings was begun in 1873 and completed in Monet's Argenteuil home-studio. When taken together, the Le Havre harbor paintings of 1873–74 have a kind of Parisian detachment—even a disregard for particularity—which makes them different from his overtly Norman paintings of the 1860s. Indeed, in the early 1870s, Monet painted Normandy not as a Norman but as a visiting Parisian staying in a hotel room with a view of the harbor.

This distance from "Norman" Normandy was surely not unintended. Monet had made his decision to go his own way, to create a life independent of the ideas—and approval—of his father and aunt. There is no doubt that his personal decision infected his pictorial "Normandy" in the very decade of separation, the 1870s. Gone are the family gardens, the beaches where childhood memories abounded, the boat-laden ports of the fishermen he had studied since childhood. Monet replaced this with views of the Norman capital painted from rented hotel rooms, almost as if he were an Englishman returning home to London after a week in Paris.

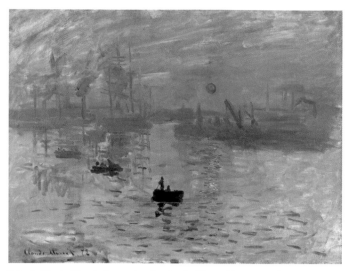

FIG. 36. Claude Monet, *Impression: Sunrise, Le Havre*, 1872, 19 x 25 in. (48 x 63 cm), Musée Marmottan, Paris.

Monet Returns to Normandy

It was to the example of Courbet that Monet turned when he went to the seacoast of Normandy in the early and mid 1880s. The death of Courbet on December 31, 1877, was at once a blow to the avant-garde and an encouragement to reconsider and reinvigorate the materialist landscape aesthetic he had promulgated throughout his working life. Monet had followed Courbet's career in the 1860s, when the ebullient master from Ornans was hard to avoid in Paris. Yet when that famous painter fled to Switzerland in 1873, eventually dying there in 1878, it became more difficult to see his contemporary work and, hence, to follow the progress of his career. This is ironic because Courbet's achievement during his Swiss exile was largely in the realm of landscape painting, and he began to work with an even greater facility and a broader range of technical experimentation than he had earlier when he painted the Norman coast.

Whatever he knew of Courbet's oeuvre of the 1870s, Monet was thinking of the Master's great Norman views of the 1860s—which he knew well—when he returned to his beloved Norman coast in September 1880 to spend a couple of weeks at the country house of his brother at Petites-Dalles. He had avoided this landscape for a decade, and his return was at once a liberation from his present circumstances and an immersion in the past. His wife, Camille Doncieux Monet, had died the previous year; he was living in almost complete poverty at the time. The weather-beaten cliffs of the north coast of Normandy surely functioned as visual carriers of his strong emotions. His works of that, and the next several autumn seasons, were painted in the fall and winter—after the fashionable Parisians had returned to the city and Monet was able to paint alone, without distraction and unwanted social attention, just as he had at the beginning of his career. What differentiates these paintings—and there are scores of differences—from his efforts of the 1860s is their clear debt to

Courbet and their concomitant fascination with the almost mythic natural landscape of the north coast.

Norman "culture"—the sailors, fishermen, peasants, and bourgeoisie—virtually disappear from Monet's landscapes of the 1880s. The Norman people were replaced by Norman nature in all its grandeur, difficulty, and sublimity. If Impressionist Normandy had been all but obsessed with the modern, the urban, and the fashionable as it strove to translate the province for a Parisian audience, Monet turned his back on these very qualities. The Normandy of Boudin or Morisot is convivial and, hence, social; Monet's Normandy in the 1880s is the opposite. The viewer, like Monet himself, is most often alone—walking on the beaches, clinging to the cliffs, staring at the waves that crash against the coast of France itself. When we do see other figures, they are tiny dabs of paint—distant, unidentifiable, and remote.

There is little doubt that Monet's return to Étretat in January 1883, a little more than three years after the death of his wife, brought back a flood of personal memories of the couple's earliest rented house, which appears, idealized, in the great Frankfurt *Dejeuner*. The Norman coastal landscape was, indeed, one of loss—of his parents and aunt as well as his wife—and his lonely walks through the countryside around Étretat can be interpreted as nothing less than a return to a site loaded with deeply personal emotion. There is, in the end, little in Monet's oeuvre that can refute the supposition that, following the death of Camille on September 5, 1879, his art changed dramatically. Gone were bourgeois revelers, leisure-class boaters on the Seine, railway passengers, and Parisian strollers. Whereas one landscape in five before Camille's death is unpopulated—and almost none are devoid of houses, boats, or carts—the majority of those after her death are empty and silent, save the sound of the waves and the wind. To put an even finer point on the contrast, the landscapes of the 1870s were composed and painted within a short walk of the painter's house, while those of the 1880s seem to be the result of long, lonely walks—even when they were not.

It is not difficult to conclude that Monet's Normandy of the 1880s—with its crashing sea, vast cliffs, isolated dwellings, and dramatically positioned churches—has absolutely no connection to his Normandy of the 1860s or 1870s. It is tempting to say that this relates to Monet's increasing interest in Courbet, who was, as we have seen, a witness at his 1870 wedding. But that is surely far from the only cause. It is likelier that Monet's Normandy of the 1860s was one of redemption and reconciliation (with his father's and aunt's families), that of the 1870s one of separation (from the same families), and that of the 1880s one of grief and loss. The fact that this reading is simplistic does not in any way undercut its truth, and both the paintings—which exist in quantity—and Monet's letters make it clear that this is the case. And, when we consider it in the terms of Sigmund Freud's concept of the "fugue"—a serial escape from home at a time of grief—Monet's career in the first half of the 1880s makes sense. He returns, in a sense, to the landscape of his childhood and early adulthood, but with a sense that it is a landscape of loss. That these losses—of his mother, father, aunt, and wife—produced conflicting results can

scarcely surprise us as we look at the dramatically empty paintings awaiting inhabitants.

Yet, we must place these works into the larger sense of Monet's fugue—of his trips to the south of France and to the north of Italy and of his other trips to the Massif Central, with its dramatic canyons and rocky escarpments. None of the these landscapes evoke any kind of human society—even the distant village of Bordighera in many of his landscapes seems almost like a mirage viewed by a hermit who lives in a remote cave. And the gardens in his southern landscapes are tangled and wild, far from the carefully managed gardens he had painted at his uncle's house, at his father-in-law's, and in his own rented properties in Argenteuil. The "Norman" Monet of the 1880s is really not very "Norman." Instead, he pours his confusion and grief into landscapes of the northern and southern extremities of France and in its very center.

A Norman Farm and a New Life: Monet's "Norman Series"

There is no more Norman a place than the farm that Monet rented—with a good deal of financial support from his dealer Durand-Ruel—on April 29, 1883. The property was at once large—ninety-six acres with one large house and another smaller one—and modest. It was a farmhouse, after all. It was far enough from Paris and, conversely, far enough from the coast, that it was not marketable to a Parisian as a weekend or summerhouse. In short, it was a Norman farmhouse with access to Paris—with effort—but without the possibilities of boating on the Seine or sea-bathing that Parisians sought. The main house, like all others in the village, clung to the main road—its long façade parallel to the street with small windows, and the opposite façade open to the garden with large windows. It was one room wide—almost like an American trailer home—in stucco, wood, and tile. The "garden" was a walled orchard and vegetable garden with room for chickens, pigs, horses, and milking cows, some of which would be let loose in the adjacent fields that ran along the nearby rivulet, the Viosne. It was, in short, a real Norman farm where the Monet family—now enlarged with the addition of Alice Hoschedé and her children in addition to Monet's two sons—could live in reasonable comfort without much money.

One can scarcely imagine droves of tourists flocking to such a place as Giverny was at the time—even had Monet died after he had made his first garden in the orchard and painted his early series of paintings in the fields around the farm in the early 1890s. No, the place then was simply too Norman, too plebian, too, in a way, like Pissarro's farm in Eragny. It was, indeed, the very "Norman-ness" that Monet celebrated in the first decade after he rented the farm. He climbed the hill to paint the village from on high (cat. 37), stressing its long houses, its walled orchards, and its wonderfully rich alluvial fields. He walked across the rivulet into the flat fields to record the grain fields mixed with poppies and to study the grainstacks in the light. He followed the Viosne to find rows of metric poplars that inspired him to a verticality absurd for a landscape painter. He reveled in the ordinary Norman-ness, the simplicity.

Monet's first true series of paintings—a group of fifteen horizontal painted representations of grainstacks in a field near Giverny—opened to rave reviews in Paris in May 1891. Even the crotchety Pissarro, who had thought that Monet painted in series for capitalist rather than aesthetic reasons, was overwhelmed by the effect created by the group of paintings, writing enthusiastically about the exhibition to his son, Lucien, in London. Their friend Gustave Geffroy wrote a poetic text to accompany the exhibition, relating the haystacks to the planets and the stars and their colors to those of gemstones, human blood, and fire. It was, indeed, the mythic qualities of the series that appealed to both critics and buyers, and the exhibition was to be an important financial success for both Monet and his dealer, Charles Durand-Ruel.

Few critics dealt with the Norman aspects of the paintings, in spite of the fact that, of all Monet's series, this earliest one dealt with a Norman hamlet and its persistence through time—both historical and seasonal. Behind the haystacks themselves—whether alone or in pairs—Monet represented the farmhouses of Giverny, peeking out amidst the trees and huddled at the base of a long hill for protection against the northern winds. Because Giverny was a hamlet without a church, the paintings do not project any clear religious overtones. Rather, they promote a profoundly secular mythology of the persistence of human agriculture in both seasonal and diurnal time. Interestingly, the paintings were arranged in a long horizontal row so that the viewer could scan them sequentially, but above them, Monet placed two large 1886 canvases of veiled women wearing white and standing on a hill, now in the Musée d'Orsay. Both of these were openly derived from his own earlier canvas of 1873 representing Camille Doncieux Monet and her son Jean on a hill outside of Argenteuil. Yet in the latter paintings, the woman is alone, more fully veiled, and hence unidentifiable. She is, in a profound sense, a pictorial embodiment of Monet's late wife, who floats above the Norman village where Monet was to define a new domestic life.

The profound psychological roots of Monet's Norman oeuvre in 1890–91 have rarely been recognized in the literature. Indeed, the focus on the "abstract" and "modern" character of the series has resulted in an interpretation of them as studies of "light" and "color," with the subject of the haystacks acting as a neutral visual armature for the painter's investigation of what he himself called the "envelope" of light that has become, for many, the true "subject" of the series. Yet, we must not forget the obvious formal—and hence psychological—links between these "houses of wheat" and Monet's earlier paintings of the isolated customs houses on the cliffs of the north of France (cat. 26–28), painted so often by him in 1882 (and shown in both his 1883 monographic exhibition at Durand-Ruel and in the famous *Monet-Rodin*

FIG. 37. Gustave Courbet, detail of *The Studio of the Painter, a Real Allegory*, 1855, 142 x 235⅜ in. (361 x 598 cm), Musée d'Orsay, Paris.

exhibition at Georges Petit in 1889) or to the roofed boathouses at Étretat in both 1883 (cat. 38) and 1885 (cat. 43).

These elemental huts—awaiting absent or even missing people—have profound psychic power and can even be linked to the isolated dwellings in Courbet's Ornans landscapes, including the isolated hut to which Courbet is adding a touch of paint in his massive *Real Allegory* of 1855 (fig. 37). We could equally well allude to the abandoned farmhouses or *mas* that give an eerie sense of isolation to Cézanne's Provençal landscapes of the mid- and late 1880s (fig. 38). Interestingly, all of these isolated dwellings can be linked to the "home landscape" of these three great painters—the Jura for Courbet, Provence for Cézanne, and Normandy for Monet.

When Monet turned to the subject of poplars (cat. 47) in the months following the close of his first series exhibition in 1891, he turned away from the Norman aspects of the landscape. Every Frenchman knows just how ubiquitous are the rows of trees that line the national roads, rivers, and canals throughout France.

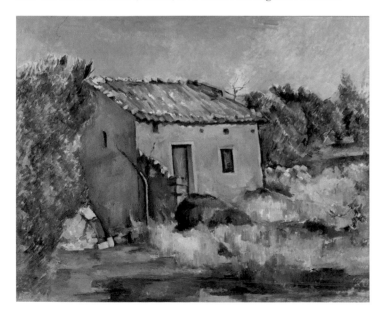

Whether we are in Picardy, Normandy, Champagne, or Burgundy, we see these rows of trees, each planted at the same time and all growing in stately simultaneity as if individual versions of a single mythic tree. Several scholars have even linked the words *peupliers* (poplars) to *peuple* (people) to suggest that Monet's series projected a clear republican—and national— political stance. Whether this is true (and there is no evidence, pro or con, from Monet himself), it does not matter to our own anti-Norman or even anti-regional reading of this second series. If the haystack is an archetypal house of wheat in the Norman landscape, the poplars bring the Norman landscape into the larger visual—and cultural—patterns of France itself.

One can surely make the same claims for a kind of universal particularity about his later series devoted to the façade of the Rouen Cathedral (cat. 50). We know, when we look at Monet's representations of this building, that we are *not* in Chartres, Rheims, Paris, or Beauvais, but we also learn very little about the identifying features of the Rouen cathedral itself. And as we have seen, Monet rarely allows us to consider the building as part of the fabric of a great Norman capital city. Instead, it rises to fill Monet's canvas almost as if the two—painting and cathedral— merged in the painter's mind. Yet, it is also impossible simply to forget about the cathedral as we look at it through the veil of Monet's "envelope of light." Because it *is* Rouen Cathedral—and nothing else—Monet's subject applies universality to particularity. Its "Norman-ness" is not essential to its meaning, but Monet's series is, nevertheless, Norman. And this balancing act was to be Monet's painterly task until his death in 1926.

The Universal Norman Coast

In 1896 and 1897, Monet alternated his production between two landscapes: the Norman coast (cat. 52, 53), to which he returned for the first time since the previous decade, and the tree-lined banks of the Seine near Giverny (cat. 54, 55). For the first series, he stood defiantly on the land and looked seaward, reprising many of his compositions from the 1880s but radically simplifying them, seemingly to concentrate on chromatic and painterly matters.

The "inland" series—with its collective title of "Mornings on the Seine"—suggests a healthy life in which the now elderly Monet rises in the morning, before the mist has risen, takes his little painting boat, and, with the help of an assistant, sails on the placid waters of the Seine until he is surrounded by nothing but mist, light, and the looming forms of trees. The landlocked water landscapes are all about "mirroring;" those of the coast emphasize the dramatic confrontation of land and sea.

This alternation of "water landscapes" seems to have mirrored the contrast inherent in Monet's own life—from what

FIG. 38. Paul Cézanne, *Abandoned House near Aix-en-Provence*, 1885–87, 25⅝ x 32½ in. (65.1 x 82.5 cm), Dallas Museum of Art, The Wendy and Emery Reves Collection.

he hoped to be the placid regularity of his family life in Giverny (back in time for lunch and a nap) to the dramatic isolation and psychologically potent memories of coastal Normandy, where he painted alone, often far from a comfortable hotel, communicating with Giverny via letter. The former was the landscape of his "new"—albeit blended—family and the latter a battleground of memories of mother, father, aunt, brother, first wife, son, and, of course, his earliest pictorial fathers—Boudin and Courbet. As we have seen, his rival for dominance as an Impressionist—Edgar Degas—was also in Monet's mind, when he dissolved the cliffs of Normandy and the waters of La Manche into a pictorial fairyland like that mythic land of "body-landscape" (fig. 31) evoked so ably by Richard Kendall in his work on Degas's enigmatic landscapes.

One is tempted to relate the elderly Monet's representations of the coastal landscapes of his middle age and youth to the simultaneous experiments in prose of the young Marcel Proust, whose experiments with the power of memory were to transform French letters utterly. Yet this comparison is surely wrong. Proust, the neurotic urbanite who reconceived his own past by populating it with fashionable phantoms, did his writing far from the visual "realities" of his memories. For Monet—always the Impressionist—the transcription of memory had to be rooted in actual experience. It is Monet who stood again—face to face with the dramatic Norman coast of his youth and middle age—and painted it. The reason it appears differently is not so much that *it* was different, but that *he* was. Yet the strong sense of felt experience is never far away from these fairy realms. The birds gather in the light around the cliffs near Dieppe, and the distant fishing boats have the same fluttering visual effect as they play in the mythic waters of La Manche. Monet was clearly *en face du motif* when he painted these Norman places, but his actual felt experience was powerfully inflected by memories.

Monet's Norman House and Garden: A Domestic Evasion

Monet painted somewhat more than 1,000 paintings between the time he moved to Giverny in the late spring of 1883 and his death in 1926. Of these, fewer than ten represent his own house and its adjacent garden. Here the contrast with Pissarro is greatest, for the older artist was all but obsessed with the orchard and vegetable garden that surrounded his Norman home and studio and devoted scores of paintings to the barns, outbuildings, and nearby views from the farmhouse. Monet seems studiously to have avoided this kind of landscape. There are a handful of luscious paintings of the flowered *allée* leading from the garden front of his Norman farmhouse to the axially located Japanese bridge across the railroad track, but very few of them actually tell us much about the house itself. And the flower gardens that

consumed so much of Monet's time—and that of his successive gardeners—are essentially absent from his painted oeuvre. In fact, Monet painted London and Venice with greater enthusiasm than he did his own Norman house and its transformed orchards and vegetable gardens. And his own pictorial indifference to his most personal environment seems to have affected the quality as well as the quantity of the few paintings that do survive, and most books and exhibitions devoted to the ubiquitous "Monet in Giverny" rarely reproduce more than one of his paintings of the house and its flowered *allée*.

This all changed when he began to create a water garden across the railroad tracks from the house in 1893, a decade after he bought the house. Today one visits this internationally famous water garden, with its peanut-shaped pool, its axially located "Japanese footbridge" (cat. 56), and its famous waterlilies, via an oddly positioned tunnel under the paved road that has replaced the railroad tracks. In the artist's lifetime, Monet and his guests could get up from the luncheon table in the yellow-and-blue dining room, walk down what he surely intended to be the *Boulevard des Capucines* (a nasturtium-lined pathway clearly conceived as a joking reference to the paintings of the Parisian boulevard with the same name he submitted to the first Impressionist exhibition), open the garden gate, and stand on the bridge to look at the water garden below. This short walk was taken daily not only by Monet himself, but by the hundreds of visitors from Asia, Europe, and America who made the pilgrimage to Giverny.

How Norman is this garden? The answer is obvious—and not. It is not Norman at all—and it is as Norman as Monet's father's and aunt's modern bourgeois flower gardens of the 1860s painted at the beginning of his career. While Monet did avoid painting—with a remarkable persistence—the orchard and vegetable garden he had created in the walled area around his Norman farmhouse, he did *not* avoid the water garden he created with no visual references to Normandy whatsoever. We must remember, however, that Monet fought throughout his life to attain the kind of personal and professional independence necessary to produce a new kind of Impressionism. Is it an accident that he chose to paint for more than thirty years in the fields and gardens of a Norman farmhouse? Is it an accident that he chose to transform these Norman apple orchards and grain fields into an artificial landscape that is, in the end, as great as any of his paintings of it? Clearly not, and it is surely time to consider Monet's garden with the same reverence as the gardens of his contemporary the great Gertrude Jekyll in southern England. Monet's first garden landscapes represent the "modern" flower gardens of his utterly bourgeois father and aunt in and around Le Havre. His last garden landscapes were painted in a place in Upper Normandy as far as possible from Le Havre. But it remains Normandy, and, in transforming and representing it, Monet chose to define himself as a modern bourgeois Norman.

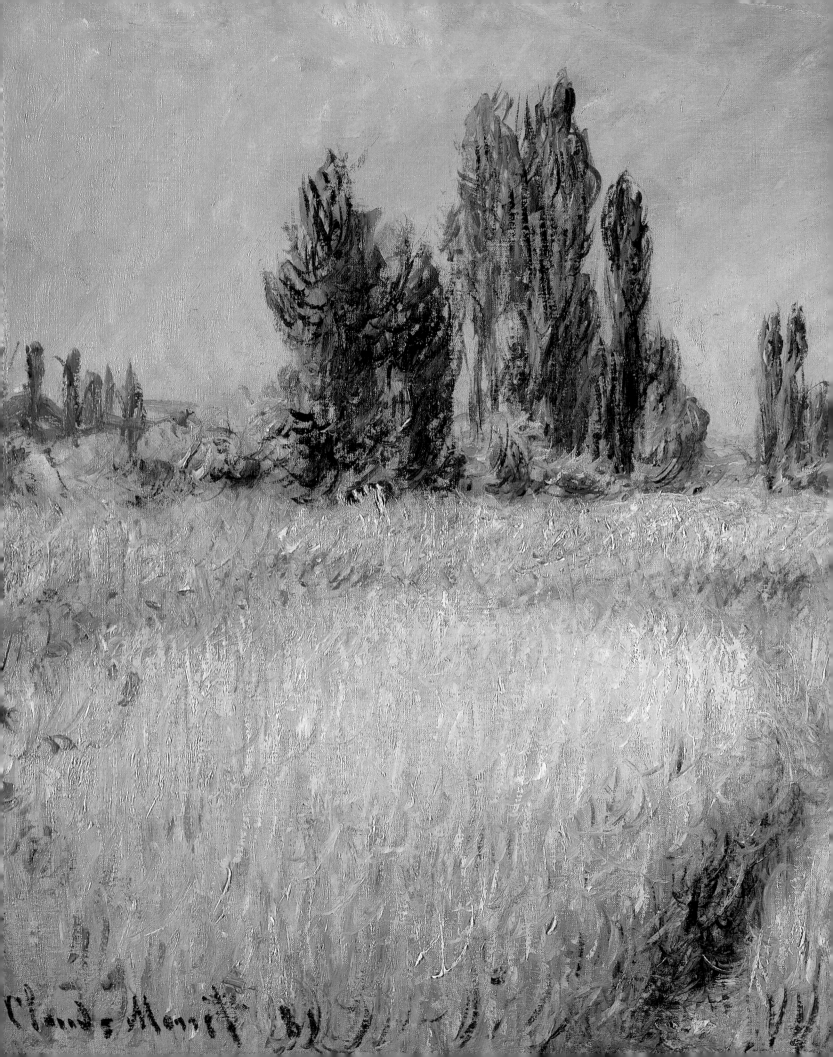

Catalogue

From the beginning of his career, Monet mined the repertoire of motifs, both natural and man-made, that personified the Normandy of his childhood. Initially, his subjects echoed those favored by contemporaries, including popular topographical subjects, quiet rural scenery, as well as village streets and structures. *La Chapelle de Notre-Dame de Grâce, Honfleur* is among Monet's earliest paintings; its frank descriptive approach and restrained palette reveal the young artist's footing in the realist tradition.

The chapel of Our Lady of Grace is situated on an esplanade above the historic fishing village of Honfleur. The symbolic relationship between the history of Honfleur and the chapel is suggested in numerous nineteenth-century guidebooks written at the time. Until the eighteenth-century emergence of Le Havre, which lies directly across the Seine river estuary, Honfleur had been the principal port controlling access to the inland waterway that provisioned the regional capital, Rouen, and ultimately Paris itself. Although reduced to a quaint tourist destination by the mid-nineteenth century, Honfleur was linked historically with France's grand voyages of discovery and colonization in the sixteenth and seventeenth centuries. Several explorers, including Jacques Cartier and Samuel de Champlain, set sail from Honfleur on their way to North America. In reference to this, the Honfleur chapel is dedicated to the Virgin Mary and her local role as protector of all those who make their living from the sea. The current structure, which replaces a medieval shrine, dates from the seventeenth century and remains a pilgrimage site to this day, as evidenced inside by many contemporary offerings to the Virgin. *Notre-Dame de Grâce* and a nearby monumental cross (or calvary) stand together on a peaceful hillside overlooking the mouth of the Seine. A symbol of refuge from the open waters of the English Channel, the hill is called the *Côte de Grâce* (the Hill of Grace).

Certainly familiar with the local lore about this place, Monet nonetheless treated the scene in a relatively factual way. The chapel is nestled within a protective screen of surrounding trees but not romanticized. The artist describes the structure in flat planes of color, which delineate and follow the forms of the architectural members, some of which are outlined in black. To bring attention to the church, Monet has positioned himself so that its lantern breaks the surface diagonal of the treetops. Similarly, the mottled description of the buttressed doorway on the side of the chapel provides a light area that balances the larger surface area devoted to the sky. Even at this early point in his career, Monet disregards conventional devices, such as aerial perspective, commonly used to develop a convincing spatial depth on a two-dimensional canvas. Here, for example, the rich chromatic definition of green foliage is countered by flat bold strokes of paint that suggest the intense reflection of light off the surface of the distant river as seen through the tree trunks.

Monet's depiction of the *Chapelle de Notre-Dame de Grâce* is closely aligned with a watercolor by Jongkind of the same subject from the same vantage point that is signed and dated September 14, 1864.[1] Documents record that Jongkind and the young Monet took sketching trips together during mid-1864, leading some scholars to suggest that the two artists worked side by side the day the Jongkind drawing was produced. In December 1866 or early 1867, the present picture was among those seized from Monet's effects in Ville-d'Avray and sold to settle extensive debts.

The painting came to Monet's attention many years later, when in 1918 the dealer Georges Bernheim visited Monet in Giverny. Bernheim recalls showing the *Church of the Calvary at Honfleur* [sic] to the seventy-year-old Monet, who, according to Bernheim, said smilingly, "A work of my youth . . . The church is well painted. . . . I don't like the trees there on the left; I'd cut them. . . ." "Impossible," Bernheim said. "This canvas belongs to Jacques Charles, the manager of the *Casino de Paris*, and he wonders if you'd sign it." Monet replied, "I would indeed . . . but it will be right of center, to show him where to cut

it. But it's split there on the left, so it's a Ville-d'Avray canvas." When asked what he meant, Monet replied with the following anecdote, which could be apocryphal:

I was living in Ville-d'Avray and owed three hundred francs to a butcher, who sent the bailiff around to me. When they were about to impound my things, I took a knife and slashed the two hundred canvases I had there. I left for Honfleur and sometime after, when I'd had some success, my father sent me the money to settle my debt. I wired Sisley at Meudon, announcing my arrival, and hurried over to Ville-d'Avray, but they'd all been sold. I went to the bailiff's to try to pick up the trail of my paintings, and he said to me, "How can you expect to follow up anything so trifling? It's impossible! Your canvases were sold in lots of fifty, and each lot brought in an average of thirty francs.[2]

LFO

One of two monumental Monet seascapes accepted for the 1865 Salon, *The Pointe de la Hève at Low Tide*, along with the *Mouth of the Seine at Honfleur* (W51), now in the Norton Simon Museum (fig. 39), announced the arrival of a new talent on the Parisian art scene. At the time a successful artistic career was predicated on acceptance at the Salon, the only regular exhibition sanctioned by French officialdom. The Salon was the conduit through which lay commissions and advancement. In Monet's initial offerings, whose scale and paired subject matter had been calculated for success, the critics found much to admire. Paul Mantz, writing for the *Gazette des Beaux-Arts*, mentions a "new name" among the exhibitors:

> We were not aware before of M. Claude Monet, creator of *The Pointe de la Hève at Low Tide* and *Mouth of the Seine at Honfleur* . . . the sensitivity to color harmony in the play of related tones, the feeling for values, the startling appearance of the whole, an audacious manner of seeing things and of commanding the observer's attention—these are virtues which M. Monet already possesses to a high degree.[1]

2. *The Pointe de la Hève at Low Tide*, 1865

35½ x 59¼ in. (90.2 x 150.5 cm)
Signed and dated lower right: *Claude Monet 1865*
Kimbell Art Museum, Forth Worth AP.7
W52

These grand seascapes are studio productions based on smaller studies Monet painted on site in Sainte-Adresse in 1864; the present painting is an elaboration of the loosely brushed *Horses at the Pointe de la Hève* (W40). Conventional beach scenes provided artistic guides for Monet's rendering of this stretch of coast just east of Le Havre's port. But the example of Jongkind, such as his 1862 *The Beach of Sainte-Adresse* (Phoenix Art Museum), has always been acknowledged, even by Monet himself, as the primary influence on the younger artist.[2] In both the scenery is essentially the same and conventional devices are employed to re-create the landscape convincingly. But Monet has shifted the vantage point, positioning himself within the tidal zone at the confluence of waves, rippled sand, and line of rock debris exposed at low tide. He capitalizes on the directional pull of dynamic diagonals that seem to sweep the viewer deep into the pictorial space. Similarly, although the restrained palette is dictated by the natural conditions observed, Monet divides the composition into four artfully balanced wedges of color. His bold and assured technique changes appropriately as his hand moves between these zones. Such choices reflect formal concerns with composition and overall surface effects, not surprising given that the present picture was destined for the Salon where convention, not novelty, ruled.

The Salon acceptance of *The Pointe de la Hève at Low Tide* and its pendant marked the official beginning of Monet's public career. With this monumental statement, the twenty-four-year-old Monet introduced himself as simultaneously within the French realist tradition yet willing to move beyond it. And the tension between pictorial realism and artifice, already evident in the Kimbell painting, would be renegotiated throughout Monet's body of work.

LFO

FIG. 39. Claude Monet, *Mouth of the Seine at Honfleur*, 1865, 35¼ x 59¼ in. (89.5 x 150.5 cm), Norton Simon Museum, The Norton Simon Foundation.

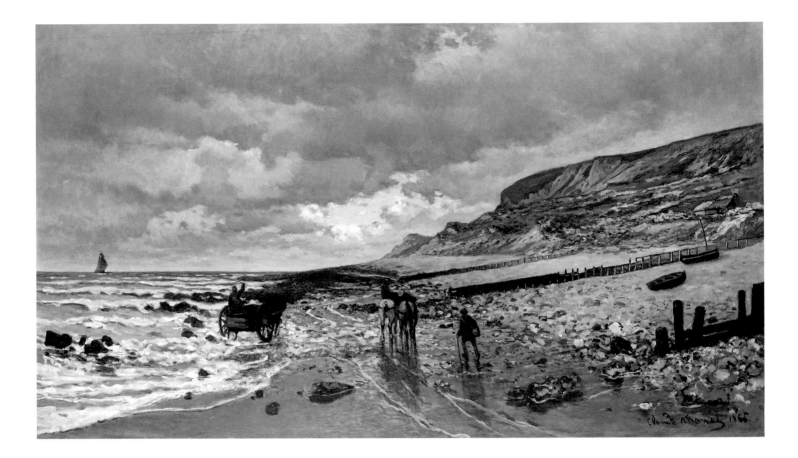

Once an important subject in the repertoire of Baroque and Romantic painters, nighttime subjects had become relatively rare until Monet, and contemporaries such as James McNeill Whistler (1834–1903), began to explore the impressionistic potential of nocturnal lighting. Monet himself painted only a few nightscapes during his long career, and this small marine is one of his most powerful "night effects."

At first glance the viewer literally feels at sea, as the shifting shimmer of moonlight dances on the waves before us. On closer inspection, however, the lighthouse of Honfleur is distinguishable on the right; individual brushstrokes suggestive of its cautionary, yet welcoming, beam animate the lower corner of the canvas. Comparison with a suite of oils depicting the port of Honfleur painted by Jongkind in the early 1860s, for example *The Jetty at Honfleur* (fig. 40), identifies Monet's inspiration as well as his vantage point.[1] Although Monet typically depicted the lighthouse as seen from downstream on the open waters of the river,[2] for this composition he stood on the jetty that forms the left wall of the entrance into Honfleur's harbor. Monet plays with the viewer's sense of equilibrium by omitting the jetty itself from the field of vision; only the stabilizing line of the horizon as it intersects with the strictly vertical rigging of the boats on the left counters the rolling pitch of the boat in the foreground. This sensation of movement is heightened by Monet's broken, and at times directional, brushwork, which accentuates the curvilinear forms of moonlit clouds and waves.

It is obvious that Monet loved boats of all types, whether sail or steam; they figure frequently in his paintings and drawings. Particularly relevant to the current picture are two beautiful pastels dating from the same period.[3] Each sheet is covered with studies of different vessels, often viewed from multiple sides. Wildenstein P25 also features the lighthouse and jetty of Honfleur, while among the vignettes on P26 is a similar grouping of a masted ship and smoking tugboat, one of the powerful little vessels known as *abeilles* (bees).

The striking beauty of the Edinburgh *A Seascape, Shipping by Moonlight* stems from the richness of color Monet achieves within a constrained palette, as dark silhouettes play against the nocturnal moodiness of sea and sky. In this marine, with its forthrightly gestural surface, Monet celebrates not only the natural scene before him, but the visceral, communicative power of paint itself.

LFO

3. *A Seascape, Shipping by Moonlight*, 1866

23⅝ x 29 in. (59.5 x 72.5 cm)
Subsequently signed on the back on the stretcher:
Claude Monet/1864
The National Galleries of Scotland,
Edinburgh NG 2399
W71

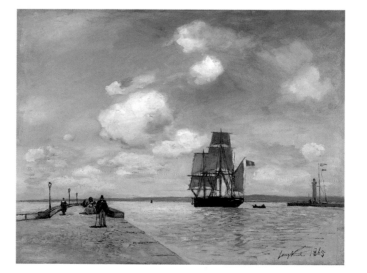

FIG. 40. J. B. Jongkind, *The Jetty at Honfleur*, 1865, 13¼ x 17 in. (33.7 x 43.2 cm), Vincent van Gogh Museum, Amsterdam.

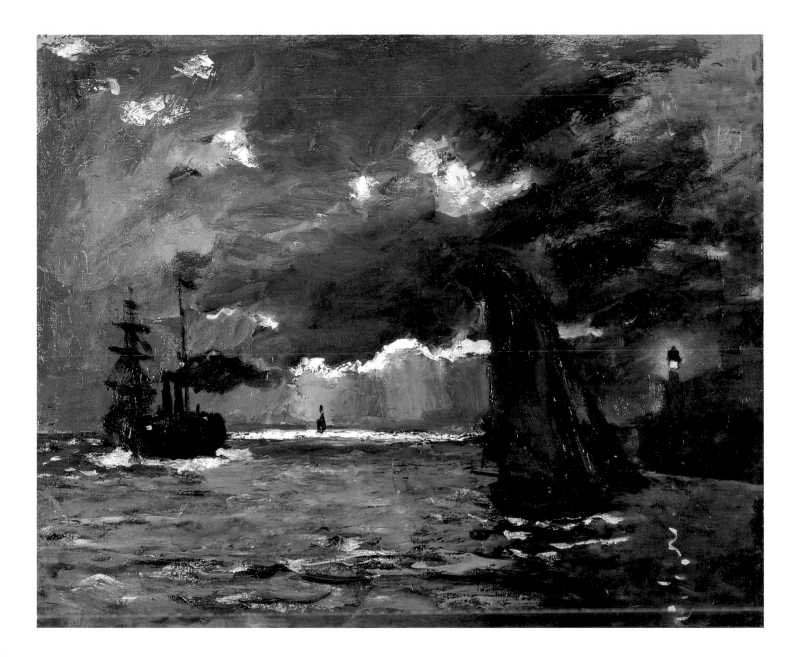

In the summer of 1867, leaving his pregnant mistress and model, Camille Doncieux, in Paris in the care of friends, Monet traveled to Normandy to stay at the villa owned by his aunt, Sophie Lecadre, at Sainte-Adresse near Le Havre. Over the next seven months, the artist shuttled between Sainte-Adresse and Camille's tiny apartment on the *impasse* Saint-Louis. He concealed the reasons for his visits to Paris from his family, who disapproved of the couple's relationship. During this stressful period, he painted seascapes that betray no signs of his emotional turmoil and urgent need for money recorded in numerous pleading letters to his friend, the artist Frédéric Bazille.

Regatta at Sainte-Adresse and *The Beach at Sainte-Adresse* are two of the most remarkable seascapes Monet painted during that difficult summer. The canvases, of nearly identical dimensions, portray the same stretch of beach, yet in atmosphere and content they are profoundly different. Serenity and stillness pervade *The Beach at Sainte-Adresse*. Three fishermen loiter alongside wooden dories drawn up on a sparsely populated expanse of sand. Activity seems to have ground to a halt: one figure smokes a pipe, empty baskets lie discarded on the sand, a fishing net dries on a frame. Beneath an overcast sky, fishing vessels head out to sea. The gray sky and inactivity suggest a place little suited for tourists. Indeed, a well-dressed pair at the water's edge is the only sign that identifies the beach as a holiday destination. The gentleman looks out to sea through a telescope; his companion, wearing a white summer dress and a straw hat adorned with a trailing red ribbon, also looks into the distance. They wait and watch for the arrival of more of their kind.

As opposed to the off-season calm and solitude that suffuses *The Beach at Sainte-Adresse*, the sliver of beach in *Regatta at Sainte-Adresse* is dotted with several areas of leisure-class activity. Four fashionable figures have positioned themselves on the beach in the foreground; in the distance, a jaunty group approaches from one of the resorts. Glittering sunshine illuminates the pale sand and turquoise water. The onlookers' gazes are fixed on sailboats engaged in a regatta, organized for the amusement of the visitors from the city. The mood is one of leisure, and the beach seems to exist purely for the tourists' pleasure. The only sign of local life is the small group of mariners on the shore by the blue dory, similar to the boat in *The Beach at Sainte-Adresse*.

The contrast between the white sailboats in *Regatta* and the black-sailed fishing boats in *The Beach* articulates the fundamental differences between the two paintings. Locals dominate the scene in *The Beach*, while in *Regatta*, the vacationers literally and figuratively have taken over the foreground. Having grown up in Le Havre, Monet understood Sainte-Adresse and its dual role as port and vacation destination. In *The Beach* he approaches his composition as a local; the presence of tourism is relegated to the couple sitting far off on the sand. On this deserted mid-week beach, fishermen and vacationers coexist in a curious juxtaposition of class and scale. In *Regatta*, however, Monet approaches Normandy with an eye toward the Parisian art market. Like the regatta organized to attract and amuse tourists, canvases like this one, describing modern life at a seaside resort, were geared toward a similar clientele.

In his seascapes in the 1860s, Monet connected with a long tradition of marine painting. Eugène Boudin (1824–1898), a forerunner of Impressionism and the first artist to capture the social phenomenon of the vacation at the beach in his paintings, was a mentor to the young Monet. The two met sometime in Le Havre during the mid-1850s, and Boudin encouraged Monet to work *en plein air*. In an interview in 1900, Monet recalled Boudin's advice: "Study, learn to see and to paint, draw, make landscapes. They are so beautiful, the sea and the sky . . . and the trees, just as nature has made them, with their character, their real way of being, in the light, in the air, just as they are." Monet acknowledged, "My eyes, finally, were opened, and I really understood nature: I learned

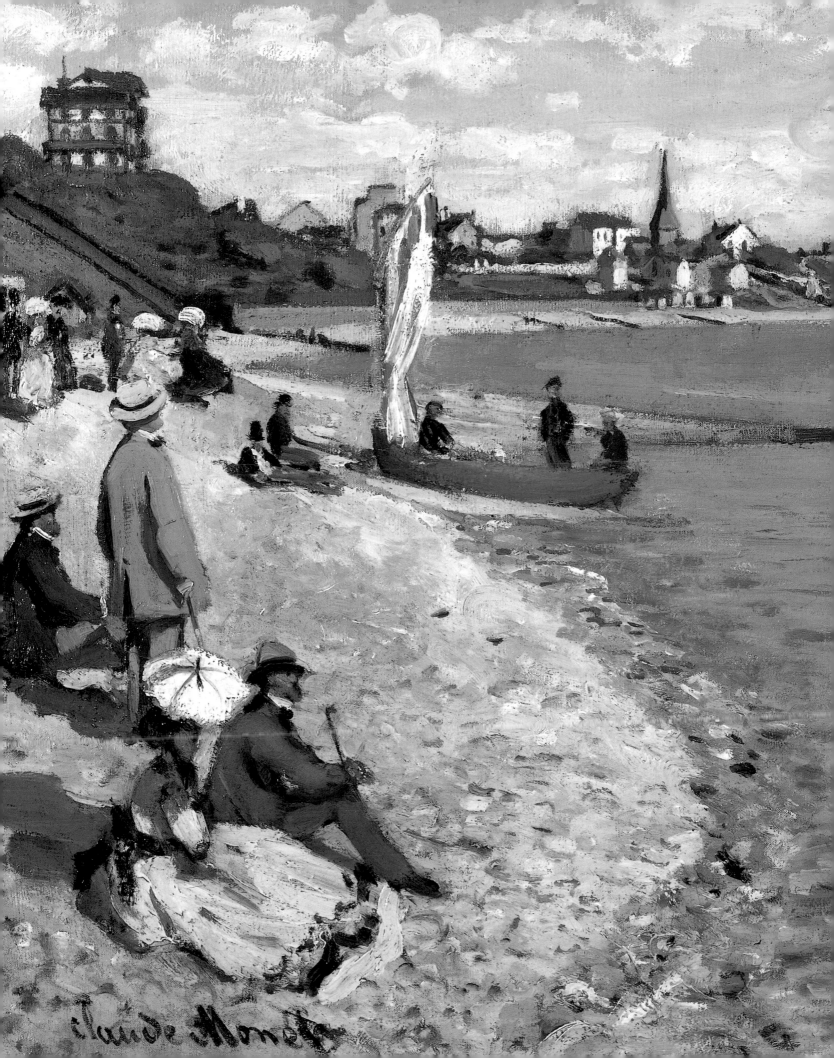

Claude Monet

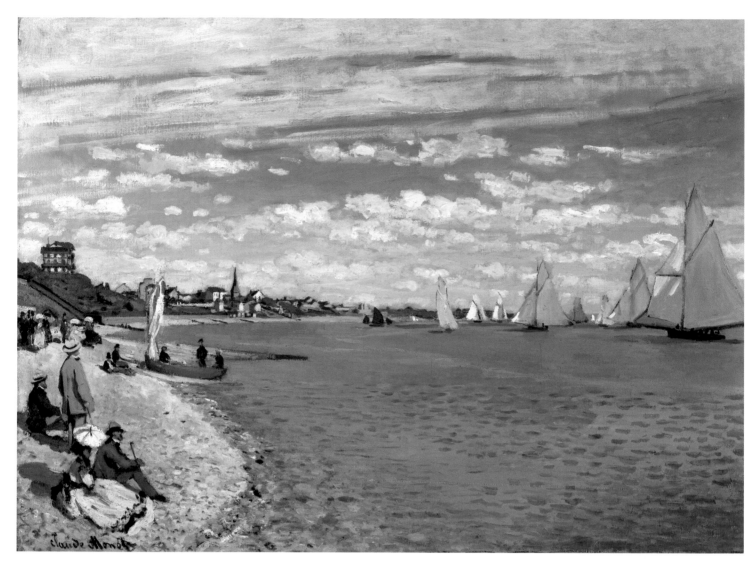

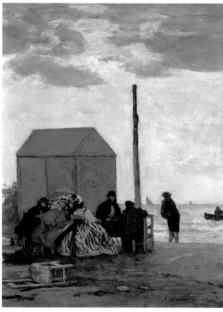

at the same time to love it."[1] Boudin made his career painting *le beau monde* of seaside resorts, which were coming into fashion in the 1860s (fig. 41). He was modern in the way he sought to represent contemporary subjects in an unprecedented manner, painting images of the regatta and vacationers in friezelike arrangements along the beach with short, free strokes, his technique echoing the sparkling light and excitement of the day.

Johan Barthold Jongkind (1819–91) also significantly influenced the young Monet. The two artists met in 1862 at Sainte-Adresse. The Dutch émigré's paintings of harbors and beaches captured the fleeting effects of sun reflected on water in a loose, evocative style, revealing a new freedom to Monet. In their painting expeditions together, Jongkind completed the training Monet had begun with Boudin. In the same interview of 1900, Monet stated that from the time they met, Jongkind "was my real master, and it was to him that I owed the final education of my eye."[2]

FIG. 41. Eugène Boudin, *The Beach at Deauville*, 1864, 14¼ x 10 in. (37 x 25.3 cm), The Cleveland Museum of Art, Gift of Mrs. Homer H. Johnson, 1946.71.

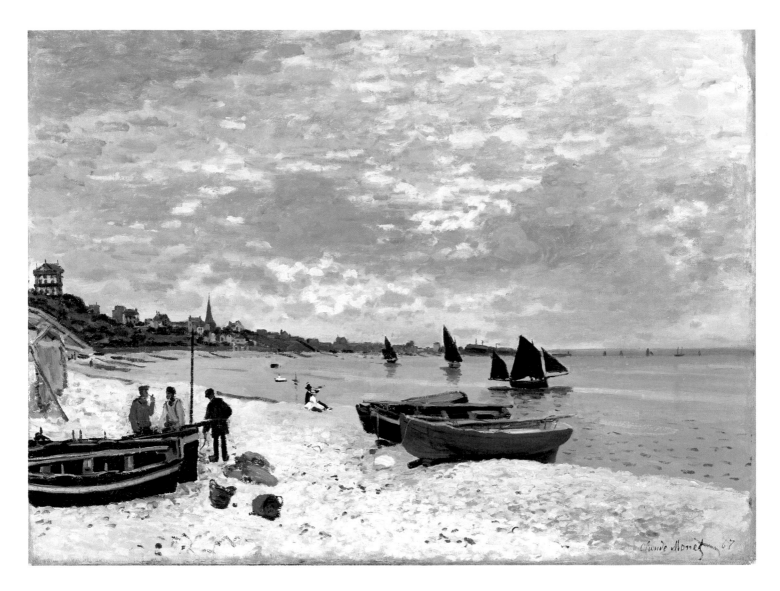

During the 1860s, Monet began painting seascapes with bold abbreviations that were more daring than the work of his mentors. In his portrayal of fashionable vacationers on the beach at Sainte-Adresse, he foreshadowed Impressionist paintings of contemporary leisure by Edouard Manet and Berthe Morisot, both of whom also painted the Normandy coast. In *Regatta at Sainte-Adresse*, Monet presented a subject that was to become a favorite Impressionist motif, the modern pastime of taking leisure by the sea. The lack of anecdote in both Sainte-Adresse paintings can be traced back to Manet's earlier depictions of modern life such as *Dejeuner sur l'herbe*. In *Beach* and *Regatta*, Monet succeeded in capturing the detachment of naturalism and the appearance of objective contemporary reality in a technique that was completely unconventional.

HL

6. *Garden at Sainte-Adresse*, 1867

38⅝ x 51⅛ in. (98.1 x 129.9 cm)
Signed lower right: *Claude Monet*
The Metropolitan Museum of Art, New York
W95

One of Monet's most beloved and extensively published works, *Garden at Sainte-Adresse* is the single most important seascape from the first decade of his career. It belongs to a sequence of paintings Monet created while staying with his Lecadre relatives in Sainte-Adresse during the summer of 1867. Originally a small fishing port, the village was resettled on the hill in the 1380s after a devastating tidal wave. By Monet's time, Sainte-Adresse was a popular suburb (fig. 42) beyond the eastern limits of Le Havre.[1] Its gentle seaward slopes—called *le Nice-Havrais* (the Nice of Le Havre)—had been colonized by the wealthy, who built pleasant vacation or weekend villas, many with extensive grounds.

The gardens adjacent to the house of Monet's aunt, Sophie Lecadre, were the setting of several of Monet's works created that summer.[2] The family home still exists, although it was rebuilt around the beginning of the twentieth century. Today *Le Coteau* (The Hill) stands at the corner of the rue des Phares and the rue Charles-Dalencourt; through the gate one can see lovely lawns and landscaping reminiscent of Monet's garden pictures. From the house's current location, however, it is impossible to see the sea, which is over the crest of the hill. To compose the Metropolitan's painting, which features the sea view for which the Sainte-Adresse district was noted, Monet had to have positioned himself closer to the water. Period maps and photographs suggest that the present painting probably depicts a terrace previously situated near the modern Alphonse-Karr path.[3]

Looking southwest from the hillside and diagonally across the mouth of the Seine, Monet depicted Sainte-Adresse's celebrated view, with (as described in John Murray's *A Handbook for Travellers in France*), "the distant hills of Calvados appearing on the horizon like an island."[4] Numerous ideas have been put forward in an effort to decode the pictorial motifs, including identification of the figures, interpretation of their positions (with specific reference to the family's displeasure about Monet's entanglements with his pregnant mistress), as well as the symbolic reading of details, such as the plant life and marine vessels depicted.[5] But while Monet provided few clues to help decipher the painting's iconography, he did comment on its formal qualities, referring to it as his "Chinese painting" with flags, a composition that was "considered daring" at the time.[6] Startling for its radiance of color, capturing the brilliant sunlit clarity possible only by the sea, the painting is aggressively modern in its organization.

"Daring" was Monet's disregard for many of the conventional devices traditionally used by Western artists to develop the illusion of three-dimensional space. The impact of Japanese prints—with their insistence on two-dimensional pattern at the expense of spatial development, coupled with the use of large areas of unmodulated color—helped move Monet and many others (including Manet) toward an increasingly abstract idiom. This novel formal vocabulary was well suited to their "modern histories," which celebrated fashionable members of the contemporary scene.

FIG. 42. *Le Havre-Le Cap de la Hève et Sainte-Adresse*, c. 1904, postcard, The Metropolitan Museum of Art, New York.

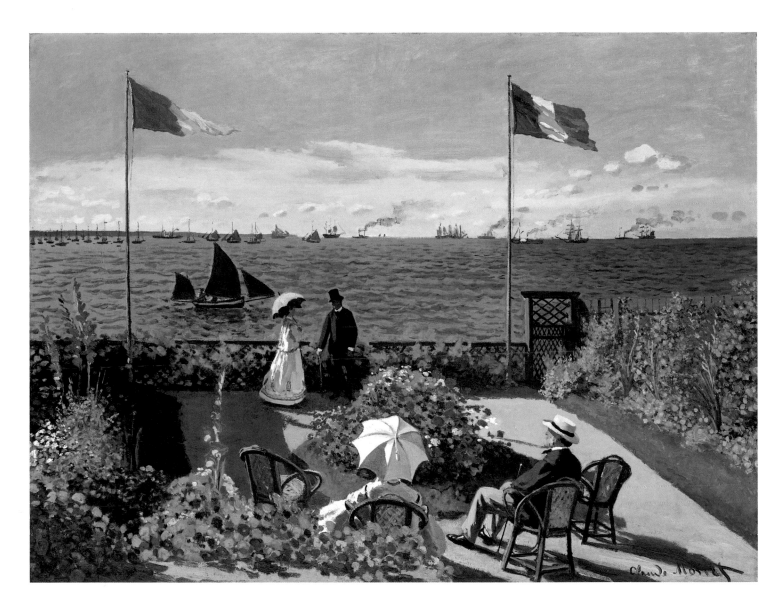

In 1868 such works attracted mention by author-critic Emile Zola, who said of Monet's "garden" paintings:

I know of no paintings that have a more personal accent, a more characteristic look. The flower beds, dotted with bright red geraniums and the flat whites of chrysanthemums, stand out against the yellow sand of the path. Basket after basket is laden with flowers, surrounded by strollers dressed in elegant informality. I would love to see one of these paintings at the Salon, but it seems that the jury is there to scrupulously prohibit their admittance. But so what? They will endure as one of the great curiosities of our art, as one of the marks of our era's tendencies.[7]

How correct Zola was in his observations!

LFO

This peaceful painting could hardly be more different from the gaudy *Garden at Sainte-Adresse* (cat. 6) of the same year. The wide range of Monet's sensibilities—ever attuned to shifting weather conditions—are brought into play in the Clark picture, here suggestive of seasonal change. Overcast skies echo the palette of the stone walls and slate-roofed buildings that front the quiet village road. A variety of muted shades of gray, brown, and dark green cast an autumnal mood relieved only occasionally by amber foliage. This is an "off-season" picture that ignores the stylish costumes, manners, and vacation entertainments of the moneyed classes who frequented the resorts along the Normandy coast, in favor of a reassuring look at the mundane surroundings and routine activities of year-round working-class residents.

The village of Sainte-Adresse portrayed in Monet's painting was, like so many small towns in Normandy and France as a whole, unremarkable in its reality, and thus reassuring and archetypal. Focusing on quiet lanes peopled by anonymous villagers going about their business, such village scenes by Monet and his close contemporaries, including Pissarro and Sisley, were also unremarkable in their repertoire of subject matter. Sisley himself wrote: "[T]he spectator should be led along the road that the painter indicates to him, and from the first be made to notice what the artist himself has felt. Every picture shows a spot with which the artist himself has fallen in love."[1]

What Monet has noticed are the muted autumnal colors, the rough textures of stonework, and the play of blue smoke against the sober church steeple. Relying on conventional formal devices, including diagonal lines, diminution of scale, and color accents, Monet invites the viewer to follow the woman and child in the foreground back into the imaginary space. Our progression down the lane is interrupted only by a male figure, standing with hands in pockets, who seems to look directly at the painter—and by extension at the viewer.

Monet followed the visual tradition of representing the chapel of Sainte-Adresse obliquely (necessitated by the structure's site on a narrow lane with no adequate frontal vantage point).[2] The church, itself a replacement for one destroyed by a 1373 tidal wave, was pulled down in 1877 and replaced by the current, grander Neo-Gothic building.[3]

LFO

7. *Street in Sainte-Adresse*, 1867

31½ x 23⅜ in. (79.7 x 59 cm)
Signed lower left: *Claude Monet*
Sterling and Francine Clark Art Institute,
Williamstown, Massachusetts
W98

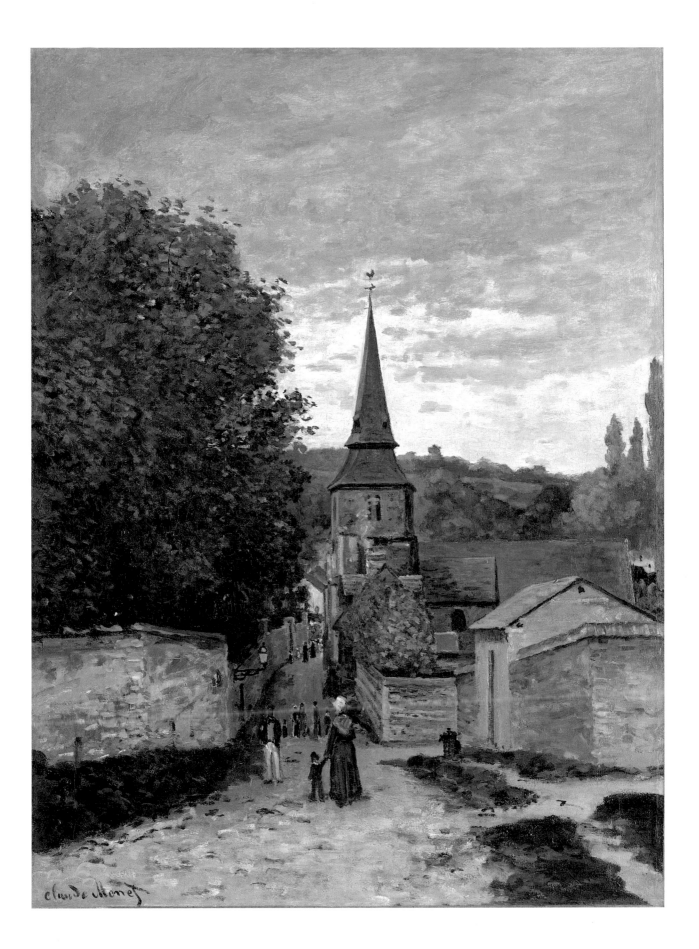

During the summer of 1870, as France and Prussia prepared for war, Monet and his new wife, Camille Doncieux (1847–1879) joined members of polite society at the fashionable seaside resort of Trouville.[1] The vacation spirit that pervades many of Monet's works from that time must have been at least partly superficial, masking worries that the artist would be recalled to military service. With humiliating speed the French army was defeated and surrendered to Prussian forces on September 2; on September 5 Monet secured a passport for travel to England. Having arrived in Trouville sometime after their June 28th wedding, the Monets departed Trouville in early October for London, there to wait out the siege of Paris and subsequent uprising of the Paris Commune.

During the weeks in Trouville, Monet, Camille and their three-year-old son Jean stayed at the Hôtel Tivoli on the rue des Bains, a short distance behind the quay-side fish market. However, as pictured in the Orsay painting, the most glamorous hotel in Trouville was the newly built Hôtel des Roches Noires, which had opened in 1865. Offering a variety of exclusive services and entertainments, including direct access to the beach, the Roches Noires catered to a cosmopolitan clientele. So many Parisians frequented Trouville that it was labeled the "Summer Boulevard of Paris." But in fact the resort drew visitors from throughout France, and indeed many vacationers from England and America, as suggested by the flags along the promenade. Such tourists were both Monet's subject and prospective audience, as he hoped to capitalize on the market for "vacation" pictures already established by Boudin and others.

The extraordinary compositional vitality of *The Hôtel des Roches Noires (Trouville)* is the result of several formal factors: its vertical format, which is accentuated by the hotel's cropped façade with its sharply receding diagonals; the striking light/dark contrasts, suggestive of strong sunlight and shadow; and the strength of coloring with clear primary hues. Added to these characteristics is the vigor of the brushwork, which asserts the artist's presence, as well as suggest a strong onshore breeze. This brilliant painting is a celebration of the seaside pleasures made more easily accessible through the construction of the railroads combined with the increased leisure time and disposable income of the moneyed classes.

These same players occupy another of Monet's Trouville paintings, the Wadsworth Atheneum's *The Beach at Trouville*. This time he utilized a horizontal format, relinquishing a significant area of his canvas to the beachfront itself. Stretching almost three-quarters of a mile, Trouville's sandy beach is one of the finest along France's northern coastline. Both paved terrace and plank boardwalk allowed tourists to enjoy its entire length. In this composition Monet follows the precedent of Boudin, for example *The Beach at Trouville*, a pastel of 1865.[2] However, Monet's image appears further removed from visual reality. He has recast the basic composition of his earlier *The Pointe de la Hève at Low Tide*, 1865 (cat. 2), into a holiday mood. In the Hartford picture, the recession of the boardwalk planks into the middle ground is suggested by emphatic individual brushstrokes. But these brushstrokes seem to move across the surface of the canvas, not back into the distance; their very boldness counteracts a convincing three-dimensional illusion. Throughout Monet's career his delight in the calligraphy of brushwork is more or less at odds with a more conventional development of pictorial space. Yet often, as here, one senses that Monet's unconventional technique is well suited to the modernity of his subject matter, because at that time, the propriety of enjoying the sea in company of other vacationers was as novel as celebrating this experience in paint.

Richard Brettell has observed that it was with the Trouville pictures that Monet started to work in "bundles."[3] *Camille on the Beach at Trouville* is one of such a sequence of five related figure studies that date from this campaign; they show the artist working out close variations on a single theme. Once more Boudin's example seems to have

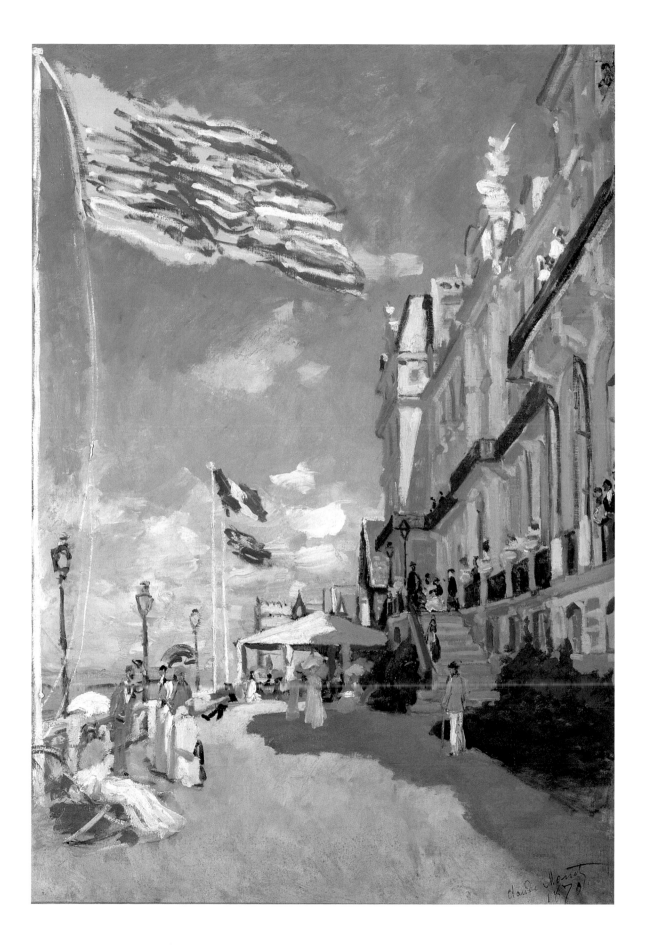

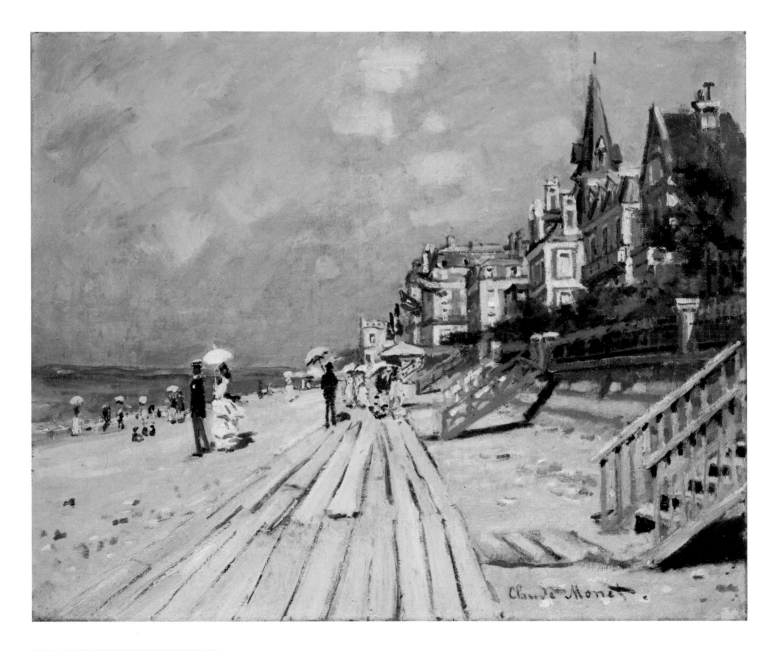

informed Monet's approach to his subject matter. The Monets had been joined by Boudin and his wife in Trouville that summer, and the two artists worked together again. A similar simplification of forms is apparent when comparing Monet's paintings of Camille sitting on the beach with like figures in Boudin's painted sketches, such as his *Princess Pauline Metternich on the Beach* (fig. 43).⁴ Figural abstraction, psychological detachment, and schematized setting characterize each. The artist, and by extension the viewer, remains at arm's length from his subject, even though Monet's sitter is his recent bride. He notes only general outlines of fashionable clothes, facial features (partially obscured by a veil protecting against sun and blowing sand), and the most summary details of the shore and fellow vacationers. However, for all this detachment, the sketch projects the

FIG. 43. Eugène Boudin, *Princess Pauline Metternich on the Beach*, c. 1865–67, 11⅜ x 9¼ in. (29.5 x 23.5 cm), The Metropolitan Museum of Art, New York, The Walter H. and Leonore Annenberg Collection.

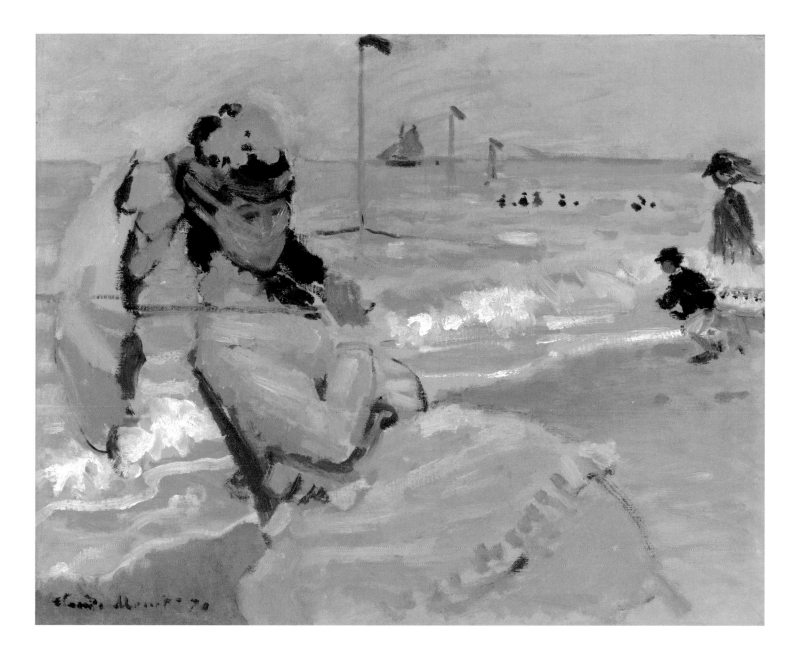

artist's deep love of seaside atmospherics caused by sun, wind, sand, and water — a
familiarity conveyed not through detail but through mastery of his medium.

Trouville's status as a chic resort was due in part to its popularity with members of
the court of Napoléon III, who frequently summered there. However at the end of the
summer of 1870, Trouville was the scene of the final moments of Napoléon's Second
Empire, as his wife, Empress Eugénie, took refuge there before fleeing to England during
the night of September 14, 1870. Similarly, the first decade of Monet's public career ended
as it had begun, with works that focused on the scenic beauty and special rhythms of life
on the Norman coast.

LFO

11. *The Seine at Rouen*, 1872

PAGE 71; DETAIL, PAGES 74–75
19½ x 30½ in. (49.5 x 77.5 cm)
Signed lower right: *Claude Monet*
Shizuoka Prefectural Museum of Art, Shizuoka
W218

12. *Ships Riding on the Seine at Rouen*, 1872–73

14⁵/₁₆ x 18⅛ in. (37.7 x 46 cm)
Signed lower left: *Claude Monet*
National Gallery of Art, Washington, D.C.
Ailsa Mellon Bruce Collection 1970.17.43
W210

13. *The Seine at Rouen*, 1873

20 x 24⅘ (50.5 x 65.5)
Signed lower right: *Claude Monet*
Staatliche Kunsthalle, Karlsruhe
W268

B etween 1872 and 1873, Monet painted thirteen views of the city of Rouen. His paintings of the city seen from the Seine bring a physical reality to Guy de Maupassant's evocative lines in *Bel-Ami*, a novel that would have been familiar to Monet:

> The glassy river flowed from one end to the other in sweeping curves . . . Then . . . slightly hazy in the morning mist, there appeared Rouen itself, its roofs gleaming in the sun and its hundreds of spires, slender, pointed or squat, frail and elaborate, like giant pieces of jewelry, its towers, square or round, crowned with armorial bearings, its belfries, its bell-towers, the whole host of Gothic church-tops dominated by the sharp-pointed spire of the cathedral, that sort of strange bronze needle, enormous, ugly and odd, the tallest in the world.[1]

Rouen, the former capital of Normandy, is located slightly beyond the mid-point on the Seine between Paris and Monet's childhood home of Le Havre on the Channel coast. A bustling center of commerce, Rouen is also rich with history, best known as the site where Joan of Arc was burned at the stake in 1431. With its busy waterways and soaring Gothic architecture, Rouen is often described as the Venice of France and offers a rich array of medieval and modern vistas.[2] Rouen was also a crucial stop for urbanites traveling north in Monet's day. Virginia Spate connects Monet's choice of views and subject matter with the illustrations and itineraries outlined in important travel guides of the time, especially Jules Janin's *Voyage de Paris à la mer*, which in her mind, "confirm the early shaping of his vision by commercial tourist imagery."[3] Monet's colleagues, including Camille Pissarro and Paul Gauguin, would also make painting trips to the city during the 1880s and 1890s.

Although Monet had visited Rouen many times before, he made his first painting excursion to the city in 1872. At the time he was living in Argenteuil, located just north of Paris on the Seine. He may have traveled to Rouen to see his older brother, Léon, who had moved there years before to become a chemist. It is also likely that Monet entertained thoughts of attracting new patrons there, since he took advantage of the trip to exhibit in the city's municipal art exhibition. A final consideration may have been a desire to paint Rouen from the middle of the Seine using the studio boat he had constructed in the early 1870s with the help of Gustave Caillebotte, an equally avid boater. Monet made his boat large enough for his family to accompany him on river excursions. More importantly, Monet followed Charles-François Daubigny's precedent and exploited the opportunity his studio-boat offered for painting unique river views, perspectives, and water reflections.[4] After all, such excursions were exactly what were expected of the modern artist. John Russell Taylor has described the era as a time when "the painter assumed the role of surrogate traveler."[5]

The views Monet painted of Rouen in 1872–73 feature two- and three-mast merchant ships at anchor or en route on the Seine. Emile Zola may have been thinking of these paintings when he wrote of Monet: "He loves the water as a mistress, he knows each piece of a ship's hull and could name any rope of the masting."[6] Three paintings from this series (Shizuoka Prefectural Museum of Art, Shizuoka; National Gallery of Art, Washington, D. C.; Staatliche Kunsthalle, Karlsruhe) share a common compositional format: They all depict majestic ships set against the backdrop of the city. They vary mainly in the time of day portrayed, the weather conditions, and the specific viewpoint, which presumably shifted as the artist navigated up and down the river. The painting now in Shizuoka (cat. 11) features the closest view of Rouen and the most detailed rendering of the city. For this composition Monet positioned himself amidst the pylons and buoys of the busy harbor. The towers of the cathedral, visible just behind the masts

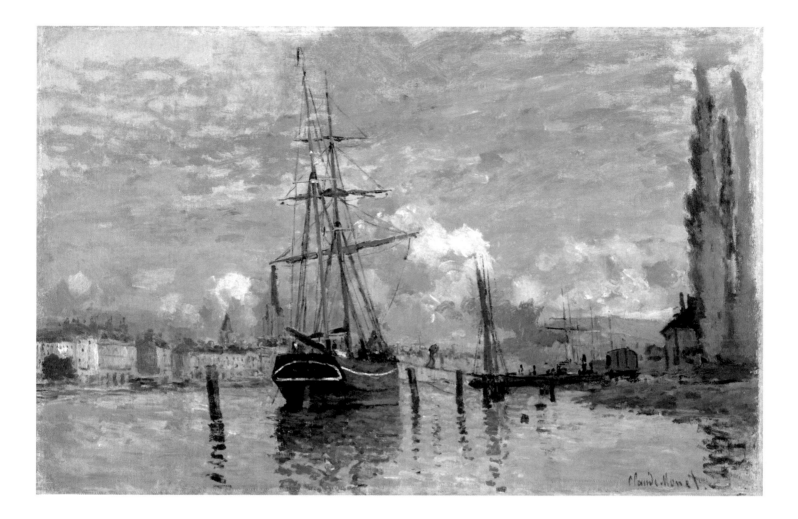

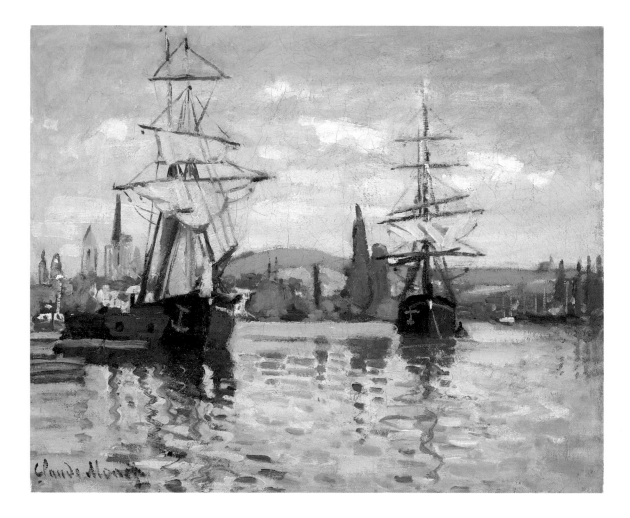

of the large ship in the center, echo the masts' upwards thrust into the sky, while a horizontal beam attached to the main mast appears barely to graze the top of the church spire, creating an intriguing geometrical pattern. Reflections of the buoys and pylons in the water cascade downward, adding to the vertical lines of force above. The orange masts of the ship are reflected in the water and echoed in the tangerine sun-glow of the clouds above. Monet balances the vertical thrust of the masts and spires with a low horizon, a compositional scheme he would have learned from Boudin. The painting from the National Gallery of Art (cat. 12) depicts Rouen from a different perspective, with the landscape assuming a more dominant role, and presumably rendered at midday. The spires of the cathedral are again visible on the far left, but they are nearly overshadowed by the great masts of the ships with their bright white sails nestled among roping. The horizon is higher and punctured by a series of rhythmic vertical shapes. Monet positioned himself farthest from the city in the Karlsruhe painting (cat. 13), where the spires of the cathedral appear just right of center. A small tugboat accompanies the ship in the left foreground, while more distant ships nearly disappear into the atmospheric haze as they approach the city. The fluid brushstrokes in the water of the National Gallery painting have been replaced by choppy slabs of silver and green, while the leaden sky has grown heavy with moisture. A hazy atmosphere now envelops the spires of the cathedral, which like the distant masts, become almost as ephemeral as the shifting clouds.

After painting pleasure boats and vacationers at Argenteuil, Monet's shift to merchant ships in Rouen may seem a bit of a *volte-face*. In reality, Monet had painted commercial ships many times before, as evident in his harbor views of Honfleur, London, Dordrecht, and especially Le Havre, a city defined by its maritime industry. Echoes of earlier paintings,

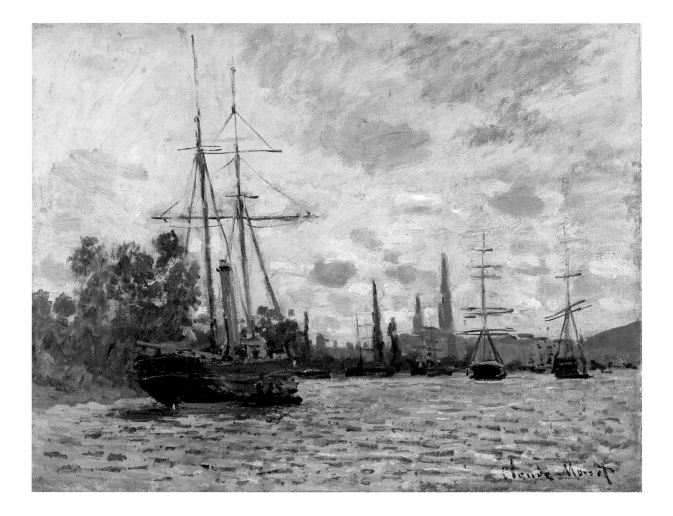

such as *A Seascape, Shipping by Moonlight* of 1866 (cat. 3), *Boats in the Port of Honfleur* of 1866–67, and *Boats on the Thames, London* of 1871, inform Monet's views of Rouen. In fact, during his early career Monet had experienced more success with paintings of commercial ships than with pleasure craft and vacationers. His painting *Mouth of the Seine at Honfleur* of 1865 (fig. 59), for instance, garnered critical acclaim at the Salon of 1865. Such paintings not only allowed Monet to align himself with the great tradition of marine compositions established by Dutch artists and taken up by Eugène Isabey and Richard Parkes Bonington, they also followed in the footsteps of his mentors Johan Barthold Jongkind and Eugène Boudin. Monet's decision to portray merchant ships at Rouen may also reflect a desire, or a financial need, to attract patrons in the city by appealing to their civic pride. These paintings of Rouen are also linked to Monet's celebrated *Impression: Sunrise* (fig. 36), dating from the same period and depicting the harbor at Le Havre, for they capture, as that work does, the majesty of ship masts soaring into the air.

Monet returned to Rouen two decades later to paint his serial compositions of the city's Gothic cathedral (cat. 50). Visiting his brother in order to settle the estate of their half-sister Marie, Monet became fascinated with the idea of painting the cathedral at different times of day and under varied conditions of light and weather. Rather than depicting the cathedral's spires seen distantly from the river, Monet turned his attention to nearly abstract patterns of light and color dappled across the surface of its intricate façade. Rouen, the great city of Normandy, inspired Monet in the early 1870s and again in the 1890s, two significant poles in the development of his artistic vision.

WR and MB

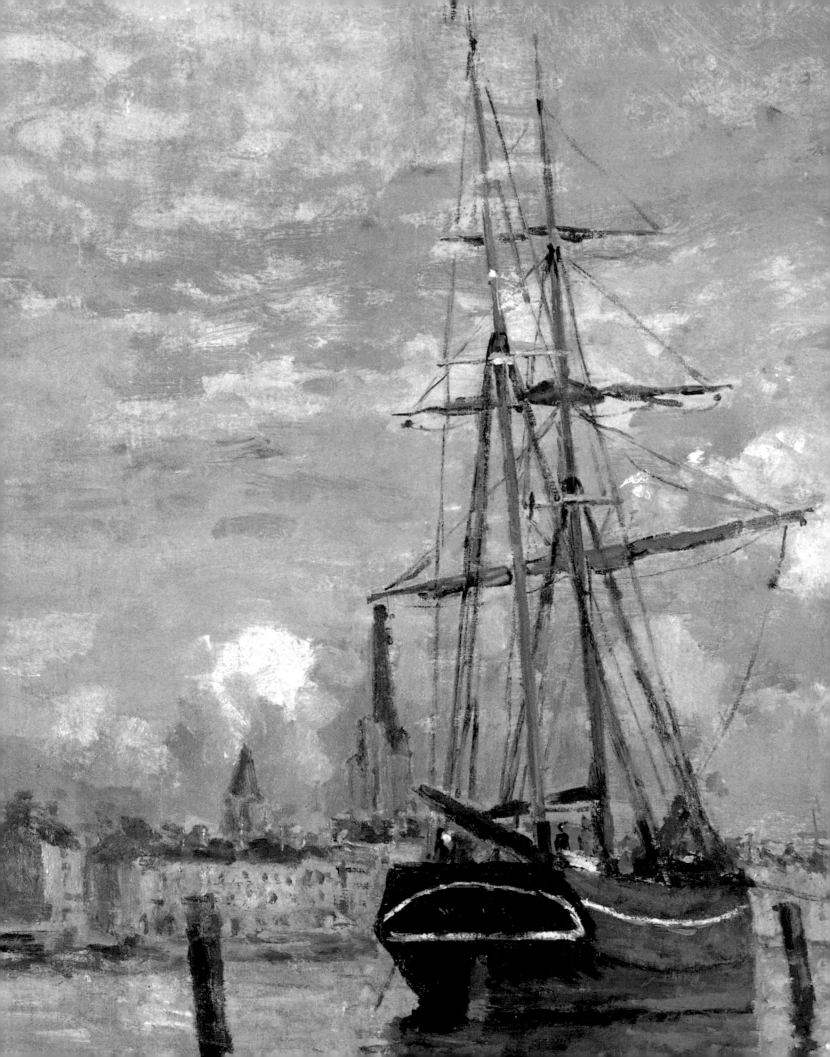

By the middle of the nineteenth century, a number of factors, including the silting up of the southern shore of the estuary, had allowed Le Havre to supersede Honfleur in importance. A thriving commercial city of approximately 70,000 inhabitants, Le Havre boasted an extensive series of man-made harbors[1] (fig. 44). These were connected by a system of locks and barriers that protected all but the outer port, or *Avant-Port*, from the marked tide differential characteristic of the coast of Normandy. In 1864 English travel writer John Murray described the colorful activity on the busy docks as "choked up with cotton-bales, sugar-casks . . . The strange cries and glittering plumage of parrots and macaws . . . [reminding] . . . the stranger of the connexion [sic] of the port with tropical countries.[2] Indeed, Le Havre was then, as now, the main French port of entry for both commercial cargo and passenger travel between France and northern Europe and the Americas.

Situated just inside the two jetties that formed old Le Havre's tidal *Avant-Port*, the original Museum of Fine Arts (Musée des Beaux-Arts) was an important cultural institution on the Grand Quai (fig. 45). The museum building, also housing the 50,000-volume Public Library, was constructed in 1845 at the harbor end of the Rue de Paris, the civic center's principal thoroughfare.[3] Already noteworthy in 1864, the art collection featured paintings by leading contemporaries, including Troyon and Couture, Old Master paintings, prints and drawings, as well as sculpture, and antiquities.[4] The collection's curator, Jacques-François Ochard (1800–70), was also a local artist from whom the young Monet had taken drawing classes.

Monet is not generally thought of as a draftsman; however, many of his drawings survive. Some were conceived as independent works of art, while others depict motifs used in painted compositions. One of Monet's surviving sketchbooks, left to the Musée Marmottan in Paris by Monet's son Michel, features three preparatory drawings for the London *The Museum at Le Havre*.[5] To frame the view Monet stationed himself on the dock directly across the harbor from the Grand Quai. Looking across the water, he sketched the façade of the museum and adjoining buildings. These structures, viewed fairly close at hand, take up a considerable portion of the picture's surface; their mass, coupled with the relatively quiet application of paint, creates a sense of solidity beyond the water's edge. In both the drawings and the oil, however, the mass of the museum's elegant beaux-arts architecture is partially screened, and thus lightened, by the repetitive angularity of many sails, a juxtaposition not unlike that in Le Gray's photograph, *The Museum and City of Le Havre* (fig. 45).[6] The combined effect is completely different from the delicate flickering forms and brushwork of the fully impressionistic *Port of Le Havre* (cat. 15).

LFO

14. *The Museum at Le Havre*, 1873

29⅓ x 39⅓ in. (75 x 100 cm)
Signed and dated, lower right: *Claude Monet 73*
The National Gallery, London
W261

FIG. 44. *Le Havre seen from a Balloon*, c. 1890, engraving, Musées Historiques du Havre.

FIG. 45. Gustave Le Gray, *The Museum and City of Le Havre*, 1865–67, albumen print from a collodion-on-glass negative, 12¼ x 16⅝ in. (32 x 41.5 cm), Amsterdams Historisch Museum.

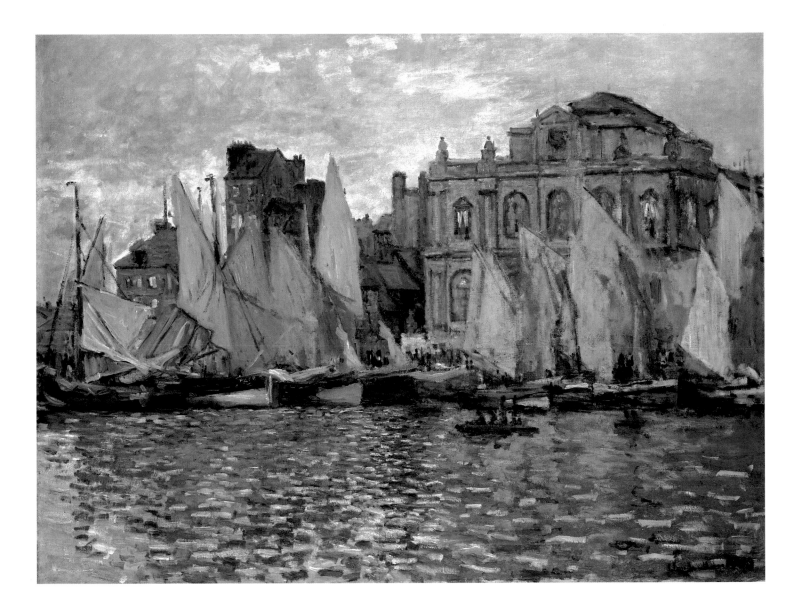

In January 1874 Monet stayed at Le Havre's Hôtel de l'Amirauté, number 41 on the harbor's Grand Quai. Various nineteenth-century guidebooks list the hotel as being particularly convenient for steamer passengers traveling in or out of Le Havre, by then France's principal northern port.[1] Similarly for Monet, being situated on the promenade overlooking the busy outer harbor, or *Avant-Port*, conveniently provided him with unobstructed views of both pedestrian and maritime traffic. For this composition the artist is looking from the *Quai des Etats-Unis* (the Quay of the United States) toward the *Grand Quai* and inner basin of the Avant-Port (fig. 46). His vividly colored strokes, obviously dashed off with great haste, create a shorthand for people, the long afternoon shadows they cast, and the sketchy forms of architecture and shipping.

This highly calligraphic image, along with the two "impressions" of Le Havre's port now in the Musée Marmottan in Paris (W262) and the Getty Museum in Los Angeles (W263), belong to a number of broadly executed works that resulted from Monet's brief visits to the area during the early 1870s. In particular, Philadelphia's *Port of Le Havre* is closely related to another version (a contrastingly blue and gray rainy version), titled *Fishing Boats Leaving the Port of Le Havre* (W296), that appeared at the first Impressionist group show in Paris in May 1874 and is now in the Los Angeles County Museum of Art.[2]

In his disparaging comments about this celebrated first exhibition of the "new painting," published in *Le Charivari* on April 25, 1874, Louis Leroy touched briefly on the Los Angeles picture. Narrating a fictional exhibition visit by a conservative artist of the "old school," Leroy observed, ". . . nothing led me to foresee the misfortune that was to ensue from his visit to this revolutionary exhibition. He even tolerated, without major damage, the sight of Mr. Claude Monet's *Fishing Boats Leaving the Port*, perhaps because I tore him from this dangerous contemplation before the small, offensive figures in the foreground could affect him."[3] Monet himself differentiated between his loosest sketches, termed "impressions," or *pochades*, and more specifically rendered, recognizable images that fit the traditional convention of "view" painting. Like the Los Angeles painting, the current work creates a definite sense of place, however sketchy. Importantly, such paintings reflect the nineteenth-century appearance and lively commercial atmosphere of old Le Havre, before the port was completely destroyed during World War II and subsequently rebuilt.

LFO

15. *Port of Le Havre*, 1874

23¾ x 40⅛ in. (60.3 x 101.9 cm)
Signed lower left: *Claude Monet*
Philadelphia Museum of Art
W297

FIG. 46. Detail of *Map of Le Havre*, as reproduced in Karl Baedeker, *Northern France from Belgium and the English Channel to the Loire*, 1899.

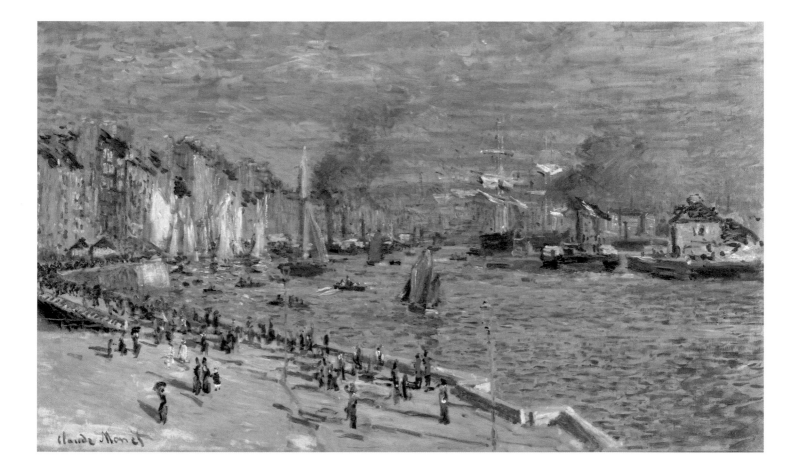

In September 1880 Monet spent a few days with his brother, Léon, in Rouen and then accompanied him to the tiny seaside resort of Les Petites-Dalles on the Normandy coast. It was Monet's first trip to the sea in seven years, and it immediately invigorated him. Although his stay there lasted only about two weeks, it initiated a sustained campaign of expeditions to the Normandy coast that occupied him for much of the decade. In February of the following year, Monet sold sixteen paintings to Durand-Ruel, including two of the four canvases painted during his visit to Les Petites-Dalles—a painting of one of the sheer cliffs, *The Cliffs of Les Petites-Dalles* (W621), and another devoted exclusively to storm-tossed waves and sky, *At Sea, Stormy Weather* (W624). This purchase was the dealer's most significant vote of confidence in the artist's work thus far, and it was accompanied by the promise to acquire more of Monet's paintings on a regular basis. Thus encouraged, Monet planned a subsequent trip to the coast with considerable optimism about future sales of seascapes.

In March 1881 Monet returned to the coast, spending several weeks in Fécamp. He had visited the fishing port briefly in 1868 and painted three harbor scenes. During his 1881 sojourn, he began twenty compositions, a number of which were later completed in his studio at Vétheuil. The Fécamp pictures were executed from a variety of perspectives—looking down to the foaming sea from rocky cliff tops, from dunes, and at the water's edge. Among the paintings were three compositions (W661–63, fig. 49) looking directly out to sea, elaborating on a theme he had first addressed at Les Petites-Dalles six months previously. From his position on the beach, his entire field of vision in the San Francisco and Ottawa pictures was filled with a vista of sky and waves. In both paintings Monet repressed any human presence to confront nature directly, his view uncluttered by boats, fishermen, or vacationers.

The horizon line in the San Francisco canvas is high; more than two-thirds of the canvas is filled with agitated swirls of blue, white, green, and yellow paint, describing layers of waves and foam. The palette is relatively pale, but the sky is a brilliant blue punctuated by cumulus clouds. From the intensity of the colors to the frequency of the waves, one breaking on top of another, one may surmise that Monet was painting the day after a storm, when the skies were bright but the water continued to churn. Row after row of loose, curving strokes of thick paint tumble toward us. The repetitive movement of the brushstrokes evokes the movement of waves; flicks of yellow pigment suggest sunlight reflected on foaming water. Only a thin stripe of horizontal strokes at the horizon indicates the vast recession of sea.

The atmosphere in the Ottawa picture is entirely different. While the San Francisco seascape sparkles with light, the Ottawa painting is darker, moodier. Touches of brown dim the sky and the sea, which churns with an oncoming storm. Here, the waves roll toward the shore more slowly, but the brushstrokes are bold, the impasto thick. Each passage of the picture—the swirling waves, the horizon line indicated by long, horizontal strokes, and the lighter, brushier touches throughout the sky—asserts the materiality of the medium, while the composition as a whole remains utterly convincing.

A third painting from the March 1881 campaign, *By the Sea at Fécamp*, was also painted from the beach, this time at the foot of the Grainval cliffs just west of Fécamp. Once again, rough waters are depicted; swirls of surf line up in rows over the surface of the sea. The cliff and the beach curve in a parenthesis, encircling the water, which seems to lap at the foot of the cliffs. The wildness of the weather is reflected in the savagery of Monet's brushstrokes. Angular slashes of orange, rose, and dark blue define the foreground beach, while the sheer face of the cliff is articulated with vertical strokes of a warm, orange-pink, descriptive of the region's rock formations in which earth is pressed

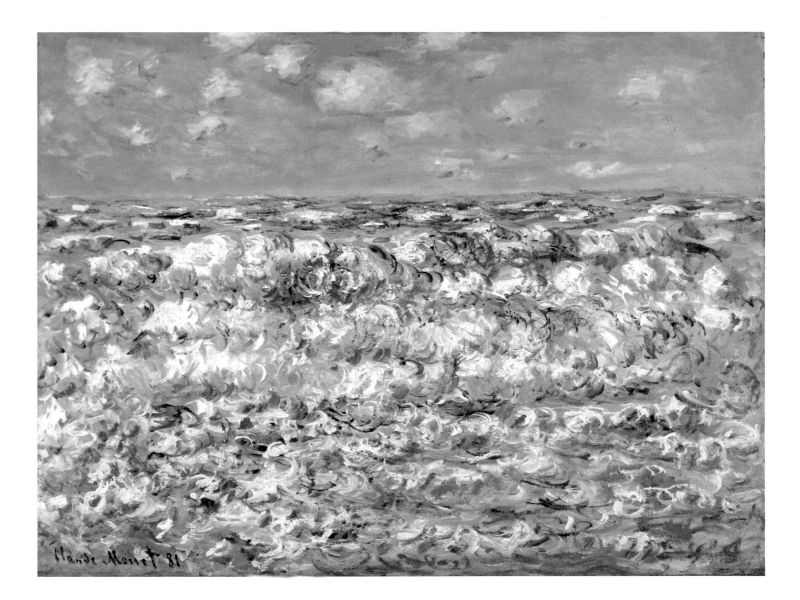

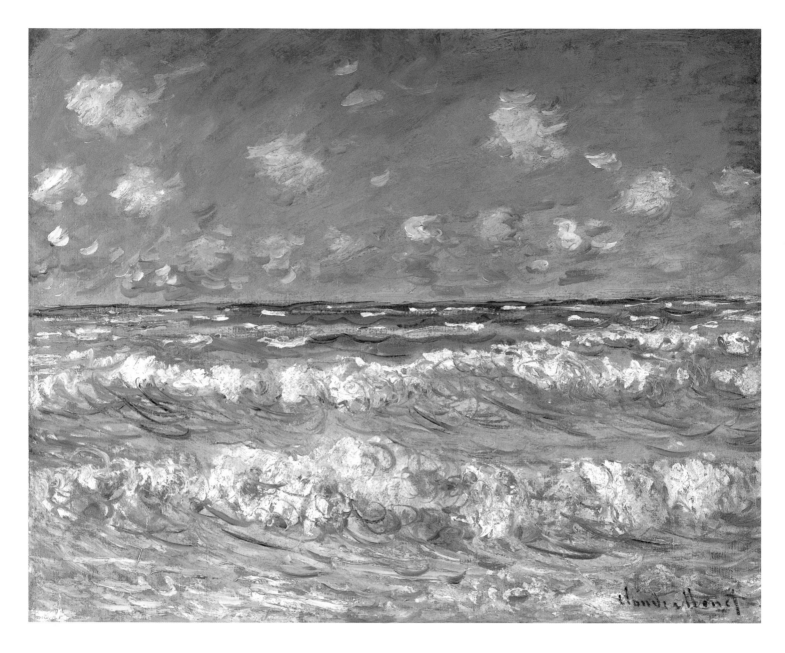

into the strata of chalk. Here the scene is as desolate as the San Francisco and Ottawa pictures; any trace of Fécamp's port or its fishing vessels is assiduously avoided.

The Fécamp pictures should be viewed against the backdrop of Courbet's seascapes, or "landscapes of the sea," as he preferred to call them. Courbet first journeyed to the Normandy coast when he was twenty-one and was immediately captivated by it. He made numerous return visits in the 1860s, painting the sea and the beach and establishing a reputation as a marine painter. In 1866 the Count de Choiseul lent Courbet his house at Trouville, where the artist spent time in the company of Monet and Boudin. One critic

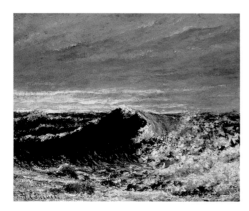

FIG. 47. Gustave Courbet, *The Wave*, 1869, 18 x 21⅝ in. (46 x 55 cm), The National Galleries of Scotland, Edinburgh.

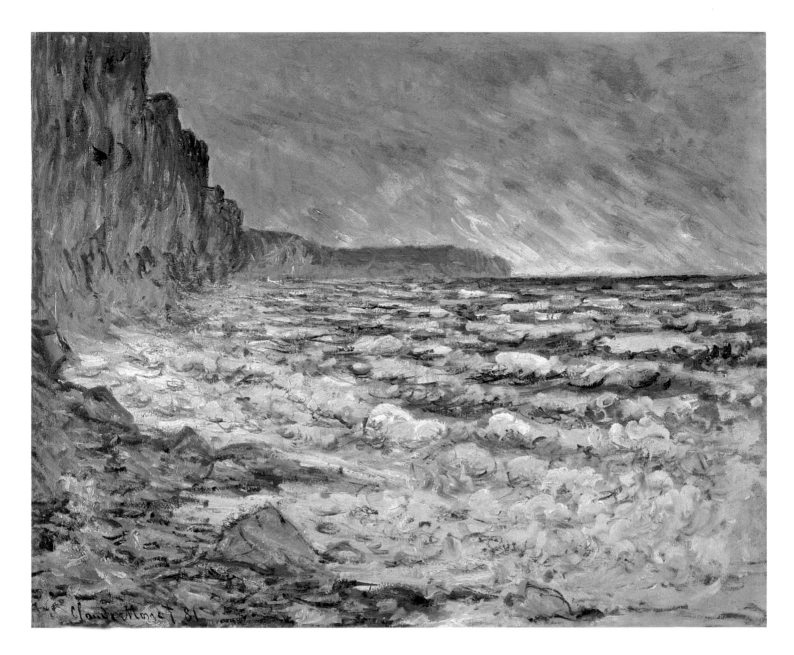

described the sea as producing "the same emotion as love" in Courbet.[1] Such passion, manifest in such pictures as *The Wave* (fig. 47), would have undoubtedly resonated with Monet. While Monet's depictions of the sea at Fécamp are more abstract, more insistently referential to the act of painting, they evoke a fascination with the subject that was in keeping with Courbet's reverence for the sea. Monet's Fécamp pictures set the tone for his two more extended painting campaigns in Pourville the following year; his stormy seascapes foreshadow the nearly abstract views of calm seas at Pourville that were to come.

HL

Like the San Francisco, Ottawa, and Le Havre paintings of rough seas and sky (cat. 16–18), *The Sea at Fécamp* was begun, and perhaps finished at Fécamp, where Monet spent March 1881. At the strong urging of Durand-Ruel, who by then owned a large stock of the artist's work, Monet showed seven of the Fécamp paintings at the Seventh Impressionist exhibition in 1882. All but one of these (W651) were cliff-top views.

The Sea at Fécamp is one of the most dramatic canvases from the 1881 campaign. Monet had descended to the base of the cliffs and set up his easel on one of the slippery rocks where wind-whipped waves crashed toward him. Here the artist—and, by implication, the viewer—is no longer merely a spectator, looking on nature's power from a safe remove, but a protagonist, in the midst of the raging elements. Yet despite extremely difficult conditions, Monet managed to pay careful attention to the compositional and technical elements of his painting. Massive rock formations fill the right side of the canvas. The nearer cliff, its base sculpted over the millennia by relentless waves, curves out toward the sea as it rises up and out of the composition. Monet describes it in bold vertical strokes and dashes of many different colors. The more distant cliff reaches a bit further out into the sea and is painted in softer, horizontal strokes. A large rock occupies the right foreground; its right contour flows down to the shore, initiating a curving diagonal channel that opens to the pounding waves and reveals a tiny corner patch of beach, rendered in diagonal strokes of plum, pink, and gray. The left side of the composition is all water: a rain-laden sky and sweeping diagonals of wind-driven whitecaps—cursive swirls and hooks of paint—that crash against the base of the cliffs. These contrasts create a vibrant surface whose dynamic patterns evoke the elemental rhythms of the scene before the artist.

It is difficult for the modern-day viewer to understand how radical a painting like *The Sea at Fécamp* was in the 1880s. Monet and his fellow Impressionists had already pushed the boundaries of traditional landscape painting. By the late 1870s they had won the grudging acceptance of a few sympathetic critics, who viewed Impressionism as an extreme form of naturalism in which certain technical aberrations or eccentricities, such as strong "unnatural" colors and sketchy brushwork, were validated by capturing a momentary effect of light or a certain "decorative" effect. Yet to many these works were not paintings at all but sketches, and even sophisticated critics dismissed them as less-than-legitimate works of art. *The Sea at Fécamp* emphasizes those qualities that the critics associated with sketches: abrupt, even fragmentary, composition; sketchy, summary execution, deliberately showing every stroke of the brush; simplified tonality; and "unnatural" juxtapositions of colors.

It is surprising, then, to learn that Monet's Fécamp paintings were generally well received. In 1880 the critic J. K. Huysmans, the champion of Realist painting, had diagnosed Monet as suffering from "indigomania" and "diseased retinas," whereby he was unable to see green, resulting in a dominance of "rude blues, shrill lilacs, surly oranges, and cruel reds," and as too easily satisfied with "hasty painting" based on "uncertain abbreviations." But in his review of the 1881 exhibition of independent artists, Huysmans would write "[Monet's] studies of the sea with the waves breaking on the cliffs are the truest marines I know." He continued, "It is with joy that I am now able to praise M. Monet, because the redemption of painting is above all due to his efforts and those of his fellow impressionists in landscape . . . Pissarro and Monet have at last emerged victorious in the terrible struggle."[1]

DS

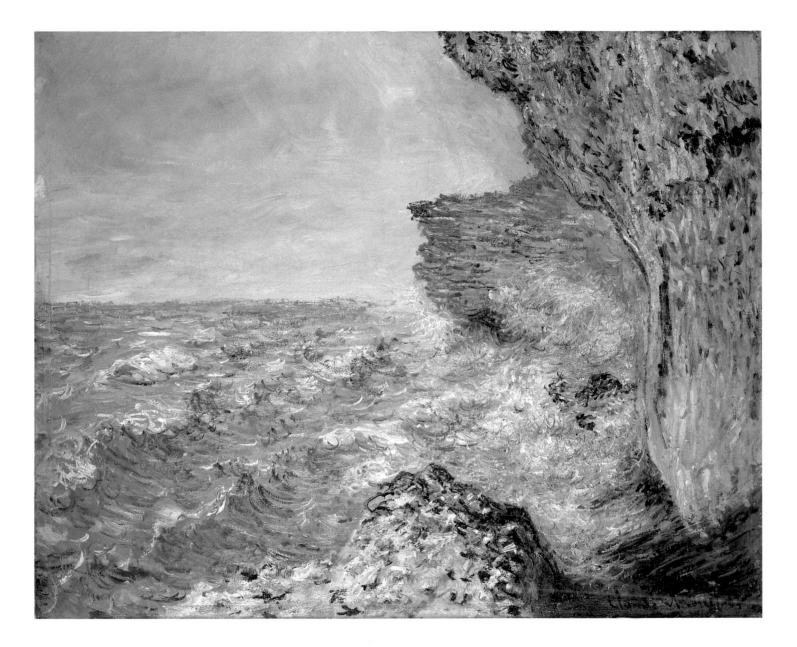

With the goal of elaborating on the success of his spring campaign in Fécamp, late in the summer of 1881 Monet returned to the Normandy coast on a brief trip to Trouville, the coastal retreat where he and Camille had spent a couple of months during the summer the Franco-Prussian War began. Inclement weather cut his 1881 trip short, however; only one letter to Durand-Ruel, dated September 13, 1881, made reference to the trip.[1] The letter was written upon his return to Vétheuil, and in it Monet complained that the sojourn had been unsuccessful and that he had returned empty-handed and discouraged. Monet was prone to exaggerate his disappointments; in fact, four canvases were made on this excursion, three on the hills above the fashionable tourist resort and one from the beach (W686–89). In these uninhabited views of the coast, Monet continued to describe the effects of the elements on the landscape, whether the bright light of midday, the setting sun, or the effects of relentless wind.

A lone tree, bent by the constant assault of coastal winds, is the single focus of *Sea Coast at Trouville*. Like many of his descriptions of the Norman coast, the painting lacks a human presence. The composition is suggestive of the relationship between the artist and nature rather than descriptive of human activity in nature. The sea and sky, separated by an indistinct blur of blue pigment, are unusually flat, suggestive of scarcely any recession of space. An abstract network of crosshatched, multicolored brushstrokes describes an expanse of land hovering above the sea.

The high-keyed palette, flat background, and stylized curve of the tree draw attention to the influence of Japanese woodcuts on Monet's work. Like many Parisians, the artist's enthusiasm for Hokusai and Hiroshige began in the 1860s, and he eventually amassed a sizable personal collection of *ukiyo-e* that was installed throughout his house at Giverny. As early as 1868, in an article on *japonisme*, the critic Zacharie Astruc described Monet as "a faithful emulator of Hokusai."[2] A veritable flood of Japanese screens, *objets d'art*, collectibles, and even books on Japanese art were available in Parisian galleries throughout the last decades of the nineteenth century. Asian art featured in the Expositions Universelles of 1867 and 1878, and increasingly *ukiyo-e* prints, infiltrated the consciousness of the Impressionists. In time, Japanese art exerted an influence over Monet's perception of the natural world. The growing abstraction of his style is apparent in paintings such as *Sea Coast at Trouville*. The landscape is essentially reduced to three bands of color: two shades of blue in the sea and sky, and a mottled green for the hillside. He flattened the space and assiduously avoided details that would have provided a sense of scale. The simplicity of the composition is in some respects similar to that of *Wheat Field*, 1881 (cat. 35). A woodcut such as Hiroshige's *The Mie River near Yokkaichi (Station 44)* (fig. 48), with its horizontal bands of color, flattened space, and wind-tossed tree, may have influenced Monet's canvases of 1881.

HL

20. *Sea Coast at Trouville*, 1881

23⅞ x 32 in. (60.7 x 81.3 cm)
Signed and dated lower right: *81. Claude Monet*
Museum of Fine Arts, Boston
W687

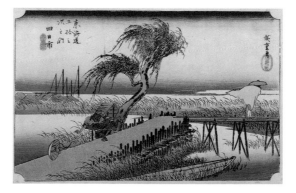

FIG. 48. Ando Hiroshige, *The Mie River near Yokkaichi (Station 44)* from the series *Fifty-Three Stations of the Tokaido*, 15 x 10 in. (38 x 25.3 cm), The Cleveland Museum of Art, Gift of Mrs. T. Wingate Todd from the Collection of Dr. T. Wingate Todd, 1948.307.

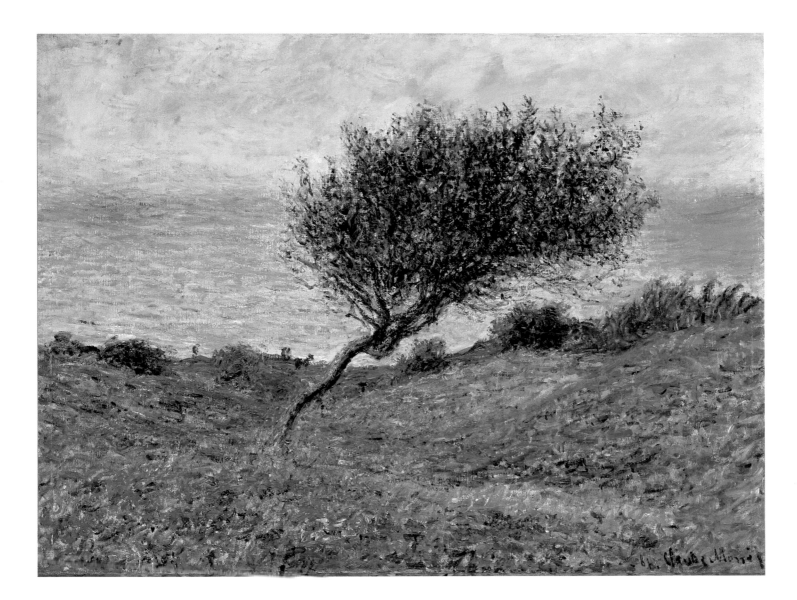

21. *Low Tide at Pourville, near Dieppe*, 1882

23⅗ x 32 in. (60 x 81 cm)
Signed and dated lower right: *82 Claude Monet*
The Cleveland Museum of Art
W716

22. *Cliffs near Pourville*, 1882

23⅗ x 32 in. (60 x 81 cm)
Signed and dated lower left: *Claude Monet 82*
Rijksmuseum Twenthe, Enschede, Netherlands
W788

23. *Low Tide at Varengeville*, 1882

23⅗ x 32 in. (60 x 81 cm)
Signed and dated lower left: *Claude Monet 82*
Carmen Thyssen-Bornemisza Collection, on loan to the
Thyssen-Bornemisza Collection, Madrid
W722

Monet left Vétheuil with Alice Hoschedé and the eight children from their two families in 1881 and settled in Poissy, a small town on the left bank of the Seine, about fifteen kilometers west of Paris. The artist quickly decided that the suburb did not suit him, and he spent much of 1882 escaping to the Normandy coast. He arrived in Dieppe in early February 1882 and several days later moved to Pourville, a village two and one-half miles west of the larger, tourist-ridden city.

Pourville featured an attractive boardwalk, a broad beach, and stunning cliffs. Monet described it to Alice as "a little nothing of a village" but much cheaper than Dieppe. He went on, "One could not be any closer to the sea than I am, on the pebbled beach itself, and the waves beat at the foot of the house."[1] He remained in Pourville from mid-February to early April, staying at a hotel owned by Paul Graff, affectionately known as Père Paul. Along with Varengeville and Étretat, Pourville became one of Monet's favorite haunts on the Norman coast. He spent part of the spring of 1882 alone in Pourville and then returned in the summer with Alice and their families for a second painting campaign.

The crisp, clear light, typical of early spring, suggests that Monet painted *Low Tide at Pourville, near Dieppe* sometime in March. He must have set up his easel on the beach at low tide, with strong, late-afternoon light shining over his shoulder. His view was of the cliff and the beach at Pourville; in the distance the coastline continues on to Dieppe and Le Tréport. His palette consists primarily of shades of blue, subtly differentiated to indicate sky and sea, with dark-blue horizontal strokes suggesting waves in the ebbing tide. The cliff is articulated in shades of light yellow, pink, and green, reflected in the water in broken brushstrokes. A cluster of small houses nestled into the cliff at the right of the composition suggests human presence and scale. Monet first sketched in outlines of the cottages with dabs of rose, later indicating volume with touches of blue.

Monet strove to identify himself as an artist working entirely *en plein air*; he perceived his originality as dependent upon his proximity to nature. In an interview with the journalist Emile Taboureux for *La Vie moderne*, Monet famously stated: "My studio! But I have never *had* one, and personally I don't understand why anybody would want to shut themselves up in some room." With an expansive gesture toward the horizon, he proclaimed, "That's my studio."[2] This was, however, essentially a myth: Monet frequently added to paintings back in the studio. *Low Tide at Pourville. near Dieppe* was painted over numerous sessions. Several days would have been required for each layer of oil paint to dry before the next was applied. X-rays reveal numerous changes to the canvas, some perhaps done in front of the motif, while others may have been done later. Traces of white can be detected in the sky above and to the left of the cliff, but Monet repainted the area so that the shimmering façade of the cliff was framed by a pristine wash of blue sea and sky. This change might be attributed to shifting weather, or it may have been an aesthetic decision made later. Additional changes to the painting cannot be explained by atmospheric conditions. Under magnification, one can discern traces of several vertical accents in the sea to the left of the cliff that have been obliterated. Monet may have drawn the lines to represent poles for hanging out fishing nets, but he simplified the composition, choosing to let the cliff stand alone, surrounded by sea and sky and uncluttered by superfluous details. The narrow strokes of black paint that dot the edge of the water at the base of the cliff indicate bathers. These touches of pigment rest on the surface of the canvas and were likely among Monet's final adjustments to the composition.

Cliffs near Pourville was painted on the second trip to the fishing village; the brilliant light of summer illuminates the sky and floods the beach with warmth. Once again Monet set up his easel on the beach, but on this occasion he looked back at the massive

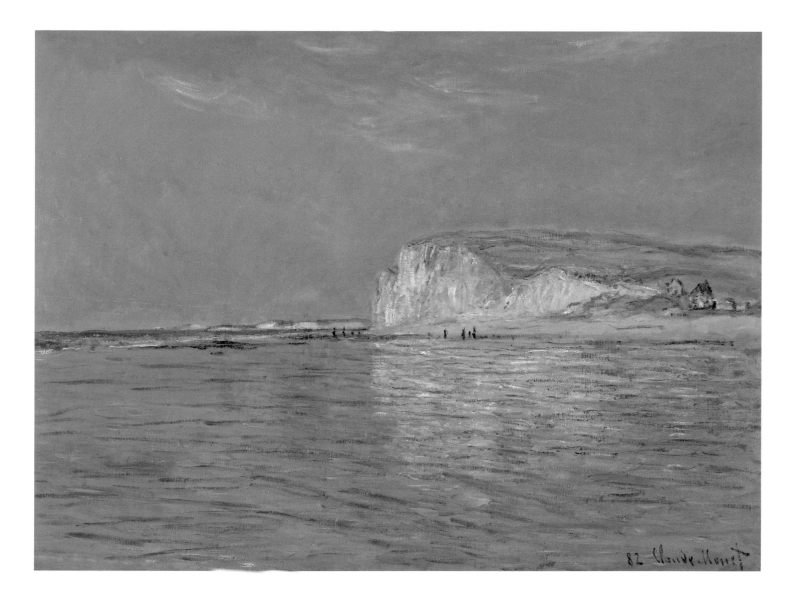

cliff-face instead of out to sea. The colossal form of the cliff and the stretch of golden-pink sand spilling forth from its base dominate the composition, obscuring much of the sky and relegating the sea to a tiny sliver of green in the lower right corner. In a spectrum of warm tones ranging from creamy yellow to pink, brilliant orange, and terracotta, Monet described the play of light on the surface of the rock; such strong colors were typical of the rock formations of this area. As in other descriptions of Pourville executed during the summer of 1882, such as *The Cliff Walk, Pourville* (cat. 30), the vigor of Monet's brushstrokes echoed the drama of the coastal landscape. Jagged strokes across the surface of the cliff convey the rough texture of rock, while yellow-green dashes of paint covering the top of the cliff evoke parched vegetation swept by relentless coastal winds. The blurred forms of white clouds rushing across the cobalt sky contribute to the sensation of a hot windy day on which Monet has taken refuge in the cool, blue shadows of Pourville's cliffs.

During his 1882 campaign along the Norman coast, Monet painted a number of compositions from the beach below during low tide. In several instances, as in the

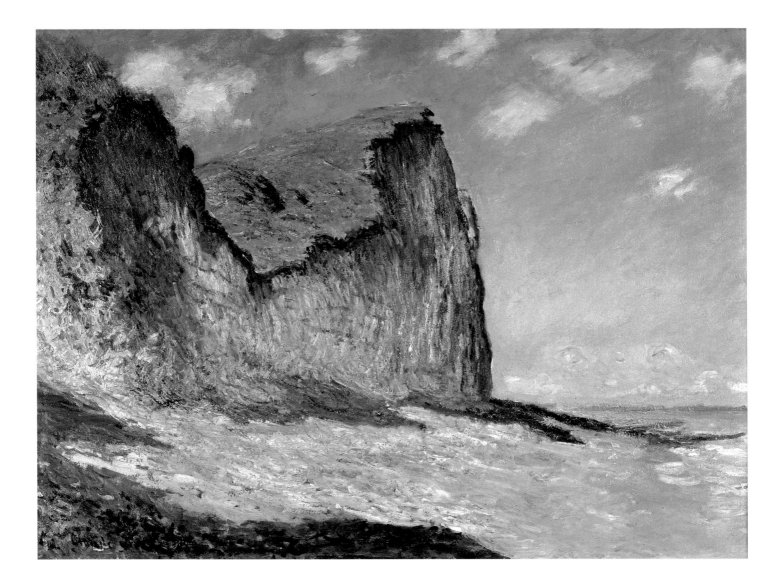

Cleveland *Low Tide at Pourville, near Dieppe*, the artist used this sea-level vantage point to exploit the contrast between the flat, reflective plane of the sea with the massive form of the bluff and the dynamic vertical of its chalky face. *Low Tide at Varengeville* is one of the finest of these sea-level views, a subtle yet extraordinary evocation of the light, colors, and textures of a Channel beach at low tide.

In other renderings of the cliff face at Varengeville in full morning sunlight (cat. 25), Monet's brushwork and palette are bold and vigorous, but in this work the dramatic setting, featuring the massive, mineral-stained face of the cliffs at Varengeville, is depicted with remarkable subtlety and restraint. In spite of the terrible weather that plagued Monet during his first stay along the coast from mid-February through mid-April, almost all of his paintings from this campaign show the coast under sunny conditions with blue skies. Here the late winter sky is completely overcast, a milky filter that tempers the usually vivid colors and range of tones. Perhaps most remarkable is his utilization of the pools that have formed on the beach as the tide receded to introduce softened reflections of the cliff face and sky. Alternating bands of muted light and dark tones of maroon-brown, violet, lavender, golden-tan, and pink are punctuated by patches of dark-green algae and rocks that seem to float on the surface of the pools, anticipating

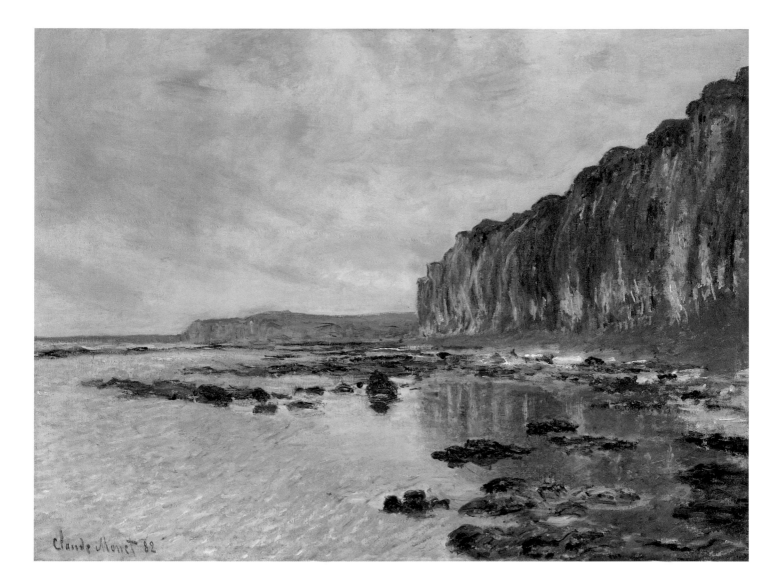

by two decades the paintings of water lilies on the pond at Giverny. These bands of colors and the massive receding form of the cliffs draw us across and through the composition to the cliffs of Pourville and the strip of sea in the distance.

Durand-Ruel purchased the work from Monet almost immediately after it was finished. He exhibited it at his London gallery in 1882 and the following year in Paris. The modern-day viewer must agree with Alfred de Lostalot, the earliest critic to describe *Low Tide at Varengeville*, in his review of the exhibition at Durand-Ruel's Paris gallery:

> The low tide, with the imposing cliffs of Varengeville, covered with algae and
> reflected in tranquil pools, filtered by the sand on the beach: a marvelous impression,
> a painting of a rare charm and accuracy; everything in its proper place and rendered
> with its natural coloration, form, and consistency.[3]

The painting was one of three by Monet included in an exposition held in Boston in 1883. This was the first time the artist's work was publicly exhibited in the United States; the painting has not been exhibited in the United States since that time.[4]

<div align="right">HL and DS</div>

24. *The Church at Varengeville and the Gorge des Moutiers*, 1882

23⅗ x 32 in. (60 x 81 cm)
Signed and dated lower left: *Claude Monet 82*
Columbus Museum of Art
W728

FIG. 49. Claude Monet, *The Church at Varengeville*, 1882, 25⅝ x 31⅞ in. (65 x 81 cm), The Barber Institute of Fine Arts, Birmingham.

The Romanesque church of Saint-Valery sits atop the cliffs a few hundred yards down the coast from the customs officer's cabin and the Petit Ailly gorge. It was a mariners' church; its rounded wooden roof and truss system call to mind the ribs of boat hulls, and its interior is decorated with a somewhat folksy array of cockleshells and mermaids. In the cemetery at the front of the church, the graves of generations of local fishermen are surmounted by simple crosses or worn tombstones bearing nautical symbols.

Monet, who respected and identified with the coastal fisherfolk, painted the church at least seven times during his two campaigns along the coast in 1882. Four of these views (W725–28) were painted from a hill known as Les Communes across the Gorge des Moutiers to the east and show the church at different times during the afternoon; another three (W794–96) depict the church from the beach below the cliff in strong morning sunlight (cat. 25).

The Columbus painting is a relatively straightforward, naturalistic rendering of the site. It is a blustery day in late March or early April. The gorse bushes in the foreground have begun to flower. Strong midafternoon sunlight floods the work; the church is rendered in a bold chiaroscuro of cream and gray-violet tones and casts a looming shadow down the bluff. The sky is clear, but despite the full sun, the air has not completely warmed; a sea mist obscures the horizon. As is the case with some of the customs cabin paintings from the same campaign (cat. 26), the foreground vegetation is painted in rough, vigorous brushstrokes that move in all directions, describing the coarseness of the gorse and the brisk gusts of wind that buffet the bluff. In contrast, the background slope is rendered in long, smooth, downward strokes that describe the contour of the bluff as it flows down to the mist-covered sea.

Another view of the church, in the Barber Institute (fig. 49), is more evocative in tenor. Painted later in the day from a spot closer to the church, a few yards from the two trees, its golden-pink light calls to mind—deliberately, one assumes—the arcadian, pastoral landscapes of France's first great landscape painter, Claude Lorrain. Although acknowledging this tradition, Monet employed a decidedly modern technique. Claude used delicate brushwork and soft, atmospheric light effects to create a timeless, dreamlike arcadia. Monet sought instead to convey the momentary elusiveness of the impression. Although the brushy vegetation in the foreground retains its descriptive texture, it is essentially an impression of texture; Monet never lets the viewer forget that he is recording this instant through the physical activity of painting.

In the Columbus view, as in the Birmingham picture, Monet emphasized the long, gentle decline of the bluff, which seems somewhat at odds with his views of the church from the beach (cat. 25), where the church seems to be perched on the very edge of the cliff. The composition is quite similar to some of his views of the customs officer's cabin (particularly cat. 26). Monet uses the assertive diagonal of the cliff edge to divide the canvas almost equally between the land, sea, and sky, using a patch of brush in the lower-right foreground and a similar area of sky at the upper left to keep the diagonal from becoming too insistent. At the same time, the distinct difference in brushwork between the foreground and background of the bluff, and the horizon line that leads us up to the top of the bluff behind the church, divide the composition into three horizontal bands that evoke recession through texture and brushwork, rather than through traditional linear perspective. The contrasts of color, light, and texture between these areas create a visually satisfying, organic equilibrium that pervades the entire composition.

DS

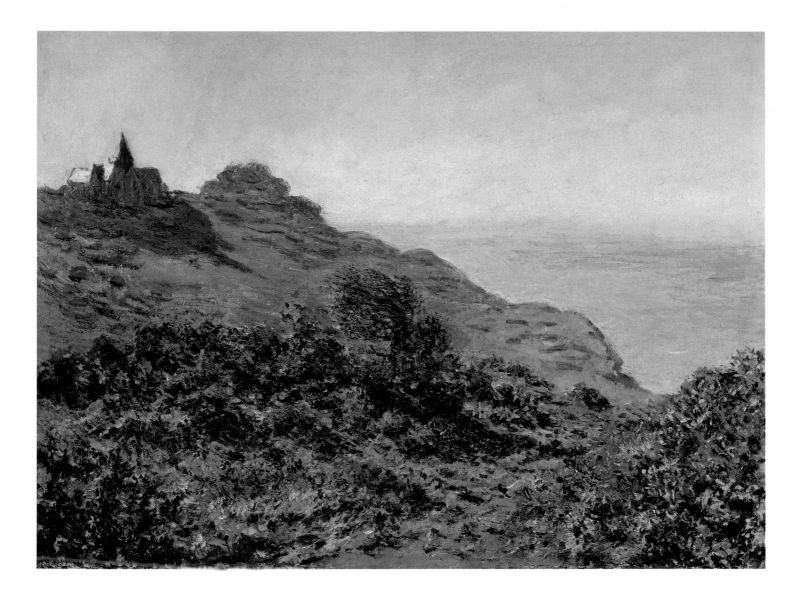

Monet's 1882 campaign in the Varengeville-Pourville area produced no painting more forcefully executed than *The Church at Varengeville, Morning Effect*. Strident brushstrokes create and describe the vertical wall of the cliffs, atop which is poised a medieval church. Before the Rouen Cathedral series, few of Monet's compositions create such a solid screening device, blocking the view into the distance.

Originally built in the twelfth century, the church to Saint-Valery still stands today, surrounded by its mariners' graveyard, outside the village of Varengeville-sur-Mer. Like other churches in the coastal region, it has been the focus of the devotions of seafaring people for centuries. The church is also renowned for the Tree of Jesse stained-glass window designed by Georges Braque (1882–1963), who is buried in the ancient cemetery.

In Monet's painting the church is viewed from the northeast looking toward the apse end of the nave; the sixteenth-century porch is hidden in shadows on the right. The church is actually about one hundred yards back from the cliff edge, a relationship that is hardly discernible in the present picture. Taking advantage of a particularly low tide, Monet settled his easel so that from his vantage point the pitched roofline of the church intersects the relatively horizontal line of the cliff edge. This raking angle maximizes the height of the cliff, which rises out of a beach of purple sand. The sensation of dramatic height is accentuated by the diminutive scale of the human figures, which are drawn with tiny smudged brushstrokes, and by the upward sweep of the brushstrokes. Muted grays and purples contrast with a range of complementary peach, salmon, and flesh colors that re-create the bright pattern of mineral stains on the cliff face. Color contrasts and technique unite to produce a vibrating paint surface conveying the energy of bright morning light. Surprisingly, the artist allows the bare canvas to suggest direct sunlight striking the cliff face, as in spots the support is left exposed, masked by only a few vibrant individual strokes. In works such as this, Monet's increasingly bold technique pushes beyond classical Impressionism toward a more expressionistic idiom.

Monet spent extended periods of time painting in the Varengeville-Pourville area. Later in life, when developing his own gardens in Giverny, Monet returned to visit the house, gardens, and park of the Bois des Moutiers in Varengeville-sur-Mer. This large Arts and Crafts house was designed in 1898 by English architect Sir Edwin Luytens (1869–1944); the gardens were laid out by Luytens in collaboration with the distinguished English garden designer Gertrude Jekyll (1849–1932). The gardening efforts of owner Guillaume Mallet (1859–1945) occasioned visits from Monet and Pissarro, among other noted artists.

LFO

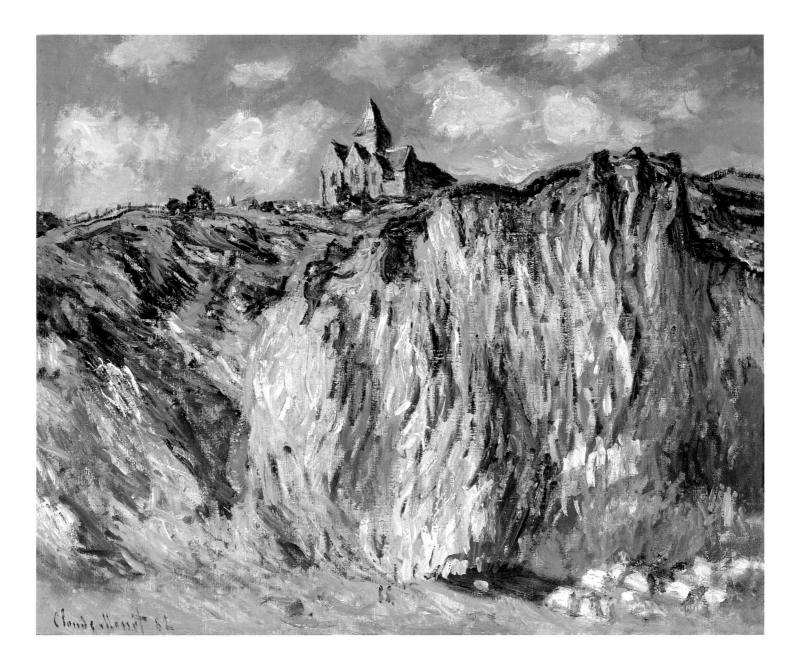

After painting inland for most of the 1870s, Monet returned to the Norman coast in early March of 1881, well before the summer tourist season began. His coastal pictures of 1881 and 1882 show him moving in significant new directions, both in his approach to the landscape and in his working method. He sought out uninhabited sites seemingly remote from civilization. Almost every sign of human activity is excluded in the paintings from this sojourn; in the few works where figures are included, they are mere dashes of paint evoking the impressive scale of the coastal cliff and rock formations or the vastness of the sea. It is as if human presence has become a distraction for Monet, diverting him from what has become his true artistic concern: exploring the myriad fugitive effects of light and atmosphere as they play out on the grand canvas of nature. By emptying his compositions of people, Monet creates the impression that the viewer is the sole witness to this dramatic natural spectacle. The artist often employs an elevated viewpoint and truncates the foreground, underscoring the illusion that we—and we alone—are the only ones contemplating these rugged, isolated sites. Even when human activity is suggested, as is the case with his paintings of the coast-guard cabin or fishing boats on the beach at Étretat, these man-made motifs serve as a kind of surrogate for human presence. No direct interaction between man and nature is depicted.

Monet's favorite motif during his two sojourns at the Norman coast in 1882 was one of a string of stone cottages built to house the customs officers who kept watch over the Channel coast during Napoléon's Continental Blockade against Britain. This particular cabin overlooked the sea at the end of Le Petit Ailly, a dry gorge located between the beach at Pourville and the church at Varengeville (fig. 50). In Monet's day local fishermen used it as a storage shed and temporary refuge, and Monet sometimes described it in the titles of his paintings as a *maison de pêcheur* (cat. 26). During the spring and summer of 1882, the artist portrayed it in at least seventeen canvases, varying the point of view, the time of day, and even the dimensions and format of the canvases. He returned to paint it again at least fourteen times in 1896–97. The cabin no longer exists, having fallen victim to the erosion of the dune caused by tides and weather.

In many respects this group of paintings from 1882—Monet refers to them as *études*—anticipates the serial paintings of the 1890s. When Durand-Ruel wrote to Monet in March of 1882, asking the artist to send more of his marketable coastal pictures, Monet replied that he had finished some additional paintings but would prefer to show the dealer "the whole series of my studies at the same time since I wish to see them all together at my home."[1] This suggests that it was part of Monet's evolving working process to view canvases of a particular motif together in his studio. There they could be more fully comprehended both individually and as a group, and he could make final adjustments before he considered them finished. To capture the varying effects of light at different times of day, Monet apparently worked on several canvases at a time, so many that he needed a porter to carry them. He wrote to Alice that on one day he worked on eight different canvases for about an hour each, concentrating so intensely that he could no longer "see clearly."[2]

The series of cabin paintings attests to Monet's inventiveness and the maturing of his technique. By the early 1880s, determined to capture even the most transitory and elusive effects of light, atmosphere, and wind, Monet developed a compositional and technical facility that enabled him to demonstrate that even a simple motif like a cabin perched on a cliff top possessed a pictorial richness worthy of repeated exploration. Employing an astonishing array of compositional strategies, brushstrokes of different shape, weight, and density, and extraordinary color and tonal combinations and juxtapositions, he repeatedly transforms the cabin and its setting, depicting it from different viewpoints (no more than three works are painted from the same spot), at

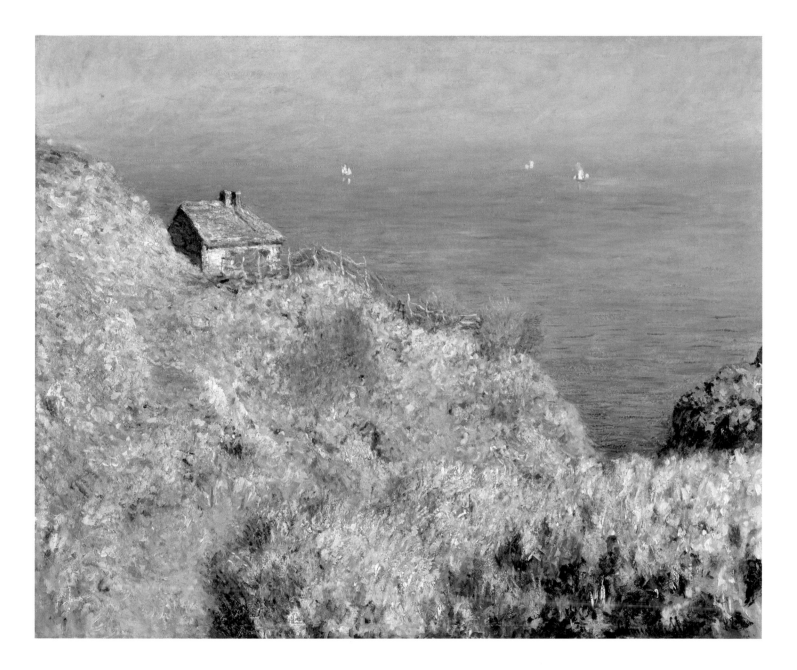

different times of day, and under varying conditions of weather and light, foreshadowing the great series of the 1890s.

Monet's conception in the cabin series (and in many of the coastal paintings from the first half of the 1880s) is more encompassing, more personal, than in his previous works. He seems to record not just a visual impression of a place but an emotional impression as well. In some of the views (e.g., cat. 28), the cabin seems almost forlorn, isolated and overwhelmed by its natural setting. In others (cat. 26), where it is nestled into the face of the cliff, it is more a part of its setting; while in others (cat. 27), it is heroic, threatened by the elements but somehow resolutely performing its duty in spite of them. In these works the cabin becomes, as Robert Herbert writes, "a surrogate for the artist or tourist contemplating the sea, but since it does not literally represent a human, the viewer is granted a solitary presence."[3] As Paul Tucker noted, "The house also takes in the attributes of a landscape painter alone with his motifs, enduring the elements in order to be one with them, much like Monet himself."[4] Certainly the cabin stands as a human (or at least a man-made) element in relationship with the varying forces and conditions of nature. These works make it clear that by the early 1880s, Monet had achieved the technical maturity and clarity of focus to express the complexity of this relationship.

The Brooklyn *Customs House at Varengeville* pulses with energy derived as much from Monet's skillful composition and technique as from the forces of nature he depicts. His brushwork, vigorous yet disciplined, creates a multitude of complex rhythms that convey the relentless assault of the wind and the surging incoming tide that roils shallows, seaweed, and sea in flattened rhythmic bands of whitecaps, moving from left to right—in the same direction as the viewer "reads" the composition. The wind-driven sea fills the canvas nearly to the top; the sky is reduced to a narrow band broken only by the distant cliffs of Pourville. Monet underscores these turbulent conditions through a variety of artistic means. He compresses the cliff top and cabin into a wedge thrusting out from the lower right-hand corner against the unceasing tide. Forceful, upward-curving brushstrokes articulate the force of the winds lashing the grasses and brush on the cliff; Monet's coastal pictures of the 1880s clearly demonstrate his uncanny ability to depict the invisible—the wind. The precipitous viewpoint—the artist offers us no place to stand—creates the impression that we, too, have been caught up by the wind. In a general sense, the composition recalls an earlier work (fig. 51), painted during Monet's sojourn at Sainte-Adresse in 1867. However, the more advanced compositional and technical sophistication of the Brooklyn painting reveals just how far Monet had matured as an artist over the ensuing fifteen years.

The Fisherman's Hut at Varengeville (Wildenstein notes that Monet himself changed the title from *The Customs Officer's Cabin* when he sold the painting) presents an entirely

FIG. 50. *Custom Officers' Cabin, Varengeville*, c. 1910, postcard.

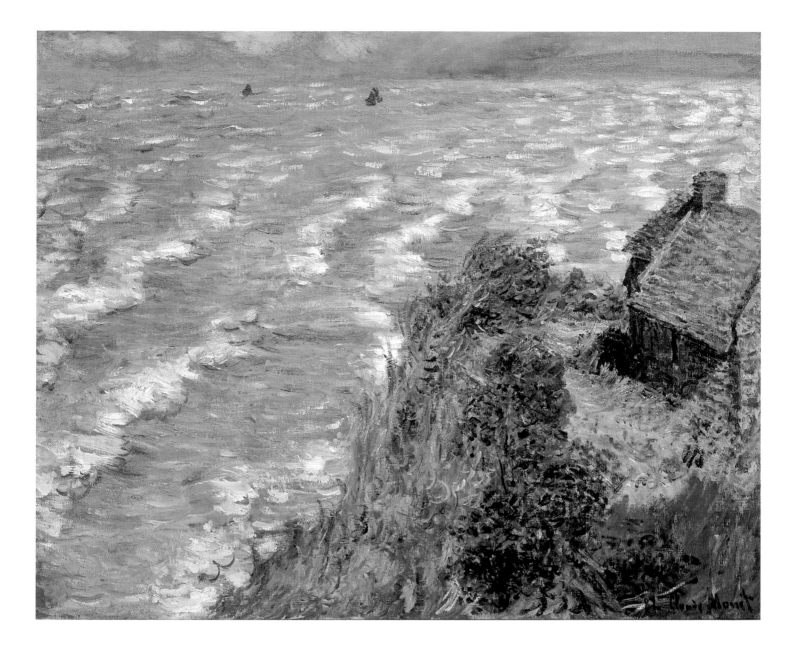

different mood and view of nature. Bathed in the glow of the early-morning sun, cabin and cliff survey a calm blue sea with sailboats gliding like seabirds over the water. The boundary line between sea and sky is blurred; distance is expressed more by color than by traditional perspective. The cliff edge forms a rough diagonal (itself interrupted by a counter-diagonal pair of bluffs at the lower right), dividing the canvas nearly equally between land and sea/sky, into two zones of distinctly different color and texture. The strong contrasts between mass and virtually empty space, abrupt truncation of the composition, and the steep and sudden jumps in space may owe something to the prints of Hokusai and Hiroshige, which Monet collected.

The cottage is seen from a distance, across a small gorge, nestled into the curve of the cliff edge. Here, more than in many works from this group, Monet uses light, color, and broken brushstrokes to integrate the building, with its unnaturally straight lines, into its natural setting, although the morning light raking across the scene casts the rear of the cabin in deep, crisp shadow, preventing it from being completely absorbed into the cliff. The play of light enables Monet to articulate the bumpy contours of the cliff

and the abundant diversity of the vegetation. To convey the density and varied texture of this vegetation, Monet must have worked on the canvas over several sessions, initially laying in a substructure of broader tones, on top of which he added layer upon layer of innumerable individual brushstrokes and *taches* (touches), many thick with pigment, others delicate and threadlike, such as those used to depict the rickety fence along the edge of the bluff or individual stalks of plants. In marked contrast to this disciplined riot of color and texture, the gentle, sailboat-dotted sea is a calm pool, rendered in thin, horizontal brushstrokes of blues, violets, and greens that become increasingly vaporous as it recedes into the distance, finally melding with the sky. In *Customs House at Varengeville*, Monet's emphasis was on the relentless power of nature, expressed through the unceasing force of the wind and the tide-driven sea; the stormy conditions he portrays there have been going on for days. Here the artist portrays nature's more fragile and momentary aspects. The sun has just begun to warm the air, but the deep-violet shadows still retain the evening's chill; out on the sea the evening mist has not yet burned off.

In the Philadelphia *Customhouse*, Monet depicted the cabin from a completely different viewpoint, resulting in an extraordinary composition. Through a variety of means he emphasized the dramatic thrust of the bluff as it rises from the western side of the gorge. The bluff's summit pushes to the very top of the canvas, surging like a wave up to the thin strip of sky and over the sea below. Shadows in the water run along a diagonal linked to both the line of the cliff edge and to the parallel brushstrokes denoting a prominent contour in the landscape running upward to the left edge of the canvas. In almost all of the other cabin pictures, the view is outward toward the sea; here Monet lets us look breathtakingly downward, so that we can *almost* see where the sea meets the beach below.

A slight rise obscures the bottom part of the awkwardly foreshortened cottage, squatting heavily within the dune, and deep shadows to the left of the cabin separate it further from the ascending bluff. In the other works in the series, Monet binds the cabin to its dune setting by using similar brushwork and similar colors and tones for both. Here, the bright pink-orange staccato brushstrokes on the cottage and the pinkish-brown tones of the adjacent sand contrast sharply with the soft brushwork and light-struck green of the rising hill. The color and brushwork anticipate the works Monet painted upon his

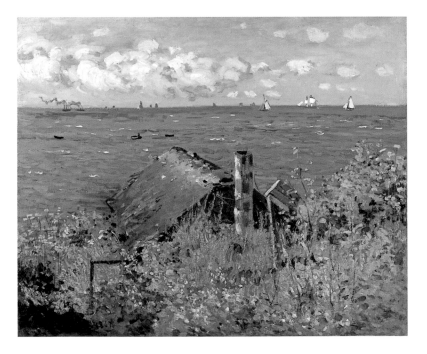

FIG. 51. Claude Monet, *Cabin at Sainte-Adresse*, 1867, 20½ x 24⅜ in. (52 x 62 cm), Musée d'art et d'histoire, Ville de Genève.

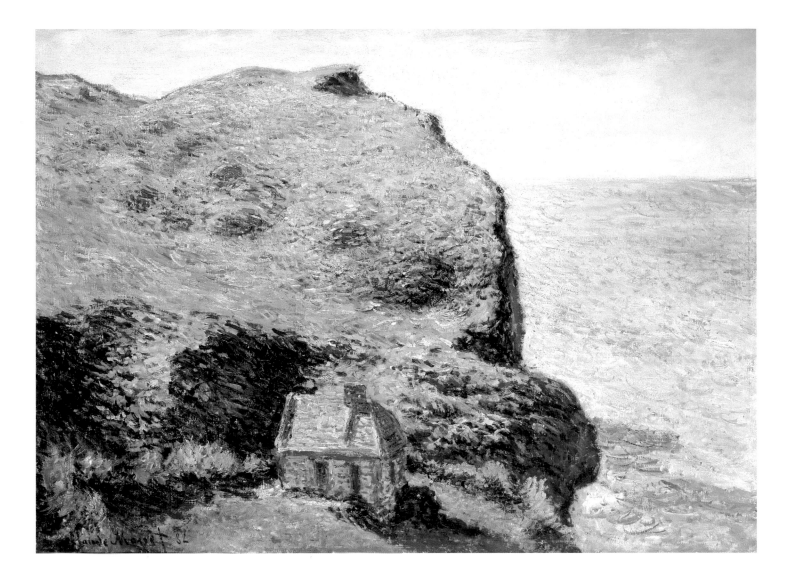

return to the coast in 1896–97 (e.g., cat. 52). Monet further emphasized the contrast between the cottage below and the ascending bluff's summit by aligning them on the same axis. This painting is one of only two from the 1882 series to depict this particular view. Monet would paint a series of five works from a position very near this one (but slightly higher and closer) when he returned to Pourville in the early months of 1896 and 1897.

DS

29. *View over the Sea*, 1882

25¼ x 32¼ in. (64 x 82 cm)
Signed and dated lower right: *Claude Monet 82*
Nationalmuseum, Stockholm
W755

30. *The Cliff Walk, Pourville*, 1882

PAGE 107; DETAIL, PAGE 105
26⅛ x 32⁷⁄₁₆ in. (66.5 x 82.3 cm)
Signed and dated lower right: *Claude Monet 82*
The Art Institute of Chicago
W758

Monet's first cliff-top views of the sea dated from a three-week stay at Fécamp in March 1881, the year before his trip to Pourville. In the Fécamp canvases, close-up views of cliffs were dramatically juxtaposed with vistas of the shoreline and sea. Paintings such as *Calm Weather, Fécamp*, 1881 (W650) reveal Monet experimenting with daring points of view along the rugged Norman coastline with a boldness that was new to his work.

The view depicted in *View over the Sea* is even more precipitous than those described in his Fécamp cliff paintings. In the Stockholm picture Monet emphasized the breathtaking plunge into the sea by positioning his easel at the edge of the cliff and looking straight down to the blue-green water below. A cluster of tiny sailboats underscores man's minute presence in the sublime setting. The drama is accentuated by the omission of sky, which would have added air and light to the composition. The deliberate exclusion of this element gives the painting its particular tension. A sense of vertigo threatens to overwhelm the viewer, who is confronted with the edge of the cliff and the sea below. The undulating line of the cliff is itself like a wave, echoed by the blue-green sea below.

Monet first visited Pourville during the off-season in 1882, and the beaches and cliffs in the seascapes from this trip are deserted except for an occasional rowboat or sailboat. He returned to the coastal town in mid-June with Alice Hoschedé and the children from their two families and spent the summer painting. While one might have expected summer resort views similar to those of Sainte-Adresse, in most of his paintings of Pourville boats or lone houses stand in for a human presence. There are few traces of the bustle of summer tourists in his paintings of the Normandy coast of this period. Instead he concentrated on the natural drama of the sea and the cliffs.

The sites of many of Monet's landscapes of the 1880s seem chosen for their difficulty, particularly such paintings of the Normandy coast. It was as if the seven years of living and painting in domestic, suburban Argenteuil in the 1870s had given him the confidence to tackle more demanding subject matter. His ambition to find a new, more modern way of painting the landscape is evident in *View over the Sea*. With its extreme perspective and lack of middle-ground or details to provide a sense of scale, the painting approaches abstraction in a strikingly modern way. The canvas was painted during Monet's second trip to the fishing village. It belongs to a group of five paintings that represent the cliff tops to the east, between Pourville and the port of Dieppe (W754–58). The Stockholm picture represents a site known as the Val Saint Nicolas, a great cleft in the chalk face of the cliff, now altered by erosion. The formation so impressed Monet that he returned to the site fifteen years later to paint another series of views of the cliff (cat. 53).

Another canvas from Monet's trip to Pourville in 1882, *The Cliff Walk, Pourville*, depicts two figures—possibly posed for by two of Alice's daughters—admiring the view of the sea. More traditional than the Stockholm canvas, this composition includes land, sea, and sky and vacationers out for a stroll, one shielding herself from the sun with a brightly colored parasol. The figures venture toward the edge of the precipice as wind whips their garments around their bodies, tosses the grasses, and sends the clouds rushing across the sky. The day is bright; sunlight illuminates the hillside, alive in a kaleidoscope of colors. *The Cliff Walk* is typical of the artist's paintings of the 1880s, in which he responded to the drama of the landscape not only in his choice of subject matter but in his technique. The network of brushstrokes on the hillside is dynamic, windswept, agitated, as though affected by the geological forces of wind and water. Monet translated the energy of nature into the forceful calligraphy of his brushstrokes, insisting in an entirely modern way upon the materiality of paint. X-rays of the painting

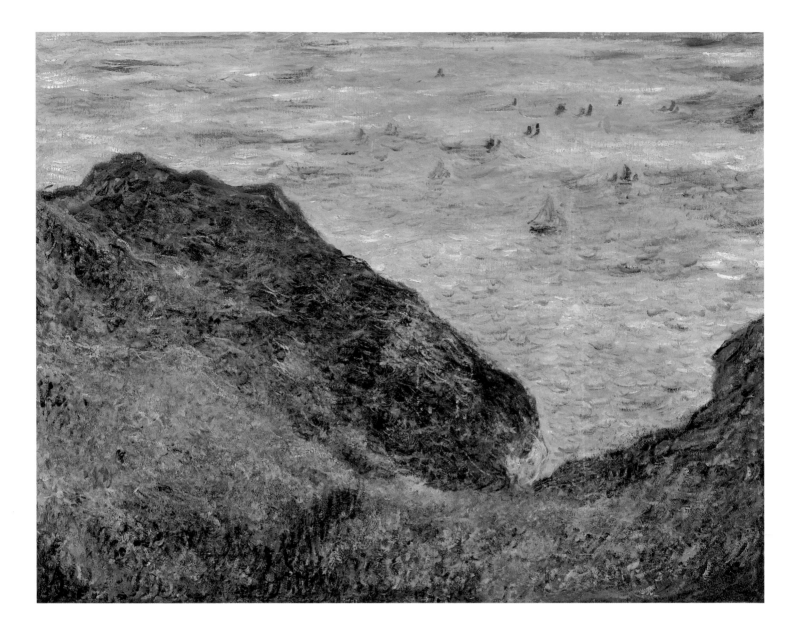

reveal that the shadowed cliff face in the upper-right edge of the picture did not originally exist (fig. 52). The second shadowy mass was added on top of the meeting of water and sky, enhancing the balance of the composition. The X-ray suggests that a third figure may have originally been present, possibly another of Alice's daughters. Monet's omission of the third figure emphasized the two remaining figures' isolation in the sublime setting.

Durand-Ruel purchased several canvases that Monet executed during the summer in Pourville, and in late February 1883, the dealer installed more than fifty of the artist's

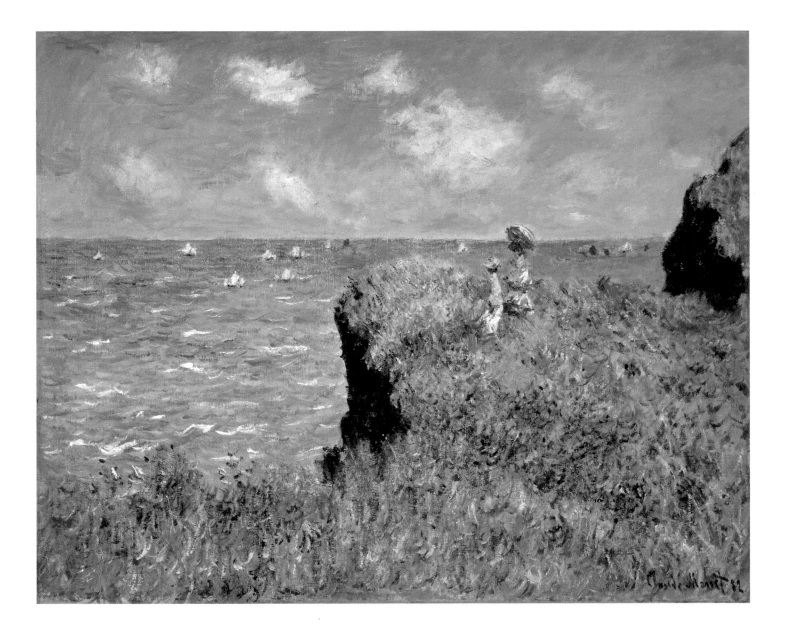

paintings in his gallery in what was to be Monet's second solo exhibition. The Chicago canvas was included in the display along with either the Stockholm painting or another composition nearly identical to it, *On the Cliff at Pourville, Bright Weather* (W756). In the Chicago canvas, the viewer observes a pair of women strolling along the cliff's edge, but in the Stockholm composition, it is as if Monet has invited us to experience the landscape for ourselves. We take the place of the figures who linger over the dramatic vista.

HL

FIG. 52. X-ray of *Cliff Walk, Pourville*, 1882, The Art Institute of Chicago.

Monet returned to the Norman coast in February 1882 for what would become a highly productive seven-week campaign. He initially planned to stay in Dieppe for the duration but found his hotel too expensive and the café full of "provincial types," and so he left after eight unhappy days, relocating to Pourville, a few miles down the coast to the west. It is somewhat surprising, then, that when he returned to the coast with his family that summer, he returned to paint this tourist-speckled view of the great cliff overlooking the western end of Dieppe's beach, surmounted by a large villa and several cottages built to accommodate the town's burgeoning tourist industry.

After the late 1870s, Monet rarely painted the type of scenes of contemporary life that had previously interested him. Only four of the ninety-six coastal views Monet painted from this highly productive period in the early 1880s include tourists. *The Cliff at Dieppe*, painted during the summer tourist season, is among the exceptions, populated with buildings and parasol-carrying strollers on the bluff above and numerous bathers on the beach below—just the sort of anecdotal details he studiously edited from his other coastal scenes from this time.

So why are they included here? Monet may have been exploring the uneasy relationship between man and nature. Explosive growth in tourism along the Channel coast during the mid- to late nineteenth century led to a dramatic shift away from the traditional economy based on fishing toward one based on tourism. In Monet's painting the buildings that protrude awkwardly from the cliff top are a vulgar intrusion on the natural splendor of the site.

Monet's choice of subject may, however, reflect more mercenary concerns. In 1882 he was beginning to establish a name for himself in the Parisian art market. It is clear from Monet's letters during this period, when he was supporting two families (including eight children!), that he was deeply concerned—indeed obsessed—with making money. It is possible, then, that the more prominent touristic aspect of the painting may have been aimed at the type of patrons Monet was cultivating—the very ones who rented or purchased similar villas and cottages at fashionable resorts like Dieppe. *The Cliff at Dieppe* was purchased by the celebrated Parisian baritone Jean-Baptiste Faure shortly after it was exhibited in the *Monet-Rodin* exhibition at Georges Petit's Paris gallery in 1889. A voracious collector of contemporary art, Faure had been collecting Monet's works since 1873; he ultimately acquired nearly fifty works by the artist, including *The Beach at Sainte-Adresse* (cat. 5). Faure owned at least two villas on the Channel coast and let Monet and his family reside in one of them during 1885, the year after he had purchased another one of Monet's paintings depicting tourist villas at Bordighera.

Despite the unusual prominence accorded the buildings on top of the bluff, it is the massive form of the cliff itself that commands the viewer's attention. The steep chalk face of the cliff and the empty space surrounding the bluff (including the immediate foreground) emphasize its bulk and verticality. Here, as in other coastal works from this year (cat. 29), Monet uses a precipitous point of view, underscored by the elimination of the immediate foreground, to enhance the drama of the site. The illusion that we are somehow suspended over the steep gorge and yet can't see where the base of the cliff reaches the beach only adds to the dramatic tension. This dizzying plunge is heightened by the sheer verticality of the great cliff, its weathered chalk face denoted in cascading strokes of white. As in other cliff-top paintings from this campaign, Monet uses richly layered, dynamic brushwork and strong, variegated colors to depict the soil and vegetation on the bluff, and contrasts this with the smoothly painted, delicate monochromy of the sea and sky, bathed in a milky white light. This contrast enhances the sense of spatial depth, based on color, atmosphere, and light, rather than traditional linear perspective.

DS

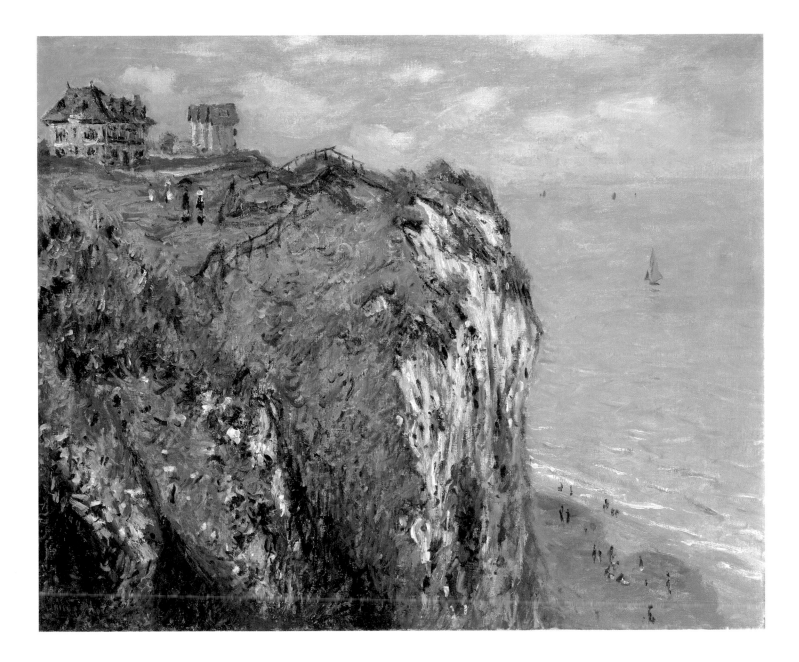

Having sold more than twenty pictures to Durand-Ruel, in June of 1882 Monet was able to return to Pourville—where he had spent nearly eight solitary weeks in February, March, and April—accompanied by Alice and their eight children. They settled into a comfortable house, the Villa Juliette, and remained there until early October. The stay was a highly productive one; Monet returned to Poissy on October 5 with approximately sixty paintings from this summer campaign.

Within days of returning home, Monet delivered twenty-six paintings to Durand-Ruel, among which were five views along the path of La Cavée, which ran from the heights of Varengeville down to Pourville near the Villa Juliette. The path wound its way between flower-flecked hills and, as one descended, offered enticing views of the sea in the distance. Monet was clearly captivated by the picturesque qualities of this route, but he seems to have been particularly sensitive to the compositional possibilities offered by one particular bend in the path above Pourville, for he painted it three times. Two of these compositions are vertical in format (W760 [fig. 53], W761), while the present canvas presents a horizontal and somewhat more symmetrical view that allowed the artist to include more of the flower-carpeted slopes on either side of the path.

Road at La Cavée enchants the viewer-traveler on several levels. Its compelling quality—the lush vitality of springtime, the promise of the empty path, the picturesque view, and Monet's mastery of his brush and palette—is based on his instinctive ability to use the inherent geometry he saw in nature to organize his composition. It is an organic (rather than hard-edged) geometry, to be sure; the only visible straight line is the horizon, where the sea meets the sky. Everywhere else the edges of these large geometric shapes are softened. Feathery pink and white touches, added on top of the darker brush behind them, rise up from the slope on the right, while similar wafts of Monet's brush and the tops of more distant foliage soften the contour of the left-hand rise. The dense rectangle of dark foliage, enlivened by the artist's vigorous brushwork and by touches of red-orange and yellow-green, becomes thinner, more transparent as it ascends; lighter touches of Monet's brush enable him to use the texture of the canvas to suggest the shimmer of leaves. The combination of interlocking triangles and rectangles, each with their own distinct colors and textures, underpins and animates the composition.

In the lower corners of the foreground, two slightly darker triangular patches initiate a series of alternating bands of tones and serve to emphasize the swelling slopes of the grassy banks on either side—a tapestry of muted pinks, yellows, mauves, and whites interwoven among rippling grasses—that draw us to the center of the composition. There, the well-worn but empty path beckons us down toward a deeply shaded spot in the brush where the trail bends to the left and disappears from view, leading us out to the two-toned wedge of distant sea (itself rendered in two distinct bands of color) and overcast sky, whose thick bank of clouds establishes another distinct band of color and texture, enhanced by the weave of the canvas itself.

Works like this and others from the early 1880s clearly show that by this time Monet regarded color, shape, pattern, and texture in nature as elements integral to his pictorial arrangement. The more intently we contemplate these compositions, the more we become aware of such relationships. Monet's subtle artistry creates a dynamic, yet delicate tension between nature and abstraction, between surface pattern and depth.

DS

32. *Road at La Cavée, Pourville,* 1882

23¾ x 32⅛ in. (60.3 x 81.6 cm)
Signed and dated lower right: *Claude Monet 82*
Museum of Fine Arts, Boston
W762

FIG. 53. Claude Monet, *The Path at La Cavée at Pourville,* 1882, 28¾ x 23⅝ in. (73 x 60 cm), private collection.

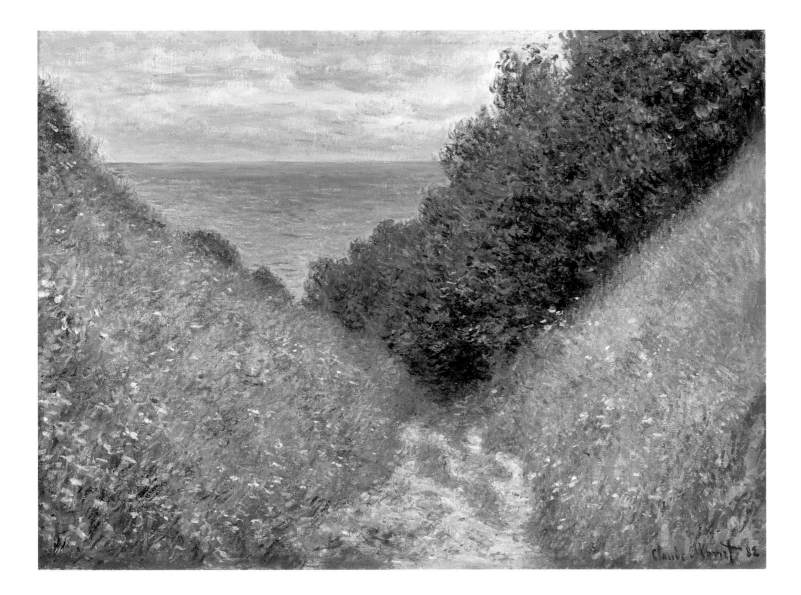

Returning to Pourville in mid-June 1882, Monet was able to settle into a long summer of painting. Among the numerous seascapes he executed during that stay were several views limited to sea and sky, possibly painted from the village's picturesque boardwalk.

The Philadelphia canvas belongs to a suite of four paintings (W771–74) that contain nothing but sea and sky. In these compositions, Monet pared the seascape down to its essentials. Water and sky fill the canvas in *Marine near Étretat*; there are no details to suggest scale or boundaries, giving the illusion of vast, limitless space. The elemental quality of the work is emphasized by the removal of expendable detail; Monet's modernism is underscored by the exclusion of anecdote. The artist's subject is the quiet splendor of the sea, as the light of dawn or dusk transforms the panorama into a delicate palette of yellow, rose, and violet.

By placing such limitations on his subject matter, Monet tested his abilities as an artist to make his subject engaging and recognizable. The brushwork in the sea and sky is differentiated with long, horizontal strokes articulating light and ripples on the sea, while clouds are described in swirls of paint. A stripe of blue suggests the horizon, and three tiny strokes indicate a sailboat in the distance. Although the picture approaches abstraction, the subject of light reflected on the surface of calm water is immensely readable.

Poetic in its simplicity, the painting recalls a group of seascapes James Abbott McNeill Whistler made on a trip to Trouville with Courbet in the autumn of 1865. By the time Monet was painting the sea in Pourville, he would have been familiar with Whistler's *marines* in which the empty sea, described in cool bands of subtle colors, suggested the infinite. Monet had known Whistler's work since the 1860s and had met the artist when he sought refuge in London during the Franco-Prussian War in 1870–71. When he visited the city again in 1887, he stayed with the expatriate. In paintings such as *Harmony in Blue and Silver, Trouville* (fig. 54), Whistler reduced the sea to its minimal formal elements. Although their attitudes toward nature diverged profoundly, Monet and Whistler found similar pleasure in evoking atmosphere, mist, and light in their paintings, creating muffled harmonies with their palettes.

33. *Marine near Étretat*, 1882

21¼ x 28¾ in. (54 x 73 cm)
Signed lower right: *Claude Monet*
Philadelphia Museum of Art
W772

34. *Seascape at Pourville*, 1882

PAGE 115; DETAIL, PAGE 113
23⅗ x 39⅓ in. (60 x 100 cm)
Signed lower right: *Claude Monet*
Columbus Museum of Art
W775

FIG. 54. James Abbott McNeill Whistler, *Harmony in Blue and Silver, Trouville*, 1865, 19½ x 29¾ in. (49.5 x 75.5 cm), Isabella Stewart Gardner Museum, Boston.

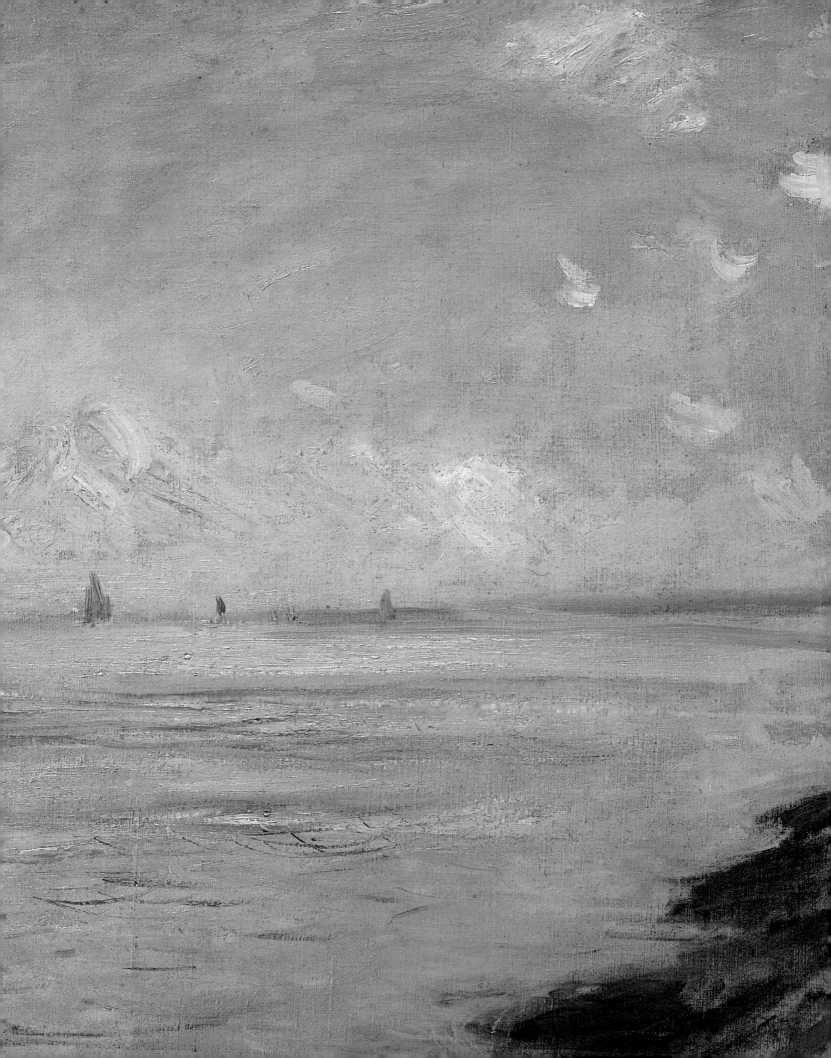

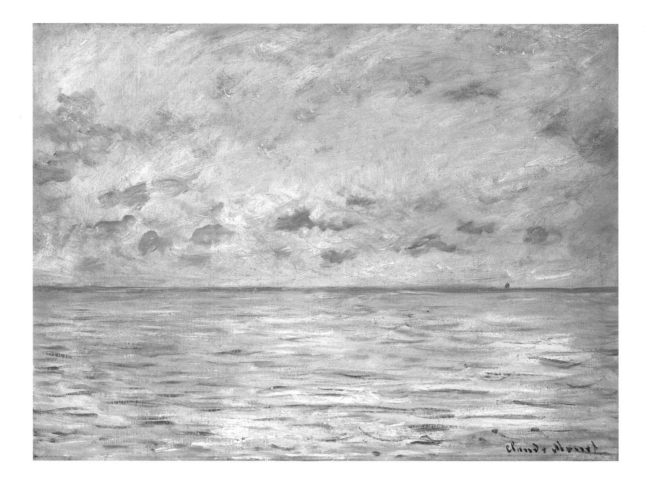

While the Philadelphia seascape borders on the abstract, the triangle of beach in the lower-right corner and the cluster of sailboats on the horizon of *Seascape at Pourville* provide the Columbus painting with anecdote and scale. Crystalline water and billowing white clouds describe a perfect summer day, yet there is a solitary quality to the scene. Alone, clinging to the shore, the viewer is distanced from the human activity suggested by pleasure boats on the horizon. The viewer has the delight of knowing that within a moment, the graceful tableau of sailboats, clouds, and sunlight glistening on the green water of the Channel will have shifted. The panoramic format of the picture, unusual within Monet's oeuvre, emphasizes the limitless expanse of the sea.

Monet's love for the sea found its way into his travels, his art, and his correspondence. He journeyed to the coast almost every year throughout the 1880s and wrote to Alice in 1886, "You know my passion for the sea . . . I'm mad about it."[1] During the First World War, longing to see the shore again, he traveled from Giverny to the Channel just to gain strength from being in its presence. The hundreds of seascapes that he painted are a testament to a favorite motif and perhaps his most important subject, and these pared-down, nearly abstract compositions offer some of the most elegant testimonies of his affection.

HL

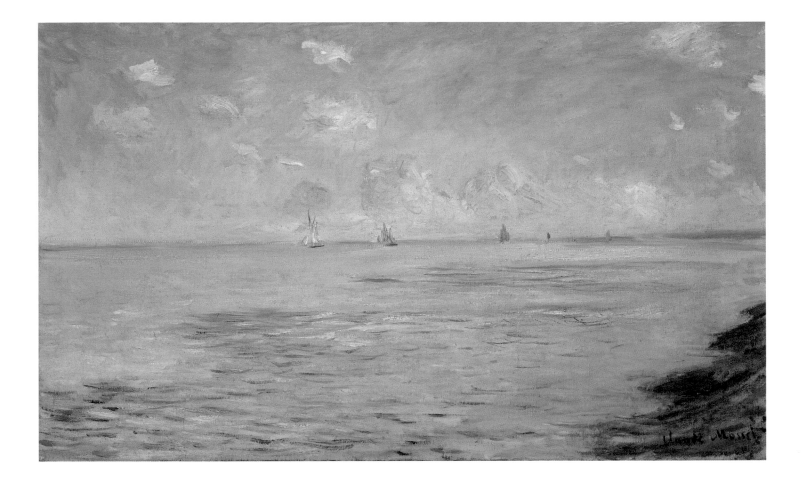

According to Wildenstein, *Wheat Field* depicts the plains of Lavacourt, a quaint hamlet on the left bank of the Seine across the river from Monet's home in Vétheuil in 1881.[1] According to Richard Thomson, however, *Wheat Field* was made just beyond Lavacourt on the presqu'île de Moisson, a flat peninsula of land that fills the great curve of the Seine that swings past Vétheuil between Rolleboise and Bonnières.[2] Lavacourt first appeared in the artist's paintings in 1878 and became one of his favorite motifs until his move to Poissy in 1882. His best-known view of the village, exhibited at the Salon of 1880, *Lavacourt*, 1880 (W578), was painted from the left bank of the Seine, opposite Vétheuil and downstream from Paris. The warm, rich view of pastoral abundance in *Wheat Field* contrasts with *Lavacourt* and similar cool views of the Seine of the period (Cf W512–17, 538–41, 557–58).

Approximately ten kilometers southeast of the Normandy border, Lavacourt is located in the Île-de-France. Nonetheless, *Wheat Field* perfectly captures the agrarian spirit of the region in high summer. Long appreciated as an agricultural center, Normandy was particularly known for its production of grain and livestock. The juxtaposition of fields of wheat and alfalfa may be seen as alluding to the region's riches. Alfalfa was the principal crop grown for hay and fodder for livestock, and wheat yields increased steadily in France following the introduction of the McCormick reaper-binder in 1855.

Deceptive in its apparent simplicity, *Wheat Field* is masterful in its choreography. Horizontal bands of cool green and blue envelop the warm stripe of golden, sunlit wheat that stretches across the canvas. Poplars punctuate the horizon line, and a curving path leads the viewer's eye toward the center of the canvas. A sequence of vivid red dashes in the lower right corner were among the final details in the execution of the painting, balancing the tall cluster of trees at the left. Touches of a softer red suggest poppies amongst the foreground grasses. In a laudatory article published in *La France*, Octave Mirbeau provided a contemporary description of the painting:

> The subjects of Monet's landscapes are always simple, no décor, no preoccupation with effects, no quest for staging. He draws his effects solely from the accuracy of things, set in their own light and surroundings, and from the state of reverie and sense of infinity that they give to the poet. A tree and the sky, he does not need more to make a masterpiece. Here is one of his paintings. First a field of alfalfa, pale green and almost bleached out by the ardent noontime sun, a small path runs through the alfalfa, like a ribbon of gold, then thick, almost pink wheat rising up like a wall, and behind this wheat, a few dark green tree tops. It is nothing, you see, and it is a pure masterpiece; this entire corner of nature exhales a silence, a tranquility, and oppressive heat.[3]

Wheat Field, under the title *Sentier dans les blés (Path in the Wheat)*, was among the thirty-five paintings Monet selected to show at the seventh Impressionist exhibition in 1882, a testament to his regard for the picture. There it was praised by Paul de Charry, who described it as *bien vrai* (very true, or very accurate).[4] The seemingly simple composition of open fields, lacking a single thematic focus, foreshadowed the series of oat and poppy fields that Monet was to execute in Giverny in 1890, such as *Oat and Poppy Field* (W1259).

HL

35. *Wheat Field*, 1881
25⁷⁄₁₆ x 31⁷⁄₈ in. (64.6 x 81 cm)
Signed and dated lower left: *Claude Monet 81*
The Cleveland Museum of Art
W676

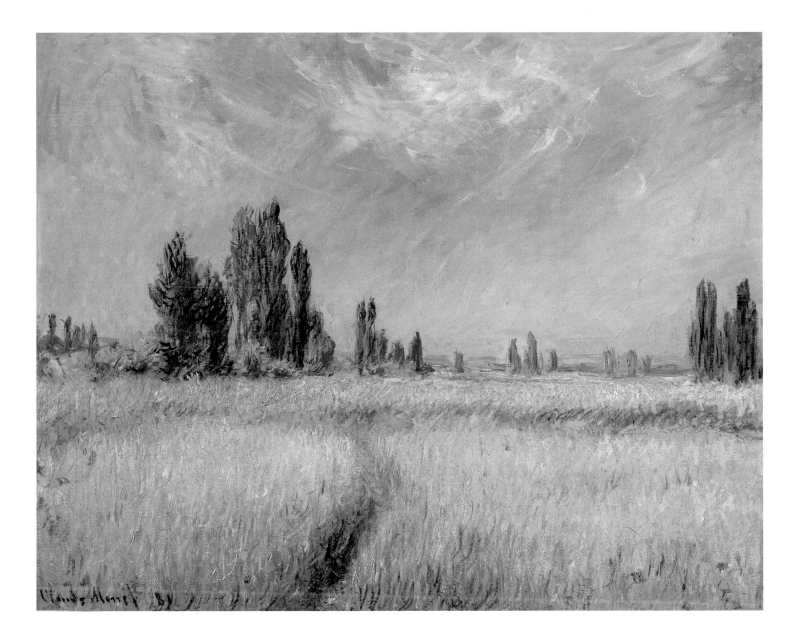

36. *Frost*, 1885

PAGE 119; DETAIL, PAGES 120—21
23½ x 31⅝ in. (60 x 80 cm)
Signed lower left: *Claude Monet*
Private collection, Dallas, Texas
W964

After an intense period of travel during the first half of the decade, Monet spent much of 1885—86 close to home in Giverny, surrounded by family and the increasingly familiar landscape of southeastern Normandy. His efforts during these two years resulted in a remarkably diverse array of canvases. He painted the Seine and its tributary the Epte, winding country roads, villages nestled into the rolling hills of the region, and women picnicking in orchards. Lingering over details particular to every season in the countryside, he explored neighboring towns such as Bennecourt, Port-Villez, Limetz, and Vernon.

The month of January 1885 was particularly cold, with average temperatures in Paris around twenty-one degrees Fahrenheit. Monet seized the opportunity to depict the landscape shrouded in snow. The majesty of winter fascinated him, and in 1885 he painted the icy hills around Giverny reflected in the Seine, as well as several compositions of the snow-covered road between Gasny and Vernon leading up to the first houses at the eastern end of Giverny (W961—68). Whereas most of these paintings depict winter vistas, *Frost* describes a more intimate, close-up view of nature.¹ In this composition, Monet focused on a thicket of trees and undergrowth following a heavy frost. The dense network of gray, brown, and lavender branches juxtaposed against a pale, nearly colorless sky evokes windy, frigid conditions. The effect of a freezing wind is suggested by agitated, broken brushstrokes executed in an almost fierce technique. Dashes of white, green, blue, red, and brown flicker across the composition, enlivening the predominantly monochromatic, cool palette. The only sign of human presence is what appears to be a rickety construction—possibly animal traps or remains of a derelict fence—almost hidden beneath the snow. Little dashes of green line the edge of the thicket, suggesting the recent presence of a small animal.

Monet painted his first *effet de neige* (snow scene) as a young artist in 1865, the same year he made his debut at the Salon. Winter scenes with muted tonalities and hushed moods were a frequent subject among the Impressionists; Monet, Renoir, Pissarro, Sisley, Caillebotte, and Gauguin all rendered the particular effects of light and atmosphere in landscapes blanketed in white. The particular character of sunlight streaming across a snowy path, and tones of red, pink, purple, and blue as reflected in the snow at dusk, were favorite motifs of these artists, experts in capturing the fleeting effects of nature. During the winter of 1879—80, while living at Vétheuil, Monet executed a series of *Débâcles*, depicting the breakup of ice floes along the frozen Seine (W552—71). Monet's most famous snow scenes, these canvases have often been interpreted as expressive of the artist's desolation after the death of Camille in September 1879 and of his extreme poverty during the following winter. Complex in mood, the paintings were alternately iridescent in their reflections of color, and heavy with gloom. An extraordinarily modern composition, daring in its experimentation and seeming simplicity, *Frost* displays a remarkable virtuosity of brushwork in a very limited palette.

HL

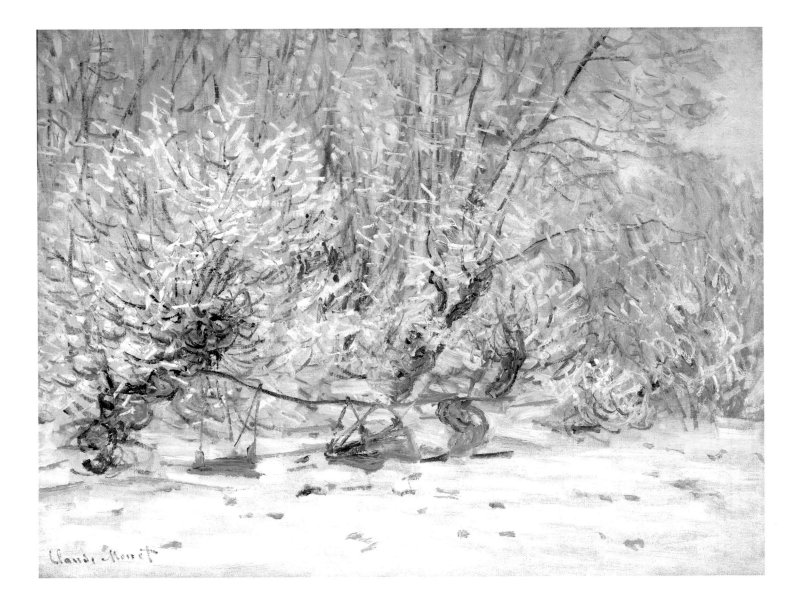

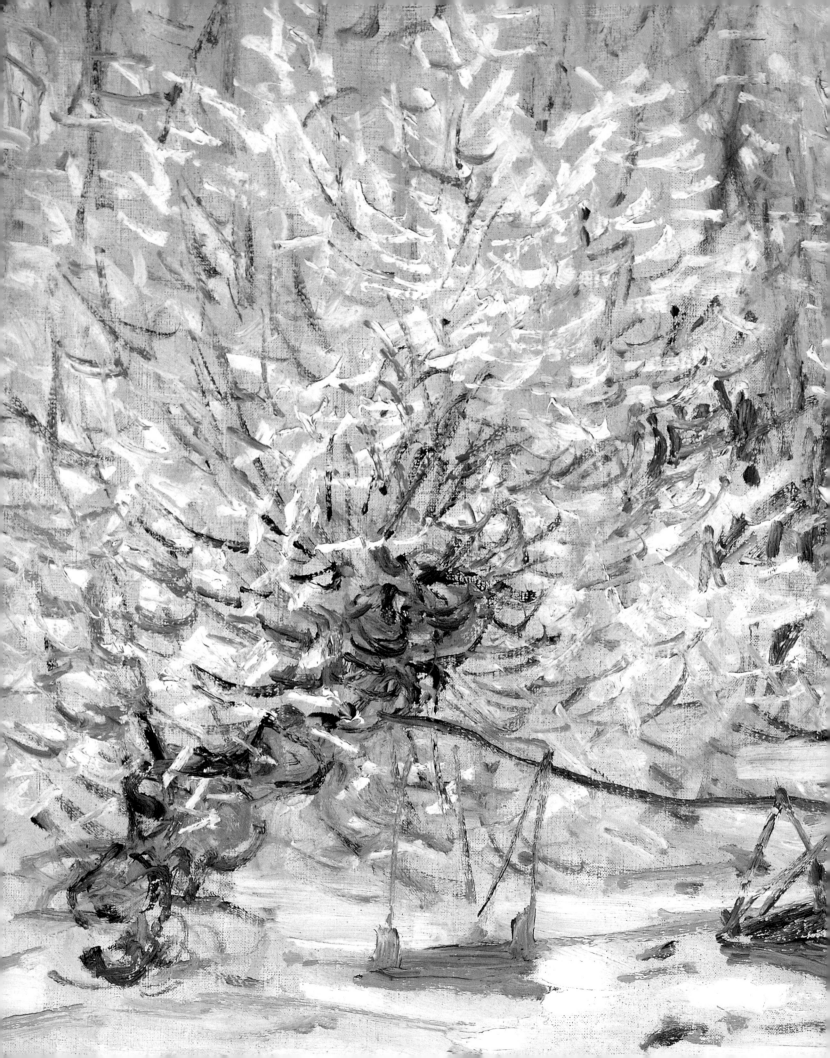

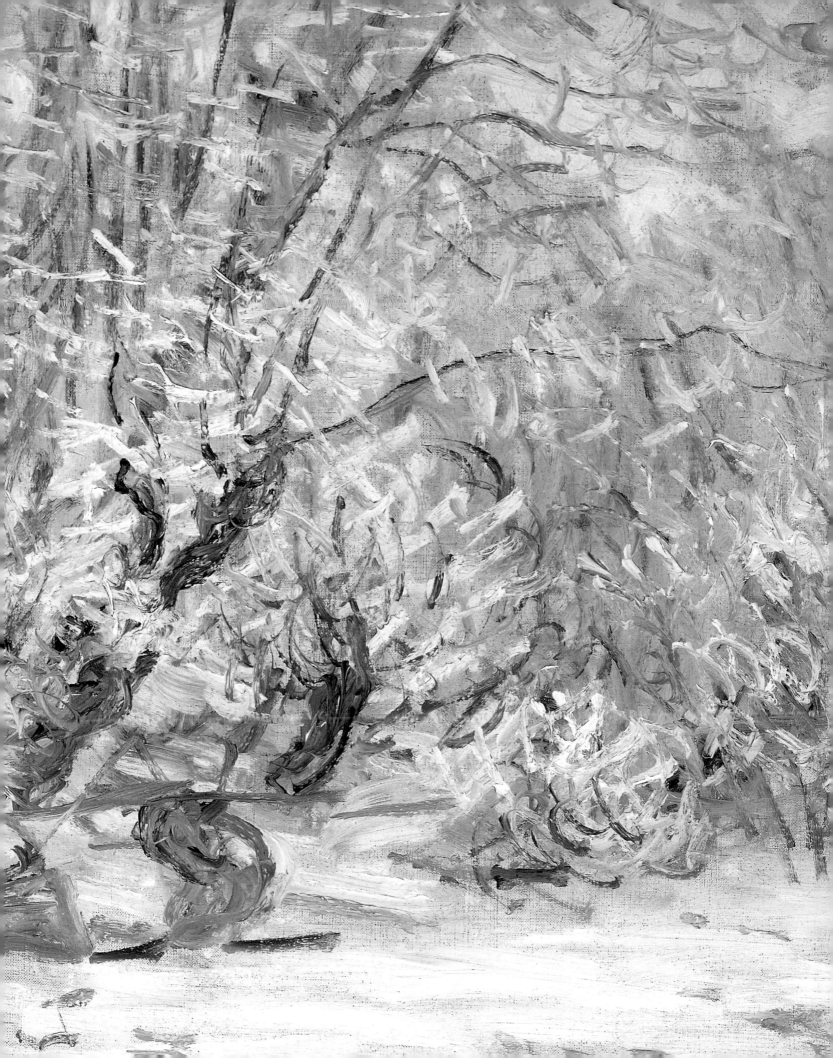

In April 1883 Monet and his extended family—Alice Hoschedé; his two sons by his first wife, Camille; and Alice's six children by her husband, Ernest (to whom she was still married)—moved from Poissy, a western suburb of Paris, to Giverny, an unassuming farming village of some two hundred and seventy-nine inhabitants. There they rented one of the largest houses in the village, a pink stucco house known as *Le Pressoir* (the cider press), which sat on ninety-six acres of land along the Ru River; the property included a barn and some outbuildings. Le Pressoir would remain Monet's home for the rest of his life; he would die there on December 5, 1926, three weeks after celebrating his eighty-sixth birthday.

Rural but prosperous, situated about forty-five miles northwest of Paris, Giverny's location and tranquil, agrarian setting were ideal for Monet. Halfway between Paris and Rouen, the village lies on the Epte, a tributary of the Seine, which formed the ancient boundary between Normandy and the Île-de-France. A railway spur to nearby Vernon connected with the main line between Le Havre and Paris, each less than an hour away. The village was nestled against gentle hills to the north (*La Côte*), while to the south and east lay the Seine and its vast plain (*Prarie*) and more distant hills. Spread out along an east-west axis, the valley was bathed in a constant, gentle light that must have been very appealing to Monet.[1] When the property became available in 1890, he immediately purchased it for 22,000 francs and quickly set to work transforming it into a floral and aquatic paradise, a project that would occupy him for nearly forty years.

Village of Giverny was painted from a hillside northeast of town, looking southeast toward the plain of Essarts and the distant hills around Bennecourt and Bonnières. Lying just beyond the right-hand edge of the view are the fields of Clos Morin, where Monet would paint his series of *Grainstacks* in 1891–92. In the foreground is the Ferme de la Côte, which belonged to the family who, in 1893, opened the Hôtel Baudy, a popular lodging for the numerous American artists who flocked to Giverny in the late 1880s and 1890s.[2] Among them was Theodore Robinson, who made the first of several visits in 1885, and over time became one of Monet's closest American friends. In 1889 Robinson painted a view of the village (fig. 55) from a spot very close to the vantage point of *Village of Giverny*.

Not a traditional "townscape," *Village of Giverny* is more remarkable than it appears at first glance. All Monet shows us of the town are the shapes, colors, and textures of rooftops. The houses at both edges, including the buildings of Le Pressoir, seem rather arbitrarily truncated. Nor is the painting a panoramic landscape in the traditional sense,

37. *Village of Giverny*, 1886

25½ x 32 in. (65 x 81 cm)
Signed and dated lower left: *Claude Monet 86*
Mrs. Frederick M. Stafford collection, courtesy of the New Orleans Museum of Art
W1072

FIG. 55. Theodore Robinson, *A Bird's-eye View: Giverny*, 1889, 25¾ x 32 in. (65.4 x 81.3 cm), The Metropolitan Museum of Art, Gift of George A. Hearn, 1910. (10.64.9).

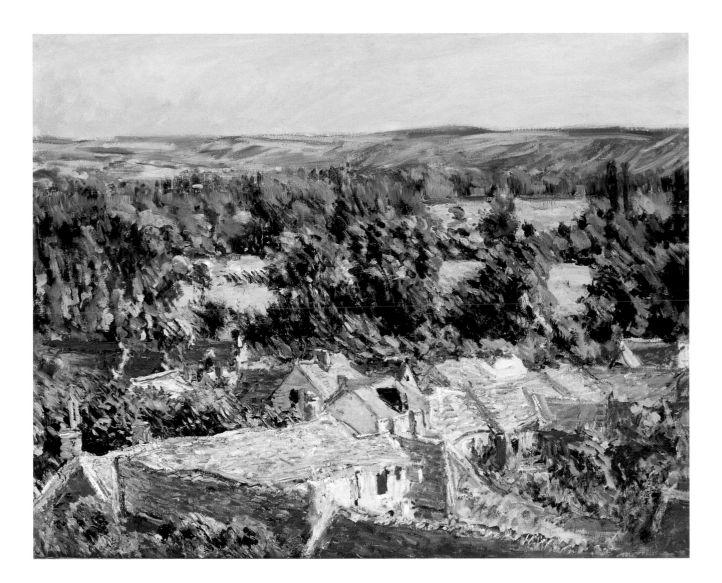

or even typical for Monet. Rather than a depiction of a particular place, the townscape and the distant landscape appear as a carefully composed patchwork of different colors and textures. The dense cluster of buildings and rooftops in the foreground are painted as a series of intersecting edges and forms, rendered in short, parallel brushstrokes of reds, grays, and pinks. Monet treated the poplars, willows, and cypresses in the middle ground as undulating clusters of vigorous vertical and diagonal strokes punctuated by flat patches of yellow-green, denoting fields. The distant hills to the southeast are a band of blues streaked with yellow-green, painted in smooth, sloping strokes below a band of lavender-gray sky. The artistic objectivity Monet brought to this scene—indeed, to all of his works—is demonstrated by the inclusion in this view of the rooftop of his own house, visible at the far left, just beyond the first cluster of trees. Here it is just another block of color and texture amidst the glorious Norman landscape; it would be thirteen years before Le Pressoir's gardens and pond would become the artist's primary, and ultimately sole, focus.

DS

38. *Étretat, Rough Sea*, 1883

31⁹⁄₁₀ x 39¹⁄₅ in. (81 x 100 cm)
Signed and dated lower left: *Claude Monet 83*
Musée des Beaux-Arts, Lyon
W821

39. *The Cliff, Étretat, Sunset*, 1882–83

PAGE 129; DETAIL, PAGE 125
23¹⁵⁄₁₆ x 32³⁄₁₆ in. (60.5 x 81.8 cm)
Signed and dated lower left: *Claude Monet 83*
North Carolina Museum of Art
W817

Located sixteen miles northeast of Le Havre, Étretat is one of the most picturesque spots on France's Norman coast. Curving out to sea from the town are massive limestone headlands, whose striated surfaces rise to dramatic heights. Most spectacular are a series of three promontories jutting out into the English Channel, each pierced by a monumental archway sculpted out of the soft stone by the wind and the pounding surf (fig. 56). Two of these arches flank the bay and beach on which the town of Étretat is situated: On the right, looking toward the bay, is a low arch known as the Porte d'Aumont (the upstream portal); on the left, at the opposite side of the bay, are the 275-foot Porte d'Aval (the downstream portal) and the detached "Needle," rising some 225 feet above the waves. The third great arch, the Manneporte, lies a few hundred feet farther southwest, beyond the Porte d'Aval and the Needle.

Étretat's origins date back at least to Roman times—the remains of ancient Roman roads and buildings were excavated in the 1830s—and it is recorded in eleventh-century documents as "Estrutat." Over the course of the late-eighteenth and early-nineteenth centuries, the town grew from a small fishing village into a thriving destination for tourists and artists (fig. 57). Étretat's cliffs were illustrated and singled out for lavish, highly romanticized praise in early nineteenth-century guidebooks, as in these two accounts from the 1830s:

> [The Porte d'Aval] is something for a painter to look at, and for a poet to dream about. Gaze upon it through half-closed lids and you see the walls and towers of a fortress of the pre-Adamite world . . . a spot still haunted by the spirits of an earlier and mightier race. . . . Peaked rocks to the right and left of us shoot up high into the air; . . . yawning gulphs open at our feet, out of which the agitated sea sends up tones like the voice of a bard singing the destruction of his race.[1]

Rapturous accounts like these naturally attracted artists, whose views of Étretat's picturesque and sublime cliffs were eagerly sought after. By 1840 a sign in front of the town's main oceanfront hotel, the Hôtel Blanquet (where Monet himself was to stay), advertised it as "Au Rendez-vous des Artistes." Eugène Isabey, Horace Vernet, and Eugène Delacroix (Monet owned one of his watercolors of the Porte d'Aval) were just a few of the artists who painted at Étretat during the first half of the 1800s, and Corot worked there in the late 1850s.

The most important artistic influence on Monet's Étretat paintings was Gustave Courbet, whose earliest views of Étretat date from 1865. Courbet returned there on commission in 1869, painting at least fourteen canvases of the cliffs and more than twenty views of the sea, two of which were exhibited in the 1870 Paris Salon. Monet's friend and mentor Boudin also painted several canvases of the cliffs during the century's last three decades.

Étretat was Monet's favorite site on the Norman coast. He made his first visit there around 1864; two small views of the Porte d'Aumont and the Porte d'Aval have been dated to that year (W22a, W22b). In October 1868 Monet returned with his family, renting a small house on the rue du Havre, where they lived until March 1869. Monet did not paint extensively during this period; Wildenstein lists only four "coastal" pictures: a single canvas of the cliffs, a view of the Porte d'Aval in stormy weather (W127), and three depicting fishing boats on the sea (W124–26). The remaining works are domestic interiors that present a euphemistically bourgeois picture of his family circumstances (W127–32, fig. 33), and one snowy landscape, the evocative *La Pie* (fig. 36).

Monet did not paint again at Étretat until 1883, returning for the following three years. He painted more than sixty views of the cliffs, the most of any single site during

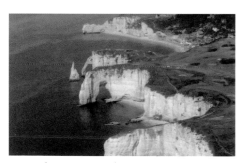

FIG. 56. *Étretat*, postcard, Éditions Vincent-Carpentier.

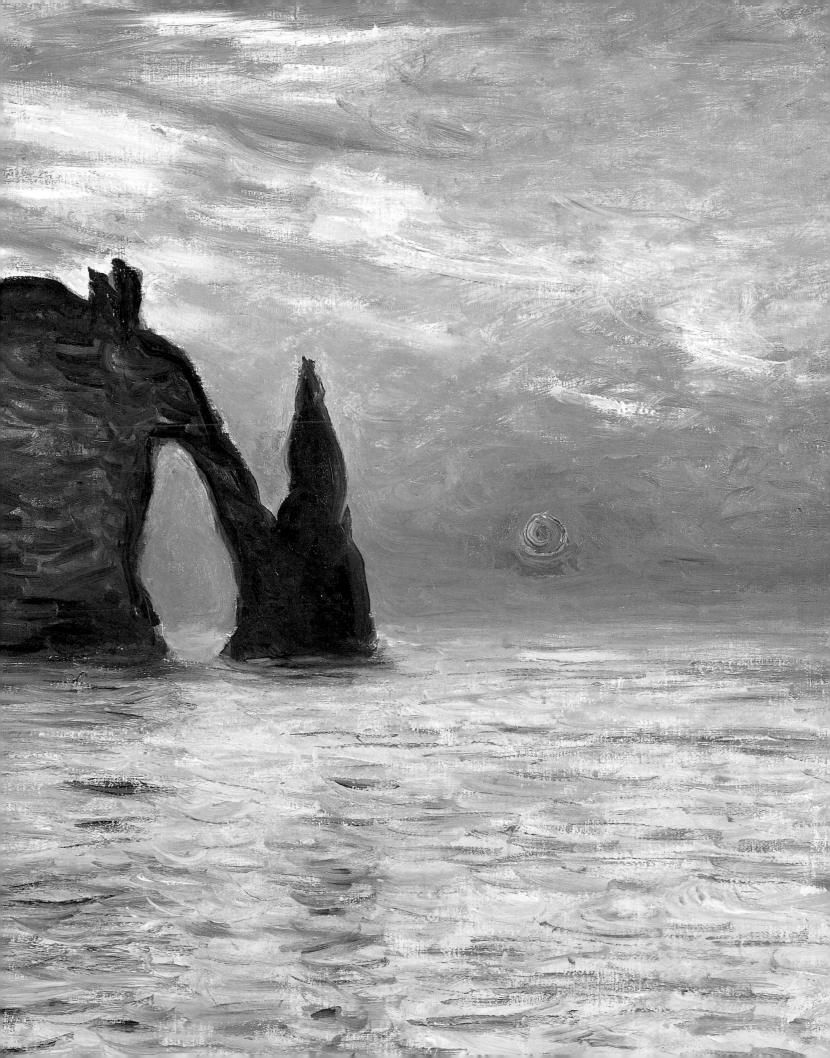

the 1880s. Even though Monet never returned to Étretat after February 1886, it remained a very special place for him. His friend Gustave Geffroy, author of the first comprehensive biography of Monet, noted how in his later years the artist would reminisce about the place:

> Étretat! Monet always preserved the memory of the bold sailors, the fragile boats, the wild cliffs. And when the nostalgia for the sea would come upon him while at tranquil Giverny, it was always Étretat he would bring to his mind, if not the landscape of the shore or the sailors that he so admired, then the great unchanging waters under the cloudy sky . . .[2]

Perhaps inspired by the eleven paintings of the Étretat cliffs he had seen at Courbet's retrospective exhibition at the École des Beaux-Arts in Paris in 1882, Monet checked into the Hôtel Blanquet in Étretat (fig. 57) on January 31, 1883, for a three-week stay. As soon as he arrived, he wrote to Alice: "I should tell you that I am very happy to have come here; it is truly wonderful, and I believe that I am going to do some very good things . . . [I have] my studio, my motifs are right out the door to the hotel, and likewise a superb view from my window."[3] When Monet left Étretat on February 21, he took with him more than twenty canvases. They depicted Étretat's cliffs and arches and the fishing boats on the beach from different viewpoints and under a variety of weather conditions, but not in the systematic, serial manner of the paintings of the Varengeville customs officer's cabin (cat. 26–28) from the previous year. Most if not all of them were completed in the studio, since none of them were included in Monet's one-man exhibition at Durand-Ruel that opened on February 28.

At Étretat, for the first time in his career, Monet was tackling motifs familiar to his audience through illustrations in guidebooks, postcards, and the works of other artists. His initial letters to Alice and to Durand-Ruel expressed his concern that his paintings might be "less new" or "perhaps not so varied." Five days after his arrival, concerns about the freshness of his new works were his "great preoccupation, but I can't help myself from being seduced by these admirable cliffs."[4] Burdened by these concerns, Monet was determined to paint something different from all of the "familiar" views that had come before, although he did paint several traditional views as well.

Étretat, Rough Sea was one of the first views he painted during his stay. On his second day in Étretat he wrote to Alice, "I have worked admirably today, I am very happy . . . I am planning to do a large canvas of the cliff of Étretat, although it will be terribly audacious on my part to do this after Courbet who had done it admirably, but I will try to do it differently."[5] Monet would have studied Courbet's placid, sunlit view of the Porte d'Aval after a storm (fig. 59), exhibited the previous year at the artist's retrospective. Courbet painted the arch from a slightly different viewpoint that presented only a thin slice of the Needle through the arch and included another, smaller cliff and a broad swath of grass in the foreground, emphasizing the solidity of the land and its rocky outcroppings. The smaller cliff, squat and massive, is firmly grounded, while the flat sea and the low horizon line emphasize the blocklike, vertical mass and density of the Porte d'Aval. Three fishing barks rest peacefully on the beach; behind them, the Channel stretches placidly into the distance below an immense sky.

Étretat, Rough Sea was the largest canvas Monet painted during this campaign and demonstrates his determination to create a novel view of this familiar site. Perhaps owing to the stormy conditions, he painted it indoors, looking out from his window on the second or third floor of the hotel. Although looking down on the water, he tilted the plane of the sea upward and raised the horizon line so that the churning sea dominates the lower two-thirds of the composition, across the canvas. The beach itself is barely visible, covered by the bulky forms of three *caloges* (boat hulls no longer seaworthy that were thatched and used for storage) and two beached boats. Two fishermen stand beside the boats, unable to put out to sea due to the storm-driven

FIG. 57. Photograph of Hôtel Blanquet, Étretat.

FIG. 58. Étretat, the beach, and the Porte d'Aval, c. 1888, photograph, Bibliothèque Nationale, Paris.

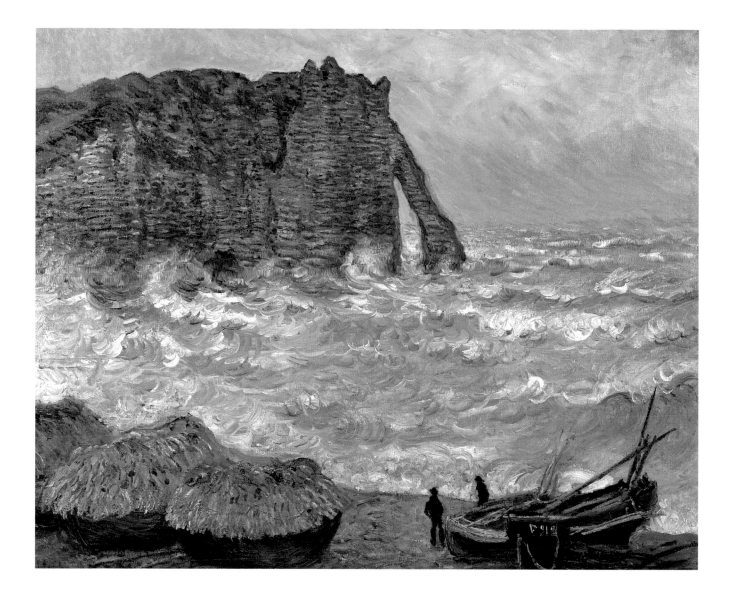

waves, expressed in vigorous sweeps and curls of paint that seem to batter the great cliff and shore.

Texture and pattern, vividly conveyed by Monet's expressive brushwork, animate this windswept scene. Whereas Courbet's painting conveys solidity and stability that emphasize the calm after a storm, Monet's painting is all about movement, energy, and the elemental forces of nature. The striations of the cliff face, echoed in the short curving brushstrokes of the thatched *caloges*, form a steadying horizontal pattern that underscores the solidity of the rock formation in the face of the assaulting waves. Yet these striations also create a vibrant surface rhythm, complementing and intensifying the surging energy of the windblown waves below. Monet's canvas is suffused with a damp gray-green tonality, underpinned by a gray ground (occasionally allowed to show through) that conveys the feel of a damp, blustery winter day along the coast. Monet enlivens the subdued palette with touches of pink, yellow, maroon-brown, and a range of blues. The result is a sense of movement throughout the composition, much like his 1882 painting that depicts the customs officer's cabin under similar weather conditions (cat. 26).

The Porte d'Aval was Monet's favorite motif at Étretat; it appears in more than thirty canvases that depict it from several different angles. *The Cliff, Étretat, Sunset* depicts the Porte d'Aval under very different conditions from those portrayed in the Lyon

FIG. 59. Gustave Courbet, *The Cliff of Étretat after the Storm*, 1870, 52⅜ x 63¾ in. (133 x 162 cm), Musée d'Orsay, Paris.

painting. When the novelist Octave Mirbeau saw the Raleigh picture at Durand-Ruel's gallery in 1884, he described it as "Night at Étretat, lit by a pink moon, a muted pink . . . a simple and mysterious thing."[6] Although his astronomy was somewhat deficient (the painting depicts the setting sun), Mirbeau identified two of the painting's essential aspects. In the same article he championed Monet as the most complete landscape painter of his generation and the most faithful to nature.

The Cliff, Étretat, Sunset presents a more traditional "souvenir" view of the cliff and Porte d'Aval. Straightforward, economical in terms of its form, color, and technique—"a simple thing"—it has the appearance of a rapid impression. The elephantine Porte d'Aval and its Needle are silhouetted against the streaked clouds and bold colors of the sunset sky. Here the spiky form of the Needle, which in actuality rises well behind the Aval, is melded with it in a single silhouette. The waters of the bay, which completely fill the foreground, are gently agitated, so that the reflections of the rock formations and the sky and clouds are rendered in broken, autonomous brushstrokes, lightly dragged across the canvas, that only come together—in the eye and mind of the viewer—at some distance from the painting. Monet painted several sunset views at Étretat, but only this one actually shows the declining orb, a single, clockwise whorl of pigment set on top of the blue-gray horizon. With this scene, Monet tapped into a rich literary and artistic tradition that extended through the Romantic era back to the seascapes of Claude Lorrain, France's first great landscape painter.

The Cliff, Étretat, Sunset was purchased by Monet's dealer Durand-Ruel in either July or November of 1883.[7] Three years later it was included in the first Impressionist exhibition in the United States.[8] The work remained unsold for fifteen years, perhaps owing in part to its austere composition and technique. Durand-Ruel finally sold the painting to William Fuller, who had written one of the first essays in English on Monet. In January 1899 Fuller published another essay on Monet for an exhibition of the artist's works at the Lotus Club in New York. He lent ten of his own Monets to the exhibition, including the Raleigh Étretat and the Metropolitan Museum of Art's Manneporte (cat. 41); two other works in the present exhibition (cat. 21, 35) were also included. One of Monet's earliest American advocates, Fuller argued that Monet's artistic achievement represented an advancement over the Barbizon School, at the time highly regarded by American collectors. Here is his description of the present painting:

> At first glance it may not be as fully understood as the picture just described [the Cleveland Wheat Field, cat. 35]. But study it a bit. There has been a storm. All day long the waves have been surging and breaking upon the rocky shore. Now the wind is dying out and the sea is becoming calm. The red sun is struggling through a bank of sullen clouds, apparently shorn of its power, as it slowly sinks to the horizon; but it still flings its radiance across the dome of the sky, from which are reflected the colors and light that fall upon the restless, foam-covered waters below. In the middle distance, with its flying buttress and its half-submerged cathedral spire, stands the dark, impressive cliff of Étretat. Unique in composition, splendid in color, suggestive in sentiment, Monet has painted in this picture one of the most transient as well as one of the most beautiful phases of the glory of the sky and sea.[9]

DS

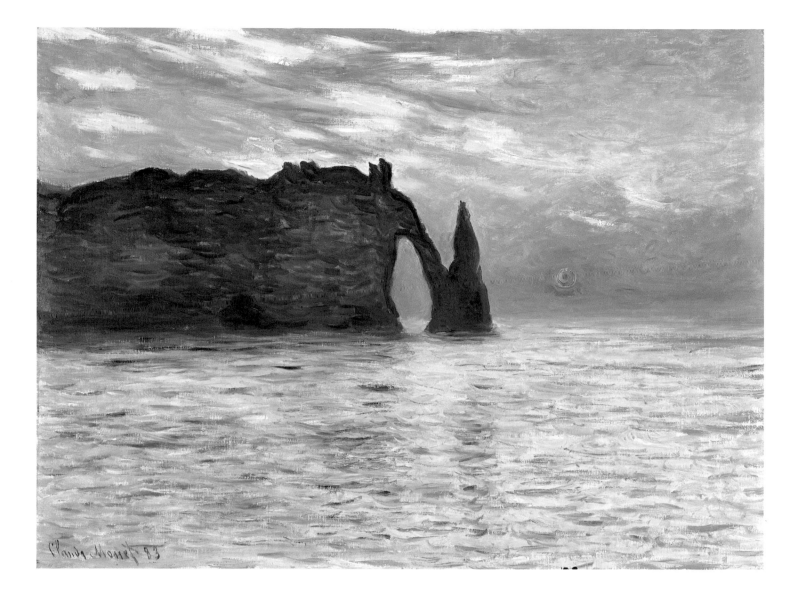

As the Latin origins of its name—*magna porta*—imply, the Manneporte, or Great Portal, is the largest and most dramatic of the three limestone arches at Étretat. Its size and relative isolation from the town serve to enhance its monumental presence. The most spectacular and awe-inspiring view of the Manneporte—looking up at the arch from the beach—was achieved by traversing a long, dank tunnel, the *Trou à l'Homme*, that passed through the cliff at the back of the Porte d'Aval, or by hiring a local with a *cabaheu* (small boat).[1] The difficulty of reaching this spot may explain why earlier artists at Étretat had rarely painted the Manneporte from this viewpoint. For Monet, who was consciously wrestling with the problem of painting motifs that had been popularized by earlier artists, the opportunity to render this most sublime landscape feature from a completely new perspective must have been exciting, in spite of the logistical challenges it presented. A letter to Alice, dated a few days after he arrived at Étretat, may refer to his first look at the Manneporte from the beach:

> You are right to envy me, you have no idea of the beauty of the sea over the last two days, but what talent is necessary to depict it, it's enough to drive one insane. As for the cliffs here, they're like nowhere else. Today, I descended to a spot where I've never dared venture before, and there I saw some admirable things, and so I returned very quickly to find my canvases, at last I am very happy.[2]

The difficulties and dangers of painting the Manneporte from this spot were not simply limited to transporting himself and his equipment down to the beach. The tides limited the time he could spend in the isolated cove, and perched on the edge of the shore, he had to pay close attention to the incoming waves. On one occasion when he did not, Monet barely escaped giving his life for his art, as he described in a letter to Alice.[3]

A thoroughly unconventional view, *Waves at the Manneporte* has the rough informality and spontaneous handling of an *impression*, a quick sketch painted on the spot. It must have required careful planning, however, in order for Monet to achieve the perfect conjunction of weather, tide, and time of day. The writer Guy de Maupassant alluded to this in an account of some time he spent with Monet at Étretat in 1885.[4]

After an arduous trip to the bay behind the Porte d'Aval, the artist moved out to the very edge of the rocky shore at dead low tide so that he could place his easel as close as possible to the enormous sculptural mass of the arch looming overhead. This low and close-up viewpoint had the effect of dramatically editing his composition. The top of the cliff is cut off, blocking out the sky, and the left side of the arch is likewise abruptly truncated before it meets the main body of the cliff, eliminating from view any support for the massive weight of the arch. This, coupled with the way that Monet covered the seaward base of the arch with the spray of the breaking waves, adds a dynamic tension to the composition that conveys both the majestic monumentality of the great portal and the relentless sculpting by water and weather that had formed it over the course of time.

Monet used staccato brushstrokes to record the momentary effects of the light striking the inner face of the arch and the spray of the breaking waves. There is little sense of a continuous surface, as in the Metropolitan Museum's more highly finished view of the arch (cat. 41). Almost every individual stroke of his brush is visible. Close examination shows that Monet occasionally dabbed a load of one color from his palette immediately followed by a smear of white pigment—making no attempt to blend the two—and then rapidly thrust his brush onto the canvas with such force that the white was pushed out to the edges of the brushstroke. The two faces of the great arch are rendered using different brushwork and contrasting red- and green-based hues. The inner arch receives the full force of the sun's illumination and is painted in vigorous, vertical

brushstrokes of salmon and rose, with touches of yellow. The shaded lateral surface of the arch is painted more softly, with more broadly brushed tonal areas; horizontal strokes and strong calligraphic accents were added on top of the initial paint layer. Darker strokes (not black; Monet used little or no pure black pigment in the painting), as much drawn as painted, were also subsequently added to the lower portion of the interior face to indicate the contours of various hollows and bulges in the rock surface.

Monet worked on the canvas in at least two separate sessions. The broad strokes outlining the contours of the arch were added after he recorded his initial impression on site, as were the thick, pasty highlights of blue, pink, and yellow at the foot of the arch. Other than painting over an inch or two of the water, in order to lower the horizon, Monet seems to have paid almost no attention to the distant background, or to the sky, a neutral scumble of creamy yellow-pink suffused with a delicate turquoise that seems to have been applied as a thin wash. He reduced the waves to a series of smears and slashes of pigment: blue, white, pink, and yellow, broken up by the dark forms of the rocks and by several bare patches where the canvas was left unpainted.

It is doubtful that Monet considered *Waves at the Manneporte* a finished painting suitable for the art market. During the first half of the 1880s, a controversy was raging among French critics as to whether Monet's *impressions* represented a new artistic vision or were merely incoherent, unrealized sketches, which, if they became accepted as legitimate works, posed a serious threat to the future of French painting. Certainly Monet's dealer, Durand-Ruel, was aware that paintings less finished in the traditional sense would be harder to sell. In a letter of September 12, 1886, Monet wrote to Durand-Ruel, "I could not do that which you asked for the great arch at Étretat. It is not retouchable, but the moment these canvases do not satisfy you, I prefer to keep them."[5]

Monet did keep *Waves at the Manneporte*, at least until the summer of 1887, when the American expatriate painter John Singer Sargent visited Giverny and purchased the picture from the artist. After he returned home, Sargent expressed his admiration for the painting in a note to Monet:

> It is with great reluctance that I pull myself away from your delectable painting for which "you do not share my admiration" (you must be kidding!) to tell you again how much I do admire it. I could spend hours looking at it in a state of voluptuous stupor, or enchantment if you prefer. I am thrilled to have such a source of pleasure in my home.[6]

The two artists were close friends. Sargent painted two portraits of Monet, who also painted a self-portrait for his American colleague, and the Frenchman stayed with Sargent when he traveled to London the following year (1888). Sargent owned at least four paintings by Monet; *Waves at the Manneporte* was one of two that he kept until his death in 1925.[7]

The Metropolitan Museum's *Manneporte (Étretat)* is painted from a slightly different angle, so that a thin slice of the cliff behind the arch is included, and the encircling contour of the arch itself is more fully articulated. Here Monet has built up the paint more densely, taking greater care to indicate the specific textures of the rock arch and the churning water. The sky has received more attention than in *Waves at the Manneporte*; more subtle variations in the intensity of light, only barely suggested in that work, are given fuller expression, and clouds are scattered throughout, adding a distinct surface texture. Background and foreground are more carefully distinguished. The horizon line has been raised to its original level in the *Waves at the Manneporte*, and the artist has indicated the receding distance by depicting the sea behind the arch in full sunlight and adding a thin stripe of darker blue to demarcate the horizon. Algae-covered rocks dot the foreground, more clearly articulating the distance between the viewer and the great arch.

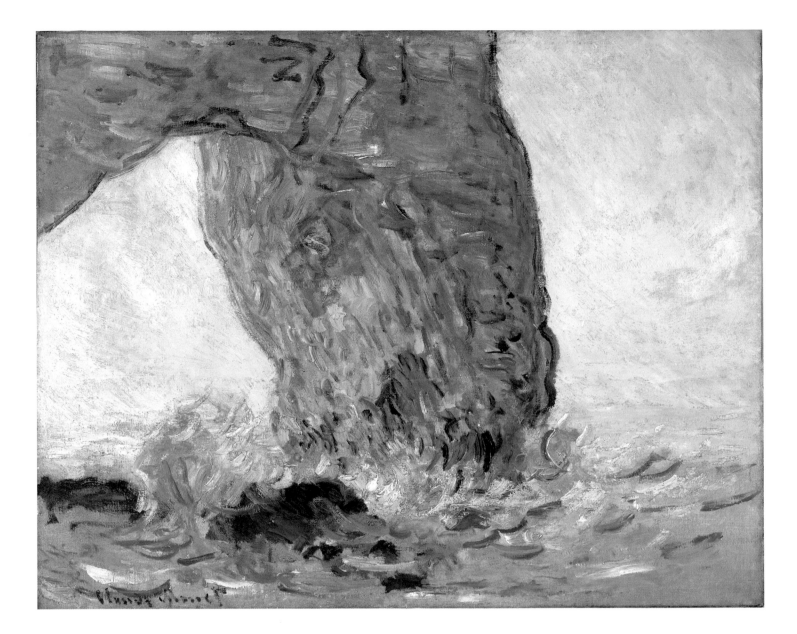

Monet included one other seemingly insignificant detail: Having made the dangerous climb over slippery rocks, two minuscule figures, mere flicks of the artist's brush, stand in perilous contemplation of the great arch, witnesses to this overwhelming natural spectacle. Scarcely recognizable though they may be, these figures are used to great effect, and they link Monet's painting to a literary and artistic tradition whose origins extend back to the second half of the eighteenth century. Among all of the artist's works, this painting may come closest to evoking the Romantic conception of the sublime—the all-consuming astonishment, exhilaration, and even terror that the mind experiences when confronted with the awesome majesty and power of nature. At the same time, it is a thoroughly "modern" *painting*, as opposed to a traditional "view," with its close-up, boldly truncated composition, vigorous brushwork, and the artist's very deliberate attempt to capture a moment in time—recorded at a specific time on a specific day of the year, measured in the split-second spray of the waves and the fleeting effects of the sunlight striking the interior surface of the arch and shimmering on the surface of the sea.

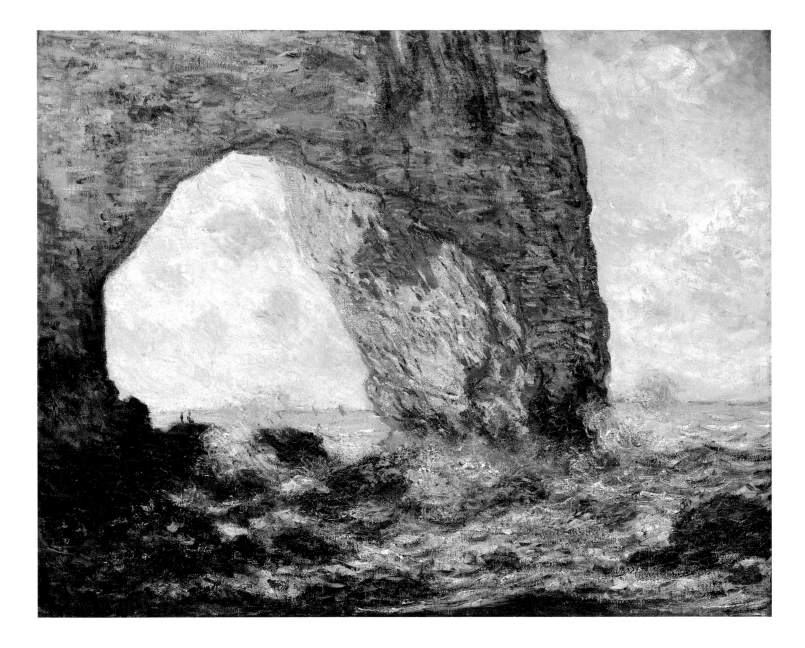

As its title indicates, the third interpretation of the Manneporte depicts the great arch at high tide; the rocks at its base, visible in the other two versions, are completely covered by the sea. Monet abruptly truncates the left side of the arch, much as he did in *Waves at the Manneporte*, but he includes more of the upper part of the rock face, emphasizing the arch's massive scale and rough surface. Nonetheless, *The Manneporte, High Tide* is characterized by an elegant classicism: the dominant forms—both horizontal and vertical—divide and organize the composition and settle the relatively calm sea. Particularly important in this regard is the aqua band that establishes the horizon line, separating the broader brushwork and larger areas of pale color in the sky

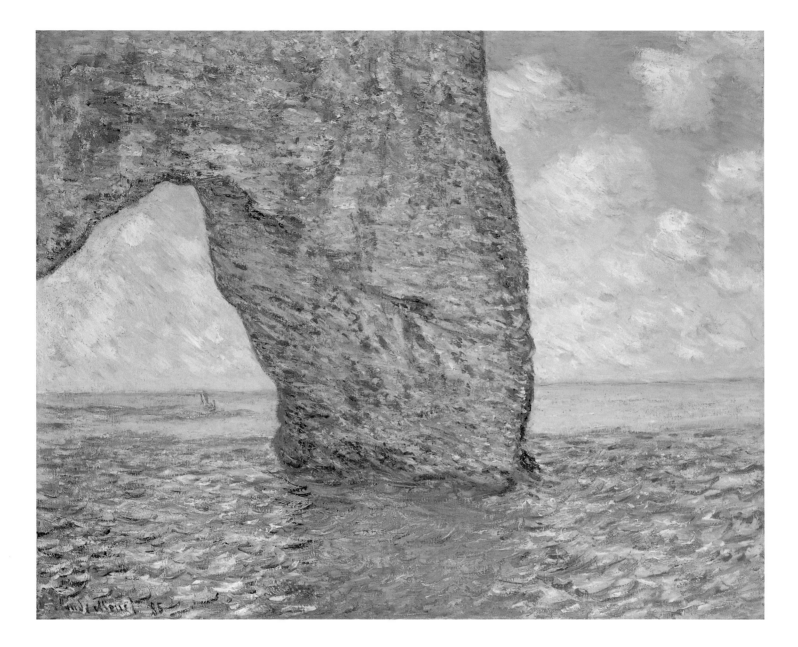

from the more densely brushed areas representing water and rock. Through such formal choices, the dynamic forces of nature are kept in equilibrium. Puffs of cumulus clouds move across the sky, forming a textural and rhythmic counterpoint to the sea and the great arch. Were it not for the familiarity of the motif and the tiny form of the sailboat behind the arch, the overall effect of the painting would be one of near abstraction. Collectively this sequence of three masterworks illustrates both the artist's shifting conception of composition and his changing technique, which allow him to keep a familiar motif fresh and evocative of the natural effects of the moment.

DS

Monet returned to Étretat for an extended stay in late September 1885. He and his family initially stayed in a house that the Parisian baritone Jean-Baptiste Faure had placed at their disposal. When Alice and the children returned to Giverny on October 10, Monet moved into the Hôtel Blanquet, where he resided until December 14. His stay was continually plagued by bad weather. Soon after his family had departed, he wrote to Alice, ". . . despite my love for the sea and my desire to return with lots of canvases, I would really like to be back in Giverny, but it is necessary to work, whatever the cost, and notwithstanding the bad weather, which shows no signs of turning fine."[1] His letters from this period are filled with frustrated references to torrential rains, furious seas, and windy conditions. And yet Étretat still captivated him. He wrote to Alice on October 20, "Étretat is becoming more and more amazing, now is the real moment, the beach with all its fine boats, it is superb, and I am enraged not to be more skillful in rendering all this. I would need two hands and hundreds of canvases."[2] Poor weather conditions persisted throughout November, compelling Monet to remain indoors on most days. From one of the top-floor windows of the Hôtel Blanquet, he painted a series of several canvases of Étretat's herring boats pulled up on the rocky beach, their owners likewise unable to go out because of the stormy conditions. A painting closely related to the present work, also in The Art Institute (fig. 60), shows the fishing fleet heading out to sea, a motif that Monet was finally able to "arrange,"[3] thanks to a break in the weather.

Boats on the Beach at Étretat depicts much harsher conditions, echoed in Monet's vigorous, "stormy" brushwork. It seems as if his frustration with the weather has been transferred to the surface of the painting. The beach, the crashing waves, and the sea beyond are rendered in brusque, agitated smears of pigment; the sky is barely distinguishable from the storm-tossed water. By comparison, the pendant canvas has been painted with greater attention to detail; individual forms, like the tarred planks on the *caloges* and the shutters on the building, are more clearly delineated, and the spatial recession back to the horizon is more methodically expressed. As Herbert points out, however, the rougher, seemingly more spontaneous handling of *Boats on the Beach at Étretat* is actually the result of deliberate calculation and careful, even delicate handling on Monet's part.[4] The rough waters are composed of longer horizontal strokes, on top of which shorter brushstrokes of related tints were later added, and the well-worn pathways around the *caloges* are rendered in as many as five different colors brushed over a single underlying stroke.

The bright patches of color on the hulls of the beached boats enliven the composition and call to mind similar motifs painted by Monet's contemporary Van Gogh. In a letter of October 13, 1888 to his art dealer and brother, Theo, Van Gogh noted that Theo "used to have a very fine Claude Monet showing four colored boats on a

43. *Boats on the Beach at Étretat*, 1885

25¾ x 32 in. (65.5 x 81.3 cm)
Signed lower right: *Claude Monet*
The Art Institute of Chicago (47.95)
W1024

FIG. 60. Claude Monet, *The Departure of the Boats, Étretat*, 1885, 29 x 36½ in. (73.5 x 93 cm), The Art Institute of Chicago.

FIG. 61. Vincent van Gogh, *Boats on the Beach*, 1888, 25⁹⁄₁₆ x 32¹⁄₁₆ in. (65 x 81.5 cm) Van Gogh Museum, Amsterdam.

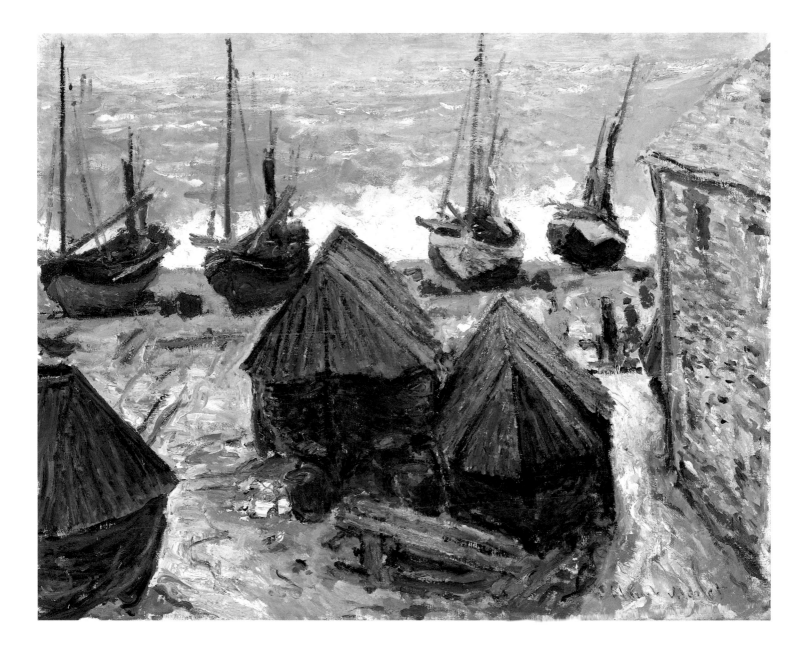

beach," and compared it to the brightly colored stagecoaches he was then painting at
Tarascon.[5] Van Gogh may very well have had in mind Monet's *Boats on the Beach at
Étretat* when four months earlier he made a painting of three fishing boats on the beach
at Les Saintes-Maries-de-la-Mer (fig. 61).

DS

Monet painted this work from the same secluded bay as his views of the Manneporte (cat. 40–42), but here he had turned his back to the great arch and looked eastward from a spot on the beach near a cleft in the cliff called the Valleuse de Jambourg. This is one of Monet's most carefully, almost academically, composed coastal pictures. Here he seems to emphasize the inherent geometry of the natural formations (fig. 62), deliberately simplifying them to cone, arc, cylinder, and sphere—albeit eroded and weathered—basic shapes that form the composition. He smoothed and strengthened their edges, particularly the seaward edges of the cliffs. The massive, vertical forms of the cliffs and the boulder on the shore dominate the right side of the composition. At a distance these forms appear somewhat drab, but when we look more closely, the multitude and variety of Monet's colors are quite astonishing.

The main cliff arch and Needle bisect the composition. Monet further emphasized this division by placing the foreground of his composition in shadow and the background in full sunlight, with the exception of the tops of the Needle and the cliff, rendered in stabs of thick, molten masses of pigment as if the rocks have been melted over time by the sun's rays. Monet achieved the overall flickering appearance of the surface by using short vigorous strokes of pigment, many applied wet on wet, brushed rapidly across the coarse weave of the canvas. One of the most beautiful passages in the painting is the reflection of the Needle in the water, done completely in pink tones—somewhat incongruously, since the Needle itself is not entirely bathed in sunlight.

In the background fishing skiffs are setting out to sea, their sails glowing orange-pink in the sun. Directly in the center of the composition, tiny figures in a rowboat make their way between the arch and the Needle, perhaps the same means of transport by which Monet himself had arrived at this site with his painting equipment. In a letter of November 21, 1885, he wrote to Alice that he was planning to hire a small boat (known as a *cabb* or *cabaheu*) to go to the Val d'Antifer, located a little over a kilometer to the west of the spot from which he painted the present work. As in Monet's 1883 canvas, *The Needle and the Porte d'Aval, Étretat* (W831, fig. 63), these figures give the composition a sense of scale. On this tranquil afternoon, their presence testifies to nature's gentler aspect, rather than its raw, sublime power, as in the Manneporte view in the Metropolitan Museum (cat. 41).

DS

44. *The Needle Rock and the Porte d'Aval, Étretat*, 1885

25⁹⁄₁₆ x 32 in. (65 x 81 cm)
Signed and dated lower right: *Claude Monet 85*
Sterling and Francine Clark Art Institute
W1034

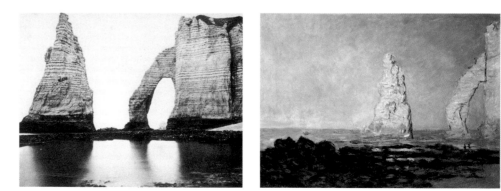

FIG. 62. Nineteenth-century photograph of the Needle and the Porte d'Aval, Étretat.

FIG. 63. Claude Monet, *The Needle and the Porte d'Aval, Étretat*, 1883, 23¾ x 31⅞ in. (60.3 x 81 cm), Christie's, New York.

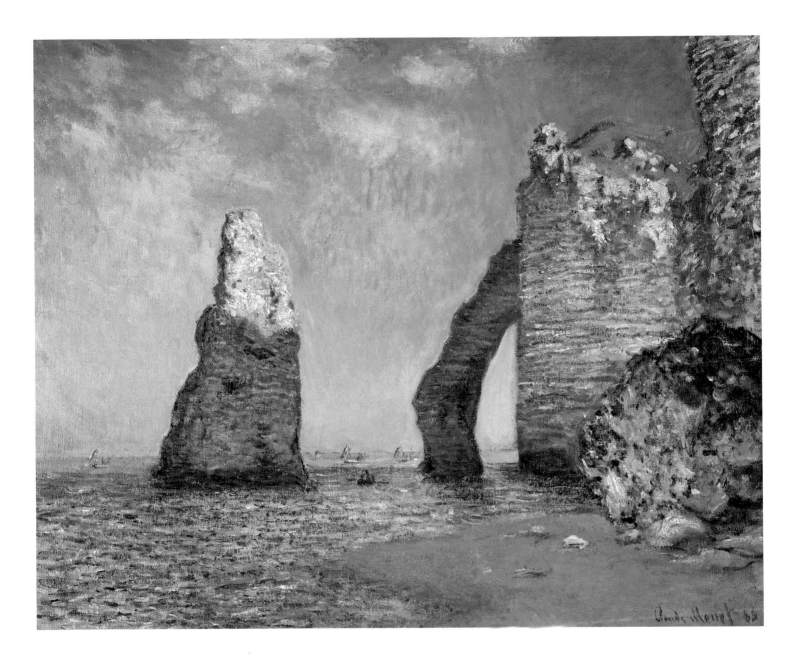

The earliest evidence of Monet's work on the series of *Grainstacks* appeared in a letter to his friend Gustave Geffroy, who eventually became the artist's first biographer:

> I'm hard at it, working stubbornly on a series of different effects (grain stacks), but at this time of the year the sun sets so fast that it's impossible to keep up with it. . . . I'm increasingly obsessed by the need to render what I experience, and I'm praying that I'll have a few more good years left to me because I think I may make some progress in that direction.[1]

The first paintings in the series were painted in late September or early October 1890. No other artist had ever conceived of painting such a large number of pictures concentrating on the same subject differentiated only by changes in light, atmosphere, weather conditions, and point of view. Monet painted at least twenty-five canvases of the stacks over a period of about seven months. By December he had recognized that their effect was cumulative and began thinking of the group as a series.

According to eyewitness accounts, Monet set out on foot from his house in Giverny either at dawn or before sunset to paint the changing effects of light on grainstacks in the nearby fields (fig. 64). He took along paints, easels, and several unfinished canvases, carrying supplies with the help of his children. As the minutes ticked away, he worked on whichever canvas most closely corresponded to the light and weather conditions before him, usually working on numerous canvases simultaneously. When traveling on painting campaigns, he had often worked obsessively, but never before had he worked so intensively in Giverny. In January 1891, delaying the delivery of several oat and poppy field paintings that Durand-Ruel had purchased, Monet explained: "I am in the thick of work. I have a huge number of things going and cannot be distracted for a minute, wanting above all to profit from these splendid winter effects."[2]

Although Monet began by working from the scene that lay before him, the *Grainstacks* were carefully constructed. He usually included only one or two stacks placed with great care relative to the horizon, altering the angles of the shadows according to the time of day. The striking color harmonies and meticulously described surfaces were the result of many working sessions. Monet revised initial effects that he had created in order to generate greater contrast among the canvases and to preserve harmony within the series. Such editing occurred not on site but in the studio, undermining the belief that Monet painted entirely *en plein air*.

45. *Grainstack in the Sunlight*, 1891

PAGE 142; DETAIL, PAGE 141
23⅗ x 39⅓ in. (60 x 100 cm)
Signed and dated lower right: *Claude Monet 91*
Kunsthaus Zürich
W1288

46. *Grainstack, Sun in the Mist*, 1891

25⅝ x 39⅜ in. (65 x 100 cm)
Signed and dated lower right: *Claude Monet 91*
The Minneapolis Institute of Arts
W1286

FIG. 64. Photograph of the view from Monet's second studio, c. 1905.

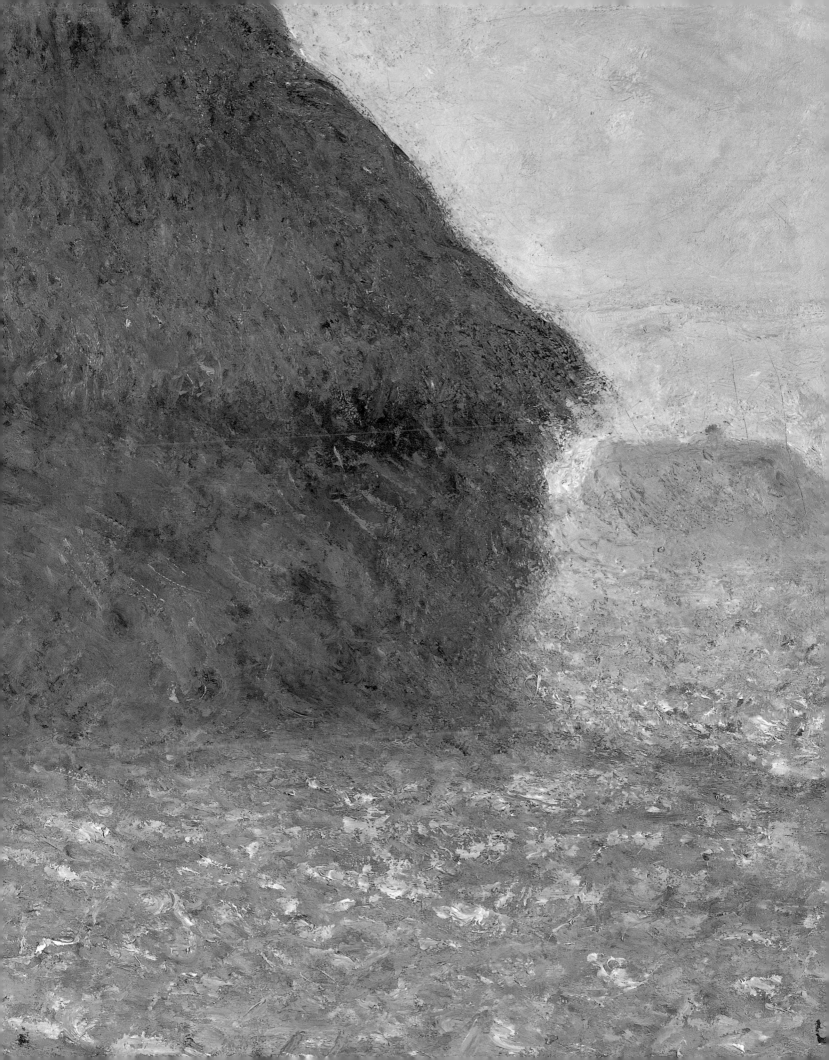

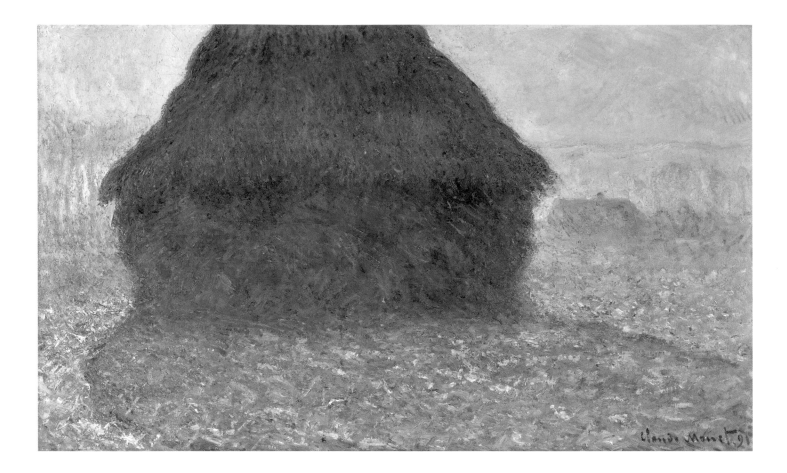

Years later the artist described the evolution of the series:

When I started, I was just like the others; I thought two canvases were enough—one for a gray day, one for a sunny day. At that time I was painting haystacks that had caught my eye; they formed a magnificent group, right near here. One day I noticed that the light had changed. I said to my daughter-in-law, "Would you go back to the house, please, and bring me another canvas." She brought it to me, but very soon the light had again changed. "One more!" and, "One more still!" And I worked on each one only until I had achieved the effect I wanted; that's all. That's not very hard to understand.[3]

Monet's account is doubtless somewhat mythologized. His insistence on the simplicity of his artistic practice and his absolute truth to nature reflected his determination to differentiate Impressionism from Neo-Impressionism. He intended the *Grainstacks* to be quintessentially Impressionist pictures, painted by instinct rather than intellect, spontaneous records of nature's shifting moods—the antithesis of the Neo-Impressionists' analytic aesthetic.

In the *Grainstacks*, as in the series that followed, Monet stripped his subject down to its essentials, omitting all extraneous detail, maintaining only a few boldly stated shapes and planes of color. At times the identity of his motif was almost lost in a blur of atmosphere or light. In *Grainstack, Sun in the Mist*, a small stack is surrounded by a lavender haze. Here, ambience, or the envelope of light, is as much his subject as the stack and field. As the series progressed, the stacks grew in size, becoming increasingly monumental, extending beyond the margins in *Grainstack in the Sunlight*, one of the most innovative compositions in the series. This canvas evokes the amplitude of the

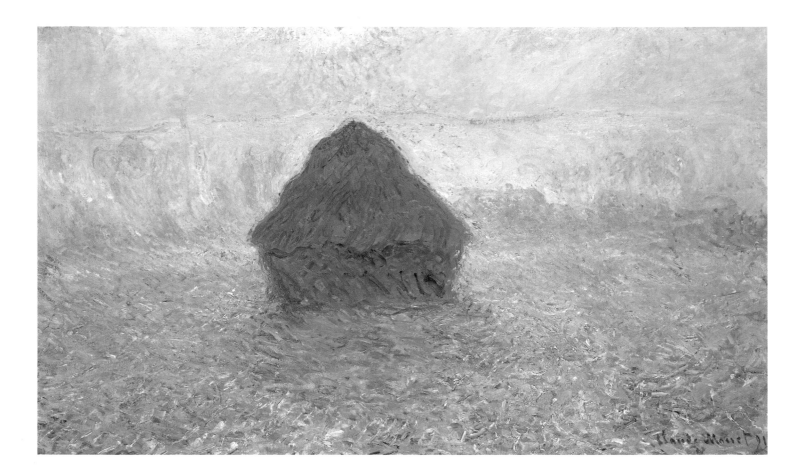

stacks that stood fifteen to twenty feet tall, grand objects that emblematized rural France, underscoring the beauty and prosperity of the countryside. The thatched roof of a tiny farmhouse in the distance suggests the structure of the stack in miniature. In fact, houses and barns appear in the background of almost all the *Grainstack* pictures, and there was symmetry in their forms and function. The stacks functioned as storage facilities, protecting farmers' wheat until spring, when the stalk and the chaff could be more easily separated; these same stacks thus protected the farmers' livelihoods and futures, just as their homes sheltered their families.

Monet exhibited fifteen *Grainstacks* at Durand-Ruel's gallery in May 1891, to great acclaim. The Symbolist Octave Mirbeau published a preview of the exhibition in the journal *L'Art dans des deux Mondes*, tantalizing his readers:

> Not an instant of weakness, not a moment of hesitation or of regression in Claude Monet's upward, direct, unswerving, and swift course toward what lies beyond progress itself. It is something rare, deserving of the highest praise, this ceaseless outpouring of masterpieces.[4]

The paintings were lavishly praised, described as "faces of the landscape, the manifestations of joy and despair, of mystery and fate."[5] The *Grainstacks* seemed to assure viewers that rural traditions continued in France despite industrialization and the growth of cities. They implied that the countryside was a place where contemporary problems vanished and where a deeper connection with nature was possible. As Pissarro wrote to his son Lucien, "These canvases breathe contentment."[6]

HL

In the spring of 1891, after exhibiting the *Grainstacks* at Durand-Ruel's gallery, Monet began a new series depicting poplars along the Epte River. In almost every aspect, the new series differed from the *Grainstacks*. Monet exaggerated the height of the trees by positioning himself at a low vantage point, likely painting from the Epte in his *bateau atelier* (floating studio). Thus where the *Grainstacks* were solid and stout, the *Poplars* were slender and elegant, painted broadly on vertical canvases. The *Poplars* were more lyrical than the elegiac *Grainstacks*, and more decorative with shimmering palettes.

The motif of the poplar was chosen very deliberately; just as the *Grainstacks* emblematized the French countryside, poplars also had patriotic significance. The trees were planted along roads and entrances to châteaus as decorative elements. On a practical level, they were planted to protect tilled fields from wind and delineate property lines, and they were grown to harvest for firewood, scaffolding, lumber, and smaller domestic products such as matches and boxes. The poplar also held symbolic significance. After the French Revolution, the tree became emblematic of liberty, and throughout the later nineteenth century, poplar-planting ceremonies were held throughout the countryside.

The trees Monet painted were growing on communal property in the town of Limetz, about two kilometers south of Giverny. On June 18, 1891, months after Monet had begun the series, the town voted to auction the trees, as they had grown to the ideal height to be harvested. Monet was distraught and pleaded for a postponement of the sale. His wish was denied, but undaunted, together with a wood merchant, he purchased the grove on the condition that the poplars be left standing until the series was completed. Monet's determination and personal financial investment attested to his commitment to the motif and the importance he placed on painting from nature.

The *Poplars* were his most decorative renditions of nature thus far, and when he exhibited fifteen canvases at Durand-Ruel's, March 1–10, 1892, they were praised for their freshness and decorative splendor. The Symbolist critic Octave Mirbeau gave the series his highest praise, writing that he experienced "complete joy" in front of the paintings, "an emotion that I cannot express, so profound [was it] that I wanted to hug you . . . Never did any artist ever render anything equal to it."[1] Like notes in a musical score, the poplars are limber and lithe, moving through the compositions in an internal rhythm. The vigorous brushwork and heightened palette in *Poplars, Pink Effect* underscore the fact that artifice had become as important to Monet as his ability to record reality.

The concept of showing paintings as a decorative series and the acknowledgment of their collective impact was in keeping with the interest in decoration in *fin-de-siècle* Paris. Since the late 1880s in Brittany, Paul Gauguin and his younger colleagues Émile Bernard and Paul Sérusier had been reacting against Impressionism and the descriptive role of painting. Instead, they explored the expressive use of color and decorative arrangement of forms to provoke profound emotions. When the *Poplars* were painted, the Impressionism of the 1870s and 1880s no longer existed, and the attenuated elegance and unnatural hues of these canvases were in keeping with the times.

The confluence of Impressionism and Japanese art is keenly felt in the *Poplars*. In 1890 an enormous exhibition of Japanese art was held at the École des Beaux-Arts. Over one thousand prints and illustrated books from the best private collections in France were on display; it was the largest exhibition of its kind that had ever been mounted, and it reflected the French craze for *japonisme*. Monet collected *ukiyo-e* prints, covering the walls of his house at Giverny with them. His dining room was painted canary yellow, the color most closely associated with Japanese art. The *Poplars* represent the culmination of Monet's interest in Japanese art. His daring simplification of the trees, radical cropping, and use of brilliant saturated colors all reflect his absorption of the aesthetic of *ukiyo-e*.

HL

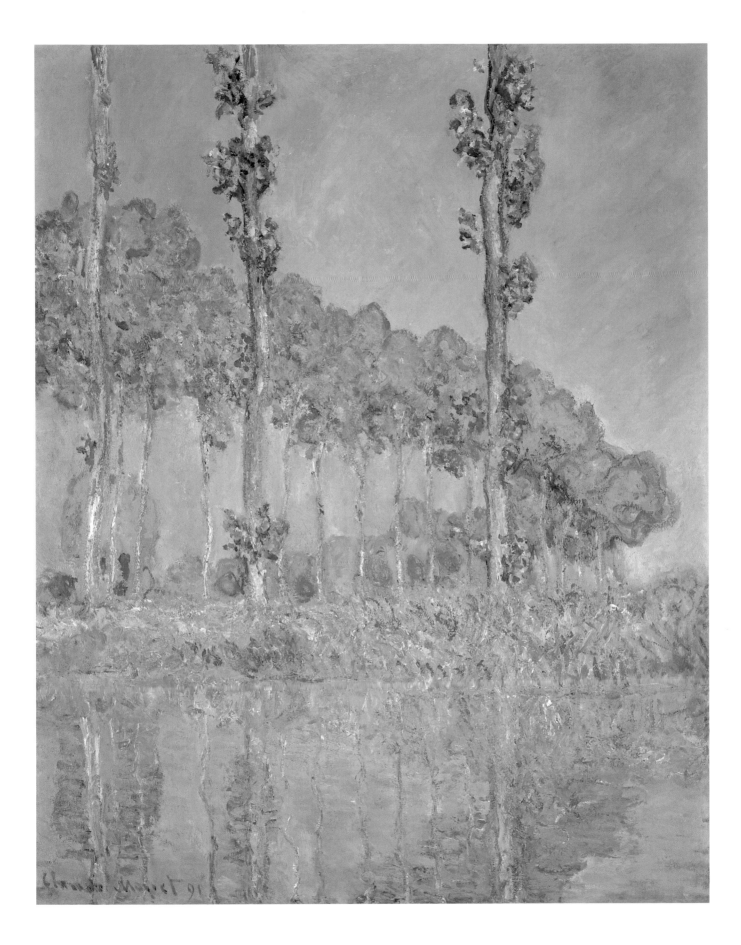

48. *Snow Effect at Giverny*, 1893

25¹⁄₃ x 36¼ in. (65 x 92 cm)

Signed and dated lower left: *Claude Monet 93*

Mrs. Frederick M. Stafford collection, courtesy of the
New Orleans Museum of Art

W1331

A number of the Impressionists painted *effets de neige* (snow scenes), analyzing the very particular qualities of light, color, and atmosphere in landscapes (both urban and rural) blanketed in white. Monet seems to have been especially dedicated in his pursuit of these *effets de neige* from the early years of his career to well into the 1890s.[1] The journalist Léon Billet, one of the first writers to feature the artist, encountered Monet on a cold winter's day in 1867:

> We have only caught sight of him once. It was during winter, after several snowy days, when communications had almost been interrupted. The desire to see the countryside beneath its white shroud had led us across the fields. It was cold enough to split rocks. We glimpsed a little heater, then an easel, then a gentleman, swathed in three overcoats, with gloved hands, his face half-frozen. It was M. Monet, studying an aspect of the snow. We must confess that this pleased us. Art has some courageous soldiers.[2]

The following winter, which the artist spent with his wife and son in a rented house in Étretat, Monet wrote to his friend, the artist Frédéric Bazille:

> I pass my time out in the open air . . . I go out into the countryside, which is so beautiful here, [and] which I still find perhaps more pleasant in winter than in summer, and naturally I am working all the time, and I believe that this year I am going to make some serious things.[3]

Monet painted very little during the summer and fall of 1892, due in part to circumstances in his personal life. On July 16 Monet wed his long-time companion Alice Hoschedé, and four days later Alice's daughter Suzanne wed the American painter Theodore Butler. Depressed by his prolonged inactivity, Monet tried to get back to painting by finishing some earlier canvases. He alluded to the disruptions in his life and his struggle to begin painting again in a letter to his dealer Durand-Ruel in September:

> As you may have thought, we have been fairly disrupted in our normally regular and peaceful life, and this has affected work so I am only just taking up my brush again which is making me very melancholic. You know how I am when I stop working. As much as I am eager to begin, I have a hard time starting up again.[4]

Monet's struggle proved to be long and difficult; he does not seem to have begun any new works until December. The weather in December and January was particularly harsh, with bitter cold and heavy snow, but Monet was determined to start painting, in spite of the intense cold. His early efforts were not encouraging: "Not having worked in so long, I only painted bad things that I had to destroy." But after some frustrating starts, he began to be heartened, writing, "I have succeeded in finding myself again. The results—just four or five canvases, and they are far from complete. But I do not despair about being able to take them up again if the cold weather returns.[5]

It was during or just after one of the heavy snowfalls in January that Monet carried his painting equipment (and presumably a heater), to a spot a little more than a kilometer from his home in Giverny, not far from where he had painted several of the *Grainstacks* in 1890–91 (cat. 45–46). He was fifty-two, and the harsh conditions must have made even this short trek arduous. *Snow Effect at Giverny* demonstrates Monet's determination to challenge himself after the long period of inactivity. The landscape is blanketed in snow and the air thick with morning fog or falling snow. Unlike *The*

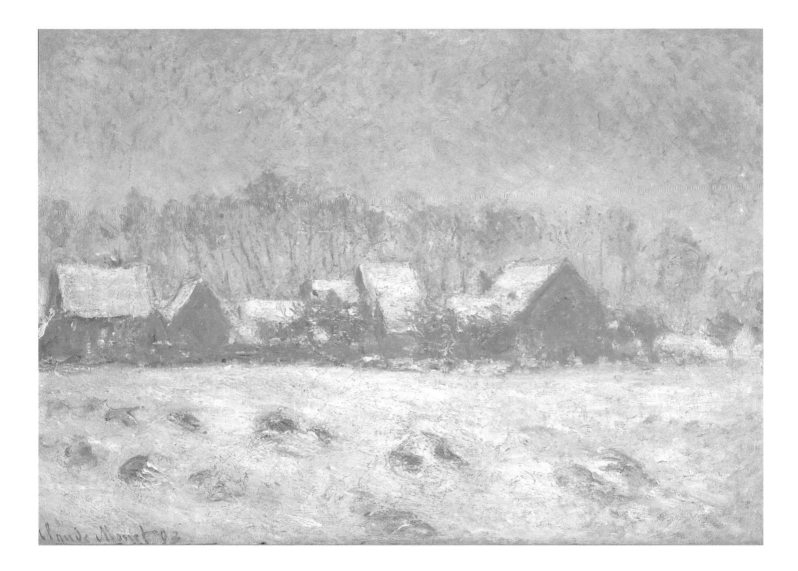

Magpie, or several of the artist's other *effets de neige*, in which the white snow contrasts starkly with the darker colors of the ground, bare trees, or buildings, *Snow Effect at Giverny* is muted in its palette, contrasts, and even its forms. Painted in shades of violet and white, it anticipates the restricted palette and veiled contours of the *Mornings on the Seine* series (cat. 54) of 1897–98, described by one of Monet's most perceptive and sympathetic reviewers, Gustave Geffroy, in terms that could well apply to the present work:

> What is new is a sort of evaporation of things, a melting of colors, a delicious contact of surfaces with the atmosphere . . . the vibrations seem to be softened, the prism has paled; gaudy brightness is succeeded by milky, caressing coloring.[6]

DS

Monet arrived in Rouen and began painting the cathedral in late January or early February 1892. Instead of working from the landscape as he had in *Poplars* and *Grainstacks*, Monet set himself up in the city, painting from an architectural motif that could only be observed from a few points of view. It is not surprising that he often felt out of place, and although his enthusiasm never flagged, it was often coupled with doubts about the enterprise. On February 25, 1893, the day after beginning his second stint in Rouen, he complained to Alice, "Good God, what work this Cathedral is! It's terrible."[1]

The Rouen pictures took an extraordinarily long time to complete—far longer to execute than his other series. Monet required more than two years for retouching and revision both in front of the motif and in the studio before he felt confident that they were ready to exhibit. Whereas the *Grainstacks* reflected long autumnal shadows and the chill light of winter, and the *Poplars* trembled beneath flickering sunlight and shifting summer winds, the static, massive form of the cathedral seemed an unyielding subject upon which to project the artist's fleeting sensations. The *Cathedrals* were a unique challenge within Monet's career, and his eventual success with them led to later series such as *Mornings on the Seine* and *Water Lilies*.

Before focusing on the west portal of the cathedral, Monet executed several panoramic views of Rouen including *View of Rouen*, 1892, seen from the Côte Bonsecours. The cathedral dominates the valley, its spire and towers piercing through undefined layers of lavender mist. In front of the cathedral on the right the viewer glimpses the smaller church of Saint-Maclou. Golden rays of sunlight stretch across the horizon, bathing the sky and the city in a warm glow. The canvas reveals the artist's search for a motif upon which to base his third series.

Initially Monet stayed in the Hotel d'Angleterre in Rouen and set up a studio in a rented apartment on the second floor of a building opposite the cathedral. An illness necessitated a brief return to Giverny in mid-February, but after ten days of recuperation he returned to Rouen. Monet did not reinstall himself in his previous studio but instead began working in the front rooms of a draper's shop several doors down on the Cour d'Albane, thus shifting his view of the church to a more oblique angle. He remained in the city painting the cathedral until April and returned to the city the following winter to paint under the same conditions of light and weather. In 1893 he leased the first apartment that he had used as a studio in order to complete at least two frontal views of the church. The draper's shop, however, was no longer available. Instead he arranged to work in a shop selling novelties at 81 rue du Grand-Pont near the draper, but with a slightly more angled vantage point. It was from this location that Monet worked for the following three months in Rouen.

The Smith College canvas concentrates not on the façade, like most of the *Cathedrals*, but on the Tour d'Albane, the shorter of the church's two towers. The picture was among the first that Monet executed in Rouen in 1892 once he began to focus closely on the cathedral as his motif. In this composition the church has the presence of an organic form inseparable from the city, an impression that persists throughout the series. Diminutive lavender-gray houses nestle against the base of the church like barnacles clinging to the surface of a colossal vessel. Windows sparkle with light and color—turquoise, bright green, yellow, and cerulean blue—animating the picture whose surface is comprised of flecks of cool tones analogous to the character of the cathedral's stone.

The Boston *Rouen Cathedral* is one of several canvases painted from the shop on the rue du Grand-Pont made during Monet's 1893 trip to Rouen. The shop offered an oblique view of the cathedral in which the Tour Saint Romain was seen in its entire width, but the Tour de Beurre was entirely omitted. The Boston canvas is one of three pictures (see also W1346 and 1347) that describes the cathedral from this angle at dawn, with the sun

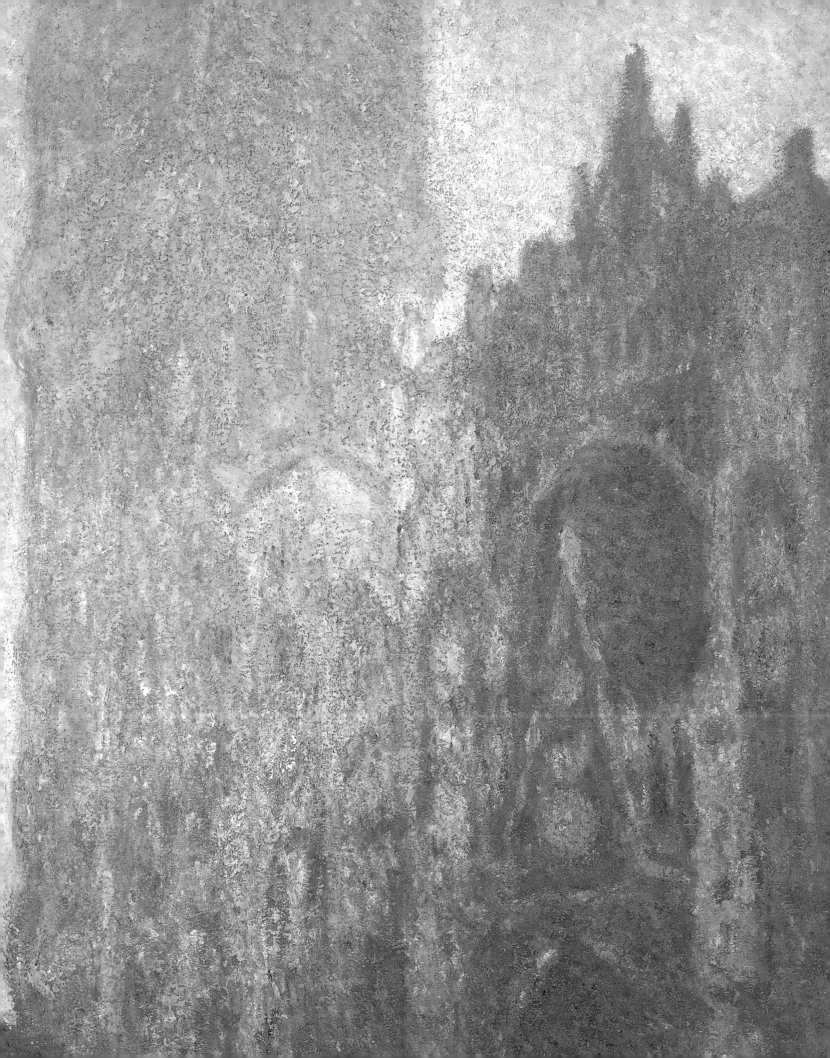

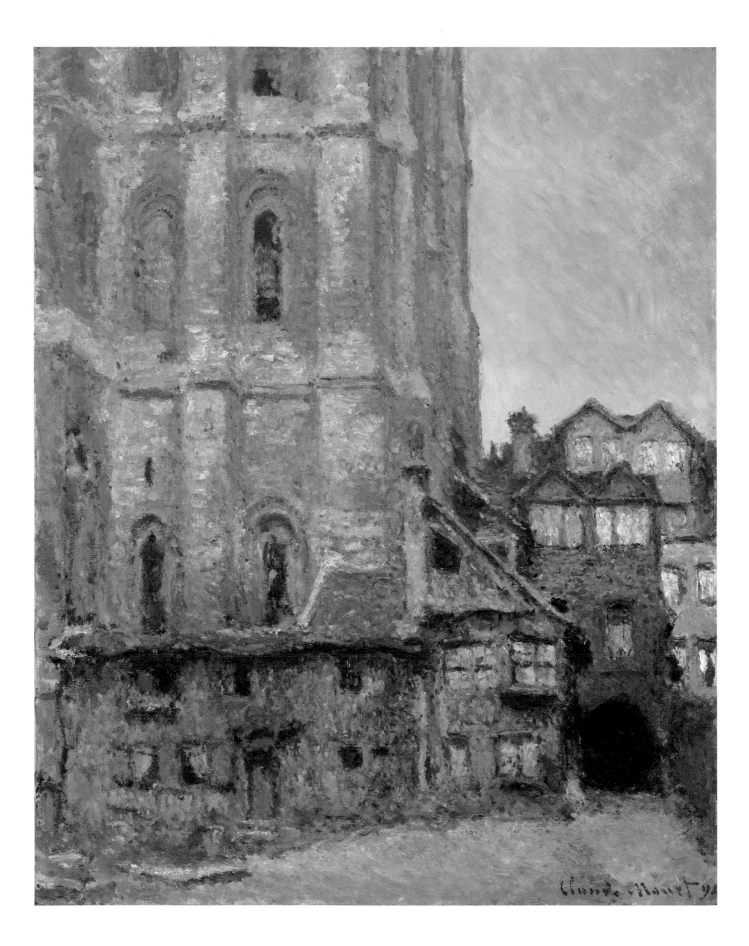

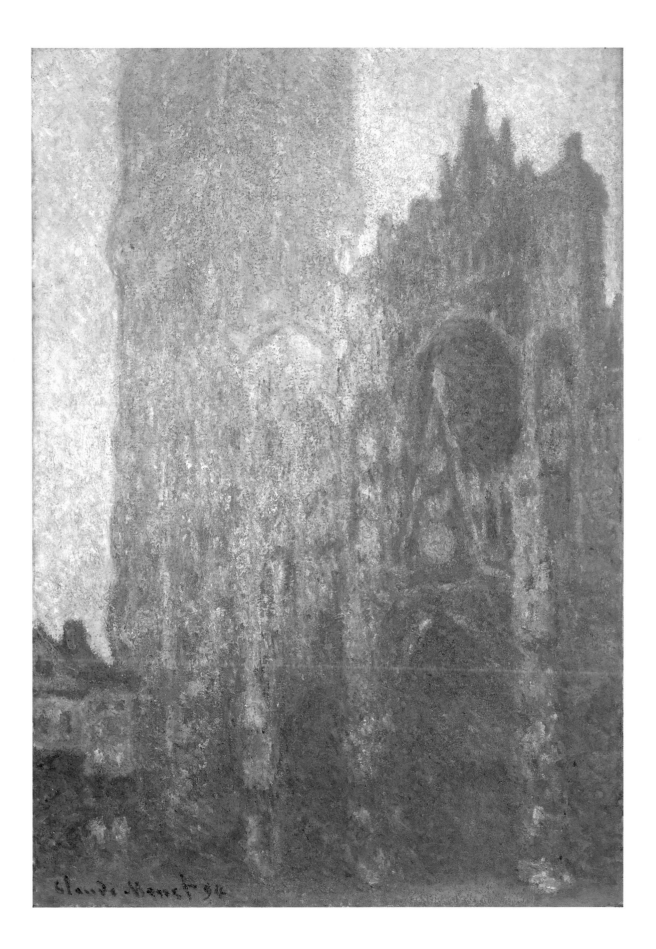

rising behind the Tour Saint Romain. Joachim Pissarro suggests that the Boston canvas represents the very first moments of dawn; the base of the cathedral lightens progressively, and details of small houses at the foot of the tower rise more sharply into focus in the second and third pictures.[2] The first moments of daylight are evoked in the transition from the shadowy blue tones of night to the golden light emanating from behind the tower. The sun is cleverly suggested in the circular form of the clock glimmering in the central portal within the gable. The surface of the Boston canvas is remarkable in its densely applied surface. From a distance the painting presents a convincing illusionistic effect, but when examined closely, many passages have little relationship to the actual motif. Back in the studio, Monet's brushstrokes, paint texture, and color assumed a significance independent from the subject.

In May 1895, more than three years after he began the series, Monet exhibited twenty of the thirty *Cathedrals* at Durand-Ruel's gallery. After a protracted absence from public view, he felt the need to reaffirm his range and versatility. Thus, in an impressive show of almost fifty pictures, Monet showed the *Cathedrals* alongside compositions of Vernon seen from the water's edge, views of Christiania from a trip to Norway in 1895, and a selection of pictures representative of his work from the 1890s, creating a small-scale retrospective. It was his first public exhibition since 1892, and the *Cathedrals* caused a sensation. Some visitors praised the new series; Georges Clemenceau asserted that Monet had made "the stones themselves live."[3] Although some of the criticism regarding Monet's choice of subject matter was mixed, many reviewers would have agreed with Theodore Robinson's praise of Monet's technique:

> They are simply colossal. Never, I believe, has architecture been painted [like this] before, the most astonishing impression of the thing, a feeling of size, grandeur and decay . . . and not a line anywhere—yet there is a wonderful sense of construction and solidity. Isn't it curious, a man taking such material and making such magnificent use of it?[4]

Some critics found Monet's treatment of the Gothic cathedral totally inappropriate, however, despite the artist's evident virtuosity. A critic for the Symbolist journal *Mercure de France* argued:

> Musical, Provençal colors laid onto this medieval structure with such insolence is the disturbing sign of a genius without a sense of the order of things . . . that Gothic art, the cerebral art par excellence, is being used as a motif by this superbly sensual, pagan [artist] is a bit repugnant.[5]

Indeed, the Gothic cathedral was a quintessentially French theme, sacred in its link with France's cultural identity. Like the poplar, the Gothic style had been intrinsically linked with France since the Revolution of 1789. Painting Rouen Cathedral was an important choice for Monet, guaranteeing his subject instant recognition and an immediate association with Normandy. Only sixty kilometers from Giverny and one-hundred and twenty from Paris, the sublime structure, astonishing in its harmony and irregularity, centrally located in the old section of Rouen, was an essential Norman symbol. By describing the timeless, religious structure as a phantasmagorical vision melting under shifting, evanescent light, Monet proclaimed himself one of the ultimate representatives of modern art.

HL

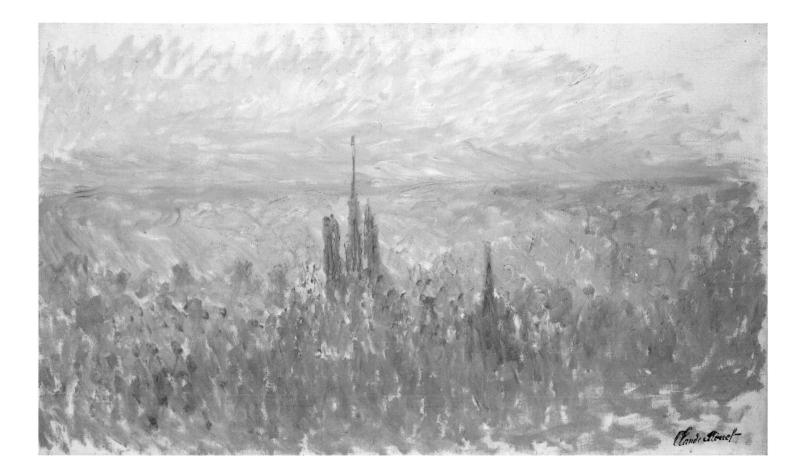

52. *Gorge of the Petit Ailly, Varengeville*, 1897

25⅗ x 36¼ in. (65.7 x 92.7 cm)
Signed and dated lower left: *Claude Monet 97*
Fogg Art Museum, Harvard University Art Museums
W1452

While embarking on new subjects, during the 1890s Monet also revisited many of the sites where he had painted previously, thinking, as he stated to one interviewer, "to resume in one or two canvases my past impressions and sensations." In February 1896 he returned to the Normandy coast for the first time in ten years. As he wrote to Durand-Ruel at the end of the month, "I needed to see the sea again and am enchanted to see again so many things I made fifteen years ago. And so I have set to work with ardor."[1]

In spite of these brave words to his dealer, Monet's six-and-a-half-week stay at the coast proved extremely frustrating. He began four groups of canvases depicting sites along the coast between Pourville and Varengeville but was plagued by difficult conditions that made it impossible for him to finish anything. In spite of all of his difficulties and frustrations, the return to his old haunts must have inspired Monet, for he still tried to see a silver lining in the storm clouds that plagued him along the coast when he wrote to Durand-Ruel from Giverny on April 12, ". . . driven from Pourville by an impossible weather, but very pleased to have gone there and intend to return there to pass the next winter."[2]

When Monet returned to Pourville and Varengeville the following January, he again struggled with the weather, the tides, and most of all, with his self-confidence: "I am altogether steady, but good God, how beautiful but difficult it is, so difficult that I can't do what I want." "I feel nature transforming herself in plain sight, finally I fight back, I grind away." "The best thing would be not to touch certain canvases any more and if the weather becomes fine, to start them over, what I ought to have done already instead of transforming them and arriving only at making bastard and imprecise things . . . what I must confess is a terrible impotence."[3]

Monet's dogged grinding away ultimately resulted in thirty-three canvases, many of which must have been finished back at his studio at Giverny. Twenty-four of them, including this one, were exhibited at Georges Petit's gallery in June 1898 as *Falaises* (Cliffs), along with several works from the *Mornings on the Seine* series painted during the same two-year period.

Gorge of the Petit Ailly, Varengeville is one of the most poetic and subtle of Monet's paintings from his two later campaigns along the coast. The pastel colors, indistinct contours, and melded tones and forms of the bluff suggest the influence of Degas's late landscape pastels and monotypes (fig. 65), which Monet would have studied when they were exhibited at Durand-Ruel's gallery in the 1890s. As in other works from 1896–97, Monet's brushwork has become less defined and more nuanced; the colors are stippled onto the surface, sometimes wet on wet. Compared to works from the cabin series of fifteen years earlier, Monet has moved closer to his motif; the bluff occupies a much greater portion of the canvas, extending all the way to the top, blocking out a good portion of the sea and sky. The latter, rendered in delicate, smeared touches, are given far less prominence here. Their function has become essentially technical rather than descriptive, as the mid-range tones, flatter surfaces, and steadying horizontals of the sea and sky provide a balanced contrast to the bumpy contours and variegated tones and textures of the bluff.

In his first letter to Alice following his return to the coast in January 1897, Monet wrote, "As soon as I had lunch, I went out to see all of my motifs. Nothing has changed."[4] What is clear is that *he* had changed. Monet's coastal works from 1896–97 reflect a distinct shift in his conception and artistic concerns. It seems that in works like this one and *At Val Saint-Nicolas near Dieppe, Morning* (cat. 53), painted when Monet was fifty-five or fifty-six, he had become interested in expressing the evocative (and perhaps nostalgic) aspects of these sites, so familiar to him from his campaigns along the coast fifteen years earlier. These later works have an ethereal, visionary quality. Monet seems

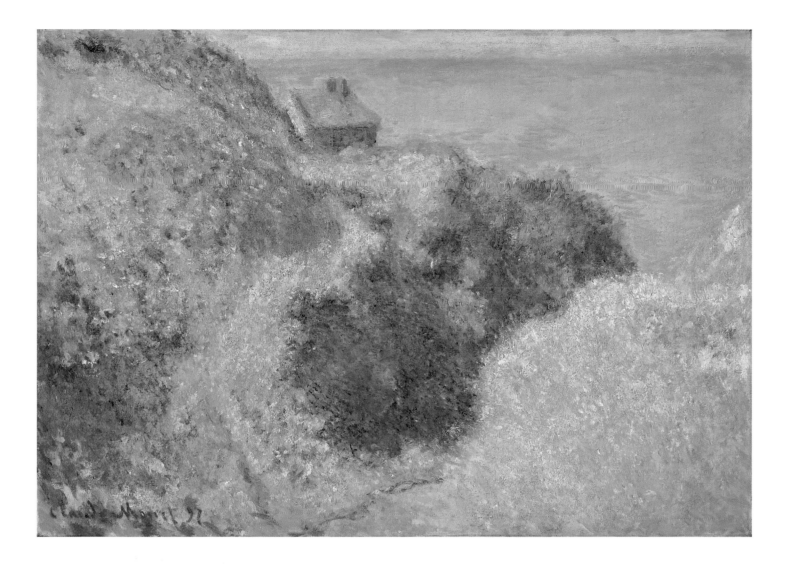

to have been intent on pushing the expressive qualities of tone, hue, and touch to the limits of representation; by eliminating the cabin, the composition becomes almost abstract. These qualities are also found in the contemporaneous *Mornings on the Seine* series, with which the coastal paintings (including the present work) were exhibited in 1898. They would become increasingly prominent in Monet's *Nymphéas* of the early twentieth century (cat. 57, 60, 62).

DS

53. *At Val Saint-Nicolas near Dieppe, Morning*, 1897

25⅝ x 39⅜ in. (65 x 100 cm)
Signed and dated lower right: *Claude Monet 97*
The Phillips Collection, Washington, D.C.
W1466

FIG. 65. Edgar Degas, *Landscape with Rocky Cliffs*, 1890,
15¼ x 11⅜ in. (40 x 29 cm), Josefowitz Collection.

In 1896, influenced by melancholy thoughts of the recent deaths of several friends, Monet decided to return to places dear to him on the Normandy coast.¹ In February he left Giverny for Pourville "to gain strength from the sea air," as he told the dealer Maurice Joyant.² He had spent several productive months in Pourville in 1882, but upon returning, he found the seaside village no longer as untrammeled as it had been. A Dieppe company had rented the land to use as a resort, and the place where Monet had begun many canvases was in jeopardy. He set himself the task of painting the place that had been so important to him fifteen years before.

In Pourville Monet struggled against inclement weather, unsurprising in midwinter. One day it was bright, the next overcast, forcing him to switch from canvas to canvas. Yet he persevered, producing almost fifty paintings from several sites along the Normandy coast. Painting in series, as he had since the early 1890s, meant that his range of subject matter was more limited than it had been on his previous trip to Pourville.

At Val Saint-Nicolas near Dieppe, Morning is one of a series of seven canvases depicting the cliffs on the Côte aux Herons, painted from the top of the bluff east of Pourville, looking toward Dieppe, close to the site where he had set up his easel for *View over the Sea* (cat. 29) and *The Cliff Walk, Pourville* (cat. 30). In his depictions of the site made fifteen years later, Monet included a greater expanse of the landscape, incorporating the profile of the distinctive precipice and the cliffs of Dieppe in the distance.

In June 1898 Monet showed forty-two canvases at Georges Petit's gallery, including twelve views of early-morning light on the Seine and twenty-four paintings of the Normandy coast seen from Pourville, Varengeville, and Dieppe, grouped under the title *Falaises* (Cliffs). It had been three years since his last exhibition of *Cathedrals*, and the public was eager to see the artist's latest innovations. The contrast between the two groups of paintings was a stroke of genius. While the views of the Seine were hushed, delicate, and restrained in palette, the Normandy views were expansive, windswept, and tumultuous. Many of the coastal views are filled with intense colors applied with vigorous brushwork. Broad touches of orange and purple enliven the surface of the cliff in *At Val Saint-Nicolas near Dieppe, Morning*. Shrouded in a soft mist, the monumental form of the cliff seems to have a life of its own as it emerges from the sea. The painting captures the way in which intense light can obliterate certain details while lifting others into sharp relief. The smoothly painted sky gradually ranges from blue to yellow to pink, evoking a sunrise. The sea, on the other hand, is comprised of shorter broken strokes, reflective of early sunlight. The rough orange face of the cliff emulates the texture of rock; touches of greens and purple on the hillside suggest vegetation.

Monet's coastal landscapes from the 1896 journey to Normandy have often been compared with a group of color monotypes that Edgar Degas began in Burgundy in 1890 and exhibited at the Durand-Ruel Gallery in the autumn of 1892. The display was an extraordinary event in Degas's career; the artist's reputation had been built on his scenes of modern urban life, and the landscape was a theme with which he had never before been publicly associated. From 1888 Durand-Ruel had actively shown paintings by all of the senior Impressionists, except Degas, who was the only Impressionist not featured in an exhibition in 1892. Heightened with pastel, Degas's monotypes achieved a liberation of color and form that transcended any literal representation of the landscape. These haunting, evocative images were unlike anything he had ever created. Soft-focused, grandly spacious vistas in works such as *Landscape with Rocky Cliffs* (fig. 65) are close in spirit to Monet's 1896–97 views of the Norman coast and undoubtedly inspired this group of late works.

HL

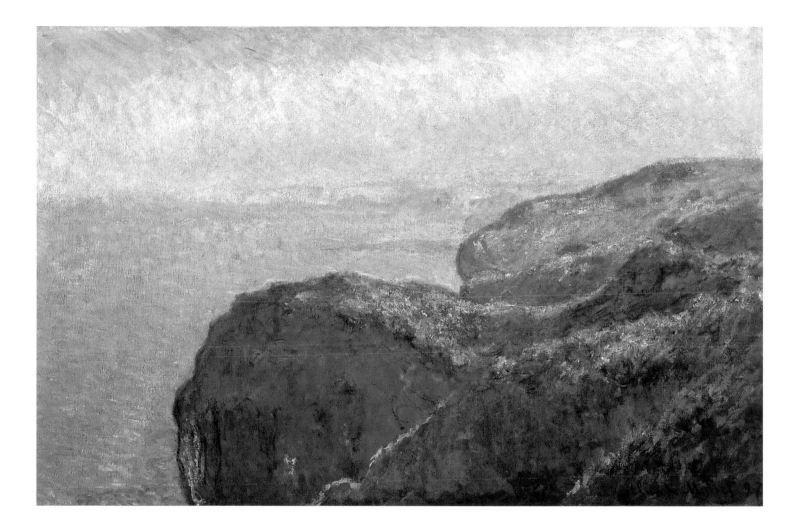

In the years following his move to Giverny in April 1883, Monet explored the banks of the Seine near his home, scouting the river for picturesque sites. In the late summer of 1896, Monet began work on what would become his most intensive look at the Seine. The series of canvases painted from his studio boat chart the progression of early-morning light on the waters and leafy banks near where the Epte tributary flows into the Seine at the Île aux Orties, a few hundred yards downstream from Giverny. Monet painted these views from a single position on the river, looking upstream, to the southeast. He continued working on the series the following summer, when the journalist Maurice Guillemot accompanied him on one of his outings:

> The crack of dawn, in August, 3:30 A.M.
>
> His torso padded in a white woolen sweater, his feet shod in a pair of sturdy hunting boots with thick soles that are impervious to dew, his head covered by a picturesquely dented brown felt hat, its brim turned down to keep off the sun, a cigarette in his mouth—a glowing spot of fire amidst his great, bushy beard—he pushes open the gate, walks down the steps, follows the path through the middle of his garden, where the flowers awaken and stretch as day breaks, crosses the road, deserted at this hour, slips through the picket fence beside the little railroad track leading from Gisors, skirts the pond dappled with water lilies, steps over the stream rippling between the willows, plunges into the mist-dimmed meadows, and reaches the river.
>
> There he unties his skiff, moored among the reeds along the bank, and with a few stroke of the oars, reaches the large rowboat at anchor that serves as his studio. The local man, a gardener's helper, who accompanies him, unties the packages—as they call the stretched canvases tied in pairs and numbered—and the artist sets to work.
>
> There are fourteen paintings, begun at the same time—practically a full range of studies—each the translation of a single, identical motif whose effect is modified by the hour, the sun, and the clouds.
>
> This is the spot where the Epte flows into the Seine, amid tiny islets shaded by tall trees, where some branches of the river seem to form peaceful, secluded lakes beneath the foliage, mirrors of water reflecting the greenery; this is where, since last summer, Claude Monet has been working, his winters being occupied by another series, the cliffs at Pourville, near Dieppe.[1]

Monet ultimately painted twenty-two canvases over the course of two years (W1435–37; 1472–88; 1499). Eighteen of the *Mornings on the Seine*, including the Raleigh canvas, were exhibited together as part of the exhibition of sixty-one paintings by the artist at the Galerie Georges Petit in Paris in June and July 1898.

The series is a testament to Monet's dedication and discipline. He was in his mid-fifties, and rising at three o'clock every morning to make the trip down to the river could not have been easy for him. Discipline is reflected in his selection of site, his deliberate working method, consistent composition, and technique, and even in his choice of canvas formats. The Impressionists were criticized for selecting their subjects at random, but in the *Mornings* series, Monet deliberately chose a motif with very specific formal and compositional possibilities that allowed him to exploit both its naturalistic and abstract aspects.

Writing about this series in 1898, the critic Gustave Geffroy discussed the artist's careful selection of the site:

Monet travels up and down the river in his boat, skirts past the islets, and searches with infinite care for a subject in nature that is propitious because of its disposition, form, horizon line, play of light, shadows, and coloration.... How could anyone believe, for example, that Monet had not expressly chosen the admirable décor of foliage which shades the *Mornings on the Seine*, this ornamental double cut-out of branches silhouetted against the sky and reflected by the water, this path through the foliage across which glides the delicious, phatasmagora of the sky and clouds?"[2]

The specific qualities of this spot on the Epte allowed Monet to repeat the composition with little or no modification, enabling him to focus on the subtle nuances of light, atmosphere, and color he observed over the course of hours, days, weeks, and months. Unlike his earlier series, the *Mornings* were painted chronologically, each one following its predecessor through the progression of dawn to full light so that each successive "effect" of morning light and atmosphere would have been captured on a separate canvas over the course of the series (fig. 66). The American painter Lila Cabot Perry, Monet's neighbor at Giverny for several years, said that Monet told her that he noticed that a particular "effect" lasted only seven minutes.[3]

Monet chose two basic formats for the series, one horizontal, the other nearly square, a shape rarely encountered elsewhere in Monet's oeuvre or those of his contemporaries. Nearly all of the *Mornings* are bisected horizontally so that sky and water, motif and reflection, are accorded equal importance, form, and substance. Monet exploited this structure to the fullest extent in the square paintings like the Raleigh *Morning Mists*, where the prominent form of the foreground foliage and its reflection bisects the composition vertically as well.

The entire series is distinguished by a refinement of technique unprecedented in Monet's career. With the notable exception of the Tokyo painting (cat. 55), the vigorous individual brushstrokes that distinguished his works of the 1870s and 1880s have become so delicate and discreet that the paint seems to have been applied in thin veils. "I should wish to prevent anyone from seeing how it was done," Monet told Guillemot at the time.[4] The evanescent tonal schemes and the softened shapes and sinuous contours of the forms and their reflections give *Mornings* a distinctly decorative and quasi-abstract character. Similar traits also distinguish the contemporaneous coastal paintings (cat. 52, 53).

Several contemporary writers invoked the name of Corot when discussing the silvery morning light and the evocative reverie (the "subtle joy" and "impression of happiness," as one put it) of the *Mornings*. A letter purportedly written by Corot himself and

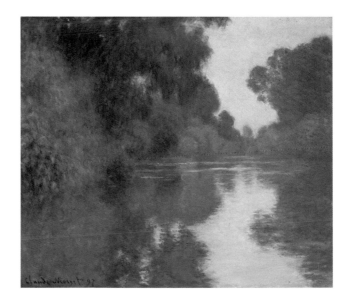

FIG. 66. Claude Monet, *Morning on the Seine, near Giverny*, 1897, 32 x 36½ in. (81.3 x 92.7 cm), Museum of Fine Arts, Boston, Gift of Mrs. W. Scott Fitz.

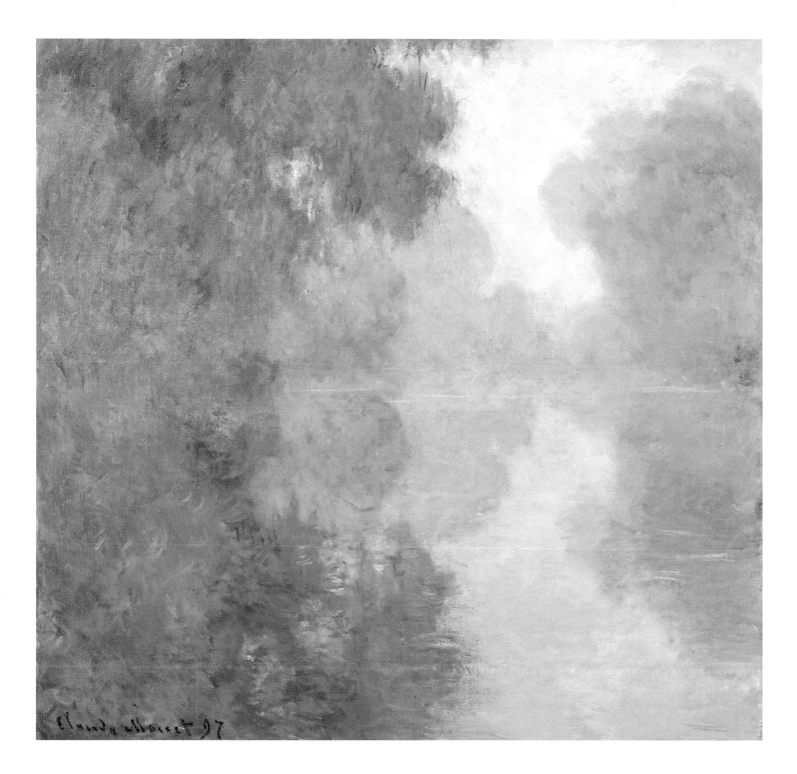

published shortly after his death in 1875 described his own early morning experiences on the river, a description that seems perfectly suited for Monet's series:

> A landscape painter's day is delightful. He rises early, at three in the morning, before sunrise; he goes to sit under a tree, and watches and waits. There is not much to be seen at first. Nature is like a white veil, upon which some masses are vaguely sketched in profile . . . One sees nothing: everything is there. The landscape lies entirely behind the transparent gauze of the ascending mist, gradually sucked by the sun, and permits us to see, as it ascends the silver-striped river, the meadows . . . the far-receding distance. At last you can see what you first imagined.[5]

More than 140 works by Corot had been exhibited in Paris in 1895 to great public acclaim, and Monet (who would later own one of Corot's landscapes) called him "the greatest landscape painter" of all. Some writers have seen Monet's evoking of the earlier master as a deliberate strategy, noting that just as Corot had become the preeminent landscapist of his day by updating and transforming the manner of France's first great landscape painter, Claude Lorrain, Monet was also asserting his ties to the great French *paysagistes* and claiming preeminence for himself.[6]

The Raleigh *Morning Mists* captures a relatively early moment of the rising dawn within the series. Layers of mist veil the trees and water and obscure the surface of the river, where the real and its reflection meet. The thickest clump of foreground foliage and its reflection form a vertical axis that extends through the exact center of the canvas, intersected by the horizontal axis of the water, dividing the composition into equal quadrants and reinforcing the serene, balanced format of the picture.

The longer we contemplate the painting, the more aware we become of Monet's artifice and artistry, the manifold means by which he intensifies and enriches our experience of a particular moment and a particular place. We are gradually struck by how tranquil this tiny piece of the world is. As the critic Octave Mirbeau remarked, "The stillness of dawn light is so fragile that one almost holds one's breath."[7] A soft morning breeze gently ripples the water's surface, but nothing else intrudes upon our unfolding perception of forms and their reflections revealed in the evaporating mist of morning.

The Tokyo *Morning* is a painting of very different character from others in the series, and it is worth noting that it is separated from them in Wildenstein's *Catalogue raisonné*. Here Monet seems to have moved slightly upstream and brought his studio boat closer to the bank of the river, for the overhanging branches of the tree on the left cover a greater portion of the composition, eliminating the rectilinear symmetry so pronounced in the other *Mornings*. The hour seems later than in the other works; the mist has completely burned off, and yellow sunlight dances on the water. But the most notable difference between the Tokyo painting and its predecessors in the series is Monet's brushwork. In the other *Mornings*, forms and contours are less differentiated, individual colors are sublimated into tonal areas, and Monet's touch is almost uniformly delicate, achieving an overall unity of texture. All of this has been changed in the Tokyo painting. The brushwork is vigorous, even aggressive; the artist makes no attempt to keep us "from seeing how it was done." Very different colors are laid aside or on top of one another, sometimes wet on wet, in calligraphic swirls and hooks. The hushed stillness and muted tonality of the other works in the series has here been transformed into a windblown symphony of vivid and varied colors. Not limited to the tossing foliage and the dancing surface of the river, Monet's loose, energetic brushwork also animates the sky and the trees in the distance, leading earlier cataloguers to describe the scene as "in the rain." With the exception of another work (W1500), dated by Wildenstein to 1897–98 and placed alongside the Tokyo *Morning* in his catalogue, these stylistic qualities, unparalleled in Monet's paintings of the later 1890s, anticipate the later *Nymphéas* and *Wisteria* paintings (cat. 57–62) of the second decade of the twentieth century.[8]

DS

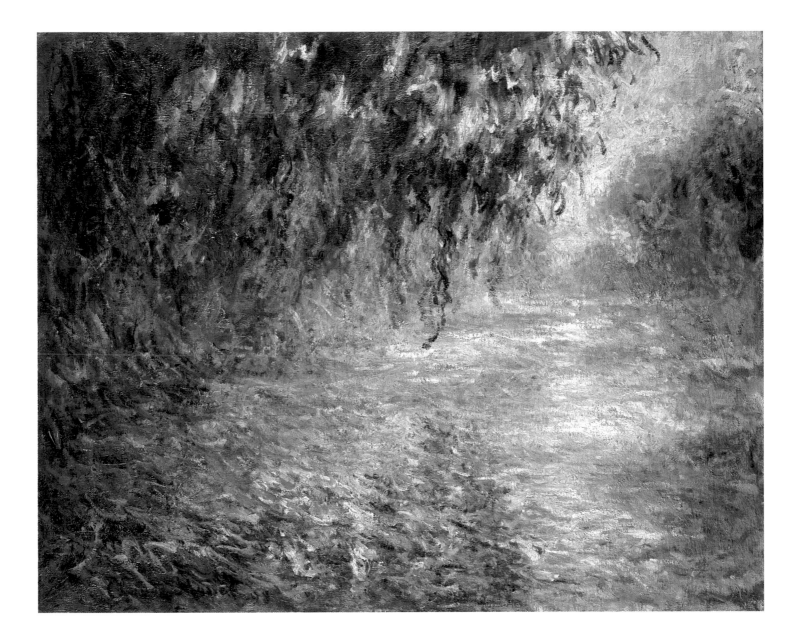

At the very end of the nineteenth century, Monet turned his artistic attention away from the Norman landscape that had engaged him for decades. He would have productive trips to London and the Mediterranean, but increasingly Monet found in his maturing Giverny gardens a compelling subject that eventually monopolized his artistic energies.

Development of the Giverny property started in May 1883 with the arrival of the Monet household at the pink stucco house named *Le Pressoir* (the Cider Press). Monet purchased the house, its common gardens, and orchard in 1890; extensive reworking of the grounds began the following year. An informative article by Georges Truffaut, gardening specialist and editor of *Jardinage* (a popular gardening magazine), lists many specific varieties Monet cultivated first in the *clos Normand* (the flower garden in front of the house) and then in the Japanese-inspired water-lily pond and garden.[1] In 1893, after buying additional land, Monet wrote to the district préfecture attempting to counter local opposition to his plans to create a water garden on his property:

> I have the honor of submitting to you a few observations regarding the opposition raised by the municipal council and several inhabitants of Giverny concerning two inquiries made . . . in view of obtaining the authorization to create a duct to draw from the Epte River to feed a pool in which I intend to cultivate aquatic plants.[2]

Monet's neighbors in this farming community feared the scheme would not only lower the level of the Epte but might also contaminate the area with foreign plants. In his letter Monet continued:

> The cultivation of aquatic plants . . . will be only a pastime, for pleasure of the eye, and for motifs to paint; and finally that I am cultivating in this pool only plants such as water lilies, reeds, different varieties of irises which generally grow in a natural state along our river, and that there is absolutely no danger of poisoning the water.

Later that year, with permits in hand, the pond was dug; it was subsequently redesigned in 1901 and enlarged again in 1911. Monet's water garden was designed as a place of contemplation, a product of his love of Japanese art and his engagement with Japanese collectors and horticulturists, a number of whom visited him in Giverny.

The Japanese footbridge (fig. 67) was built by 1895. In 1899 the first series of paintings to focus on the water-lily pond featured the Japanese bridge; they depict an already lush screen of vegetation at the pond's edge. Tightly cropping the motif, Monet has eliminated superfluous elements, such as distant terrain or even the sky; he suggests a totally self-contained world. Narrowing the view, Monet intensifies the focus and encourages exploration of relationships between reflections and their sources. The paintings' square format, the gentle arch of the bridge, and the horizontal ranks of water lilies are among the formal devices that establish order within the "delicious jumble,"[3] caused by the mass of plant life and lively Impressionist technique. The controlled palette is equally important in this regard; here color, always a foremost concern of the Impressionist artist, becomes increasingly nuanced. The prevailing scheme of cool, variegated greens, blues, and lavenders is punctuated by small pink, white, and yellow brushstrokes suggestive of flowers, leaves, and reflections that crisscross the pond surface.

Through such repetition, and endless variation, Monet familiarized his audience with the new focus of his energies—the Giverny water garden.[4]

LFO

56. *Waterlilies and Japanese Bridge*, 1898–99

35⅝ x 35⁵⁄₁₆ in. (90.5 x 89.7 cm)
Signed and dated lower right: *Claude Monet 99*
Princeton University Art Museum
W1509

FIG. 67. Water-Lily Pond and Japanese Footbridge, 1900, photograph, Durand-Ruel Archives, Paris.

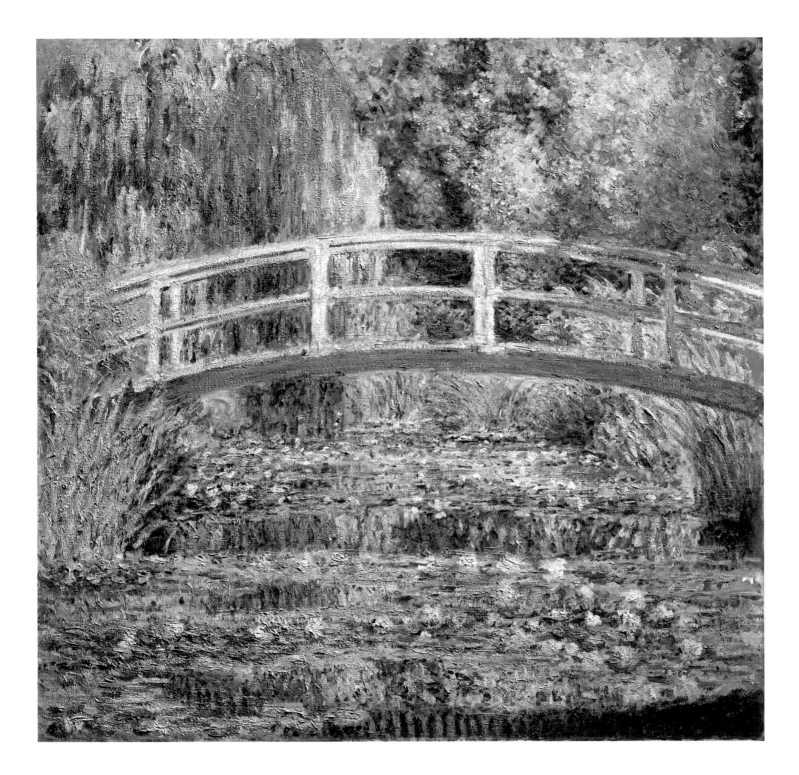

After the 1900 exhibition of his Japanese bridge paintings, Monet purchased additional land to expand the water-lily pond and worked energetically to enhance the surrounding garden. Extensive new plantings included species and varieties identified with the East, such as Japanese cherry trees, peonies, and bamboo. Monet's horticultural activity is echoed in his artistic output, both in quantity and subject matter. In these paintings Monet indulged his fascination with the poetic potential of reflections—once satisfied by tidal pools at the coast or by the flowing waters of the Seine—now viewed on the surface of the water-lily pond. Forty-eight paintings, each exploring this garden motif, were presented to the public by Durand-Ruel in 1909. Reviewer Roger Marx found the visual experience disorienting, bewildering.[1]

The paintings now in Dayton and Dallas were shown at the 1909 Paris exhibition. Together they illustrate Monet's continuing pictorial experimentations, by which he further restricted the field of vision, omitting any reference to either land or sky, except as viewed as reflections. In response to such works, Marx observed that "Monet has now severed his last ties to the Barbizon School."[2] Indeed, traditional components of Western picture making have been discarded; the rectangular format of the Dayton picture and its standard "cabinet" size are about its only conventional aspects. All anchoring elements, such as the pond's edge, horizon, and sky, are eliminated except for the suggestion of a few willow leaves draped over the upper left-hand corner. What is presented is a colored expanse only minimally representational of the water lilies and their lily pads.

Dated five years later, the Dallas painting is supremely decorative, with its round shape and vaporous image realized in pastel hues. Here, as in the Dayton painting, much of the surface is covered with delicate passages suggesting the inverted reflections of trees unseen at water's edge. Novel, however, is the viewer's proximity to the lilies themselves, which appear in large cuplike forms at the bottom of the canvas. While the viewer instinctively constructs spatial relationships based on scale, position, and color, the artist himself seems no longer bound by such conventions. He does seek a decorative balance among the pictorial elements. Responsive to the aesthetics of Eastern art, particularly as exhibited in Japanese textiles and woodblock prints, Monet establishes an asymmetrical equilibrium between disparate shapes and colors. Small areas of intense color balance larger areas of pale shades of complementary blues and yellowy-greens. This tonal balance is echoed in the use of different techniques across the canvas, in places more or less opaque, as well as more or less broadly drawn. As Monet's artistic interest turned away from the specifics of the wider French landscape, he developed an increasingly two-dimensional vocabulary well suited to his concentration on the purified experience of color, light, and pattern.

Monet carefully selected the pictorial motifs for his paintings; with equal care every detail in the garden was calculated for effect. He chose plants not only for the color of their blooms but also for the specific size, shape, color, texture, and reflective quality of their leaves. Monet the artist developed into a knowledgeable horticulturalist and landscape designer with an extensive personal library of specialty books, such as the twenty-six volumes of *La Flore des Serres et des Jardins d'Europe*.[3] He kept up with the latest gardening journals and nursery catalogues and purchased plants from leading nurseries. In addition, he followed with interest the cultivation of new plant varieties, such as a water-lily hybrid developed by famed botanist Joseph Bory Latour-Marliac. Latour-Marliac's unique pink-flowered water lily was featured in an extensive water-garden display at the 1889 Universal Exhibition in Paris.[4] Monet subsequently acquired specimens from the Latour-Marliac nursery. Such unusual species figure in his paintings, including San Francisco's *Water Lilies*, which has also been titled *The Red Water Lilies* (cat. 59).

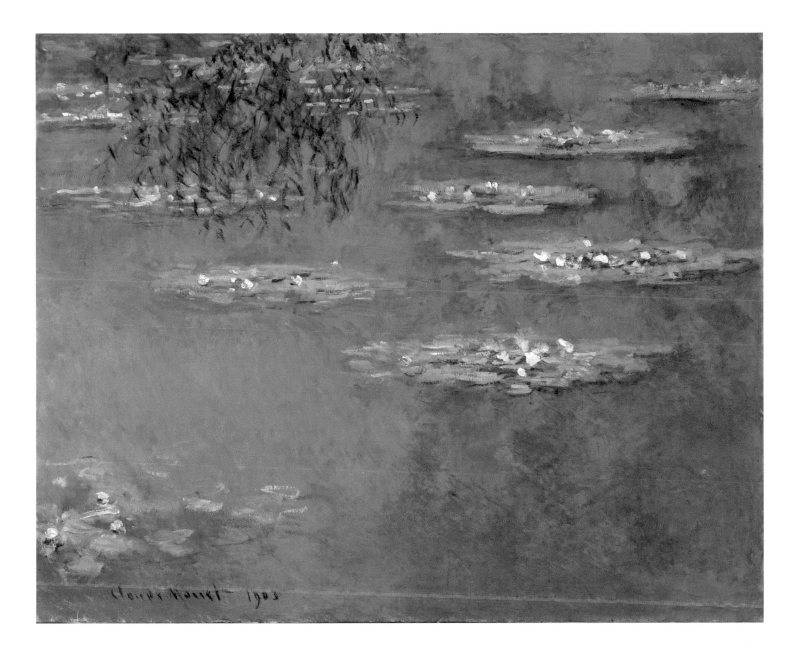

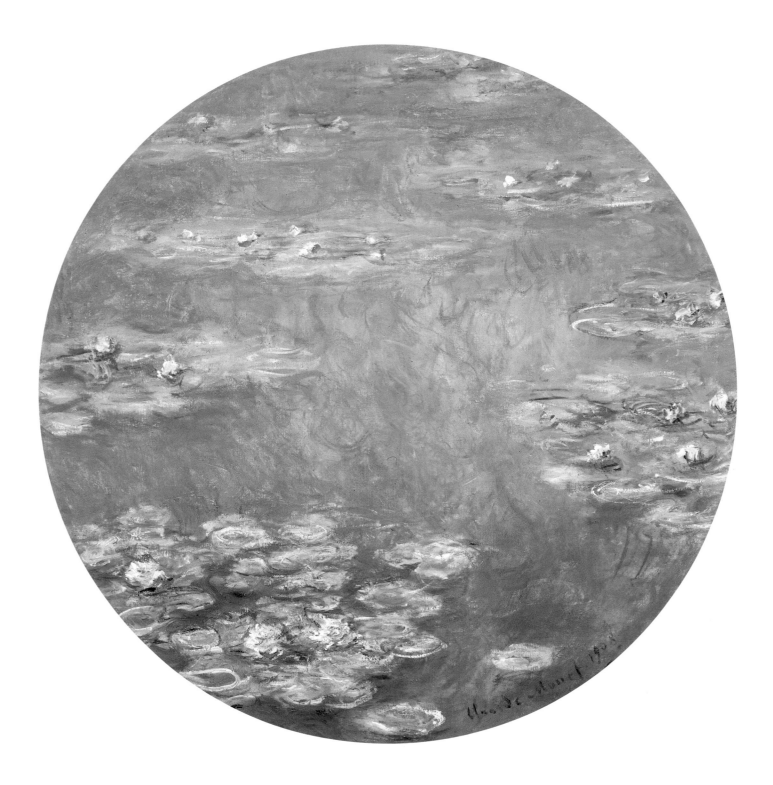

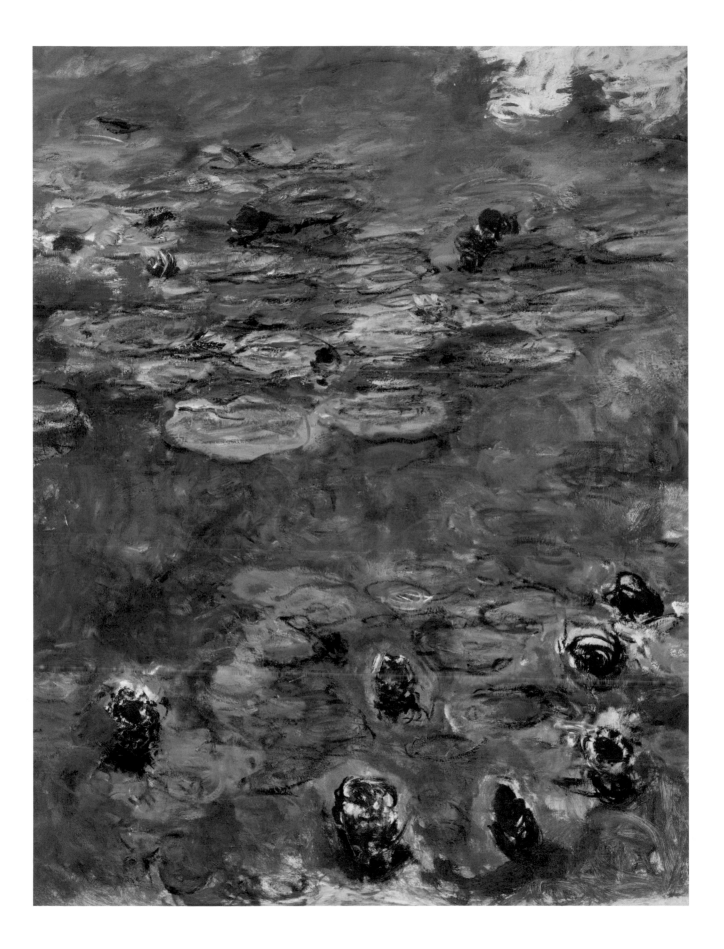

The scale of the San Francisco and Portland paintings evidence major changes in the Monet's conception of his art and technique. Although he still painted outside directly before nature—as recorded in a photograph that shows Monet working on the canvas now in Portland (fig. 68)—in his later career, Monet spent increasingly more time in the studio working to bring cohesion to a number of related panels. The relatively small cabinet-sized format was exchanged for monumental canvases, and small Impressionistic dabs were replaced by very broadly stroked brushwork. The cause of these changes is Monet's evolving desire to create a large and unified painted environment. In early 1914 Monet began to plan construction of a vast new studio to facilitate this project.

Wildenstein dates both the current paintings to the period 1914–17, at the time when Monet had begun to utilize such expanded formats. A combination of thick impasto and thin washes creates a fascinating and resonating image representative of complex natural phenomena. Monet's subject is the transparent but reflective zone where light, air, water, and plant life meet. The plant forms depicted in paintings from this period are also of enhanced scale, as foliage and flowers approach their actual size. The viewer no longer peers into a small painted world but rather seems to be surrounded by it. The new and grander dimensions of these works matched the scale of Monet's maturing vision of a national monument—realized in the two oval water-lily rooms today housed in the Musée de l'Orangerie in Paris.

LFO

FIG. 68. Monet painting in the water-lily garden, July 1915, photograph, Collection Philippe Piguet.

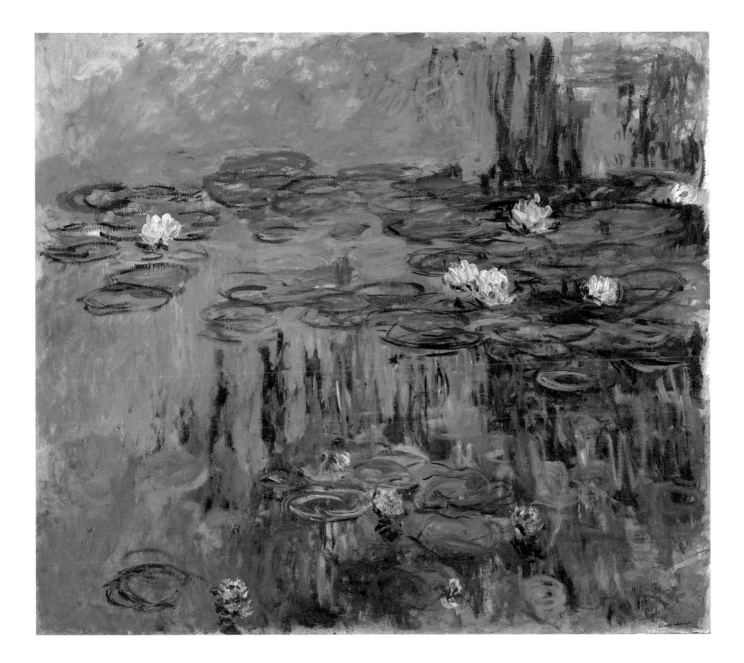

61. *Wisteria (Glycines),*
about 1919–20

59 x 78⅞ in. (149.8 x 200.5 cm)
Estate stamp lower left: *Claude Monet*
Allen Memorial Art Museum, Oberlin College
W1909

Monet's early thoughts for a suite of coordinated murals date to the 1890s. He was further encouraged by the success of the 1909 exhibition of his "water landscapes." Years later, as the decorative cycle took shape in his mind, Monet began working out its various components. The water-lily pond was always to be the principal subject; however, initial plans included an additional painted zone, or frieze, above the water-lily panels. To decorate these narrower panels, Monet envisioned great swags of wisteria (*glycines* in French) that would link the entire pictorial decoration.[1] The present painting is one of nine surviving paintings that bear witness to this unrealized aspect of the project.

Wisteria became a favored subject in Monet's paintings after the construction of a trellis over the Japanese footbridge. This was part of a wider program that Monet implemented to spread color above low-lying flowerbeds. For this design reason, Monet the landscaper employed arbors and trellises in both gardens. These flower-covered structures ultimately benefited the composition of Monet's paintings. In addition to being structural, the Japanese footbridge with its trellis is an expression of Monet's fascination with elements of Japanese culture and art. It has been proposed that the juxtaposition of bridge and wisteria blossoms in Utagawa Hiroshige's color woodblock print *Inside Kameido Tenjin Shrine*,[2] gave Monet the idea for his own garden. Whether or not this was the case, the trellis had been added by 1895. Mauve-and-white-colored wisteria soon covered the metal support, echoing and embellishing the bridge's arched form and providing the painter with a new motif.

By November 1920, when Monet was visited by the Duc de Trévise, work on the large wisteria paintings was underway. In an article written for the art press after Monet's death, Trévise remarked about having been shown "disconcerting studies done out-of-doors during the past few summers." He went on to talk about paintings composed of brushstrokes like "skeins of kindred shades that no other eye could have unraveled."[3] That passage brings to mind the ribbonlike strokes of color that bind together the various elements in the Oberlin picture. Here marvelously tangled brushstrokes re-create swags of heavy blossom clusters. These botanical compositions—so novel in their immense scale (several were larger than any of the water-lily canvases that had been produced by that date) and in their lovely lyrical sweep—were without compare.

As related by François Thiébault-Sisson in 1920, a pavilion to house Monet's decorative cycle was to be constructed on the grounds of the Hôtel Biron (the new Musée Rodin) in Paris.[4] The project was eventually transferred to the renovated Musée de l'Orangerie, where the walls were not tall enough to accommodate the wisteria panels.

LFO

This monumental canvas was part of the ensemble designed by Monet as his memorial commemorating the end of World War I. Originally titled *Agapanthus*, the Cleveland painting formed the left panel of a decorative triptych that included canvases now in the Saint Louis Museum of Art and the Nelson-Atkins Museum of Art, Kansas City.[1] A black-and-white photograph (fig. 69) taken in Monet's studio by Joseph Durand-Ruel on November 11, 1917 (a year to the day before the Armistice was signed ending World War II) records the Cleveland painting's original composition at an early stage (the left edge of the Saint Louis panel is also seen). Sometime before March 1921, the dealer Bernheim-Jeune took additional black-and-white photographs, which record all three paintings in a more advanced state of execution.

Negotiations with Paul Léon, director of the Ministry of Fine Arts, to find a suitable site to house Monet's grand mural project got serious in 1920, resulting in plans for the Hôtel Biron pavillion designed by architect Louis Bonnier.[2] The eighty-year-old Monet selected the *Agapanthus* triptych to be among the twelve canvases hung in the rotunda. The construction phase of the project did not proceed, however. By April 1921, as the ministry sought to control costs, the Hôtel Biron plan was superceded by another plan, calling for the renovation of the Orangerie (a building centrally located on the Place de la Concorde), to accommodate Monet's paintings. At this stage, two panels of the *Agapanthus* triptych were still included in the design and were destined to cover a section of wall between two doorways, but eventually, Monet omitted them altogether. Following the decision to delete the three panels from the Orangerie installation, Monet reworked them.[3] The Cleveland composition, in particular, was altered significantly. And now only ghost forms of the agapanthus underneath the current paint surface identify the motif for which the triptych was named.

As Roger Diederen explained, the changes in the Cleveland painting greatly altered the viewer's orientation to the image.[4] Originally, the two agapanthus plants, with willowy stalks and great flower heads, anchored the left edge of the composition and suggested a stable vantage point for the viewer on the shore at the pond's edge. Once this motif was eliminated, the viewer and the water lilies themselves seem cut loose from the shore. All three paintings exhibit an increased angle of foreshortening which accentuates the sense of distance between the viewer and the flowers, which now drift toward the canvas's top edge.

The inherent fragility of such very large paintings on canvas precluded exhibiting the three panels of the *Agapanthus* triptych together for this exhibition. Even individually, however, they wrap the viewer in an expansive and tranquil image of the Giverny water garden. Their subtly abstracted motifs and delicate tonal surfaces bespeak the soothing properties of nature. As such, they are the summation of the artist's intimate relationship with the natural world. Monet's profound understanding of and ability to convey nature's ineffable gifts proceeded from a life spent out of doors watching, listening, and absorbing the visual lessons that the landscape of Normandy offered.

LFO

62. *Water Lilies (Agapanthus)*, about 1920–26

PAGES 180–81; DETAIL, PAGE 179
79 x 167½ in. (201.3 x 425.8 cm)
Estate stamp lower left: *Claude Monet*
The Cleveland Museum of Art
W1975

FIG. 69. Third studio of Claude Monet, 1917, photograph, Durand-Ruel Archives, Paris.

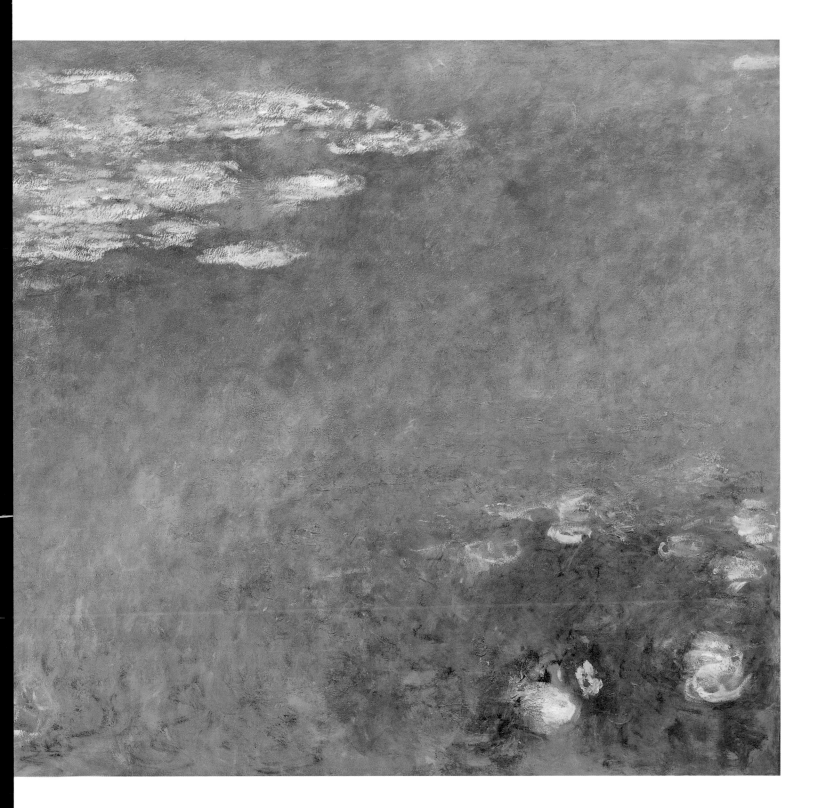

EXHIBITION CHECKLIST

All works illustrated are oil on canvas, unless otherwise noted.

Numbers preceded by the letter *W* refer to the numbers assigned to the paintings in Daniel Wildenstein's 1996 catalogue raisonné, listed in the Bibliography.

Paintings listed below are exhibited at all three venues unless otherwise noted.

1. *La Chapelle de Notre-Dame de Grâce, Honfleur*, 1864
20½ x 26¾ in. (52 x 68 cm)
Subsequently signed lower edge center: *Claude Monet*
Private Collection
W35

2. *The Pointe de la Hève at Low Tide*, 1865
(also known as *The Point of La Hève, Low Tide*)
35½ x 59¼ in. (90.2 x 150.5 cm)
Signed and dated lower right: *Claude Monet 1865*
Kimbell Art Museum, Forth Worth AP 7
W52

3. *A Seascape, Shipping by Moonlight*, 1866
(also known as *Marine, Night Effect*)
23⅜ x 29 in. (59.5 x 72.5 cm)
Subsequently signed on the back on the stretcher: *Claude Monet/1864*
The National Galleries of Scotland, Edinburgh NG 2399
W71

4. *Regatta at Sainte-Adresse*, 1867
29⅝ x 40 in. (75.2 x 101.6 cm)
Signed lower left: *Claude Monet*
The Metropolitan Museum of Art, New York
Bequest of William Church Osborn, 1951, 51.30.4
W91

5. *The Beach at Sainte-Adresse*, 1867
(also known as *The Beach at Sainte-Adresse, Gray Weather*)
29¹⁵/₁₆ x 40⁵/₁₆ in. (75.8 x 102.5 cm)
Signed and dated lower right: *Claude Monet 67*
The Art Institute of Chicago
Mr. and Mrs. Lewis Larned Coburn Memorial Collection 1933.439
W92
Cleveland only

6. *Garden at Sainte-Adresse*, 1867
(also known as *Garden Terrace at Sainte-Adresse*)
38⅝ x 51⅛ in. (98.1 x 129.9 cm)
Signed lower right: *Claude Monet*
The Metropolitan Museum of Art, New York, Purchase,
special contributions and funds given or bequeathed
by friends of the Museum, 1967, 67.241
W95

7. *Street in Sainte-Adresse*, 1867
31½ x 23⅜ in. (79.7 x 59 cm)
Signed lower left: *Claude Monet*
Sterling and Francine Clark Art Institute, Williamstown, Massachusetts, 1955.523
W98
Raleigh and Cleveland only

8. *The Hôtel des Roches Noires (Trouville)*, 1870
(also known as *L'Hôtel des Roches Noires [Trouville]*)
31½ x 21⅝ in. (80 x 55 cm)
Signed and dated lower right: *Claude Monet/1870*
Musée d'Orsay, Paris
Gift of Jacques Laroche RF1947.30
W155

9. *The Beach at Trouville*, 1870
21⁵/₁₆ x 25⅝ in. (52.1 x 59.1 cm)
Signed lower right: *Claude Monet*
Wadsworth Atheneum, Hartford
The Ella Gallup Sumner and Mary Catlin Sumner Collection 1948.116
W156
San Francisco and Raleigh only

10. *Camille on the Beach at Trouville*, 1870
15 x 18¼ in. (38.1 x 46.4 cm)
Subsequently signed and dated lower left: *Claude Monet 70*
Yale University Art Gallery, New Haven
Collection of Mr. and Mrs. John Hay Whitney 1998.46.1
W160
San Francisco only

11. *The Seine at Rouen*, 1872
19½ x 30½ in. (49.5 x 77.5 cm)
Signed lower right: *Claude Monet*
Shizuoka Prefectural Museum of Art, Shizuoka, Japan 0-61-732
W218
San Francisco and Raleigh only

12. *Ships Riding on the Seine at Rouen*, 1872–73
(also known as *The Seine at Rouen*)
14¹⁵/₁₆ x 18⅛ in. (37.7 x 46 cm)
Signed lower left: *Claude Monet*
National Gallery of Art, Washington, D.C.
Ailsa Mellon Bruce Collection 1970.17.43
W210

13. *The Seine at Rouen*, 1873
20 x 24⅘ in. (50.5 x 65.5 cm)
Signed lower right: *Claude Monet*
Staatliche Kunsthalle, Karlsruhe 2505
W268
Cleveland only

14. *The Museum at Le Havre*, 1873
(also known as *Le Havre Museum*)
29⅓ x 39⅓ in. (75 x 100 cm)
Signed and dated, lower right: *Claude Monet 73*
The National Gallery, London
Bequeathed by Helena and Kenneth Levy, 1990 NG 6527
W261

FIG. 70. Claude Monet, *Self-Portrait*, 1886, 22 x 18⅛ in.
(56 x 46 cm), private collection.

15. *Port of Le Havre*, 1874
(also known as *View of the Old Outer Harbor at Le Havre*)
23¾ x 40⅛ in. (60.3 x 101.9 cm)
Signed lower left: *Claude Monet*
Philadelphia Museum of Art 1961.48.3
W297

16. *Waves Breaking*, 1881
(also known as *Rough Sea*)
23⅝ x 31⅞ in. (60 x 81 cm)
Signed and dated lower left: *Claude Monet 81*
Fine Arts Museums of San Francisco
Gift of Prentis Cobb Hale 1970.10
W661

17. *A Stormy Sea*, 1881
(also known as *Rough Sea*)
23⅓ x 29 in. (60 x 73.7 cm)
Signed lower right: *Claude Monet*
The National Gallery of Canada, Ottawa 4636
W663

18. *By the Sea at Fécamp*, 1881
26⅓ x 31½ in. (67 x 80 cm)
Signed and dated lower left: *Claude Monet 81*
Musée Malraux, Le Havre 994-01
W652

19. *The Sea at Fécamp*, 1881
25¾ x 32¼ in. (65.5 x 82 cm)
Signed and dated lower right: *Claude Monet 81*
Staatsgalerie Stuttgart 2410
W660
Cleveland only

20. *Sea Coast at Trouville*, 1881
(also known as *On the Coast at Trouville*)
23⅞ x 32 in. (60.7 x 81.3 cm)
Signed and dated lower right: *81. Claude Monet*
Museum of Fine Arts, Boston
The John Pickering Lyman Collection. Gift of Miss Theodora Lyman 19.1314
W687

21. *Low Tide at Pourville, near Dieppe*, 1882
(also known as *Low Tide at Pourville*)
23⅓ x 32 in. (60 x 81 cm)
Signed and dated lower right: *82 Claude Monet*
The Cleveland Museum of Art 1947.196
Gift of Mrs. Henry White Cannon
W716

22. *Cliffs near Pourville*, 1882
(also known as *Falaises prés de Pourville*)
23 ⅓ x 32 in. (60 x 81 cm)
Signed and dated lower left: *Claude Monet 82*
Rijksmuseum Twenthe, Enschede, Netherlands
W788

23. *Low Tide at Varengeville*, 1882
23⅓ x 32 in. (60 x 81 cm)
Signed and dated lower left: *Claude Monet 82*
Carmen Thyssen-Bornemisza Collection, on loan to the Thyssen-Bornemisza Collection, Madrid CTB 1994.7
W722
San Francisco and Raleigh only

24. *The Church at Varengeville and the Gorge des Moutiers*, 1882
23⅓ x 32 in. (60 x 81 cm)
Signed and dated lower left: *Claude Monet 82*
Columbus Museum of Art
Gift of Mr. and Mrs. Arthur J. Kobacker 81.015
W728

25. *The Church at Varengeville, Morning Effect*, 1882
24⅛ x 29⅛ in. (61.3 x 74 cm)
Signed and dated lower left: *Claude Monet 82*
Private collection
W794
San Francisco only

26. *The Fisherman's Hut at Varengeville*, 1882
23⅓ x 30¾ in. (60 x 78 cm)
Signed and dated lower right: *Claude Monet 82*
Museum Boijmans-van Beuningen, Rotterdam 1544
W732

27. *Customs House at Varengeville*, 1882
(also known as *Rising Tide at Pourville*)
26 x 32 in. (66 x 81.3 cm)
Signed and dated lower right: *82 Claude Monet*
Brooklyn Museum
Gift of Mrs. Horace O. Havemeyer 41.1260
W740

28. *Customshouse, Varengeville*, 1882
(also known as *The Customs House*)
23⅓ x 32 in. (60 x 81 cm)
Signed and dated lower left: *Claude Monet 82*
Philadelphia Museum of Art, William L. Elkins Collection E1924.3.61
W743

29. *View over the Sea*, 1882
(also known as *On the Cliff at Pourville*)
25¼ x 32¼ in. (64 x 82 cm)
Signed and dated lower right: *Claude Monet 82*
Nationalmuseum, Stockholm NM2122
W755

30. *The Cliff Walk, Pourville*, 1882
(also known as *Walk on the Cliff, Pourville*)
26⅛ x 32⁷⁄₁₆ in. (66.5 x 82.3 cm)
Signed and dated lower right: *Claude Monet 82*
The Art Institute of Chicago
Mr. and Mrs. Lewis Larned Coburn Memorial Collection 1933.443
W758

31. *The Cliff at Dieppe*, 1882
26 x 32¼ in. (65 x 81 cm)
Signed and dated lower left: *Claude Monet 82*
Kunsthaus Zürich 2252
W759

32. *Road at La Cavée, Pourville*, 1882
(also known as *The Path of La Cavée, Pourville*)
23¾ x 32⅛ in. (60.3 x 81.6 cm)
Signed and dated lower right: *Claude Monet 82*
Museum of Fine Arts, Boston
Bequest of Mrs. Susan Mason Loring 24.1755
W762

33. *Marine near Étretat*, 1882
(also known as *The Sea at Pourville*)
21¼ x 28¾ in. (54 x 73 cm)
Signed lower right: *Claude Monet*
Philadelphia Museum of Art 1961.48.1
W772

34. *Seascape at Pourville*, 1882
23⅗ x 39⅓ in. (60 x 100 cm)
Signed lower right: *Claude Monet*
Columbus Museum of Art 91.001.039
W775
Cleveland only

35. *Wheat Field*, 1881
(also known as *Field of Corn*)
25⁷⁄₁₆ x 31⅞ in. (64.6 x 81 cm)
Signed and dated lower left: *Claude Monet 81*
The Cleveland Museum of Art 1947.197
Gift of Mrs. Henry White Cannon
W676

36. *Frost*, 1885
23½ x 31⅝ in. (60 x 80 cm)
Signed lower left: *Claude Monet*
Private collection, Dallas, Texas
W964

37. *Village of Giverny*, 1886
25½ x 32 in. (65 x 81 cm)
Signed and dated lower left: *Claude Monet 86*
Mrs. Frederick M. Stafford collection, courtesy of the New Orleans Museum
of Art
W1072

38. *Étretat, Rough Sea*, 1883
31⁹⁄₁₀ x 39⅓ in. (81 x 100 cm)
Signed and dated lower left: *Claude Monet 83*
Musée des Beaux-Arts, Lyon B.647
W821

39. *The Cliff, Étretat, Sunset*, 1882–83
(also known as *Étretat, Sunset*)
23¹⁵⁄₁₆ x 32³⁄₁₆ in. (60.5 x 81.8 cm)
Signed and dated lower left: *Claude Monet 83*
North Carolina Museum of Art, Purchased with funds from the State of
North Carolina 67.24.1
W817

40. *Waves at the Manneporte*, 1883 or 1885
(also known as *Rough Seas at the Manneporte*)
29 x 36½ in. (73.7 x 92.7 cm)
Signed lower left: *Claude Monet*
Private collection
W1036

41. *The Manneporte (Étretat)*, 1883
(also known as *The Manneporte*)
25¼ x 32 in. (65 x 81 cm)
Signed and dated lower left: *Claude Monet 83*
The Metropolitan Museum of Art, New York
Bequest of William Church Osborn, 1951, 51.30.5
W832

42. *The Manneporte, High Tide*, 1885
26 x 32¼ in. (66 x 82 cm)
Signed lower left: *Claude Monet 85*
Private collection
W1035

43. *Boats on the Beach at Étretat*, 1885
25¾ x 32 in. (65.5 x 81.3 cm)
Signed lower right: *Claude Monet*
The Art Institute of Chicago
Charles H. and Mary F. S. Worcester Collection 47.95
W1024

44. *The Needle Rock and the Porte d'Aval, Étretat*, 1885
25⁹⁄₁₆ x 32 in. (65 x 81 cm)
Signed and dated lower right: *Claude Monet 85*
Sterling and Francine Clark Art Institute, Williamstown, Massachusetts, 1955.528
W1034
San Francisco and Raleigh only

45. *Grainstack in the Sunlight*, 1891
23⅗ x 39⅓ in. (60 x 100 cm)
Signed and dated lower right: *Claude Monet 91*
Kunsthaus Zürich 1969/7
W1288
Cleveland only

46. *Grainstack, Sun in the Mist*, 1891
25⅜ x 39⅜ in. (65 x 100 cm)
Signed and dated lower right: *Claude Monet 91*
The Minneapolis Institute of Arts, Gift of Ruth and Bruce Dayton, The
Putnam Dana McMillan Fund, The John R. Van Derlip Fund, The William
Hood Dunwoody Fund, The Ethel Morrison Van Derlip Fund, Alfred and
Ingrid Lenz Harrison, and Mary Joann and James R. Jundt 1993.20
W1286
Cleveland only

47. *Poplars, Pink Effect*, 1891
(also known as *The Three Trees in Spring [Poplars]*)
36⅞ x 29⅛ in. (92 x 73 cm)
Signed and dated lower left: *Claude Monet 91*
Private Collection
W1304

48. *Snow Effect at Giverny*, 1893
25⅗ x 36¼ in. (65 x 92 cm)
Signed and dated lower left: *Claude Monet 93*
Mrs. Frederick M. Stafford collection, courtesy of the New Orleans Museum
of Art
W1331

49. *Cathedral at Rouen (La Cour d'Albane)*, 1892–94
36½ x 29¹⁄₁₆ in. (92.7 x 73.8 cm)
Signed and dated lower right: *Claude Monet 94*
Smith College Museum of Art, Northampton, Massachusetts, SC 1956:24
W1317
San Francisco and Raleigh only

50. *Rouen Cathedral Façade and Tour d'Albane (Morning Effect)*, 1893–94
(also known as *Rouen Cathedral: The Portal and the Tour l'Albane at Dawn*)
41¾ x 29⅛ in. (106.1 x 73.9 cm)
Signed and dated lower left: *Claude Monet 94*
Museum of Fine Arts, Boston
Tompkins Collection 24.6
W1348

51. *View of Rouen*, 1892
25⅗ x 39⅕ in. (65 x 100 cm)
Signed with estate stamp lower right: *Claude Monet*
Musée des Beaux-Arts et de la Céramique, Rouen
W1315

52. *Gorge of the Petit Ailly, Varengeville*, 1897
(also known as *The Gorge at Varengeville, Late Afternoon*)
25⅗ x 36¼ in. (65.7 x 92.7 cm)
Signed and dated lower left: *Claude Monet 97*
Fogg Art Museum, Harvard University Art Museums
Gift of Ella Milbank Foshay, FAM 1972.31
W1452

53. *At Val Saint-Nicolas near Dieppe, Morning*, 1897
25⅝ x 39⅜ in. (65 x 100 cm)
Signed and dated lower right: *Claude Monet 97*
The Phillips Collection, Washington, D.C. 1377
W1466
Cleveland only

54. *The Seine at Giverny, Morning Mists*, 1897
(also known as *The Seine near Giverny in the Fog*)
35 x 36 in. (89 x 92 cm)
Signed and dated lower left: *Claude Monet 97*
North Carolina Museum of Art, Purchased with funds from the Sarah
Graham Kenan Foundation and the North Carolina Art Society (Robert F.
Phifer Bequest) 75.24.1
W1474

55. *Morning on the Seine*, 1897–98
(also known as *Morning on the Seine in the Rain*)
28¾ x 36 in. (73 x 92 cm)
Signed and dated lower left: *Claude Monet 98*
The National Museum of Western Art, Tokyo P.1965.4
W1499
San Francisco and Raleigh only

56. *Waterlilies and Japanese Bridge*, 1898–99
(also known as *Water Lily Pond and Bridge*)
35⅝ x 35⁵⁄₁₆ in. (90.5 x 89.7 cm)
Signed and dated lower right: *Claude Monet 99*
Princeton University Art Museum
Collection of William Church Osborn Y1972-15
W1509
San Francisco only

57. *Water Lilies*, 1903
(also known as *Nymphéas*)
32 x 39⅖ in. (81.3 x 101.6 cm)
Signed and dated lower left: *Claude Monet 1903*
The Dayton Art Institute
Gift of Mr. Joseph Rubin 53.11
W1657

58. *Water Lilies*, 1908
(also known as *Nymphéas*)
31⅞ in. (81 cm) diameter
Signed and dated lower right: *Claude Monet 1908*
Dallas Museum of Art
Gift of the Meadows Foundation Incorporated 1981.128
W1729

59. *Water Lilies*, 1914–17
(also known as *Red Nymphéas*)
70¾ x 57⅝ in. (179.7 x 146.5 cm)
Fine Arts Museums of San Francisco
Mildred Anna Williams Collection 1973.3
W1788

60. *Nymphéas*, 1914–17
(also known as *Water Lilies*)
63 x 78¾ in. (160 x 180 cm)
Portland Art Museum, Portland, Oregon
Helen Thurston Ayer Fund 59.16
W1795
San Francisco only

61. *Wisteria (Glycines)*, about 1919–20
(also known as *Wisteria*)
59 x 78⅞ in. (149.8 x 200.5 cm)
Estate stamp lower left: *Claude Monet*
Allen Memorial Art Museum, Oberlin College
R. T. Miller, Jr. Fund 1960.5
W1909

62. *Water Lilies (Agapanthus)*, about 1920–26
(also known as *Agapanthus [Nymphéas]*)
79 x 167½ in. (201.3 x 425.8 cm)
Estate stamp lower left: *Claude Monet*
The Cleveland Museum of Art
John L. Severance Fund 1960.81
W1975
Cleveland only

Not illustrated:
Grainstack (Sunset), 1891
28⅞ x 36½ in. (73.3 x 92.6 cm)
Signed and dated lower left: *Claude Monet 91*
Museum of Fine Arts, Boston
Julia Cheney Edwards Collection 25.112
W1289
San Francisco and Raleigh only

L'Île aux Orties, 1897
28 x 35 in. (71 x 89 cm)
Signed and dated lower left: *Claude Monet 97*
Columbia Museum of Art, Columbia, South Carolina
Gift of Mary T. Chambers CMA 1964.29
W1489
Raleigh only

SELECTED BIBLIOGRAPHY

Baedeker 1899
Karl Baedeker, *Northern France from Belgium and the English Channel to the Loire*. New York: Charles Scribner's Sons, 1899.

Baltimore-Phoenix-Hartford 2004–5
Sona Johnston and Paul Tucker, *In Monet's Light: Theodore Robinson at Giverny*, exh. cat. The Baltimore Museum of Art, October 17, 2004–January 9, 2005; The Phoenix Museum of Art, February 6–May 8, 2005; Wadsworth Atheneum, Hartford, June 4–September 4, 2005.

Barrey 1913
Ph. Barrey, *Guide du Havre et de la region*. Le Havre: Syndicat d'Initative, 1913.

Berson 1996
Ruth Berson, *The New Painting: Impressionism 1874–1886, Documentation*, 2 vols. Fine Arts Museums of San Francisco, 1996.

Black 1899
C. B. Black, *Normandy and Picardy: Their Relics, Castles, Churches and Footprints of William the Conqueror*, 5th ed. London: Adam and Charles Black, 1899.

Boston-Chicago-London 1990
Paul Hayes Tucker, *Monet in the '90s: The Series Paintings*, exh. cat. Museum of Fine Arts, Boston, February 7–April 29, 1990; The Art Institute of Chicago, May 19–August 12, 1990; Royal Academy of Arts, London, September 7–December 9, 1990.

Boston-London 1998–99
Paul Hayes Tucker, George T. M. Shackelford, and MaryAnne Stevens, *Monet in the 20th Century*, exh. cat. Museum of Fine Arts, Boston, September 20–December 27, 1998; Royal Academy of Arts, London, January 23–April 18, 1999.

Canberra-Perth 2001
Monet & Japan, exh. cat. National Gallery of Australia, Canberra, March 9–June 11, 2001; Art Gallery of Western Australia, Perth, July 7–September 16, 2001.

Chicago 1995
Charles F. Stuckey, *Claude Monet, 1840–1926*, exh. cat. The Art Institute of Chicago, July 22–November 26, 1995.

Chicago-Philadelphia-Amsterdam 2003–4
Juliet Wilson-Bareau and David Degener, *Manet and the Sea*, exh. cat. The Art Institute of Chicago, October 20, 2003–January 19, 2004; Philadelphia Museum of Art, February 15–May 30, 2004; Van Gogh Museum, Amsterdam, June 18–September 26, 2004.

D'Argencourt and Diederen 1999
Louise d'Argencourt and Roger Diederen, *European Paintings of the 19th Century*, 2 vols. The Cleveland Museum of Art, 1999.

Edinburgh 2003
Michael Clarke and Richard Thomson, *Monet: The Seine and the Sea 1878–1883*, exh. cat. National Galleries of Scotland, Edinburgh, August 6–October 26, 2003.

Fuller 1899
William H. Fuller, *Claude Monet and His Paintings*. New York: Press of J. J. Little & Co., 1899.

Geffroy 1892–1903
Gustave Geffroy, *La vie artistique*, 8 vols. Paris: E. Dentu (vols. I–IV) and H. Floury (vols. V–VIII), 1892–1903.

Geffroy 1922
Gustave Geffroy, *Cl. Monet, sa vie, son temps, son oeuvre*. Paris, 1922.

Gordon and Forge 1983
Robert Gordon and Andrew Forge, *Monet*. New York: Abradale Press, 1983.

The Hague-Cologne-Paris 2003–4
Jongkind 1819–1891, exh. cat. Gemeentemuseum, The Hague, October 11, 2003–January 17, 2004; Wallraf-Richartz-Museum, Foundation Corboud, Cologne, February 6–May 8, 2004; Musée d'Orsay, Paris, June 1–September 5, 2004, Paris: Réunion des Musées Nationaux.

Herbert 1988
Robert L. Herbert, *Impressionism: Art, Leisure, and Parisian Society*. New Haven and London: Yale University Press, 1988.

Herbert 1994
Robert L. Herbert, *Monet on the Normandy Coast: Tourism and Painting, 1867–1886*. New Haven and London: Yale University Press, 1994.

Hoog 1990
Michel Hoog, *The Nymphéas of Claude Monet at the Musée de l'Orangerie*, Paris: Réunion des Musées Nationaux, 1990.

Jean-Aubry 1977
G. Jean-Aubry, *Eugène Boudin*. Neuchatel: Editions Ides et Calendes, 1977.

Kendall 1993
Richard Kendall, *Degas Landscapes*. New Haven and London: Yale University Press, 1993.

Klein 1999
Jacques-Sylvain Klein, *La Normandie: Berceau de l'Impressionisme 1820–1900*. Rennes: Éditions Ouest-France, 1999.

Levine 1976
Steven Z. Levine, *Monet and His Critics*. New York and London: Garland Publishing, Inc., 1976.

Lindon 1963
Raymond Lindon, *Étretat, son histoire, ses legends*. Paris: Les Éditions de Minuit, 1963; reprint, 1999.

London-Amsterdam-Williamstown 2000–1
Richard R. Brettell, *Impression: Painting Quickly in France, 1860–1890*, exh. cat., The National Gallery, London, November 1, 2000–January 28, 2001; Van Gogh Museum, Amsterdam, March 2–May 20, 2001; Sterling and Francine Clark Art Institute, Williamstown, Massachusetts, June 16–September 9, 2001.

Murray 1864
John Murray, *A Handbook for Travellers in France*, 9th ed. London: John Murray, 1864.

Narazaki 1974
Muneshige Narazaki, *Hiroshige: The 53 Stations of the Tokaido*. New York: Kodansha International, 1974.

New York-Cleveland-Chicago-Ottawa 1975–76
Felice Stample and Cara D. Denison, *Drawings from the Collection of Mr. & Mrs. Eugene V. Thaw*, exh. cat. The Pierpont Morgan Library, New York, December 10, 1975–February 15, 1976; The Cleveland Museum of Art, March 16–May 2, 1976; The Art Institute of Chicago, May 28–July 5, 1976; The National Gallery of Canada, Ottawa, August 6–September 17, 1976.

New York-Saint Louis 1978
Monet's Years at Giverny: Beyond Impressionism, exh. cat. The Metropolitan Museum of Art, New York, April 22–July 9, 1978; Saint Louis Art Museum, August 1–October 8, 1978.

New York-Chicago 1987
Eugenia Parry Janis, *The Photography of Gustave Le Gray*, exh. cat. The Metropolitan Museum of Art, New York, June 4–August 16, 1987; The Art Institute of Chicago, September 18–December 6, 1987.

Paris-Ottawa-New York 1996–97
Gary Tinterow, Michael Pantazzi, and Vincent Pomarède, *Corot*, exh. cat. Galeries Nationales du Grand Palais, Paris, February 27–May 27, 1996; National Gallery of Canada, Ottawa, June 21–September 22, 1996; The Metropolitan Museum of Art, New York, October 22, 1996–January 19, 1997.

Paris-New York 1994–95
Gary Tinterow and Henri Loyrette, *Origins of Impressionism*, exh. cat. Galleries Nationales du Grand Palais, Paris, April 19–August 8, 1994; The Metropolitan Museum of Art, New York, September 27, 1994–January 8, 1995.

Pissarro 1990
Joachim Pissarro, *Monet's Cathedral: Rouen 1892–1894*. London: Pavilion, 1990.

Rachman 1997
Carla Rachman, *Monet*. London: Phaidon Press, 1997.

Reff 1981
Theodore Reff, ed. *Impressionist Group Exhibitions*. New York: Garland Publishing, 1981.

Rewald 1973
John Rewald, *The History of Impressionism*, rev. ed. New York: Museum of Modern Art, 1973.

Roberts 1980
Nesta Roberts, *The Companion Guide to Normandy*. London: Collins, 1980.

Russell 1995
Vivian Russell, *Monet's Garden, Through the Seasons at Giverny*. New York: Stewart, Tabori & Chang, 1995.

Sieberling 1981
Grace Sieberling, *Monet's Series*. New York and London: Garland Publishing, Inc., 1981.

Spate 1992
Virginia Spate, *Claude Monet: Life and Work*. New York: Rizzoli, 1992. Also published as *Claude Monet: The Color of Time*. London: Thames and Hudson, 1992.

Stuckey 1985
Charles F. Stuckey, ed. *Monet: A Retrospective*. New York: Hugh Lauter Levin Associates, Inc., 1985.

Taylor 1995
John Russell Taylor, *Claude Monet: Impressions of France, From Le Havre to Giverny*. London: Collins Ltd., 1995.

Tucker 1995
Paul Tucker, *Claude Monet: Life and Art*. New Haven and London: Yale University Press, 1995.

Washington 1996–97
Eliza E. Rathbone, Katherine Rothkopf, Richard R. Brettell, and Charles S. Moffett, *Impressionists on the Seine: A Celebration of Renoir's* Luncheon of the Boating Party, exh. cat. The Phillips Collection, Washington, D.C., September 21, 1996–February 9, 1997.

Washington-San Francisco 1998–99
Charles S. Moffett, Eliza E. Rathbone, Katherine Rothkopf, and Joel Isaacson, *Impressionists in Winter, Effets de Niege*, exh. cat. The Phillips Collection, Washington, D.C., September 19, 1998–January 3, 1999; Fine Arts Museums of San Francisco at the Center for the Arts at Yerba Buena Gardens, January 30–May 2, 1999.

White 1984
Barbara Ehrlich White, *Renoir, His Life, Art, and Letters*. New York: Harry N. Abrams, Inc., 1984.

Wildenstein 1979
Daniel Wildenstein, *Claude Monet: Bibliographie et catalogue raisonné*. 5 vols. Lausanne & Paris: La Bibliothèque des Arts, 1979–91.

Wildenstein 1996
Daniel Wildenstein, *Monet or The Triumph of Impressionism, Catalogue Raisonné*. 4 vols. Cologne: Benedikt Taschen Verlag, 1996.

Willsdon 2004
Clare A. P. Willsdon, *In the Gardens of Impressionism*. Paris: The Vendome Press, 2004.

NOTES

Numbers in boldface type refer to the catalogue numbers of the paintings featured in the exhibition.

ESSAYS

Monet's Normandy Before Monet
1. Herbert 1994.
2. Philip Gilbert Hamerton, *Landscape*. London: Seeley, 1885, 359.
3. Paris-Ottawa-New York 1996–97, 111.

Normandy and Impressionism
1. Jean-Aubry 1969, 24–27.
2. Ibid., 232.
3. Kendall 1993. Also see Kendall, *Degas: Beyond Impressionism*. New York and London, 1996; and Kendall, *Edgar Degas: Defining the Edge*. New York and London, 2003. Kendall is presently collaborating with James A. Ganz of the Clark Art Institute on an exhibition, *The Unknown Monet: Drawings and Pastels*, that will be shown at the Royal Academy of Arts, London, and the Clark Institute in 2007.
4. The imposing and partially ruined Abbey Church of the Trinity, founded by Richard II and built and rebuilt many times between the thirteenth and eighteenth centuries, is mentioned in every guidebook entry for Fécamp but seems to have held no pictorial interest for Morisot.
5. White 1984.

CATALOGUE

1 W35
1. Collection of Mr. and Mrs. Eugene V. Thaw. Stample and Denison, 1975, cat. no. 114, 102–03, ill. pl. 114.
2. Stuckey 1985, 307–08.

2 W52
1. Paul Mantz, "The Salon of 1865," *Gazette des Beaux-Arts*, 1st Ser., 19 (July 1865), 26; as translated in Stuckey 1985, 32.
2. Johan Barthold Jongkind, *On the Beach at Saint-Adresse*, 1862, oil on canvas, 10¹¹⁄₁₆ x 16⁵⁄₁₆ inches (27 x 41 cm), Phoenix Art Museum, Mrs. Oliver B. James Bequest; see Paris-New York 1994–95, cat. 80, 391, repro color 62. For Monet's recollections of his early conversations with Jongkind, as published by François Thiébault-Sisson (*Le Temps*, November 27, 1900), see translation in Stuckey 1985, 208, 217.

3 W71
1. See The Hague-Cologne-Paris 2003–04, cat. 111, 138, ill.
2. See, for example, Wildenstein 1996, W37, W38, and W51.
3. Wildenstein 1979, V, 159, P25, and 160, P26.

4, 5 W91, W92
1. François Thiébault-Sisson, "Claude Monet: An Interview," *Le Temps*, November 27, 1900, translated in Stuckey 1985, 205–06.
2. Ibid., 217.

6 W95
1. I wish to thank Kathryn Calley Galitz, assistant curator at The Metropolitan Museum of Art, for bringing this postcard to my attention.
2. In addition to the present work, see Wildenstein 1996, W68, W68a, and W69.
3. Wildenstein 1996, II, 51.
4. Murray 1864, 65.
5. See bibliographical references cited in Paris-New York 1994–95, cat. no. 137, 433–43. Recent discussions include Willsdon 2004, 86–90.

6. During Monet's era, the terms "Chinese" and "Japanese" were used interchangeably. The flags are actually those of France and the city of Le Havre.
7. Emile Zola, "Mon Salon: IV. Les Actualistes," *L'Evenement Illustré*, May 24, 1868, as translated in Stuckey 1985, 39.

7 W98
1. Undated letter to an unidentified correspondent; as translated in Moffett Washington-San Francisco 1998–99, 172.
2. I wish to thank Sarah Lees, curator at the Sterling and Francine Clark Art Institute, for sharing with me the museum's information about this work. Some years ago, the mayor of Sainte-Adresse had provided the Clark with reproductions of various eighteenth- and nineteenth-century images of the chapel, confirming its identification and the veracity of Monet's view.
3. Barrey 1913, 77. At the time, Barrey was Le Havre's town archivist.

8, 9, and 10 W155, W156, W160
1. For an extensive discussion of Monet's Trouville summer, see Herbert 1988, 293–99.
2. Eugène Boudin, *The Beach at Trouville*, 1865, pastel on paper, 7¹⁄₁₆ x 11⁷⁄₁₆ inches (18 x 29 cm), 1865, formerly Gustave Cahen Collection; reproduced in Jean-Aubry 1977, 239.
3. London-Amsterdam-Williamstown 2000–1, 118–22.
4. This work is particularly close in spirit to Monet's *Camille on the Beach*, Musée Marmottan, Paris (W161); see Wildenstein 1996, II, 76–77, ill.

11, 12, and 13 W218, W210, W268
1. Pissarro 1990, 11.
2. John Ruskin, author of *Stones of Venice*, considered Rouen "the place of north Europe, as Venice is of south Europe." See Roberts 1980, 60.
3. Spate 1992, 80.
4. Rewald 1973, 346.
5. Taylor 1995, 30.
6. Paris-New York 1994–95, 126.

14 W261
1. See *Port of Le Havre* (cat. 15).
2. Murray 1864, 63.
3. The Musée des Beaux-Arts was completely destroyed during the WWII bombing of Le Havre. The harbor district, including the museum (now called the Musée Malraux), has been rebuilt.
4. Murray 1864, 65.
5. Wildenstein 1979 (vol. V) presents a catalogue of Monet's sketchbooks, drawings, and pastels. Musée Marmotton Inv. No. MM.5134, folios 35 verso, 36 recto and verso; see Wildenstein 1991, V, 94, D213, D214, D215.
6. For a discussion of the relationship between Monet's paintings, including the *Garden at Sainte-Adresse* (cat. 6), and Le Gray's photographs of the Normandy coast, see New York-Chicago 1987, 81–83.

15 W297
1. See for example, Murray 1864, 65. In 1899 C. B. Black (56) listed the cost of board as starting at 10 francs a day (without wine), which was about the same cost as a train ticket from Paris to Le Havre.
2. W296: Wildenstein 1996, II, 126, ill. The two paintings are illustrated side by side in color in Chicago 1995, cat. 35 and 36, ill. 58–59.
3. Leroy continued, "Unfortunately, I was careless enough to leave him too long in front of the same painter's *Boulevard des Capucines*. 'Ha, ha,' he laughed diabolically, 'this one's pretty good! . . . Here's an impression if I don't say so myself. . . . Only, tell me what these countless little black licking marks are at the bottom of the painting.' 'Those? They're people strolling.' 'Is that what I look like when I stroll down the boulevard des Capucines? . . . Hell and damnation! Are you trying to make a fool of me?' " As translated in Stuckey 1985, 57. For Leroy's entire article, see Berson 1996, 26.

16, 17, and 18 W661 , W663, W652

1. Georges Riat, *Gustave Courbet: Peintre, Maîtres de l'art moderne* (Paris: H. Floury, 1906), 120; cited in Chicago-Philadelphia-Amsterdam 2003–04, 159.

19 W660

1. Huysmans, Joris-Karl, "Le Salon Officiel de 1880," "Appendice," reprinted in J. K. Huysmans, *L'art moderne*, Paris: Librairie Plon, 1908, 103–5, 292–3.

20 W687

1. Wildenstein 1979, I, L222.
2. Zacharie Astruc, "Le Japon chez nous," *L'Etendard*, May 26, 1868, cited in Geneviève Lacambre, "Chronologie," *Le japonisme*, Paris: Réunion des Musées Nationaux, 1988, 80.

21, 22, 23 W716, W788, W722

1. Wildenstein 1979, II, 214, L242.
2. Stuckey 1985, 90.
3. "Exposition des oeuvres de M. Claude Monet," *Gazette des Beaux-Arts*, 2nd ser., 27 (April 1883), 346.
4. Boston, Mechanics Hall of the Massachusetts Charitable Mechanics Association, "The American Exhibition of Products, Art, and Manufactures of Foreign Nations," September 3, 1883–January 12, 1884, no. 13.

26, 27, and 28 W732, W740, W743

1. Wildenstein 1979, II, 217, L260.
2. Ibid., 217–18, L270, 266, 264, 263 *bis*.
3. Herbert 1994, 48.
4. Tucker 1995, 108–09.

33, 34 W772, W775

1. Wildenstein 1979, II, 285, L730.

35 W676

1. Wildenstein 1979, 254.
2. Edinburgh 2003, 108.
3. Octave Mirbeau, "Notes sur l'art, Claude Monet," *La France*, November 21, 1884, 84.
4. Paul de Charry, "Beaux Arts," *Le Pays*, March 14, 1882, reprinted in Berson 1996, Vol. 1, 384.

36 W964

1. In his catalogue raisonné of Monet's paintings, Daniel Wildenstein supplied the date of 1885 based on the stylistic qualities of this painting. Wildenstein suggested, however, that the painting could have been executed during the cold winter of 1879–80.

37 W1072

1. Shortly after moving into Le Pressoir, Monet wrote his friend, the critic Théodore Duret, "I am in ecstasy. Giverny is a splendid place for me" (Wildenstein 1979, II, L354). In 1908 the American artist and writer on art Will Low described Giverny's setting, "Its greatest charm lies in the atmospheric conditions over the lowlands, where the moisture from the rivers, imprisoned through the night by the valley's bordering hills, dissolve[s] before the sun and bathe[s] the landscape in an iridescent flood of vaporous hues, of which Monet in his transcripts has portrayed the charm. . . ." *A Chronicle of Friendships, 1873–1900*, New York: Charles Scribner's Sons, 1908, 446–47.
2. See William H. Gerdts, *Monet's Giverny: An Impressionist Colony*. New York: Abbeville, 1993, 30–31, 103–8, 222–27.

38, 39 W821, W817

1. Leitch Ritchie, *Travelling Sketches on the Sea-Coasts of France*, London, 1834, 54; Jacob Venedey, *Reise und Rasttage in der Normandy*, Leipzig 1838, transl. as *Excursions in Normandy*, London: 1841, 316, cited in Herbert 1994, 63. Herbert's chapter, "Étretat's History and Fame," 61–69) offers an excellent account of Étretat's rise as a tourist destination. The best survey on the history of Étretat remains Lindon 1963.
2. Geffroy 1922, 269.
3. Wildenstein 1979, II, L310.
4. Wildenstein 1979, II, L315.
5. Wildenstein 1979, II, L312.
6. Mirbeau, "Notes sur l'art. Claude Monet," *La France*, November 21, 1884.
7. In a letter to the dealer on July 27 Monet states that he is sending seven paintings, among them a "Coucher de soleil à Étretat, l'hiver," while in another letter, dated November 9, he notes that on the following day Durand-Ruel will receive seven more paintings, including a "Soleil couchant (Étretat)" (Wildenstein 1979, II, 230–31, L367, L380).
8. "Works in Oil and Pastel by the Impressionists of Paris," New York, Anderson Galleries (April), National Academy of Design (May–June) 1886, no. 287.
9. Fuller 1899, 17.

40, 41, 42 W1036, W832, W1035

1. See Wildenstein 1979, II, L.626.
2. Ibid., L314.
3. After yet another rainy morning, I was pleased to see the weather improve a bit; although a strong wind was blowing and the sea was furious, yet because of that I counted on having a rich session at the Manneporte, but an accident occurred: do not alarm yourself, I am safe and sound since I am writing to you, but little was lacking for you to have no news of me and for me not to ever see you again. I was in the full throes of work beneath the cliff, well sheltered from the wind, at the place where you came with me; convinced that the tide was receding, I wasn't alarmed by the waves that were dying out a few steps from me. In short, completely absorbed, I did not see an enormous wave that threw me against the cliff and I went head over heels into the foam, with all my materials! Immediately I felt myself lost, for the water held me, but finally I was able to get out on all fours, but in such a state, good God!, with my boots, my heavy socks, and my old coat soaked; stuck in my hand, my palette smacked me in the face and my beard was covered with blue, yellow, etc. But finally, the commotion passed; it is nothing at all. The worst thing is that I lost my canvas, which was instantly broken, as well as my easel, my pack, etc. Impossible to fish anything out. Moreover, it was all crushed by the sea, the tramp, as your sister says. In sum, I had a narrow escape, but how I raged to see myself unable to work once I had changed, and to see my canvas, on which I was counting, lost, I was furious.

 (Wildenstein 1979, II, L631).

4. Last year, right here [at Etretat], I often followed Claude Monet in his search for impressions. In fact, he was no longer a painter but a hunter. He used to walk along, followed by children, who carried five or six of his canvases, all depicting the same motif at different times of the day and with different effects.

 He took them up in turn and put them down again, depending on the changes in the sky. Standing before his subject, the painter lay in wait, watching the sun and shadows, capturing in a few brushstrokes a falling ray of light or a passing cloud. Scorning falseness and convention, he put them rapidly on his canvas.

 In this way I saw him snatch a sparkling shower of light on a white cliff and render it in a stream of yellow tones, that depicted amazingly the surprising and fleeting effect of this elusive and dazzling brilliance.

 Quoted in "La vie d'un paysagiste," *Le Gil Blas*, September 28, 1886.

5. Monet was probably referring to the present painting or to W833, which remained in his possession until his death. Wildenstein 1979, II, 275, L684.
6. Evan Charteris, *John Sargent*, New York: Charles Scribner's Sons, 1927, 97.
7. Baltimore 2004–5, 189. Monet himself referred to *Waves at the Manneporte* several years later in a conversation with the American painter Theodore Robinson, as recorded in Robinson's diary (June 3, 1892):

> Called on Monet. He said that he regretted he could not work in the same spirit as once, speaking of the sea sketch Sargent liked so much. At that time anything that pleased him, no matter how transitory, he painted, regardless of the inability to go further than one painting. Now it is only a long continued effort that satisfies him, and it must be an important motif, that is sufficiently *entraînant*.

43 W1024
1. Wildenstein 1979, II, L589.
2. Ibid., L592.
3. Ibid., L629.
4. Herbert 1994, 107-8.
5. *The Complete Letters of Vincent van Gogh*, Greenwich, CT: New York Graphic Society, 1958, III, 77–78, Letter 552.

45, 46 W1288, W1286
1. Wildenstein 1979, III, 258, L1076.
2. Ibid., 260, L1096.
3. Duc de Trévise, "Pilgrimage to Giverny," *La Revue de l'Art Ancien et Moderne*, January and February 1927. Translated in Stuckey 1985, 337.
4. Octave Mirbeau, March 7, 1891, translated in Stuckey, 1985, 157–62.
5. Gustave Geffroy, "Les Meules de Claude Monet," preface to catalogue of *Grainstack* exhibition, translated in Stuckey 1985, 262–65.
6. Camille Pissarro letter of May 5, 1891, John Rewald, ed. *Camille Pissarro, Letters to His Son Lucien* (Santa Barbara: Peregrine Smith, 1981) 165–66.

47 W1304
1. See letter of February 17, 1891, in "Lettres à Monet," *Cahiers d'aujourd'hui*, 5 (November 29, 1922), 170–71.

48 W1331
1. See Washington-San Francisco, 1998–99, 13–23, 79–129.
2. Léon Billet, "Exposition des Beaux-arts," *Journal du Havre*, October 9, 1868, quoted in Stuckey 1985, 40.
3. Wildenstein 1979, I, 425–6, L44.
4. Ibid., III, 268, L1164.
5. Ibid., III, 269, L1172, L1173, L1174. On December 2, Alice's son, Jacques Hoschedé told the American artist Theodore Robinson that this hiatus in Monet's production was the longest the artist had gone without painting (Baltimore-Phoenix-Hartford, 2004–5, 193).
6. Geffroy 1892–1903, VI, 171.

49, 50, and 51 W1317, W1348, W1315
1. Wildenstein, 1979, III, 264, L1156.
2. Pissarro 1990, 85.
3. Georges Clemenceau, "Révolution de cathedrals," *La Justice*, May 20, 1895, cited in Boston-Chicago-London 1989, 180.
4. Robinson to J. Alden Weir, May 1892, cited in Dorothy Weir Young, *The Life and Letters of J. Alden Weir* (New Haven, 1960) 190. Quoted in Boston-Chicago-London 1989–90, 180.
5. Anon., "Claude Monet: Chez Durand-Ruel—le maître impressioniste—un doué," *Le Matin*, May 10, 1895. Quoted in Boston-Chicago-London 1989–90, 180.

52 W1452
1. Wildenstein 1979, III, 289, L1324.
2. Ibid., 291, L1345.
3. Ibid., 294, L1373, L1374, L1386.
4. Ibid., 292, L1358.

53 W1466
1. Fellow Impressionist Gustave Caillebotte died in 1894. Monet was deeply saddened when news of Berthe Morisot's death on March 2, 1895, reached him in Sandviken, Norway. Along with Impressionists Edgar Degas and Auguste Renoir and the Symbolist poet Stéphane Mallarmé, he helped organize a retrospective of her work at Durand-Ruel's gallery.
2. Wildenstein 1979, III, 289, L1322.

54, 55 W1474, W1499
1. Maurice Guillemot, "Claude Monet," *La Revue Illustré*, 13 (March 15, 1898).
2. "Claude Monet." *Le Journal*, June 7, 1898; reprinted in *Le Gaulois*, June 16, 1898 (supplement). *La Vie artistique*, op. cit., VI, 171.
3. Perry,"Reminiscences of Claude Monet from 1889 to 1909," *The American Magazine of Art*, March 1927; in Stuckey 1985, 184.
4. See note 1.
5. René Ménard, in *Portfolio*, October 1875 (quoted in Clara Clement and Laurence Hutton, *Artists of the Nineteenth Century and Their Works* . . . 2 vols., Boston, 1879 I, 161). Also see Michael Clarke, *Corot and the Art of Landscape*, exh. cat. London: British Museum, 1991, 89.
6. Tucker 1995, 164–5.
7. Mirbeau, *Exposition Claude Monet–Auguste Rodin: Galerie Georges Petit*. Paris, 1889, 25.
8. Both W1499 and W1500 were sold to Japanese collectors and are now in the Museum of Western Art in Tokyo. *Morning on the Seine* was first recorded in the Majima collection around 1937, and W1500 is thought to have been purchased by Baron Kojiro Matsukata, who first met Monet in 1921, and acquired thirty-four paintings from him in that year. In light of the stylistic differences between the Tokyo *Morning* and the other works from the series, it is tempting to hypothesize that Monet may have done considerable work on the painting at some point well after 1897.

56 W1509
1. Georges Truffaut, "The Garden of a Great Painter," *Jardinage*, no. 87 (November 1924); as translated in Stuckey 1985, 313–17.
2. As translated in Hoog 1990, 107.
3. A. E. Guyon-Vérax, "Exposition Claude Monet, Galeries Durand-Ruel," *Journal des Artistes*, December 9, 1900, 3314; as translated in Boston-London 1998–99, 34.
4. In 1900 Paris dealer Durand-Ruel exhibited twelve closely related Japanese bridge paintings, including the Princeton picture. Reviewers criticized Monet

> . . . for not having moved around his bridge, for not having sufficiently varied his viewpoint. They cite the Japanese. One is very conscious that they have seen Hokusai's series of bridges . . . [But] Claude Monet has other ideas. It is light, always the play of light that he pursues; and so that we won't question this, he does not wish to distract us by varying his composition. So there are ten versions of the same bridge . . . the water is ten times different . . . the shadows between the trees are lighter or darker . . . the waterlilies sing ten melodies which the grasses accompany in ten different manners

Julien Leclercq 1900, "Le Bassin aux Nymphéas de Claude Monet," *La Chronique des Arts et de la Curiosité*, (December 1, 1900), 36. As translated in Canberra-Perth 2001, 53.

57, 58, 59, 60 W1657, W1729, W1988, W1795
1. Roger Marx, "Les 'Nymphéas' de M. Claude Monet," *Gazette des Beaux-Arts*, 4th series, 1 (June 1909), 523; as translated in Stuckey 1985, 255.
2. Ibid., 256.
3. There are now numerous books on Monet as a garden designer; see, for example, Russell 1995.
4. Willsdon 2004, 220, reproduces an illustration of Latour-Marliac's water garden at the Trocadéro and relates the density of its planting to Monet's water-lily paintings of ca. 1900, such as cat. 56.

61 W1909

1. This idea for a segmented decorative scheme with separate, but thematically related, elements may have been inspired by the decorations Monet devised for Paul Durand-Ruel's paneled dining-room doors, but later elaborated into a grand public monument. On the Durand-Ruel panels, see Wildenstein 1996, II, 344–55.
2. Reproduced in Tucker 1995, 184, fig. 211.
3. Duc de Trévise, "Le Pélerinage á Giverny," *La Revue de l'art ancien et moderne*, LI (February 1927); 130–31; as translated in Stuckey 1985, quotations taken from 339, whole translation 318–41.
4. François Thiébault-Sisson, "Art et curiosité: Un don de Claude Monet á l'Etat," *Le Temps*, October 14, 1920, 2; translated in Stuckey 1985, 302–04.

62 W1975

1. W1975–77; see Wildenstein 1996, IV, 964–65.
2. For a month-to-month chronology of the project, see Chicago 1995, 250–57.
3. For an extensive discussion of the Cleveland painting, see D'Argencourt and Diederen 1999, vol. 2, 458–62. Interestingly, the 1921 photographs are compared with photographs of each canvas in its current state.
4. Ibid.

PHOTOGRAPHY CREDITS